THE TURNER PRIZE

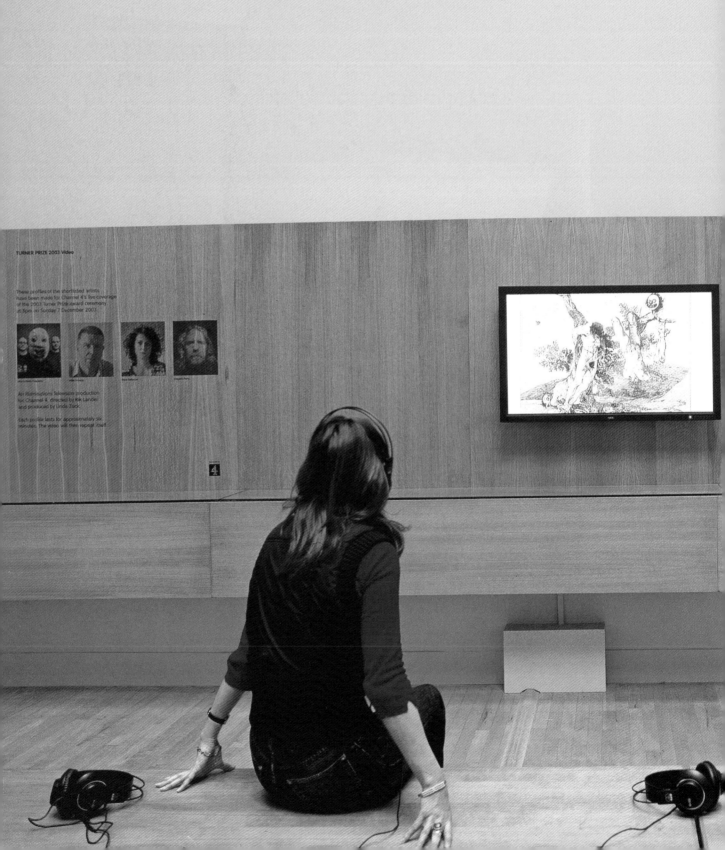

Virginia Button

THE TURNER PRIZE

Tate Publishing

First published 1997 by order
of the Tate Trustees
by Tate Publishing, a division
of Tate Enterprises Ltd,
Millbank, London SW1P 4RG
www.tate.org.uk/publishing

Updated edition published 1999

Revised edition under the title
The Turner Prize: Twenty Years
published 2003

Revised and updated edition
published 2005

This revised and updated edition
published 2007

*British Library Cataloguing in
Publication Data*
A catalogue record for this book is
available from the British Library

ISBN 978 1 85437 756 2

Distributed in the United States and
Canada by Harry N. Abrams, Inc.,
New York

*Library of Congress Cataloging in
Publication Data*
Library of Congress Control Number:
2007934785

Designed by 01.02
Printed by Balding and Mansell

Front cover:
Douglas Gordon, *Confessions of
 a Justified Sinner* 1995 (detail)
Jeremy Deller, *Memory Bucket* 2003
(detail)
Tomma Abts, *Teete* 2003 (detail)
Damien Hirst, *Amodiaquin* 1993
 (detail)
Gillian Wearing, *60 Minutes Silence*
 1996 (detail)
Richard Long, *White Water Line* 1990
(detail)
Chris Ofili, *Afrodizzia (2nd Version)*
 1996 (detail)
Rachel Whiteread, *House* 1993 (detail)
Howard Hodgkin, *A Small Thing
 But My Own* 1983–5 (detail)
Simon Starling, *Shedboatshed
(Mobile Architecture No.2)* 2005
(detail)
Keith Tyson, *Bubble Chambers:
 2 Discrete Modules of Simultaneity*
 2002 (detail)
Antony Gormley, *Testing a World View*
 1993 (detail)

p.2: Installation shot of
the Turner Prize exhibition 2003
Photo: Mark Heathcote

p.6: Installing Damien Hirst's
Mother and Child, Divided for the
Turner Prize exhibition in 1995
Photo: Philip Pestell

*Measurements of artworks
are given in centimetres,
height before width*

Dedication
I would like to dedicate this
book to my daughter Marina,
born on 3 February 1997

Contents

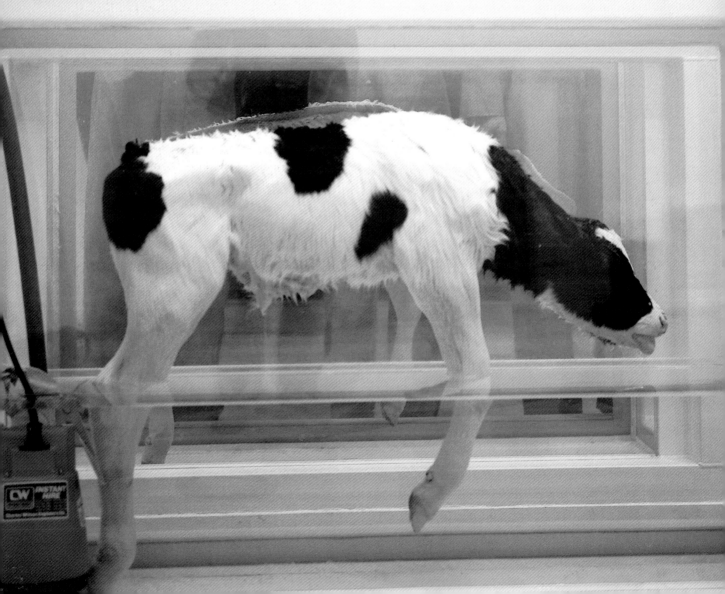

Virginia Button

Author's Note

While working as a Tate curator between 1991 and 2001, I curated the Turner Prize exhibition for six years (1993–8). The idea for this book, first published in 1997 and now in its fifth revised edition, was suggested by Penny Alexander, formerly a Tate Information Officer, in response to growing public demand for information about the event and its participants. Although my account is by no means exhaustive, I hope that it will function as a useful source of reference, and provide an introduction to some of the key achievements in recent British art. I am especially grateful to Claire Bishop, whose preface thoughtfully and knowledgably discusses the wider context of these achievements.

My essay on the history of the Turner Prize draws heavily on Tate Records, and all unfootnoted letters, minutes and background information come from this source. But institutional records, however informative, cannot tell the whole story and I am most grateful to those who provided candid accounts of their involvement with the Turner Prize and its evolution. I am particularly indebted to Sir Alan Bowness, Oliver and Nyda Prenn, and Waldemar Januszczak, who gave generously of their time, and without whom it would have been difficult to write a balanced account of the early history of the prize.

The year-by-year survey aims to provide a basic introduction to each artist, focusing on the time of their association with the prize, and, as far as possible, on work exhibited. For the period 1991–8, I have edited existing Turner Prize exhibition broadsheets, written by me, with the exception of the years 1991–3, when the authors were Sean Rainbird and Simon Wilson, and 1998, when Michela Parkin contributed two essays. For subsequent years – with the exceptions of 2003, 2005 and 2007 – I have edited essays from exhibition broadsheets written by Mary Horlock, Sean Rainbird and Simon Wilson in 1999; Mary Horlock, Ben Tufnell and Jemima Montagu in 2000; Katharine Stout, Tanya Barson and Rachel Meredith in 2001; Lizzie Carey-Thomas and Katharine Stout in 2002; Carolyn Kerr, Lizzie Carey-Thomas, Katharine Stout and Rachel Tant in 2004; and Lizzie Carey-Thomas, Katharine Stout and Gair Boase in 2006. I would like to credit all these authors for their invaluable contributions. I am also grateful to artists and their representatives for generously supplying information and many of the illustrations.

Clearly, a project of this kind is by its nature collaborative, and I would like to acknowledge all my former colleagues at Tate who have in some way contributed to the book's production, in particular Brenda Brinkley, Celia Clear, Mary Horlock and Jane Ruddell. Special thanks also go to Adam Brown, Melissa Larner, Ben Luke, Katharine Stout, Lizzie Carey-Thomas, and the editors of previous editions, Sarah Derry and Mary Richards. I also extend my warmest thanks to the Tate Publishing team: Roger Thorp, Emma Woodiwiss and Beth Thomas, and finally special thanks to Alice Chasey, who expertly edited and guided revision of the book in 2005. It has been a great pleasure working with her again to produce this new edition.

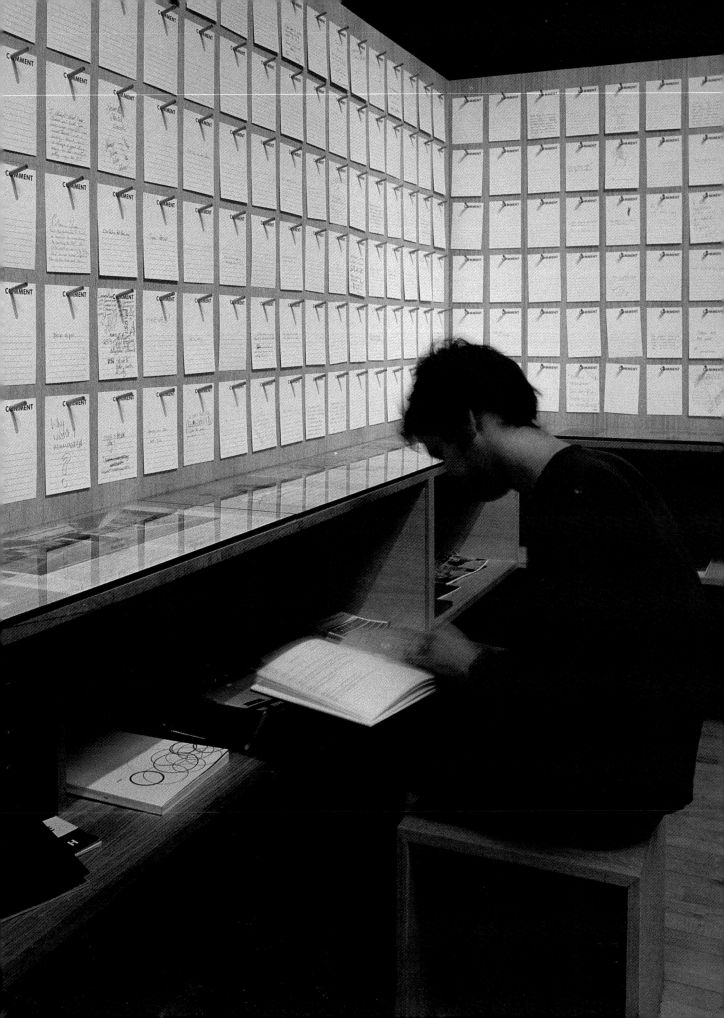

Claire Bishop

Preface

It could be argued that there are too many prizes for contemporary art. In Britain alone there are at least eight, usually for achievements in specific media (painting, sculpture, photography). Each one offers the winner a handsome cheque and a potential catapult to future success. Amidst this glut of competitions, the Turner Prize retains a distinct identity – an effect of its high-profile media sponsorship, the simplicity of its format (four nominees, one winner) and the fact that it does not focus exclusively on traditional artistic media such as painting and sculpture; traffic cones, dead animals, blackboards, beanbags, dung and beds have all featured as materials. As such, the Turner Prize has found itself ripe for annual tabloid derision – but this is not solely as a result of the type of art it promotes. What prompts the media to home in on this prize over all the others is the fact that it is backed by the full weight of a national and historical museum: Tate. The institutional support of this art, and the press amusement it engenders, have consequently made the Turner Prize the only contemporary art award to impinge in any way upon national consciousness.

Nevertheless, the general reaction to the prize has noticeably shifted since the early 1990s when it established its present format. Looking back at this period, it is alarming to see how the general tenor of press response was like teenage boys giggling at the back of the classroom. What little discussion took place was cursory and often wildly inappropriate, zooming in on the *moral* implications of a particular artist's methods or choice of materials: the amount of rice wasted in Vong Phaophanit's *Neon Rice Field* in 1993, the rights of animals in relation to Damien Hirst's *Mother and Child, Divided* in 1995, and the artist's own integrity when the policemen in Gillian Wearing's video *60 Minutes Silence* were revealed to be actors (1997). But by this year, the mood had begun to change. Newspapers started to run substantially longer profiles on the nominated artists, while colour supplements and style magazines covered individual figures in more depth – although it is telling that this shift occurred in a year when the shortlist was all female. New public awareness of key figures in young British art, such as Damien Hirst and Tracey Emin (following her infamous drunken appearance on a television panel following the 1997 Turner Prize), owed much to the distinctive media personalities of these artists, who regarded press attention as an important means to cultivate a wider audience. Most importantly, 1997 witnessed the establishment's affirmation of young British art through the Royal Academy's exhibition of Charles Saatchi's collection, *Sensation*, as well as numerous overseas shows organised by the British Council. The embrace of contemporary culture by the recently elected New Labour further consolidated the mood of celebratory approval in regard to young British achievements in art, fashion, design and music.

The quality and quantity of debate around the Turner Prize has on the whole continued to improve since 1997, but press coverage still remains superficial. Focused discussion of the art's wider context is a rarity, as both popular and specialist press remain content to provide characterisations of the four nominees without reference to the bigger picture, desperate to keep the subject easy to digest. Complex works of art are time and again reduced to a sketchy caricature and a catchy headline. Such an aversion to

Comments Room,
Turner Prize exhibition,
2002

complexity lamentably presupposes that the 'public' (presumed to be low in IQ and resistant if not hostile to the new) is incapable of investigating ideas in depth. Some of the feeblest responses to the shortlisted artists have come from the broadsheets, who sneer at the artists precisely for their reticence to explain what the work is 'about'. In a culture overexposed to the means–ends relationships of marketing – the dominant mode of our day-to-day visual experience – it is seen as desirable for images to bear a quick-sell message. Much art of the 1990s has explored this soundbite culture, cynically beating the press at its own game (Hirst is a good example) – but this has made it harder for artists who choose to work in more subtle ways. It would be nice to think that the heightened public appetite for art in the 1990s derives from a desire for alternatives to dumbing down, but it remains a fact that most people experience the Turner Prize primarily through press coverage, and only secondarily through the Tate exhibition itself.

One effect of this media overemphasis on the 'message' of works of art has been to treat Turner Prize art in a historical and political vacuum. For example, it is never remarked that the Turner Prize display is always shown in conjunction with historical exhibitions, such as Thomas Gainsborough (2002), John Singer Sargent (1998), or the Bloomsbury Group (1999). By programming in this way, Tate implies that the work shown in the context of the Prize might be the future of British art history, and may one day enter its collection. It is not unsurprising, then, that so many of the winners do go on to have their work acquired by Tate; one jury member is always a collector, a representative of the Patrons of New Art. The institution benefits from the publicity afforded by the Turner Prize, while using the latter to legitimate its acquisition policy. This has a direct bearing on the type of art nominated for the Prize, as I will discuss below. What follows, then, is an attempt to compensate for the general lack of engagement with the broader context of the art shown in the Turner Prize, and to offer some thoughts about how it is possible to compare and judge the different types of work that the exhibition presents.

2.

As an award for British artists, and artists working in Britain, the Turner Prize reflects trends prominent in this country but not necessarily representative of today's art as a whole. Continental Europe has recently seen a different type of work emerging. Less preoccupied with the creation of discrete objects, and preferring instead to stage situations that solicit the interaction of the viewer, these artists make work to be *used* rather than contemplated, and the results often appear to be a branch of design or architecture as opposed to art. This tendency – which the French art critic Nicolas Bourriaud has termed 'relational aesthetics' – has made little impact on the Turner Prize, appearing only in the work of Angela Bulloch (1997) and Liam Gillick (2002). It is telling that the displays of both artists were regarded as difficult and esoteric by the press. Bourriaud also identified the idea of 'post-production' as paradigmatic of 1990s art; in other words, work that remixes (and thereby recontextualises) already existing cultural products such as film, television programmes and other works of art. Among the Turner Prize artists, perhaps only Douglas Gordon (1996) could be considered exemplary of this trend.

The United States, by contrast, has witnessed a different range of artistic tendencies since the 1990s. The first half of the decade saw the institutional apotheosis of large-scale, surrealistic installations (Robert Gober, Ann Hamilton, Tony Oursler), counterbalanced by a cool, analytical, research-based practice that investigated phenomena from a variety of political and media-critical positions (Mark Dion, Andrea Fraser, Renée Green); this latter type of work has been represented in the Turner Prize only through the work of Christine Borland (1997). US art of the later 1990s and early twenty-first century offers more parallels with British art: a renewed interest in

painting (John Currin, Elizabeth Peyton) – reflecting the conservative tendencies of the art market – but also the rise of a polished and sophisticated brand of video installation (Doug Aitken, Shirin Neshat, Matthew Barney), well represented in the Turner Prize exhibitions through the work of Jane and Louise Wilson (1999), Isaac Julien (2000) and many others.

Charles Saatchi's attempt to generate a post-YBA movement in the form of 'Neurotic Realism' (1998) made little impact on the Prize. Work with a DIY, homespun aesthetic formed an important part of this trend, but has so far been represented only by Tomoko Takahashi (2000). Those artists whose practice comprises more ephemeral interventions into public space have rarely been represented, and performance art never. This is significant: the Turner Prize is a museum-endorsed competition, and therefore favours art that allows it to perpetuate a conservational role as the repository of national treasures. The transient and ephemeral are invariably sidelined, since they cannot be accommodated by such an institution. The same goes for site-specific installation art, which was seen at the time of its inception as a way to circumvent the art market – because the pieces were inextricably bound to their location they couldn't be sold – and thereby the museum. Although there have been many installations in the Turner Prize shows, few have been made specifically for the galleries in the Tate. Works by Tomoko Takahashi and Mike Nelson (2001) are notable exceptions, but it is perhaps indicative of the pressure that the Prize places on artists that those working *in situ* in this risky medium have not produced their best work in these conditions, and have not yet been among the winners. This points to a persistent problem with the Prize: even though it is supposed to be awarded for an artist's all-round contribution to art, the final exhibition can play a more significant role than is ever officially acknowledged.

Installation and video are widely presupposed to be the privileged mode of Turner Prize art, and the whole exhibition is often pigeonholed as 'conceptual'. Yet these labels are used loosely, without acknowledgement that the majority of works shown in the exhibitions still comprise self-contained, portable objects: photography, sculpture and variations on painting. 'Conceptualism' has become a catch-all term for any art with an idea, and is pretty much divorced from the type of art that initially emerged under this epithet in the late 1960s and 1970s. During this period, an important strand of conceptual art was referred to as 'dematerialised', because documentation (in the form of typewritten instructions or black and white snapshots) was all that remained of the work. This austerity is a far cry from the visually lavish work of 'conceptualist' Turner nominees such as Mark Wallinger (1995), Cornelia Parker (1997) and Glenn Brown (2000), but an interest in dematerialised gestures and textual substitutes nonetheless persists in the work of Martin Creed (2001) and to a lesser extent Fiona Banner (2002).

Many visitors – like the MP Kim Howells in 2002 – regard art in the Turner Prize as 'cold' and 'mechanical' for its conceptualist leanings. In this respect, it is worth considering the overwhelming public response to Tracey Emin's display in 1999, when visitor figures reached an all-time high. Emin is one of the few artists working today whose practice is explicitly expressionist (rather than conceptual); referencing her colourful life history, Emin's art appeals to an immediate experience of human emotions. This autobiographical stance is noticeably at odds with the majority of Turner nominees, many of whom were subject to courses in theory at art school, and whose thinking has as a consequence been filtered through critiques of authenticity and originality, and through an acknowledgement of the omnipresence of mass-media. In this context it is ironic that the centrepiece of Emin's display, *My Bed*, became one of the most 'mediated' icons of that year, spoofed everywhere from cartoons to quiz shows.

Emin's videos, along with the work of Steven Pippin (also 1999), are among the few examples of video art in the Turner Prize to resemble the early days of this medium.

In the late 1960s and 1970s, artists adopted a casual, often chaotic approach to recording video, frequently as the documentation of a performance, and in direct opposition to the slick productions of commercial television. The rise of video installation and the availability of new technology have led to a more professionalised approach to production values. There is more attention to formal detail and seduction of the viewer in the work of Gillian Wearing (1997), Jane and Louise Wilson (1999) and Steve McQueen (1999) than their precursors in the early 1970s would ever have permitted or thought possible.

Photography, like installation art, only acquired institutional recognition as 'high art' in the 1980s, when artists such as Cindy Sherman and Jeff Wall approached the medium conceptually, staging images and manipulating them digitally. Only one winner of the Turner Prize to date has been a photographer – Wolfgang Tillmans (2000) – and it is significant that his work not only combines documentary and fiction, but straddles two distribution contexts (lifestyle magazines and art galleries). Moreover, in Tillmans's careful presentation of his images, tailoring their arrangement to each venue, he encroaches on the terrains of installation art and curating.

3.

The Turner Prize, then, is the 'post-medium' art prize *par excellence*: its photographers are curators, its painters are conceptualists, its film-makers are sculptors, and its installation artists merge many of these disciplines into one. Other art prizes in Britain remain tied to the conventions of a medium-specific practice and the judging of art has traditionally occurred within a medium-specific context – as painting, photography or sculpture. This raises the question of how – given the collapse of medium-specificity – we are to judge art today. Many critics avoid this question by disparaging the very idea of comparing art, claiming that competition is inimical to aesthetics. They argue that a collapse of medium-specificity is liberating, and frees us not only from the shackles of tradition, but also from the dangerous myth that objective judgements are possible. Yet the drawbacks of this open-armed, ecstatic postmodernism are manifold: everything in the world becomes equalised in value, since all that matters is our personal, subjective engagement with the object. Orphaned from a historical context, the works of art become isolated phenomena that render comparative judgements redundant.

This presents us with a problem, because the concept of a prize continues to uphold a belief that aesthetic judgement is possible. This dimension is often lost in press coverage, which presents the task of the jury as either arbitrary or entirely subjective. The former might be called the 'dice-roll theory', in which the very task of deciding on a winner is deemed impossible, since each artist presents such radically distinct work that they cannot be compared. As Adrian Searle observed in 1996, 'the current contenders are dealing with issues so divergent, and working in such utterly different ways, as to make a nonsense of comparative judgements. Do you prefer bananas or Ford Fiestas, the Cairngorms or Persil?' (*The Guardian*, 29 November). The second theory suggests that it's all about verbal persuasion: the award is made by a small group of insiders (the jury), presided over by the gallery director (Nicholas Serota), each advocating their favourite nominee. Elizabeth Macgregor, a member of the jury in 1995, testified to the absurdity of 'a prize for visual merit being decided by the force of argument'; the winner, she asserted, is decided by 'the judge most adept at presenting his or her personal choice' (*New Statesman*, 28 November 1997). The subjectivity theory has in recent years been reinforced by the inclusion of jury members' photographs in the exhibition broadsheet, alongside those of the artists.

Yet even if rhetoric does play such a leading role in establishing the winner, identifiable criteria must still underpin the jury members' arguments. Is it possible to observe, from the trajectory of Prize winners past, what these criteria might be? Endless lists of qualities could be drawn up – formal coherence, conceptual rigour, subtlety,

versatility, concision – but this naming feels authoritarian and old-fashioned, not to mention a little random. How might we instead begin to reinvent the idea of criteria in relation to post-medium works of art? How might we go about comparing the Cairngorms and Persil?

In my view, good art structures the terms of our encounter with it in a way that is appropriate to its theme and presentation, and which allows these themes to speak to us on many levels. This is not a question of flatly imposing an array of externally conjured criteria onto all art, but a matter of engaging with the artist's practice as a whole, and its relationship to history. Tate Britain attempts to assist the viewer in doing this: the dedicated information space at the end of the Turner Prize display – with books, a video, and more recently the opportunity to give feedback – is one of the largest and most comprehensive to be offered in that museum. Even so, understanding an artist's entire practice is not necessarily possible in the context of Tate: some art is simply not made to be seen in those galleries, or for that matter in any museum. Institutional framing can make or break our perception of an artist's work. On top of this, the sequential presentation of the four nominees in the gallery must be carefully staged if justice is to be done to each. The exhibition in 2002 showed how dramatic juxtapositions can backfire: the opening room, packed with Keith Tyson's vibrantly explosive drawings, was followed by Liam Gillick's pared-down installation, and did no favours to the latter. The shift was visually spectacular, but did not allow for an adequate transition in the viewer's mode of attention.

Despite the importance of contextual issues and curatorial (dis)servicing, I would like to defend the idea of aesthetic judgement – not as an absolute verdict on the genius of a particular artist for all time, but as an exercise in thinking about what we value. I believe that we *can* say, at any given moment, that some works of art are better than others. I have indicated my own criteria, but ultimately it doesn't matter whether yours are the same as mine. The important point is that when I say 'this is good art' and justify it, I presuppose that people can agree with me – although of course they're free not to. This judgement is not a dispensation from on high (although with museums you'd often be forgiven for thinking so), but an expression of the fact that I exist among other human beings, and that we are capable of regulating and modulating our ideas together. In other words, judging isn't about the outcome, but the process. Understanding what we value in a work of art – or for that matter a play, a record, a book or a film – reveals to us not simply our personal preferences, but a whole array of values that inevitably produce the temper of our society as a whole.

A History of the Turner Prize

The Turner Prize is now established as a national and international event, on a par with Wimbledon or the Grand National. As such, it has made a significant contribution to the surge of interest in contemporary British art over the last decade. Through events such as the Turner Prize, Tate undoubtedly endorses changing ideas of contemporary art practice, but the prize does not create art movements. Museums by their nature respond to what is already happening, and often after a slight time-lag.

The prize was not set up to attract controversy, but it has always actively sought publicity. For this it has, at times, been condemned as nothing but a media circus, pandering to the worst aspects of our headline- and celebrity-driven culture. But as a mechanism for raising awareness of contemporary British art, and widening access to high culture in this country, the Turner Prize is without peer. Numerous other awards followed in its wake, both at home and abroad, notably the Jerwood prizes for painting, sculpture and drawing, the Guggenheim's Hugo Boss Art Prize in New York, and the Prix Marcel Duchamp in Paris.[1] But, as art critic Iain Gale recently commented: 'Art prizes abound – all might learn from the Turner. It is a benchmark. If it didn't exist we would have to invent it. It stimulates debate, it engages and provokes. We need such catalysts. Love it or loathe it, the Turner has gradually put contemporary art within the public domain.'[2]

The uncompromising aim of the prize – to promote new art – has been both its strength and the cause of intense criticism. In 2002, following particularly fierce condemnation of the jury's disregard for traditional forms of art practice in favour of so-called conceptual art, Tate Director Nicholas Serota reminded the press that the Turner 'was established as a prize that would bring to the fore younger artists and artists working in new ways. It wasn't intended to be an objective survey of all artists across all fields saying, "This is the best."' Its juries, he pointed out, make judgements that are subjective, contingent and temporal. As Guardian critic Jonathan Jones summed up: 'This is not an objective prize ... It is intentionally outrageous. As such, it is the antithesis of the Oscars or the Eisteddfod, which in their different ways maintain a tradition. Uniquely, the Turner assaults tradition.'[3]

The success of the prize in drawing contemporary British art to the attention of a wider audience owes a huge debt to media-generated outrage. But the 'shock-horror' headlines are surely more revealing of a resistance to the 'new' in British culture, particularly in the visual arts, than of the radicalism of contemporary art. Many of the shortlisted artists have previously established reputations abroad, where their work has been admired and collected without sparking national scandal. And given that the history of art in the twentieth century was in part defined by a non-traditional or non-hierarchical use of materials, it seems curious that a piece such as Vong Phaophanit's *Neon Rice Field* should so exercise the British press when exhibited in 1993.

In its infancy, public debate around the prize centred on serious questioning of its purpose and format – its current terms and conditions evolved in response to such criticisms. Although its format has not altered since 1991, the earlier chameleon-like identity of the prize served to foster its contentious reputation. This book aims to give

1 In 2007, the Jerwood Painting Prize, established by the Jerwood Foundation in the 1990s, was replaced by 'Jerwood Contemporary Painters', an exhibition representing thirty artists, although the Jerwood Drawing Prize continues to exist together with a range of Jerwood Charitable Foundation awards for other activities, such as applied arts. Beck's Futures Art Prize at the Institute of Contemporary Arts (ICA), London, set up in the late 1990s in reaction to promote young, emerging artists, has also run its course. Howver, the ICA has announced its intention to launch a new prize in 2008 to coincide with its sixtieth anniversary. Other prizes established in the UK include, for example, Comme Ca Art Prize North, worth £10,000, launched by the Manchester art agency Comme Ca Art in March 2003 to draw attention to artists working in the North of England (its first patron is Chris Ofili, Turner Prize winner in 1998); and most recently Artes Mundi, the Wales International Visual Arts Prize, the first of which was awarded in spring 2004.
2 Iain Gale, 'The Turner Prize – What a turnaround', *Scotland on Sunday*, 4 November 2001, p.13.
3 Jonathan Jones, 'Everyone's a critic', *Guardian*, 9 April 2002, pp.12, 14.

Vong Phaophanit at work on *Neon Rice Field* at the Tate Gallery in 1993

Evening Standard, 4 November 1993

an account of the development of the prize, and to introduce the reader to some of the debates and controversies it has engendered in its now twenty-year history. More importantly, it documents the artists who have been shortlisted, and provides a record of the work successive juries have considered to be the most interesting new art of their day. It also pays tribute to those who instigated a prize that has forced contemporary British art from its peripheral position, into the heart of national cultural life.

The Patrons of New Art

The Turner Prize was founded by the Patrons of New Art (PNA) in 1984. Its genesis is inextricably linked to the early history of this group, established in 1982 under the directorship of Alan Bowness to assist in the acquisition of new art for the Tate Gallery's collection, and to encourage a wider interest in contemporary art.

The early 1980s marked a sea change in the status of national museums as publicly funded institutions. Under the Thatcher government, elected in 1979, it soon became clear that such institutions would need increasingly to rely on entrepreneurial endeavour and private sources to finance many of their activities. This shift was summed up by Alan Bowness in 1986:

> Political decisions have been taken to give the museums greater independence, and much is being done to stimulate an increase in private giving in order to reduce the financial dependence on Government-provided funds. All this involves a new status for the museums: instead of being institutions in receipt of a directly provided parliamentary vote, they are to become grant-assisted bodies ... it signifies a fundamental shift of responsibility for the financial well-being of the museum from Government to Trustees.[4]

4 *The Tate Gallery Illustrated Biennial Report 1984–6*, p.17. In 1980 the traditional annual increase in the level of grant-in-aid ceased.

Bowness arrived as director of the Tate in 1980. He had belonged to the existing support group, the Friends of the Tate, for many years. Although he admired what the Friends

"The repose and calm of this work of art reflects the simplicity and restraint of my earlier period, the symbolism remains personal and eludes exact interpretation."

were doing he felt there was room for a smaller, high-powered group particularly interested in contemporary art. In establishing the patrons he hoped to foster a cluster of enthusiastic collectors who would support the British art of their own time, thus helping to enrich the nation's future heritage. Charles and Doris Saatchi, two of the most important collectors of contemporary art, were living in London, and the time seemed ripe to encourage others to follow their example in collecting contemporary work.[5] It was part of the Gallery's remit to acquire contemporary British art, but there was a need to avoid the furore caused in the 1970s by the purchase of Carl Andre's *Equivalent VIII* (dubbed 'the bricks'). In purchasing contemporary work for the Gallery, with money raised annually through subscriptions, the patrons could usefully assist the Tate in acquiring difficult or controversial new work without the need for 'public' expenditure.

The founding of the PNA also dovetailed with the Gallery's existing plans to develop the site at Millbank which had begun with the Clore Foundation's donation in 1980 for a gallery to house the Turner Bequest. Central to these plans was the creation of a 'Gallery of New Art', along with a gallery dedicated to sculpture and a study centre. A press release announcing the aims of the patrons anticipated that acquisitions made by the group would 'eventually become the nucleus of a Museum of New Art, devoted exclusively to recent developments, which will become an integral, but distinct, part of the Tate Gallery'.

The early 1980s witnessed a shift in the aesthetic climate of international modernism, which during the 1970s had been dominated by minimal and conceptual art. The return of a more expressive and figurative style of painting seemed symptomatic of this change. Variously described as 'new painting', 'new image painting', 'new expressionist', 'wild painting' or '*heftige malerei*' this emergent tendency was perhaps most clearly defined by *A New Spirit in Painting*, an exhibition organised by Christos M. Joachimides, Norman Rosenthal and Nicholas Serota for the Royal Academy of Arts in London at the beginning of 1981. In their selection, including thirty-eight artists from three generations, the organisers attempted to 'discover ... common threads which cross national boundaries and which can be related to the great traditions of European and American painting. By doing so we hope that we might help regain for painting that wide audience which it has always claimed, but which it has recently lost.'[6] The 'New Spirit' was passionate. Unlike the cool and apparently cerebral art of the 1970s, much of which had notoriously alienated audiences, this 'new' art, with its reassessment of traditional values and emphasis on

5 Charles Saatchi, with his brother Maurice, founded the advertising agency Saatchi & Saatchi in 1970. Charles's interest in contemporary art began in the 1960s and later, with the encouragement of his first wife, Doris Lockhart, he became a serious collector. In 1985 he opened a gallery in Boundary Road, St John's Wood, London, as a public showcase for his collection.
6 *A New Spirit in Painting*, Royal Academy of Arts (15 January–18 March 1981) 1981, p.12.

'subjective vision', seemed less forbidding. It thrived on the cult of artistic personalities such as Georg Baselitz, Francis Bacon and Julian Schnabel. By promoting a universal expressionist style, the new painting also encouraged and celebrated the revival of specifically national schools.

Inspired by such developments and a new generation of emerging British artists, the Patrons of New Art aimed to help the Tate record the moment for the future and to bring new developments in art to the attention of a wide audience. A number of critics, however, could only view the 'New Painting' as evidence of the art world's need to reinvent itself, to keep art markets buoyant. This view was particularly attractive to British critics, who felt uneasy about the presence of Charles and Doris Saatchi, collectors whose taste could sway the international market. Saatchi & Saatchi had, after all, helped the Tories sweep to power with their 'Labour isn't Working' advertising campaign. Charles Saatchi's enthusiasm for 'New Painting' accrued notoriety in the summer of 1982 when the Tate held a small exhibition of paintings by the young American artist Julian Schnabel. The fact that nine of the eleven pictures were lent by the Saatchis sparked a fit of critical rage. In a country unused to blatant consumption of contemporary art, and amidst fears that private sponsors would soon be calling the shots in public spaces, such a hostile response might seem inevitable. Saatchi had been on the founding committee of the PNA with Felicity Waley-Cohen and Max Gordon, but curtailed his involvement shortly after this incident.[7]

A Glittering Prize

Administered under the umbrella of the Friends of the Tate Gallery, the PNA were keen to establish their own identity and to find ways of actively extending their support for the Tate. On 30 November 1982 at the second meeting of the New Art Committee (the executive committee of the PNA), the architect Max Gordon suggested the idea of an annual prize.[8] He proposed – prophetically, as it turned out – that such an event should be 'sponsored by a large company, possibly in collaboration with Channel 4 Television, for achievement in the visual arts'. At the first formal general meeting of the PNA, held on 17 October 1983, Alan Bowness announced outline plans for a scholarship or prize similar in status to the Booker Prize. The following month he reported to the New Art Committee that an anonymous sponsor had offered to fund the prize for three years at £10,000 per year. This sponsor was Oliver Prenn, a founder member of the PNA, who with his wife Nyda had been collecting modern art since the early 1970s. Prenn had attended the general meeting and, after giving the matter some thought, approached Bowness with an offer of sponsorship. Prenn had enjoyed business success in the 1970s and had set up a charitable fund, but sponsoring the Turner Prize represented his first charitable support for the visual arts. He was anxious to avoid any kind of national newspaper story at the time, and asked that anonymity be the only condition of his sponsorship. Such terms suited the needs of the institution and Bowness was extremely grateful to Prenn for stepping forward. Although he had successfully worked with sponsors for exhibitions, the director was against the idea of attaching a sponsor's name to the prize: 'that was the risk, the "Polo-Mint" Turner Prize, or something similar, whereas Oliver was generous enough to say it was a good idea and he would just supply the cash'. Although he was personally enthusiastic about the prize, Prenn was a model sponsor and respected the hands-off policy adopted by the Tate Gallery. Ironically, against a backdrop of conspiracy theories, the secrecy surrounding his sponsorship led to wild accusations about the source of funding.[9]

Now that the prize had secured tangible means of financial support, the next step was to find an appropriate name.

In the Name of Turner

Critics have frequently speculated as to whether the prize would have had Turner's personal blessing. Reporting on the first award ceremony, Marina Vaizey wrote: 'I can't

7 Despite Saatchi's withdrawal from the patrons he was again accused of pulling strings when Malcom Morley won the first Turner Prize, as he was a keen collector of Morley's work (see Peter Fuller, New Society, 15 November 1984, p.249).

8 In 1981, after a distinguished career in various architectural partnerships, Max Gordon (1931–1990) set up an independent practice and consultancy devoted to art-related architecture. Writing Gordon's obituary for the Independent, 27 August 1990, Michael Craig-Martin commented: 'Gordon was a true internationalist ... A distinguished art collector himself ... He used his professional connections to bring together people in the art world from both sides of the Atlantic. He was discreetly but significantly helpful in internationalising the reputations of many British artists over the past twenty-five years.' Gordon was also widely praised for his conversion of a paint warehouse in Boundary Road into a gallery for the Saatchi Collection.

The original members of the New Art Committee were Penny Allen, Cherry Barnett, Max Gordon, Patrick Rodier, Charles Saatchi, Felicity Samuel (Mrs Waley-Cohen), Alan Bowness, Michael Compton and Richard Francis.

9 See, for example, Peter Fuller, Art Monthly, no.82, Dec.–Jan. 1984–5, pp.2–6, p.4; Turner Society News, no.33, Summer 1984, p.7.

help feeling that Turner, a dab hand at making an impact, in his top hat with brush at the ready on Varnishing Day at the Royal Academy, would have taken to it no end.' But Peter Fuller stated: 'I am sure that, like me, Turner would have boycotted the goings on at the Tate.'[10]

Whatever Turner's view, the naming of the prize has proved as provocative as any other aspect of its history. What they perceived as the hijacking of Turner's name for an upstart contemporary prize incensed Turner's supporters, as did the fact that the gallery at the Tate designated to house Turner's bequest was to be called the 'Clore Gallery for the Turner Collection', not simply 'Turner's Gallery', as had been stipulated in his will. It seemed that sponsors or donors were again to blame.

When the prize was first announced, the chief complaint was that there appeared to be no connection between Joseph Mallard William Turner and the newly launched prize. As one writer inveighed:

> What, one might wonder, has all this got to do with Turner? The simple answer is nothing. Not one of the judges has any particular connection with Turner and any connections between the artists' work and that of Turner are remote in the extreme.

Worse still was that Turner himself had left provision for a young artists' prize, which had been ignored along with other wishes expressed in his will. In his first codicil of August 1832 he gave money to the Royal Academy so that they might have a dinner to celebrate his birthday and award 'a Medal called Turner's Medal', together with a prize of about £20, 'for the best Landscape every two years'. In the fifth codicil of 1 February 1849, he made 'a Medal for Landscape Painting and marked with my name upon it as Turner's Medal silver or gold on their discretion' the condition of their receiving any money at all. Despite the fact that the Academy got £20,000 out of Turner's estate, neither the medal nor the prize was given in perpetuity as he had clearly intended.[11]

Waldemar Januszczak was among the critics angered by the handling of the Turner Bequest, and against this background he too questioned the propriety of attaching Turner's name to the prize. However, years later, as Commissioning Editor for Arts at Channel 4, he argued cogently in favour of retaining the name in the sponsor's foreword to the 1991 Turner Prize exhibition pamphlet. His defence pivoted around the fact that Turner, widely recognised as Britain's greatest artist, had been dismissed in his own day as a fraud: 'We now know that these angry contemporaries of Turner were wrong, and guilty of massive misunderstanding. Which is why it is so appropriate that Turner should have given his name to an award whose ambition is to look at, encourage and champion new art in Britain.'

Considerable debate took place before the name of the new prize was announced. Indeed, the first jury had already been appointed before it had even been decided. In January 1984 Alan Bowness reported to the New Art Committee that he had discussed their suggestions with the Trustees. The Trustees were opposed to the name 'Tate', unenthusiastic about 'Turner', and preferred 'New Art' or 'Millbank'. But in May, at the tenth meeting of the New Art Committee, Bowness confirmed that the annual award was to be called the Turner Prize, having in the intervening months convinced the Trustees that it deserved a name that would stand for great achievement in British art, as well as appealing to a wider audience. Bowness knew of Turner's desire to establish a prize for younger artists, and felt it was legitimate to appropriate Turner's name. He had served on panels for a number of prestigious foreign prizes in the 1970s (among them the Rembrandt Prize), and was convinced that Britain should have its own illustrious award. Most countries honour the achievements of their living artists. In France, for example, the Ministry of Culture awards the Grand Prix National des Arts annually to a French artist for outstanding work in one of the fine arts. In Holland, the Amsterdam Prizes, awarded by the Amsterdam Foundation for the Arts, are given every two to three

10 Marina Vaizey, *Sunday Times*, 11 November 1984, p.40; Peter Fuller, *Art Monthly*, no.82, Dec.–Jan. 1984–5, pp.2–6, p.2.
11 *Turner Society News*, no.33, Summer 1984, p.7.

years, the individual prizes bearing the names of great Dutch artists.

The PNA's prize would need to distinguish itself from existing awards, such as the John Moores Prize for painting and the Hunting Group Art Prizes, and from a flurry of more recently established arts prizes such as the Imperial Tobacco Portrait Awards at the National Portrait Gallery. However, it was not a visual arts prize that the Turner was set up to rival, but a literary one – the Booker Prize for Fiction sponsored by Booker McConnell Ltd.

A Novel Idea

The Booker Prize, administered by the National Book League, was established in 1968 for the best full-length novel written in English by a citizen of the United Kingdom, Commonwealth, Eire or South Africa. Bowness recalls being impressed with the way in which the Booker had become a household name: 'The first ten years of the Booker were not much publicised, but suddenly – in the 1980s particularly when people like Anita Brookner won the Booker Prize for *Hotel du Lac* ... everybody but everybody was talking about it.' He made no secret of the fact that this sure-footed literary prize had been consciously emulated. For the Booker, publishers are invited to submit entries from which a shortlist is chosen, the winner being selected by a panel of jurors and announced at a televised award ceremony in the autumn. Each year this format brings a handful of novels under public scrutiny. The competitive edge seems to encourage people to buy and read the books, and to make up their own minds about the novelists under consideration.

Bowness, Prenn and Gordon hoped that contemporary art would attain a position in British cultural life on a par with that of the 'English' novel. But during the first few years of the Turner Prize, as it gradually muscled its way into the spotlight, the pertinence of a literary model for a visual arts prize was questioned. Commenting on the advent of the first Turner Prize, Laurence Marks reported: 'The idea ... is to do for new art what the Booker Prize has done for new fiction: generate a great cloud of fuss, feuding, gossip, theatrical controversy, dismissive remarks about the great modernists, and so forth, that will focus public attention on what artists are up to.' But he doubted whether the Turner could outstrip the success of the Booker. The prize money of £10,000 was a paltry sum compared with the cost of some contemporary art. Was it thus worth winning? Another problem was the gulf between contemporary art and levels of critical understanding:

> Most novelists who reach the Booker shortlist are writing within a recognisable narrative tradition. Anyone who is even casually interested in contemporary fiction can express a reasonably confident personal opinion as to their literary value, however fallible ... Nothing like the same exists in relation to 1980s visual art, whose frontiers seem to change every time you look up.[12]

The Booker, he concluded, was worth winning, as it could significantly enlarge an author's readership. But how could the Turner possibly swell the number of an artist's collectors?

A 'Knees-up at Aunt Tate'?

A 'razzmatazz knees-up' at stuffy aunt Tate was how Grey Gowrie, Minister for the Arts, described the first Turner Prize award ceremony, as he declared Malcolm Morley the winner: 'It is a credit to Alan Bowness,' he concluded, 'that he has allowed the Tate to let her hair down.'[13] In the early 1980s this descent from Mount Olympus into the machiavellian world of the media offended several sensibilities. Many critics objected to the close relationship between the Turner Prize and the media, arguing that the highbrow aims of art are inevitably tarnished by the lowbrow mechanisms of mass communications. But such channels of communication and information are a requisite for raising awareness of contemporary art. Since 1991 the prize has enjoyed guaranteed annual television coverage from its Channel 4 sponsors. Such, indeed, is its media status that

12 Laurence Marks, *Observer Review*, 4 Nov. 1984, p.23.
13 *PNA Newsletter*, no.6, Spring 1985, p.6.

since 1991 various groups have cruised into the public eye on the back of it, often staging protests at Millbank on the evening of the award ceremony. These have included the pressure group Fanny Adams, protesting against the male domination of the art world, the K Foundation (formerly the pop band KLF, who awarded £40,000 to Rachel Whiteread as the 'worst' shortlisted artist in 1993), and FAT (Fashion Architecture and Taste) who have also objected to the 'cultural élitism' of the art establishment. Since 1999, the 'Stuckists', led by Billy Childish, artist and former boyfriend of Tracey Emin, have regularly staged protests at Millbank to promote the interests of traditional art practitioners.

From its inception, the organisers of the prize concurred that publicity was crucial if the prize was to succeed in its aims. But arousing media interest wasn't altogether easy. On 1 June 1984 a patron wrote to Felicity Waley-Cohen of his concern at the lack of press response to the announcement of the prize, which had been widely publicised in March:

> It is extraordinary that as far as I am aware, this [publicity] has produced no editorial whatsoever. I consider the Turner Prize to be one of the most significant events that has happened in the contemporary art world and I am astonished that the art critics, who so often complain about the lack of interest in contemporary art in the UK (compared with the USA) should have ignored it so totally.

In the run-up to the first prize Gordon Burn reported John McEwen as remarking: 'It's all really rather English ... It's a bit like the election of a new Conservative Prime Minister in the good old days. All done with a couple of telephone calls.' Burn went on to observe that: 'Good taste and discretion, for all the talk of upsetting applecarts and setting cats upon pigeons, is what has typified the Turner Prize so far.'[14] But BBC2's *Omnibus* programme agreed to cover the event, marking the beginning of the mediation of the prize to an audience far beyond the immediate environs of the capital. Since then the media's love affair with the Turner Prize has, as Robert Hughes commented when awarding the prize to Anish Kapoor in 1991, 'rattled the teacups'.

Turn-about Terms

In the mid-to-late 1980s the terms of the prize were redefined, particularly those relating to the shortlist and the shortlist exhibition. The jury, which selects the shortlist and awards the prize, is appointed annually by the Patrons in consultation with the Tate, thereby bringing a fresh set of enthusiasms and prejudices to the shortlist each year. Although public nomination for the prize itself has always been encouraged and is valued by the jury, the jury has always reserved the right to add its own nominations to those received. Initially the prize was given to 'the person who, in the opinion of the Jury, "has made the greatest contribution to art in Britain in the previous twelve months"'. Thus artists, critics and arts administrators alike were eligible and there was no imposed age limit. However, over the years the rubric of the Turner Prize has undergone several modifications. In 1987, for example, the phrase 'greatest contribution' was altered to 'outstanding contribution'. The word 'greatest' had proved contentious, implying that the rightful winner should be the greatest living British artist: why, indeed, under these terms had Henry Moore, Francis Bacon and Lucian Freud never won the prize? The main aim of the prize needed to be publicly acknowledged rather than implied: it was not to honour a lifetime's achievement, but rather to celebrate younger talent and focus on recent developments.

That the terms of the prize have been subject to such unrelenting critical comment has much to do with the jury's choice of winner in 1984, viewed by many as wilful misinterpretation of the rules. The winner, Malcolm Morley, had enjoyed a successful exhibition at the Whitechapel Art Gallery. But as he had not lived in Britain since 1958 his contribution to art in this country seemed dubious. Scenting a story, the press seized onto the fact that he had served a short prison sentence in his youth, revelling in the implications this might have for his art practice.

14 Gordon Burn, *Sunday Times Magazine*, 4 November 1984, pp.44–8, p.46.

The level of critical dissatisfaction with the prize continued unabated over the next few years, and even Patrons queried its efficacy. In the *PNA Newsletter* of spring 1986 (no.7) the director was forced to address the membership on the issue of the Turner Prize, to convince them of its merits:

> Such events are controversial, and I know that some Patrons have not been happy about the decision, nor about the conditions of the Prize ... The reason for the Turner Prize is the same as that which lay behind the setting up of the Patrons – namely, to enlarge the audience for contemporary art, and to increase public understanding and awareness ... I have always thought that this is more important than whoever actually wins the prize each year. We do need an award however, to ensure both media and public attention, and the Turner Prize has proved to be most successful in both respects.

Harping against the prize did not deter Drexel Burnham Lambert International Inc., an American investment company, from taking over the sponsorship at the end of Prenn's three-year term in 1987. Drexel was new to sponsorship, but Roger Jospé, the company's senior officer in Europe, was keen to support the Turner Prize. On top of the £10,000 prize money, Drexel promised to provide an extra £10,000 annually for the next three years in order to boost publicity, the exhibition, educational publications and events surrounding the prize. A report by DBL published in the *PNA Newsletter* of spring 1987 (no.9) explained the thrust of the company's sponsorship:

> The sponsors feel it is to everyone's benefit if British art is recognised. Tedious arguments in the press are disabling and will not be understood. People should not quaff champagne and complain. The British love debunking but they need to facilitate in a constructive way as well. The learning process takes a long time and the resources are now available for improving the perception of the prize.[15]

DBL's support won them an award from the Association for Business Sponsorship of the Arts under the government's Business Sponsorship Incentive Scheme, thus making a further £5,000 available to the Tate for the first year of their sponsorship. Yet the 'Drexel years', from 1987 to 1989, though full of promise, proved to be the most turbulent.

Prize Fighters v. Also-Rans

The competitive nature of the prize has always been a bone of contention. The terms of the shortlist seemed increasingly inappropriate as they placed artists of varying age and distinction in the same competition. Writing to Alan Bowness on 1 February 1988 to accept his place on the jury, critic Richard Cork nevertheless felt compelled to express widely held reservations about the nature of the shortlist:

> I am happy to accept although I would welcome the chance to discuss with the other jurors the whole question of the shortlist. There is a widespread feeling, which I tend to share, that the shortlist sets very disparate artists up in competition with each other, with rather invidious results. Are you thinking of changing the shortlist arrangements in any way?

A few weeks earlier Bowness had received a letter from the director-designate of the Tate, Nicholas Serota, who already had the question of the shortlist on his mind.

Although he admired Bowness's initiative, Serota was anxious to address aspects of the prize that he and others in the wider art community felt were unsatisfactory. Many found the unequal weighting of the shortlist particularly offensive. Writing in the *Financial Times* in November 1987, William Packer, for example, though praising the choice of Richard Deacon as winner, declared that the prize had lost its way:

> Each year, and this is no exception, we have been presented with a choice that is

15 *PNA Newsletter*, no.9, Spring 1987. Drexel Burnham Lambert had at the time $1.8 billion in capital, 10,000 employees and more than fifty offices in the United States, Europe, South America and Asia.

no choice, a race in which any winner would be unthinkable – or at best bizarre – but for two or three, with the rest nowhere. This is demeaning for the also-rans – who had not asked to be entered – and infuriating to those left out yet with a far better claim.[16]

On the same day Richard Dorment, writing in the *Daily Telegraph,* opined:

> The exhibition in the Central Hall of the Tate Gallery – of one work by each of the artists on the shortlist – makes such depressing viewing that one wonders what purpose it serves. Perhaps in future these unsatisfactory shortlists should be dispensed with and the winner announced outright. Then, in addition to the prize money, he or she should automatically be given a one-man show at the Tate, and leave it at that.[17]

Taking such criticisms on board, Serota's main aims were to eliminate the combative selection process and to improve the presentation of work in the Gallery. Writing to Bowness on 21 January 1988 he suggested that in following the Booker model too closely, the prize had not yet found a format appropriate to the visual arts. Serota felt the time had come to restrict the shortlist to artists alone, and that a better exhibition would be possible if the shortlist comprised fewer candidates. He later sent a more detailed list of proposals culled from discussions with various people including artists, critics, curators and former jurors. Of most concern was the public nature of the shortlist:

> The announcement of a shortlist causes anguish to artists without giving compensating edification to the public. There is a sense of a horse race between unevenly handicapped mounts and disappointment and embarrassment at being a senior artist who is good enough to run, but not to win.

A case in point, perhaps, was Richard Long who had failed to win the prize in 1984. He was considered yet again in 1987 and 1988, finally winning the award in 1989, just as Serota had initiated changes to avoid such embarrassing circumstances. By the time he was awarded the prize, Long's disaffection was such that he turned down his invitation to the award cermony at which the result was announced.

Serota also expressed misgivings about the exhibition:

> The shortlist and its accompanying catalogue lack impact, largely because of the short notice at which the exhibition is mounted. Furthermore, the public is confused because they believe that the quality of the work on view has some influence on the final choice.

As a result of Serota's consultations it was decided that from 1988 the shortlist would be

16 William Packer, *Financial Times,* 26 Nov. 1987, p.25.
17 Richard Dorment, *Daily Telegraph,* 26 Nov. 1987, p.8.

agreed by the jury, but would not be made public. Resources that would have been used on the shortlist exhibition were to be diverted to fund a proper show for the winner of the prize, with an accompanying catalogue, the following year. Serota's justification for these changes was prepared in advance for the critics:

> It was felt that the publication of the shortlist, including both well-known names and 'unknowns' led to confusion about the scope of the prize, as well as making it difficult for the jury to award the prize to a younger artist without appearing to snub a major figure like Bacon, Freud or Auerbach.[18]

But although this revised format focused more successfully on the achievements of a British artist in one particular year, it completely failed to convey those achievements effectively to a wider public. The event had gained in dignity, but its edge had been dulled, as had the opportunity to draw attention to a broader spectrum of activity in contemporary art practice. There was also a minor point that had been overlooked: in 1987 a rule had been added to the prize, that artists shortlisted for two years would not be eligible for nomination in the following two years. Without a publicised shortlist it would be impossible to monitor adherence to this rule.

On 10 January 1989, Prenn wrote to Serota to express his feeling that the prize had lost some of its earlier impetus: 'The shortlist system was good because it enabled a great deal of public debate to take place, and because it enabled juries to draw attention to artists who might not yet be likely to win.' In a letter to Prenn some months later, Serota confided his intention to rethink the procedure:

> This year, without introducing a formal shortlist I am considering the possibility of publishing a short 'review of the year', highlights which will indicate the field considered by the jury without placing such a focus on six names, five of whom must be 'losers' in a race that they have not chosen to enter.[19]

That year the jury publicised, not a shortlist, but a much longer list of 'commended' artists, alongside the name of the winner, Richard Long. This still proved unsatisfactory, as the director implied to Judith Bumpus of the BBC in a letter following the award ceremony: 'I am glad that Richard has won but we obviously need to give further thought to the way in which we promote the work of the winner to a general audience.'[20]

Press curiosity in the Tate had escalated during the late 1980s owing to the arrival of a new director, and excitement surrounded the proposed rehang of the Collection. However, the unusual level of critical displeasure with the prize after the announcement in 1989 was such that the director and curators of the Tate's Modern Collection had already met on 20 December to studiously reconsider all aspects of the prize. A shortlist, they agreed, was unavoidable since any publicised list of names would assume this status. Clearly, an effective shortlist should comprise no more than three or four artists, all of whom should be strongly supported by the jury, so that each would have an equal chance of winning the prize. It was also agreed that there should be no bar on the number of times an artist could be shortlisted.

Several of the curators present had been involved in organising the Turner Prize exhibition and the meeting questioned the feasibility of mounting a successful show given the restrictions on space, time and availability of suitable work. They were also keen to explore other ways of promoting the artists' work, such as videos, lectures and publications.

Many of these reforms were to come into play at a future date (see pp.28–9). But the prevalent cynicism towards the prize at this time found a natural rather than administered cure. Disaffection centred, understandably, on what appeared to be the rule of Buggins's turn. With the exception of Tony Cragg, all winners of the prize (Morley, Hodgkin, Gilbert and George, Deacon and Long) had been on the very first shortlist in 1984. The winner of the prize seemed to be predetermined each year and the principle of fair

18 Tate Gallery Archive 121, Nicholas Serota, unpublished statement, 9 Oct. 1988.
19 TGA 121, Letter from Nicholas Serota to Oliver Prenn, 15 May 1989.
20 TGA 121, Letter from Nicholas Serota to Judith Bumpus, 1 Dec. 1989 in reply to her congratulatory note of 22 Nov. 1989. See also Marina Vaizey, *Sunday Times*, 27 Nov. 1988, p.8.

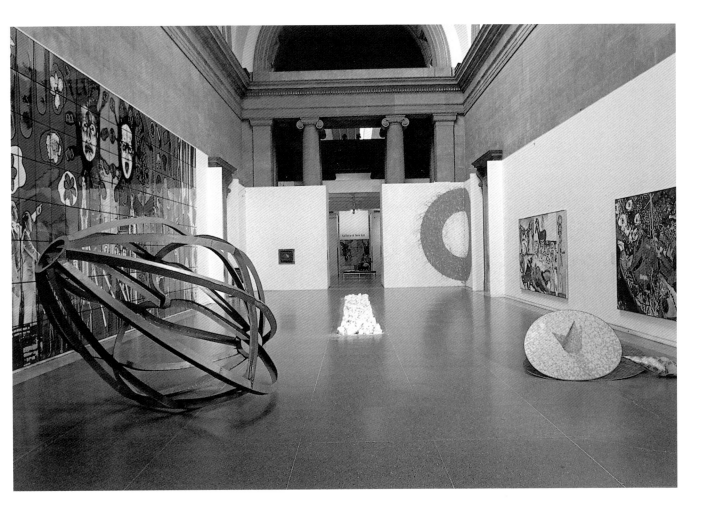

The Turner Prize exhibition in 1984

competition undermined as a result. The formative period of the prize, committed to honouring a generation of established British artists, had run its course.

Onsite Insight: The Turner Prize Exhibition

The exhibition, which opens about a month before the winner is selected, plays a crucial role in achieving the main aim of the Turner Prize. Its primary function is to give a non-specialist art audience the opportunity of seeing work by the shortlisted artists. It also provides a focus for both formal and informal discussion about contemporary art as a whole. In one sense the success of the Turner Prize has depended on the success of the exhibition. As one critic noted in the aftermath of the first prize:

> Though this rush of prizes may seem to be inspired by the hoo-ha surrounding the Booker, and the consequent increase in novel sales, the most important thing about art prizes is that so many of the entrants have their work hung in exhibitions, with all attendant publicity, where public, critics and dealers can see them.[21]

But the exhibition has had a troubled history. During the 1980s, difficulties over timing, lack of space and a limited budget dogged the organisation of a satisfactory display. Richard Francis, at the time a curator at the Tate, wrote to the shortlisted artists on 30 July 1985 asking them to consider suitable works for the exhibition that was to open in just over two months' time. The criteria for appropriate works illustrate the particular problems of organising such an exhibition: 'It [the work] should be easily available, in your collection with your dealer or in a London private collection, and have been made in the last year.'

In 1986, juror Michael Newman, upset by criticisms of the panel's choice of artists, emphasised the important role of the exhibition in a letter to Bowness, dated 10 July:

21 Liz Jobey, *The Times*, 18 Nov. 1984, p.41.

Although controversy is bound to raise interest, I think we do have a problem with the negative criticism ... people will come to the exhibition ... to find out what it is all about, and I think their attitude will be almost to want to have the negative view confirmed. This means that presentation at that stage will be very important. Therefore I am disturbed to learn that the artists have been offered 11 ft of wall space, again in the rather gloomy rotunda, to be approached by a tunnel through a building site. This is bound to put the display at a disadvantage, particularly since we have some difficult work which needs adequate representation and possibly some explanation. To counter the response to the list so far I think we need to have a spectacular presentation in which the work will be seen in its best light. Each artist should have adequate space to make a good account of themselves.

Bowness reassured Newman that he would look into the possibility of a more extensive exhibition and catalogue, but explained that practicalities and cost would make this prohibitive. He later outlined the difficulties of the Turner Prize exhibition to the patrons in their newsletter of spring 1987 (no.9):

People never quite realise that it takes eighteen months to two years to plan a big show and we can have, at the moment, a limited number of large shows in any one year ... We can make quite an impact with a group of ten or twelve works ... People are critical of our exhibitions for shortlisted artists, but I remain unapologetic about them ... The time between the shortlist announcement and the exhibition of nominees is not very long and it is not always possible to make a satisfactory exhibition ...

In 1988 the shortlist exhibition was abandoned completely in favour of a winner's exhibition in the following year. But the idea of giving the winner a show twelve months later also proved problematic. Richard Deacon, for example, declined this proposal as a Tate exhibition would have conflicted with his previously scheduled solo exhibition at the Whitechapel Art Gallery. Instead he chose to install a large sculpture, *Like a Snail (A)*, in the garden at the front of the Tate from July to November 1988.

A Year of Suspension

In 1990, as if to give the prize time to heal its wounds, the Turner Prize was given an 'unsought, but not perhaps unwelcome' year's sabbatical. On 7 March 1990 Serota announced that Drexel Burnham Lambert had gone bankrupt, and had been forced to discontinue their sponsorship. They also withdrew financial support for the winner's exhibition of 1989. In July Serota gave a statement to the press that the Trustees had decided to suspend the prize for 1990, but that negotiations with a potential new sponsor were under way. The new sponsor was Channel 4 and in 1991 the prize was relaunched in its current format.

1990s Make-Over: The Turner Prize and Channel 4

As art critic of the *Guardian* in the 1980s, Waldemar Januszczak had often fiercely objected to aspects of the Turner Prize. As the Commissioning Editor for Arts at Channel 4, he saw an opportunity to facilitate change and give the prize the kind of boost it needed. A few weeks after Serota announced the withdrawal of Drexel's sponsorship, Januszczak made enquiries at the Tate. A series of exchanges followed. On 22 June 1990 he wrote to Serota:

There is no doubt that the Turner Prize is Britain's most prestigious art award. But there is no doubt that the prize has never fully realised its potential as whipper-up of enthusiasm and understanding for new art. To be perfectly honest there have been years when it has hardly seemed worth going to the trouble of having the prize at all. And yet even in these bad years when mouthy young critics like myself sounded off

against it … there is no doubt that something important about the Turner Prize survived the attacks and confusions. It's not perfect – but it's the best there is. And because it's not perfect it has, in my opinion, a future full of potential.

Once Januszczak knew that the Gallery was prepared to consider a sponsorship proposal, he approached Michael Grade, the Chief Executive of Channel 4, who fully supported his initiative.

The Booker Prize had been successfully publicised by BBC2 and Januszczak was convinced that Channel 4 could do the same for the Turner Prize – it could guarantee television exposure, and offer expanded coverage, including profile films on the artists and live transmission of the award ceremony. He felt that the prize had previously lacked coherence and gravitas. The latter could be attained by improving the media presentation of the prize, and more importantly, by raising the prize money. But the pinnacle of his wish-list was an extensive exhibition for the shortlisted artists. With the demise of the Hayward Annual in the mid-1980s, London lacked a consistent focus for public discussion of contemporary art. Januszczak believed that a substantial exhibition at the Tate would provide such a platform and encourage further public interest in the event.

Replying to Januszczak's robust suggestions, in a letter dated 17 July 1990, Serota identified the key areas of the prize which needed attention, and in doing so indicated his own enthusiasm for a potential partnership with Channel 4:

> two philosophical difficulties have vexed judges, artists, critics and public alike. First the impossibility of comparing artists of established practice and reputation with those only recently emerged into prominence, and second the continuing difficulty of achieving the first objective of the Prize – to make new art interesting and accessible to the Tate Gallery's own mixed-interest public, and to the public at large. In this objective the model of the Booker is of course axiomatic, and a primary purpose of the Turner Prize must be to attract sympathetic media attention for the artists selected by the jury and so to raise awareness and understanding of contemporary art.

The Tate was confident that a more successful format could be established and maintained under this new sponsor. During discussions, the idea of an age limit was suggested as a solution to ignominious comparisons between artists at different stages in their careers. Initially, Januszczak was keen to set the limit at forty years old, but concurred with the director's view that fifty would be fairer, as a number of artists produce their best work in mid-career. It was agreed that the rubric of the prize, once reformulated, should resist alteration. This, it was hoped, would prevent confusion and allow the prize a period of gestation. The following terms were then quickly established. The Turner Prize would now be awarded to a British artist under fifty for an outstanding exhibition or other presentation of their work in the twelve months preceding the closing date for nominations. The prize would be highlighted by a display of shortlisted artists' work, mounted in the month preceding the televised award ceremony. The display would comprise at least six gallery spaces. Furthermore, the award itself would be increased to the sum of £20,000.

The first jury took the new age restriction seriously and, to the horror of many critics, selected a group of artists mostly in their twenties.[22] In drawing attention to the emergence of a new and vibrant generation of British artists who were already enjoying success at home and abroad, the jury had effectively dismissed the residual notion that the Turner Prize was a medal for distinguished service.

In 1995 the exhibition was expanded to allow artists discrete spaces in which to show their work, and this was accompanied by other, partly audience-led, changes in its presentation.[23] The extraordinary attendance figures, which often forced the gallery to turn people away on Sunday afternoons and resulted in an extension of the exhibition run, gave

22 See, for example, *Evening Standard*, 7 Nov. 1991, p.30; Richard Cork, *The Times*, 8 Nov. 1991, p.14.
23 Most important of these was the provision of an information area attached to the exhibition, where visitors could view the artists' films (made since 1993 by Illuminations), and consult publications.

The information area for
the Turner Prize exhibition,
first introduced in 1995

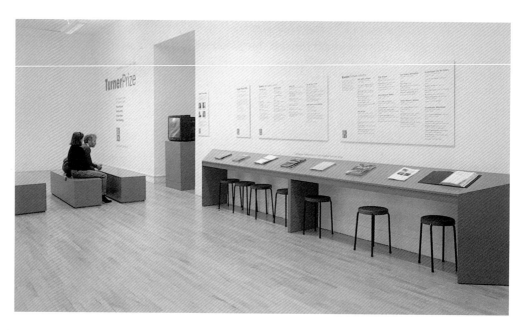

Tate Trustees a strong indication that there was a growing audience for contemporary art in this country. Arguably, the success of the Turner Prize provided concrete evidence that Tate Modern, a breathtakingly ambitious project, would be welcomed by the public.

Although the success of the prize is in no small part due to the consistent media coverage by Channel 4, the whole event would be meaningless without the exhibition, as Januszczak remarked in the broadsheet accompanying the show in 1992: 'However cleverly or inventively you film art on television, you can never capture its true presence. That can only happen in a gallery when the visitor is face to face with the art object.'

Response to the 1993 exhibition revealed that audiences were prepared to challenge the often reactionary or scornful approach of many art critics. They voted with their feet and overcame the deeply ingrained national suspicion of new art. Since then, attendance figures have continued to climb. In years when particularly sensational exhibits were showcased – Damien Hirst's *Mother and Child, Divided* in 1995 and Tracey Emin's *My Bed* in 1999 – visitor numbers almost doubled, hitting figures they have not yet repeated. Hirst's iconic work featuring a bisected cow and calf was almost guaranteed to upset a nation of animal lovers. But genuine interest appears to have superseded pure sensationalism. During the run of the exhibition an undergraduate at Leeds University, Fiona Darling-Glinski, undertook an independent visitor survey. She concluded that the Turner Prize was not only increasing the profile of contemporary art, but also encouraging visitors to question and interpret the work on display.[24]

Size Matters: 'Accessibility' v. Quality of Experience
In 1998, the success of the prize was noted by Chris Smith, then Secretary of State for Culture, Media and Sport. As a privately sponsored event designed to entice new audiences to the gallery, it seemed to exemplify New Labour's aim of increasing public access to high culture. In July that year, Smith announced that an extra £290 million would be allocated over the next three years to the arts and museums. Widening audience access was clearly key to the government's new policy.

Such unusual generosity was welcomed by institutions, but financial handouts came with certain conditions, as Smith hinted in his announcement: 'The new investment places a clear responsibility on funding bodies for agreed improvements in efficiency, access and private sector sponsorship.' By the late 1990s, the Turner Prize had become an exemplar of how a museum could regularly increase audience access to its collections and exhibitions.[25]

24 Fiona Darling-Glinski, 'The Turner Prize 1995: Visitor Survey', unpublished dissertation, University of Leeds 1996.
25 The prize did not always find favour with the Secretary of State, who in 1999 criticised the jury for concentrating too much on videos and 'shock' installations. See p.154.

But, although size matters, it isn't everything. And attendance figures, however gratifyingly large, say nothing about the quality of visitor experience. To some it seemed – following pop superstar Madonna's presentation of the prize in 2001 – that desire for media exposure was now finally driving the prize at the expense of its real aims. As if to counteract this impression, in 2002, keen to increase the level of public engagement, Tate Britain took further measures to encourage discussion of the exhibition. In addition to the customary books and catalogues, a range of newspaper and magazine reviews, and a comments board, were installed in an information room situated at the end of the show, and visitors were invited to contribute their views. Despite – or perhaps because of – the column inches spawned by Kim Howells, a junior minister in the Department for Culture, Media and Sport, who publicly aired his criticisms on a comments card pinned to the wall, 2002 was undoubtedly a success in terms of enriching audience appreciation and debate about the art on display.[26]

Although continuing their coverage of the event, Channel 4's remarkably successful sponsorship of the Prize came to an end in 2003. From the outset of their three-year sponsorship in 2004, new sponsors Gordon's Gin (owned by Diageo plc) set about introducing improvements, notably by doubling the prize money to £40,000. This facilitated the increase of the winner's prize from £20,000 to £25,000, and for the first time rewarded the contribution made by the other shortlisted artists, who would each receive a prize of £5,000. Gordon's also promised to introduce new initiatives that would encourage audiences to 'look in detail at the path many modern artists take when creating art'. The first of these was the provision of a free audio guide to the exhibition to help explain the work on display in the wider context of each artist's practice. Then in 2005, as a strategy aimed to reach a non-gallery-going audience, Gordon's launched its 'Judge for Yourself' tour, taking the London-based Turner Prize exhibition to an estimated three million rail commuters at three mainline railway stations – London Victoria, Manchester Piccadilly and Edinburgh Waverley – in the form of a virtual tour accompanied by a comments billboard.[27]

In recent years, Tate's media presentation of the prize has also undergone some changes. In 2006, the task of making films about the shortlisted artists for Channel 4, performed by Illuminations since 1991, was taken over by Tate Media, a newly established in-house branch of Tate's Communications department, set up to generate content for broadcast and broadband. Tate Media experimented with a number of new programme formats, for example in its 2005 film, where four art students were invited to shadow the shortlisted artists in the run-up to the award that year. This was intended to give viewers fresh insight into the process of preparing for the exhibition, while watching students weighing up the relative merits of the artists would encourage people to do the same for themselves. This was followed in 2006 by the 'Turner Prize Challenge', a competition to select a budding young art critic, with the winner invited to present a news feature live from the award ceremony.

In addition to this closer scrutiny of artists' practice and achievements, the internal workings of the jury have also come in for greater public exposure, albeit unplanned. Since 1991, the Turner Prize jury had always included a representative of the Patrons of New Art, often a collector. But by 2005, this direct link with the founders of the prize had run its course, and the following year Tate widened the pool of potential jurors by transforming this seemingly exclusive category into that of 'non-art specialist' with a proven interest in contemporary British art. The first such non-art professional to serve on the panel, journalist Lynn Barber, made headlines with confessional revelations about the jury process.[28] Commenting later on the dynamic of the jury, Nicholas Serota told one journalist: 'Every curator or critic has opinions and I expect them to bring those into the room. You want prizes to be opinionated and not third choices'.[29]

26 See pp.178–9.
27 See p.212.
28 See p.222.
29 Quoted by Patrick Marmion, 'Prize and Prejudice', *Financial Times Magazine*, 4/5 March, 2006, p.212.

If Barber had felt excluded from such passionate discussion on account of her non-art-professional status, her participation and readiness to talk about it contributed a democratising frankness to a process often regarded as remote and secretive.

In a radical move for 2007 – and with the support of Arts Council England, the Liverpool Culture Company and Northwest Regional Development Agency – Tate is taking the unprecedented step of staging the Turner Prize exhibition outside London at Tate Liverpool, as a curtain-raiser to celebrate the city's European Capital of Culture status in 2008. Meanwhile, Tate Britain will fill the gap in its autumn exhibition programme with a Turner Prize retrospective featuring the work of previous winners.

How does one increase accessibility, thereby justifying the existence of the institution as a viable public resource, without diluting or dumbing down the experience for the individual visitor? This is a challenge facing art museums as a whole, and it is one that the Turner Prize has consistently sought to address head-on. There is no denying that the event is surrounded by an annual media circus, yet if this stirs an interest in people who might otherwise never cross the threshold of a gallery, one can easily argue that the pros outweigh the cons. As the evidence of one critics's formative experience suggests: 'The abiding purpose of the award is to bring new art to new audiences, and it is hard to deny it achieves this. I was sixteen when I first visited the Turner Prize exhibition ... It was 1993 ... I can still remember the glow of Phaophanit's Neon Rice Field (1993) and elegiac presence of Whiteread's Untitled (Room) (1993). Good art endures. The trappings don't matter.'[30]

There will always be opposition to the concept of the prize, and many who disagree with the choice of shortlisted artists. When such criticism takes the form of serious discussion of contemporary art, it shows that the event is successfully fulfilling one of its essential functions. For participating artists, the prize will continue to be an ambiguous experience: most will welcome new-found fame or notoriety, but dread the barrage of tabloid mud-slinging. Some will find taking part in a high-profile competition challenging; others may be damaged by the pressure of intense public exposure. In response to speculation about how the Turner Prize affects the monetary value of an artist's work, popular winner

30 Tim Norton, 'Everyone's a Winner', *Tate International Arts and Culture*, issue 2, Nov/Dec 2002, p.73.
31 Grayson Perry, 'With the Turner Prize you just can't win', *The Times*, times2, 14 February 2005, p.21.

Grayson Perry has commented: 'People often ask me if winning the big T has changed my life and I say, yes, I get to go to some great parties, but I don't know how much it means in the status of the art world ... I get to open fetes now, but whether my prices rise or not depends on the quality of my work and the kudos I acquire from the venues in which I exhibit'.[31] Most importantly the Turner Prize offers artists a unique opportunity to display their work at Tate Britain, where it can stimulate and give pleasure to growing audiences, curious to discover something of the richness of creative activity taking place in British art today.

Malcolm Morley
*Day Fishing in
Heraklion* 1983

In the modest booklet accompanying
the first Turner Prize exhibition Alan
Bowness, Director of the Tate Gallery,
announced the terms and aims of the
prize:

> The award is for the person who, in
> the opinion of the Jury, 'has made the
> greatest contribution to art in Britain
> in the previous twelve months'.
> Artists, writers on art and arts
> administrators alike are therefore
> eligible. We intend to encourage
> excellence in contemporary British art
> and its presentation and to foster a
> greater public interest in it.

Despite the intentions of the organisers,
media 'fuss' and public interest prior to
the announcement of the winner proved
fairly low key. The only seriously
discussed and contested issue was the
naming of the upstart prize after an
illustrious British artist. There seemed to
be nothing controversial about the works
by shortlisted artists on display at the
Tate. Laurence Marks, in the *Observer
Review* of 4 November 1984 even
remarked on their accessibility:

> No smashed crockery. No chopped-up
> furniture. No shabby old suits
> suspended in space. It would be a
> dull soul who didn't warm to the
> exuberance of the exhibit, whatever
> critical judgement the cognoscenti
> may eventually hand down.

But two things altered this relative calm.
One was coverage of the event by BBC1's
Omnibus programme, watched by up to
two million people. The other was the
choice of winner. Robert Hughes,
speaking on *Omnibus*, suggested that
Britain was still diffident to American art,
despite the fact that British artists were
producing some of the strongest and best
art in the world. Unfortunately, this view
was compounded when the prize was
given to Malcolm Morley, who had lived
in the United States since 1958 and had
not even been present to receive his
award. A critical outburst ensued.
Although Waldemar Januszczak
conceded that Morley was a painter of
'uncommon force', like many other
critics he could see no evidence of the
artist's impact in Britain in the previous
twelve months: 'Whatever Morley's
historical significance – and I for one

think it has been vastly overestimated –
it has had absolutely nothing to do
with art in Britain and merely confirms
the continuing cultural dominance
of the New York art world.'(*Guardian*,
10 November 1984, p.10).

For a critic such as Peter Fuller,
Morley, a 'shallow' artist, was the worst
possible choice. The jury's decision
confirmed Fuller's repeatedly published
conspiracy theories about influential
collectors and the Tate Gallery's Patrons
of New Art: 'Why did he get the Turner
Prize? Ask any one in the art world this
question and, within minutes, they will
point out that Morley is one of the artists
avidly collected by Charles Saatchi ... The
only good thing Malcolm Morley ever did
for the arts in Britain was to leave these
shores more than quarter of a century
ago.' (*New Society*, 15 November 1984,
p.249).

Malcolm Morley

Morley's work combines a rich
autobiographical, mythical and emotional
content with a complex, formal approach
to the practice of painting. His success
lies in this fusion of explosive,
unconscious expression and intellectual,
almost programmatic method. In a
conversation with Arnold Glimcher
(*Malcolm Morley*, Pace Gallery, New York
1988, p.3) the artist commented:
'Essentially I have this tremendous belief
in the relationship between what we call
the unconscious and conscious life.
I think we're really more like icebergs.
There's this huge underbelly. The idea is
to integrate the two so they become one.'

Morley's passion for painting is driven
by both pleasure and anxiety. He has
often talked about the 'pornography' of
a painting, of the potential of paint on
a surface to arouse desire. Describing his
and the viewer's relationship to his
pictures in the Pace Gallery catalogue
(p.3) he has commented: 'I'm the first
observer, the first spectator; a spectator
who is impossible to please, who plays
Russian roulette with pleasure. We must
remember why we do a painting, which
I was forced eventually to say – for the
pleasure of it.'

Morley is viewed as a wilfully
individualistic artist, contemptuous of
stylistic fashions in art and committed to
'playing for high stakes'. Summing up

1984

Malcolm Morley
1931 Born in London
1952–3 Camberwell
School of Arts and
Crafts
1954–7 Royal College
of Art, London
1958 Moved to
New York, USA

Richard Deacon
1949 Born in Bangor,
Wales
1954–6 Lived in
Sri Lanka where his
father was stationed
with the RAF
1969–72 St Martin's
School of Art, London
1974–7 Environmental
Media MA at the Royal
College of Art, London
1977 History of Art,
Chelsea School of Art,
London
1991–6 Trustee of the
Tate Gallery

Gilbert
1943 Born in
Dolomites, Italy
Studied at
Wolkenstein School
of Art
Hallein School of Art
Munich School of Art
1967–8 St Martin's
School of Art, London
George
1942 Born in Devon
Studied at
Dartington Adult
Education Centre
Dartington Hall
College of Art
Oxford School of Art,
Oxford
1966–8 St Martin's
School of Art, London

Morley's aspirations in *Malcolm Morley: Watercolours* (Tate Gallery Liverpool 1991, p.11) Richard Francis wrote:

> He is ambitious to be a great painter, both in the sense of the modernist painters and a classical (a word he prefers to traditional) painter, in the sense of subject and method, making him, of course, a supremely post-modern painter. This is an ambition that he acknowledges is very difficult for him to fulfil, for it means that he must challenge, if he is to succeed, the champions, at least, of the twentieth century (Picasso, Dali, Matisse, Pollock *et al.*) and, simultaneously, provide himself with sufficient pleasure from making his work.

By the early 1980s, when 'post-modern' was first widely used to describe the condition of post-1960s art and culture, it became possible for critics to 'classify' Morley's work. Although heavily influenced by Cézanne, Morley had also absorbed a heady mixture of twentieth-century movements including Cubism, Expressionism, Dadaism, Surrealism, Abstract Expressionism, as well as Pop, Minimal and Conceptual art. The freedom with which he assimilated elements from the history of art seemed commensurate with the post-modernist disregard for modernism's slavish adherence to the 'new' in art.

Morley's unstable and lonely childhood produced experiences that later fed into his work. He has never known his father. A fascination with the sea led him to make balsa wood models of famous ships and later to serve as a galley boy in the merchant navy. As a youth, delinquent behaviour culminated in a short prison sentence. In prison he started to paint. On his release, encouraged by his teacher, he began to pursue a career in painting, first by making a painting trip to St Ives, and then securing a place at Camberwell School of Art and Crafts. Later, at the Royal College of Art, he belonged to the generation of young artists, including Peter Blake, who were to become associated with Pop art. But in 1956, Morley was dazzled by the exhibition of American abstract painting held at the Tate Gallery and determined to move to New York, where he has lived since 1958.

In 1964, after experimenting with abstraction under the influence of Barnett Newman, Morley began a series of paintings of battleships and sailors. Finding it too difficult to paint a ship from life, owing to the distortion of scale, he divided a postcard into a grid of squares so that he could faithfully transcribe the image of a ship, segment by segment, onto a larger canvas. The grid was used as a device by others at the time, notably by Richard Artswager, but Morley had also learned this traditional method of transferring a scaled image at Camberwell and the Royal College. Each section of the grid was painted independently of the whole in a 'super-realistic' style. The use of sections has subsequently been central to Morley's picture-making.

In the early 1970s he started to subvert the precision of his paintings by introducing 'accidental' marks which relate to his interest in violent images of crashes and accidents. His paintings were now made from toy models rather than postcards. Towards the end of the decade he began to paint from his own watercolours of toy models with the result that his brushstrokes became even more idiosyncratic and expressive. By the early 1980s his pictures were highly charged images, epic both in scale and content, full of obscurely personal interpretations of the world around him.

In 1980 he visited England for the first time in twenty years. In the interim he had rarely shown work in this country, and exhibitions of his work elsewhere had been so sporadic that his Whitechapel restrospective of 1983 was met with curiosity. For the first time critics had a chance to assess the development of his work over two decades. The exhibition began with early ship paintings such as *Cristoforo Columbus* (1965) and culminated with large-scale, eroticised imaginative landscapes such as *Christmas Tree – The Lonely Ranger Lost in the Jungle of Erotic Desires* (1979), and fleshy mythological paintings inspired by his recent visit to Greece. The exhibition was a revelation. Morley, whose self-styled 'super-realism' of the 1960s had marked him as a progenitor of Photorealism was now also seen as a precursor to the New Expressionism of the 1980s.

Richard Deacon
Boys and Girls 1982

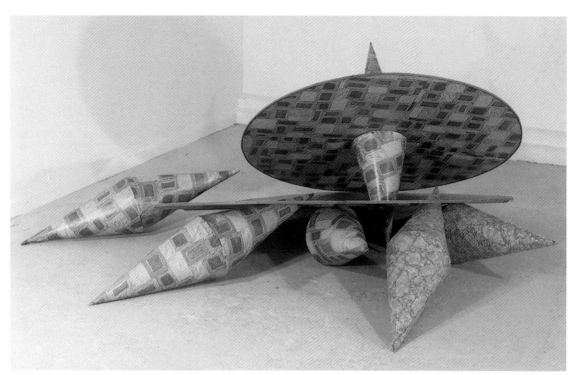

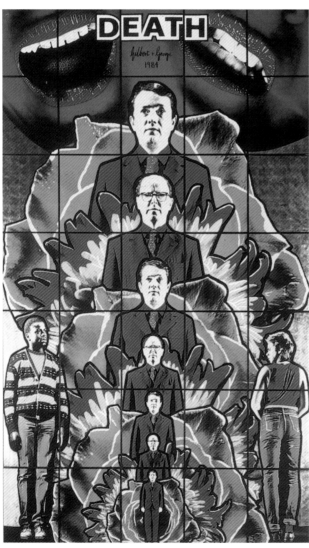

Gilbert and George
Death Hope Life Fear
1984
One of four panels

35

1984

Howard Hodgkin
1932 Born in London
1940–3 Lived in USA
1949–50 Camberwell
School of Art, London
1950–4 Bath Academy
of Art, Corsham
1970–6 Trustee of the
Tate Gallery, London
1978–5 Trustee of
the National Gallery,
London

Richard Long
1945 Born in Bristol
1962–5 West of
England College
of Art, Bristol
1966–8 St Martin's
School of Art

The aim of the large, richly-painted works of the early 1980s was conveyed in a comment to his interviewer, Sarah MacFadden in *Art in America* in December 1982 (vol.70, no.11, p.68, New York):

> I'm after making pictures that contain a combination of images that have the power to brand, in the way that a branding iron sears. I figured that a combination of unique image arrangements could have a similar effect, the way de Chirico hits. The images just get lodged in your brain – there's no way of dislodging them once they're there.

Richard Deacon

Deacon was represented in the 1984 shortlist exhibition by the British Council's *Boys and Girls* (1982) and *The Heart's in the Right Place* (1983) from the Saatchi Collection. A discussion of his work can be found under 1987 when he was awarded the prize.

Gilbert and George

In 1984 Gilbert and George were represented in the shortlist exhibition by *Drunk with God* of 1983. A discussion of their work can be found under 1986 when they won the prize.

Howard Hodgkin

In the shortlist exhibition of 1984 Hodgkin was represented by *Still Life* (1982–4) and *Son et Lumière* (1983–4). A discussion of his work can be found under 1985 when he was winner of the prize.

Richard Long

In the 1984 exhibition Long was represented by two works of that year, *Chalk Line* and *River Avon Mud Circle*. He was shortlisted in 1987 and considered as a contender in 1988. A discussion of his work can be found under 1989 when he was awarded the prize.

Howard Hodgkin
Son et Lumière 1983–4

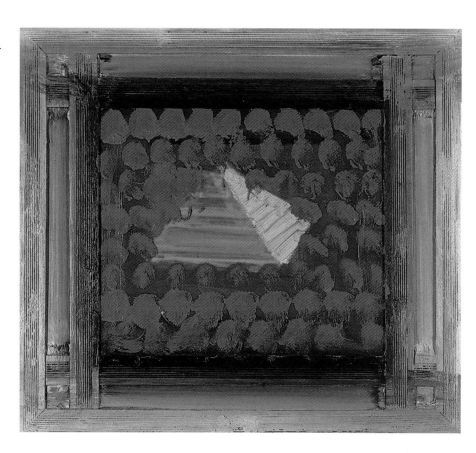

Richard Long
Chalk Line 1984

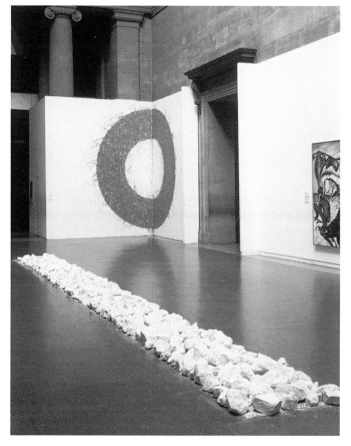

Howard Hodgkin 1985

Winner
Howard Hodgkin

Shortlisted artists
Terry Atkinson for his exhibitions of work in London, Venice, and elsewhere for his activities as a teacher and writer
Tony Cragg for important exhibitions held in Europe and the USA and for a notable contribution to the Hayward Annual, London, in 1985
Ian Hamilton Finlay for a major contribution to British art, and in support of his beleaguered position at Stonypath, Dunsyre, Scotland
Howard Hodgkin for the continuing international impact of his painting, exemplified by his successful exhibition at the 1984 Venice Biennale, which was subsequently shown in the USA and Germany, and in an extended form at the Whitechapel Art Gallery, London, in 1985
Milena Kalinovska Exhibitions Director, Riverside Studios, London, shortlisted in recognition of her series of exhibitions devoted to work by younger artists
John Walker for the exhibition of his paintings at the Hayward Gallery, London, and his graphic work at the Tate Gallery; and in special recognition of the work he has recently done in Australia.

Jury
Max Gordon
Architect, representative of the the Patrons of New Art
Mark Francis
Director, the Fruitmarket Gallery, Edinburgh
Lynne Cooke
Lecturer in the History of Art, University College London
Kynaston McShine
Senior Curator of Paintings and Sculpture, Museum of Modern Art, New York
Alan Bowness
Director of the Tate Gallery and Chairman of the Jury

Exhibition
17 October–1 December 1985
Prize of £10,000 presented by Sir Richard Attenborough, 12 November 1985

In 1985 the Turner Prize was nourished by the media attention, or rather storm of controversy, it had attracted following Malcolm Morley's win the previous year. Some critics even greeted the return of the 'Great Autumn Handicap of our Visual Art World' with delight (William Packer, *Financial Times*, 22 October 1985, p.21). However, this year's winner, Howard Hodgkin, came as no surprise and met with widespread approval as he had been the favourite for two consecutive years.

For the first time a non-artist, Milena Kalinovska, Exhibitions Director at Riverside Studios, London, was shortlisted in recognition of her innovative exhibition programme. The exhibition of shortlisted artists was staged in the Octagon, the space dividing the North and South Duveen galleries, the central spine of the Tate Gallery.

Attempts were made in 1985 to introduce an educational element: lunchtime lectures on the contenders were held at the Tate, and the Institute of Contemporary Arts hosted a discussion with a panel comprising Alan Bowness, Max Gordon, Peter Fuller, Mark Francis and Kynaston McShine, with Christopher Frayling as chairman.

Howard Hodgkin

Howard Hodgkin established his reputation as a painter with a retrospective exhibition organised by the Arts Council of Great Britain in 1976. By this time he was also a well-known and respected member of the art community in Britain. But his international standing, which continues today, was not fully realised until the early 1980s. It has remained unquestioned since 1984 when his exhibition at the British Pavilion in Venice – subsequently touring in the United States, Germany and culminating at the Whitechapel Art Gallery in July 1985 – caused a sensation. At the time John McEwen assessed Hodgkin's achievement in *Howard Hodgkin: Forty Paintings* 1973–84 (Whitechapel Art Gallery, London 1984, p.10):

> All Hodgkin's pictures can be thought of as the grit of some experience pearled by reflection. They begin where words fail, evocations of mood and sensation more than visual record, but descriptions indubitably of the physical as well as the emotional reality. And this perhaps explains why in an artistically conservative country like England he is thought to be an abstract painter, while in a more artistically sophisticated one like America he is admired for being representational. For Hodgkin himself the pictures could not be more intentionally specific.

Hodgkin's main preoccupation has been to convey the emotional, psychological and physical character of particular encounters. Guided by memory, he evokes the ambience of a domestic interior, the subtle meanings and effects of conversations – pauses, silences, emotional undercurrents.

Since the late 1960s he has been a frequent visitor to India and is a collector of Indian painting. He first became interested in Indian painting in his early teens, attracted by what seemed to be a completely different way of representing the world. Although Indian painting has not influenced his work in any specific way, he feels that something about the atmosphere and nature of human exchange in India has probably had an effect. He has said: 'It's the sort of nakedness of their very inhibited emotions. I mean, everything is very visible, somehow, there. Life isn't covered up with masses of objects, masses of possessions, so that the difference between being indoor and out of doors and all the sort of functions of life are much more visible' (*Howard Hodgkin*, exh. cat., Anthony d'Offay Gallery, London 1983, p.66–7).

Between the late 1950s and 1970s Hodgkin produced a series of portraits of friends, usually artists, in their own interiors, often mimicking their style. This helped him to establish his own artistic identity or 'space' in relation to the plethora of existing contemporary styles. Comparisons were drawn between his work and some British Pop artists, but Hodgkin remained relatively isolated in his art practice throughout the 1950s and 1960s. His paintings were unfashionably small and, unlike many abstract painters of the time, he worked slowly, creating the finished image through a process of layered corrections.

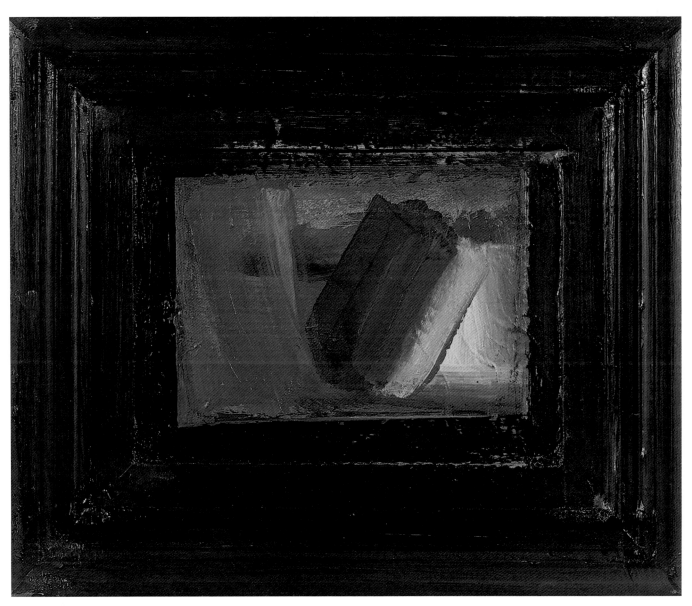

Howard Hodgkin
*A Small Thing But
My Own* 1983–5

Howard Hodgkin
1932 Born in London
1940–3 Lived in USA
1949–50 Camberwell
School of Art, London
1950–4 Bath Academy
of Art, Corsham
1970–6 Trustee of the
Tate Gallery, London
1978–85 Trustee of the
National Gallery,
London

Hodgkin's desire to produce 'physically contained' images which pull the viewer into an illusionistic space sets him within a particular tradition in Western painting, as he has pointed out (*Howard Hodgkin: Forty Paintings*, p.100):

> In the museum culture in which we now live, small contemporary paintings don't rate. And yet a Morandi, a Mondrian, a Vermeer, a Chardin, a Fragonard, a small Picasso or a small early Vuillard, to take a few random examples, can knock you out across a room ... I would like to paint a picture of sufficient emotional and physical volume that it could hang in a room alone, without seeming pretentious.

Although his painting has been influenced by numerous forbears, including Corot, Ingres, Delacroix, David, Bonnard and Degas, it was perhaps the early paintings of Edouard Vuillard that nurtured his mature style. David Sylvester noted the effect of Vuillard's intimiste paintings of late nineteenth-century interiors on Hodgkin's development, in such works of the mid-1970s as *Grantchester Road* (1975). In conversation with Hodgkin for *Howard Hodgkin: Forty Paintings* (p.105) he suggested:

> If one was doing a kind of placing of your work art-historically, I'd say that it's as if you'd taken these Vuillards and done two things to them: you've moved in, you've moved into close-up; and it's as if this flat unbroken, unbreakable surface of a Vuillard had been deflowered.

Sylvester felt that Hodgkin had, by using illusionistic painterly devices, suggested 'cavernous spaces' without 'violating the flatness of the picture-plane' (ibid. p.101). Hodgkin paints with oil on wood rather than canvas, the wood providing a solid and enduring surface for his often tentative, ephemeral subjects. Since the 1970s his most characteristic illusionistic device has been the painting of the picture frame. Rather than simply closing the picture off from the space around it, the frame acquires a more active role.

Hodgkin's subjects at this time were increasingly based on personal encounters. But his consistent aim has been to develop a language of paint capable of producing images that are not limited by his own experience. Talking with David Sylvester he discussed the motivating force behind the development of his painterly techniques:

> I want the language to be as impersonal as possible ... It's a major concern of mine that every mark that I put down should not be a piece of personal autograph but just a mark, which then can be used with any other to contain something. I want to make marks that are anonymous as well as autonomous. They can't be one without the other it seems to me; otherwise, they would remind you of somebody's handling.

By the early 1980s Hodgkin had evolved a visual vocabulary of abstract marks – blobs, stripes, spots, swirls, feathery strokes – together with a robust and sensitive use of colour that effectively realised his ambition to create somehow, by painterly means, metaphors for lived experience. Teresa Gleadowe, writing in *Howard Hodgkin: Paintings* 1977–84 (XLI Venice Biennale 1984), the guide to the British Pavilion's exhibition, remarked:

> His current vocabulary ... asserts the abstract authority of each mark set down. And yet, in this net of voluptuous colour, the ghost of memory seems to cling more tenderly, as if he had discovered the perfect medium for its preservation.

Terry Atkinson

Terry Atkinson's practice stems from the belief that art cannot be divorced from the context in which it is made. He therefore holds the view that through art it is possible to further our understanding of the complex social and political world in which we live. Using commonplace visual forms such as snapshots, cartoons, postcards and sketches, his paintings describe people and events. Texts often accompany the pictures, giving clues as to Atkinson's intended meanings, but also serving to highlight the ways in which images are misinterpreted.

In the late 1960s Atkinson visited America and met a number of artists whose work interested him, including Sol LeWitt, Dan Graham, Carl Andre

Terry Atkinson
1939 Born in
Thurnscoe, near
Barnsley, Yorkshire
1959–60 Barnsley Art
School
1960–4 Slade School
of Art, London

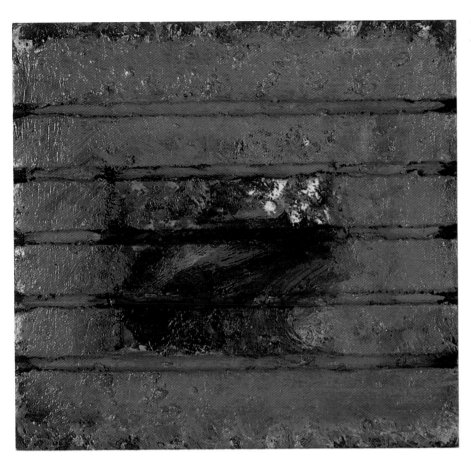

Howard Hodgkin
Still Life 1982–4

Terry Atkinson
*Art for the Bunker 4:
The Stone Touchers
Ruby and Amber in the
Gardens of their Old
Empire History Dressed
Men* 1985

and Robert Smithson. In 1968 he founded Art & Language with Harold Hurrell, David Bainbridge, and Mel Ramsden. Art & Language gained exposure in the early 1970s as part of the Conceptual Art movement and Atkinson remained an active member until 1974.

During the 1980s Atkinson's work explored the relationship between politics and representation with particular emphasis on such issues as the construction of history and artistic identity. Two pictures from a new series of work called *Art for the Bunker* were included in the Turner Prize exhibition. The series consists of two contrasting narrative parts; the *Happysnap/ Historysnap* pictures, and works centring on the history of British-Irish relations. The *Happysnap/Historysnap* paintings, intimate in scale and painted on white grounds, are based on images of the artist's family. They present a notion of domestic life threatened by nuclear war and at the same time suggest the family's ability to combat this with pacifism. The second half of the series comprises larger works in coloured conte crayon, drawn on black grounds, in which the artist attempts to make visible his own unavoidable cultural position as an English artist in relation to reactions to Irish Republican violence.

Tony Cragg

In the 1985 shortlist exhibition Cragg was represented by *Still Life: Belongings* (1985). A discussion of his work can be found under 1988 when he was awarded the prize.

Ian Hamilton Finlay

Until the 1970s Finlay was better known for his poetry, plays and stories than as a maker of prints, medals and sculpture. A love of language and a deeply-felt poetic sensibility has always influenced his art, as has a belief that the aesthetic appearance should stimulate the viewer to contemplate the underlying sources and references of his work.

At his Dunsyre home, 'Stonypath', later renamed 'Little Sparta', Finlay has created a unique artwork with the collaboration of his wife Sue and a range of artists and craftsmen. It has attracted both notoriety and international acclaim.

In the midst of wild moorland he designed and constructed a garden with a 'Temple' containing sculptural monuments which together represent meditations on philosophical and classical issues. Finlay maintains that the 'Canova-type temple' was conceived as a building in which to house works of art rather than as an 'art gallery'. But in the late 1970s he entered a dispute with his local authority, which refused to accept that the 'Temple' qualified for the rates exemption granted to religious buildings. In 1983 the authorities removed works from the temple and the garden was subsequently closed to visitors for a year. Finlay named the ongoing disagreement 'The Little Spartan Wars'. For him it represented a serious conflict concerning the 'nature of culture' and 'the relation between law and culture'. In support of his cause he looked to historical precedent, drawing particular courage from the heroes of the French Revolution: 'For some time I have felt inspired by the neo-classical triumvirate of Robespierre, Saint-Just and J.-L. David. These three created that astonishing idealist pastoral, the French Revolution (whose Virgil was Rousseau). Presumably my work will "progress" towards my being in prison, unless the necessity of revolution (a return to Western Traditions) is understood first' ('Spartan Defence: Ian Hamilton Finlay In Conversation with Peter Hill', *Studio*, 1984, vol.196, no.1004, p.61).

After 1984 he established the 'Temple' as a homage to the classical and pastoral values of the French Revolution. While its main room was conceived as an extension of the garden, an increasing number of columns and capitals were placed outside so that the 'interpenetration' of garden and 'Temple' became a key feature (see Biographical Notes in Yves Abrioux and Stephen Bann, *Ian Hamilton Finlay: A Visual Primer* 1985). The Finlays' refusal to concede over what they believe to be a matter of principle caused them considerable hardship. However, Finlay remained insistent that a bureaucracy should not be allowed to determine a cultural question which in his view it had failed properly to examine.

Tony Cragg
1949 Born in Liverpool
1969–72 Wimbledon School of Art, London
1973–7 Royal College of Art, London
1977 Moved to West Germany

Ian Hamilton Finlay
1925 Born in Nassau, Bahamas
1942–5 Briefly attended Glasgow School of Art before serving in the army during the Second World War
1961 Founded The Wild Hawthorn Press, Edinburgh
1964–6 Lived at Easter Ross near Inverness, Scotland
1966 Moved to Dunsyre, Scotland

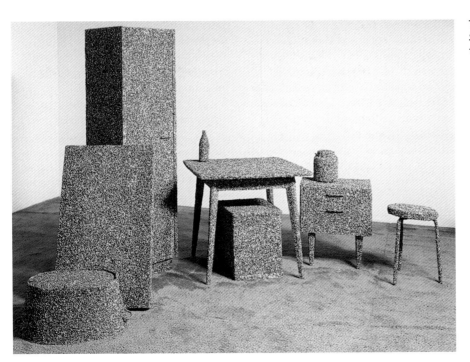

Tony Cragg
Still Life Belongings
1985

Ian Hamilton Finlay
*The Present Order is
the Disorder of the
Future* 1983

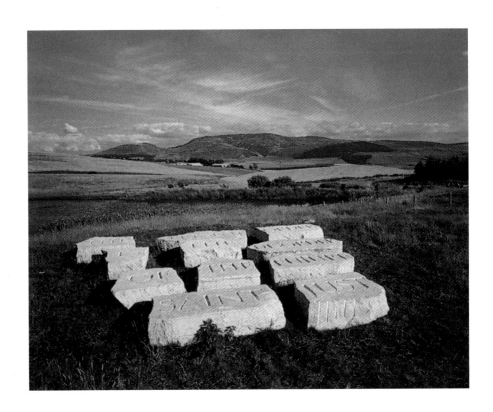

Milena Kalinovska
1948 Born in Prague,
Czechoslovakia
Studied at Charles
University, Prague
1970 Moved to Britain,
becoming a British
citizen in 1977
Studied at Essex
University
1978–80
Commonwealth
Scholarship to
University of British
Columbia

Milena Kalinovska

Milena Kalinovska was Exhibitions Director of the Gallery at Riverside Studios in Hammersmith, London from August 1982 to November 1986. Under her management the Gallery presented over twenty exhibitions each year, including the work of over two hundred artists. The gallery's policy was to exhibit work by young artists both from Britain and abroad. But the policy also promoted neglected older artists and incorporated historical exhibitions. The flexibility of the programming, together with unusual sensitivity towards the artists' intentions for the display of their work, resulted in a dynamic view of contemporary art, relatively unhindered by institutional imperatives. The gallery was run by two people, Kalinovska and her Assistant Exhibitions Organiser, Greg Hilty. They were helped by temporary gallery assistants who worked, often without pay, on specific projects and supervised the gallery. An important development in the year 1985–6 was the initiation and single-handed operation of an education programme by Kate Macfarlane.

Riverside Studios is governed by a charitable trust, and was supported until March 1985 by the Greater London Council and the Arts Council of Great Britain; at the time of Kalinovska's shortlisting it was funded solely by the GLC which was subsequently abolished. In April 1994 Riverside closed for six months owing to lack of funding. Unable to sustain an exhibition programme, it has since channelled resources into theatre production and performance.

Kalinovska became Associate Director of Riverside until January 1989 when she took the post of Senior Curator at the New Museum of Contemporary Art in New York. Between 1991 and 1997 she was the James Sachs Plaut Director at the Institute of Contemporary Art in Boston.

John Walker

John Walker was shortlisted primarily for works he had made in the previous five years. During this period he significantly developed what had been his main preoccupation as a painter, namely, how to make images that are not representational, yet which somehow convey the drama of painting. This approach relates to a tradition of painting begun by Venetian painters of the Renaissance, who invented and developed a variety of pictorial means designed to celebrate the 'wonder' of painting.

Early on in his career Walker was impressed by American Abstract Expressionism: he was particularly drawn to the paintings of Jackson Pollock. However, he rejected the Americans' insistence on all-over fields of colour in favour of shapes which, since the late 1960s, he has depicted within complex illusionistic spaces. Walker's shapes are often motifs derived from or influenced by such sources as the Bible. But he resists any narrative interpretation of his work, preferring to emphasise the language of painting rather than iconography.

In the *Alba* series of the mid-1980s Walker recast meninas, infantas and the Duchess of Alba from paintings by Velasquez and Goya. Using a variety of painterly techniques, such as highlighting, glazing and contrasting brushwork he suggested a theatrical world with its roots in the Western tradition of painting. The highly coloured *Oceania* series, also of this period, represents Walker's response to Australia, where he lived and worked at the end of the 1970s and early 1980s. In 1985 Dore Ashton, in *John Walker: Paintings from the Alba and Oceania Series 1979–84* (Hayward Gallery, London 1985, p.7), observed that Walker's pictures seemed to be asking:

> By what process ... can a modern painter reintegrate all the traditional ways of making a canvas into an image? In the long story that goes back to Venice, and Spain, and Holland, there has been a conversation from painter to painter that Walker enthusiastically extends. It seems to me that the overwhelming sense of inner freedom his recent works convey is a function of the perpetual animated dialogue with other painters dead and alive.

John Walker
1939 Born in
Birmingham
1956–60 Birmingham
College of Art

John Walker
Form and Sepik Mask
1984

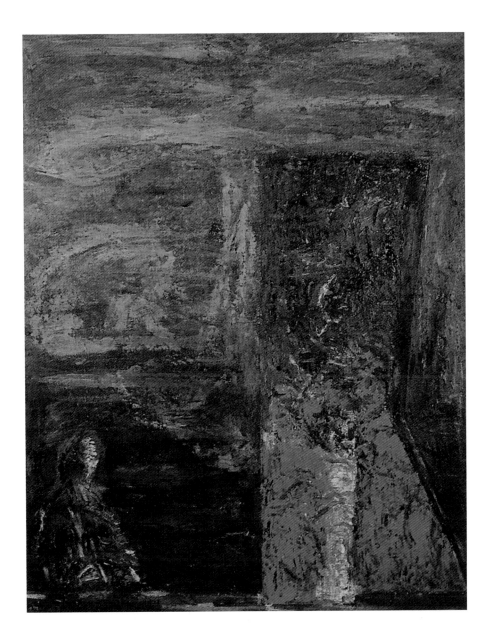

Winner
Gilbert and George

Shortlisted artists
Art & Language
(Michael Baldwin and Mel Ramsden)
for their exhibition at the the Lisson
Gallery, London and for their continuing
contribution to the critical debate about
modern art and its context
Victor Burgin for his exhibitions at the
Institute of Contemporary Arts, London
and at Kettle's Yard Gallery, Cambridge;
for the book of work and commentary,
Between, and for his book of collected
essays, *The End of Art Theory*
Gilbert and George for their exhibition
at the Guggenheim Museum, New
York, for the major European touring
exhibition which began at the CAPC
Bordeaux (subsequently at the Hayward
Gallery, London) and for the exhibition
held at the Fruitmarket Gallery,
Edinburgh
Derek Jarman shortlisted in recognition
of the outstanding visual quality of his
films, in particular *Sebastiane, Jubliee,
The Tempest* and *Caravaggio*
Stephen McKenna for the exhibition of
his paintings at the Institute of
Contemporary Art and the Edward Totah
Gallery, London and at the Kunsthalle,
Dusseldorf
Bill Woodrow for his exhibition of
sculpture *Natural Produce, an Armed
Response*, at La Jolla Museum of
Contemporary Art, California, and for
his many contributions to exhibitions
in Britain, Europe and the USA

Commended
Nicholas Serota on the reopening of the
Whitechapel Art Gallery, London
Matthew Collings for expanding *Artscribe*
into an international magazine
Robin Klassnik for his continuing
support of new art and particularly
installation work at Matt's Gallery,
London

Jury
Jean Christophe Ammann
Director of the Kunsthalle, Basel
David Elliott
Director of the Museum of Modern Art,
Oxford
Michael Newman
Art critic and lecturer
Fredrik Roos
Representative of the Patrons of New Art
Alan Bowness
Director of the Tate Gallery

Exhibition
3 November–7 December 1986
Prize of £10,000 presented by
Melvyn Bragg, 25 November 1986

Gilbert and George
Coming 1983

By its third year no one could deny that
the prize had become British art's biggest
media event. Its success ensured that at
the end of Oliver Prenn's initial three-
year sponsorship another sponsor, Drexel
Burnham Lambert, had fallen easily into
place. But despite this apparent
achievement, the Turner Prize was
experiencing serious problems. Judging
by various articles and letters it seems
that almost everyone involved was
dissatisfied.

Michael Newman, one of the 1986
jurors, wrote to Alan Bowness about the
response to the shortlist: 'Somehow we
seemed to have managed to upset
everybody, quite unintentionally' (Letter
of 10 July 1986). Worse still was that it
had been publicly reported that a trustee
of the Tate thought the shortlist 'silly,
pathetic and depressing' (Marina Vaizey,
Sunday Times, 6 July 1986, p.45).
Newman urged Bowness to change the
proposed site of the exhibition from the
Octagon. In his view the artists should be
allowed 'a spectacular presentation in
which the work will be seen in its best
possible light ... If the display falls flat,
then it really will be a disaster for the
prize, for the artists and for the public
appreciation of new art'.

A few weeks later the inadequacy of
the likely exhibition space became the
subject of an article by Andrew Graham-
Dixon in the *Sunday Times*: 'Poorly lit and
claustrophobically low-ceilinged, the
Octagon's worst feature is its shortage
of wall space ... Turner Prize exhibitors
will have to make do with an average of
eleven feet of running wall space each'
(*Sunday Times*, 3 August 1986, p.40).
Graham-Dixon canvassed some of the
participating artists, most of whom
seemed clearly disappointed by the
arrangements for the exhibition. Mel
Ramsden of Art & Language was
particularly aggrieved: 'They mount this
elaborate media operation to popularise
British art, and then fail to do anything
about showing the art properly.'

The Gallery recognised that the
Octagon was not ideal but the imminent
re-roofing of the Duveen galleries meant
that these grander spaces would not be
available for the display. However,
recognising the need to improve the
exhibition, the Director of the Tate agreed
to allocate the Turner Prize a gallery space
usually reserved for the permanent
collection. Sadly, this did little to quell
negative reviews of the both the shortlist
and the exhibition, typified by the
comments of a critic writing in the
Sunday Telegraph: 'Neither the shortlist
nor the pathetically inadequate,
unexplained, timid and esoteric
presentation currently at the Tate, are
going to "increase public interest in
contemporary art"' (Michael Shepherd,
Sunday Telegraph, 16 November 1986,
p.19).

In 1986 critics were also beginning
to question what appeared to be the
predictability of the winner. Gilbert and
George, William Hill's favourites at 6/4,
went home with the award and commen-
tators ranging from John Russell Taylor
of *The Times* to Waldemar Januszczak
of the *Guardian* questioned the validity
of a prize which appeared to be a reward
for long service, 'an occasion during
which art world inhabitants can pat each
other on the back in the vague way that
Hollywood does when it distributes its
honorary distinguished service Oscars'
(Januszczak, *Guardian*, 27 November
1986, p.14).

Gilbert and George

Gilbert and George have constantly
attempted to address themes and subjects
from human experience in such a way
that their work would be accessible to
untutored audiences. They have often
declared a belief in beauty, although as
self-styled 'campaigning artists' their
overriding aim has been to challenge or
improve society, rather than congratulate
it. In Carter Ratcliff's *Gilbert and George:
The Complete Pictures 1971–1985*,
(London 1986, vii), they stated:

> We want Our Art to speak across the
> barriers of knowledge directly to
> People about their life and not about
> their knowledge of art ... The content
> of mankind is our subject and our
> inspiration. We stand each day for
> good traditions and necessary
> changes. We want to find and accept
> all the good and bad in ourselves.

They met at St Martin's School of Art in
London in 1967, and have worked
together as one artist ever since. As
students they were among a generation,
including Barry Flanagan, Richard Long

COMING

Gilbert
1943 Born in
Dolomites, Italy
Studied at
Wolkenstein School
of Art
Hallein School of Art
Munich School of Art
1967–8 St Martin's
School of Art, London
George
1942 Born in Devon
Studied at
Dartington Adult
Education Centre
Dartington Hall
College of Art
Oxford School of Art,
Oxford
1966–8 St Martin's
School of Art, London

and Bruce McLean, who rebelled against the ideas of Anthony Caro and New Generation sculpture which dominated St Martin's at that time. In 1969 they began to perform 'actions', referring to themselves not as performance artists, but as 'living sculptures'. The first of these was *The Singing Sculpture*, in which they acted out the lyrics to Hardy and Hudson's version of Flanagan and Allan's music hall song *Underneath the Arches*. In 1970 a presentation of this piece lasted for eight hours each on two consecutive days.

Such has been their commitment to the transformative role of the artist that Gilbert and George have devoted their entire lives to art, adopting the persona of living sculpture in their everday lives. Both dress in white shirts, loud or emblematic ties and worsted suits – 'the responsibility-suits of our art' – which convey the seriousness of their task, and maintain a measured formality in their behaviour towards each other, and the rest of world. Assessing their achievement in 1985, Brenda Richardson wrote:

> They grew up as artists in the mid-to-late 1960s under the domination of Pop Art and Minimalism, movements given to non-judgemental content and anti-expressionist form. Gilbert and George, quite contrarily, were committed to meaning and morality in art and to imaginative expression as the most honest and direct form of communication. When they decided to use their own bodies as art material and their personal convictions as content, they literally invented their own medium and carved out a unique and memorable place for themselves in the evolution of contemporary art.

In addition to the so-called 'living pieces', which they ceased to perform in 1977, Gilbert and George have worked in a variety of media, including video, drawing, painting and photography. Since 1980 their photographic pieces have become the dominant vehicle for their meditations on the human condition. Their subjects have included sex, religion, nature, urban development, authority, fear, ecstasy and death. The intellect, the soul and sex are ever-present components of their work: 'We often say

that within the person, when we are working, we have our brain, our soul, and our sex. These are the three things that we work with. Sometimes we do a picture more for sex, sometimes more for our brain, and sometimes more for our spirit. It's always with a combination of those three that we work. The whole of civilisation continues because of those driving work forces' (*Gilbert and George: The Complete Pictures*, xxxi).

Their photo-pieces comprise groups of abutted photographs, which, framed in black, form a grid. This format has several advantages. It enables them to overcome the restrictions of printing and produce mural-sized images that can convey their ideas forcefully and directly to the viewer. But the grid format also has a philosophical motive, as Gilbert and George perceives the world as having natural divisions. Again in *The Complete Pictures* (xvi) they state:

> The grids are a natural part of making large photo-pieces. It is like a week had to be divided into days, for convenience. A house has to be made of Bricks. You can't make a house from one big brick ... Everything is in sections.

The grids also give the luminous photo-pieces the appearance of stained glass, which enhances the serious intention underlying their use of often shocking, and even comic, imagery. The works are laboriously hand made with exemplary precision. But their effect is that of images effortlessly magicked into existence.

Gilbert and George have used their own experience as the basis of all of their works. The photo-pieces are made from photographs of themselves, models and their immediate environment. On one level the images might be interpreted autobiographically. But they are deliberately composed as symbolic icons, rather than as narratives, devised as confrontational mediations on aspects of human activity and emotion. As Brenda Richardson explains: 'Their omnipresent self-images ... are not necessarily to suggest the literal role of Gilbert and George in the specific setting depicted. As symbolic images, they become Everyman – pilgrim, guide, and *alter ego* for their fellows' (p.15).

Gilbert and George
Death Hope Life Fear
1984
One of four panels

Art & Language
Michael Baldwin
1945 Born in Chipping Norton, Oxfordshire
1964–7 Coventry College of Art
Mel Ramsden
1944 Born in Ikeston, Derbyshire
1960–2 Nottingham School of Art

Victor Burgin
1941 Born in Sheffield
1962–5 Royal College of Art, London
1965–7 Yale University, Connecticut

During the 1980s Gilbert and George were prolific, both in the quantity and range of their work. During the 1970s they had combined only the powerful and emotive colour red with their black-and-white photographs. But from 1980 onwards they began to exploit the emotional, spiritual and symbolic qualities of green, blue, violet, pink, orange and yellow, favouring vivid hues. They also experimented with photographic and compositional techniques and devices such as overlapping images, superimpositions and photograms, so that the images became more complex. One such example is *Death Hope Life Fear* of 1984. In this four part polyptych (or tetraptych), the artists appear with many of their favourite motifs. These include the flower, a symbol of sex and fecundity, and youths from the East End, who frequently appear in their works as symbols of ideal manhood.

Their significance for a younger generation of British artists has been publicly acknowledged by their inclusion in such recent exhibitions as *Minky Manky*, curated by Carl Freedman at the South London Gallery in 1995 and *Some Went Mad, Some Ran Away*, curated by Damien Hirst at the Serpentine Gallery, London in 1994.

Art & Language

Art & Language has promoted theoretical debate about the social and political identity of works of art, and encouraged a thoroughgoing questioning of the cultural status of the art object and the artist. Founded in Coventry in 1968 by Terry Atkinson, David Bainbridge, Michael Baldwin and Harold Hurrell, Art & Language played an important role in the development of Conceptual Art, largely through the vehicle of its magazine *Art-Language*. Soon after its inception the magazine included contributions from Joseph Kosuth, Ian Burn and Mel Ramsden in New York. Within a few years a number of other writers were also involved, expanding the interests and alliances of the group. However, by the mid-1970s, various members and associates were pursuing individual paths, leaving Baldwin and Ramsden as the remaining protagonists of Art & Language; they now also share their collaborative writings with Charles Harrison.

In 1986 Art & Language produced a new series of paintings called *Incidents in a Museum*, based on the spaces of the Whitney Museum of American Art in New York, an institution that had been crucial to the rise of American modernism. The paintings depict imaginary installation shots of Art & Language works as 'incidents' inside the museum. The works are shown either in the form of fragments so that details are enlarged, or as complete compositions seen scaled down. John Roberts in *Art & Language: The Paintings*, Société des Expositions du Palais des Beaux-Arts, (Brussels 1987, p.86) has commented on this strategy with particular reference to *Index: Incident in a Museum, Madison Avenue*, one of two pieces used to represent Art & Language in the Turner Prize exhibition:

> The content of the series shifts its allegorical focus from the museum as a space of provisional democracy to a space where art is made quite literally incoherent. In their work included in the Turner Prize exhibition at the Tate Gallery (November 1986) this shift of focus is given a grievously ironical emphasis. The only way we can view the museum interior is through scattered holes drilled into sheets of plywood attached an inch above the surface. These sheets are organised in the pattern of the exterior cladding of the museum.

Victor Burgin

Victor Burgin's art practice is inseparable from his theoretical writings, which are steeped in the ideas of political, psychoanalytical and linguistic theorists such as Marx, Freud, Foucault and Barthes. Influenced by a commitment to left-wing ideas, his work entails a critique of how both art and individual identity are perceived and produced in relation to specific social and historical contexts. He has said: 'What still interests me in art is its ability to criticise. Art is, in fact, the only area in which such criticism can still take place'(*Victor Burgin: Passages*, Musée d'Art Moderne de la Communaute Urbaine de Lille, Villeneuve d'Ascq, Ville de Blois, 1991, p.19). Like other conceptual artists such as Joseph Kosuth

Art & Language
*Index: Incident in a
Museum, Madison
Avenue* 1986

Victor Burgin
Office at Night 1986
From a series of seven
triptychs

and Art & Language, Burgin believes that art is a system of information produced within a social context, although he has never rejected its subjective and imaginative potential.

During the 1970s Burgin developed a style of work based on the juxtaposition of texts and images. He also used familiar forms of mass communication such as photography and advertising, which he hoped would make his images more relevant to a wider audience:

> At that time, I had the feeling that the world was saturated with images, and that there was no point in manufacturing more ... I felt that an artist's job was to take already existing images and rearrange them so that new meanings appeared ... My strategy was a kind of 'guerilla semiotics': capturing images and turning them against themselves [ibid. p.24].

Since the late 1970s one of Burgin's key projects has been an exploration of the representation of women. Alluding to, parodying, or actually quoting well-known images of women from art history, he draws attention to and questions how women are repeatedly 'fetishised' through types of imagery. In *Office at Night*, for example, included in the Turner Prize exhibition (together with another image from this series, *Danaides,* both of 1986), Burgin positions a photograph of a contemporary female figure alongside the secretary from a painting by Edward Hopper.

Derek Jarman

Jarman's creativity had many outlets. As an artist, teacher, film-maker, theatre designer, poet and polemicist he engaged with important intellectual, political and moral questions. He had trained as a painter and continued to paint until his death in 1994, despite the near-blindness he suffered as a result of AIDS, producing a series of vividly coloured and expressive canvases. These late works deal uncompromisingly with mortality and with the experience of being gay.

In 1986 Jarman was shortlisted for his achievements as a film-maker, and in particular for his feature film *Caravaggio*, funded by the British Film Institute. Earlier that year at the Berlin Film Festival it had already won the prestigious

Silver Bear award for 'visual conception'. At its London opening *Caravaggio* was met with critical acclaim. Unusually for a low-budget, art-house film (made with £475,000 in a warehouse in London's then derelict Docklands) it successfully competed against Hollywood blockbusters for audiences. The creative energy and unconventional lifestyle of the seventeenth-century Italian painter Caravaggio had long been a source of inspiration for Jarman. His film drew attention to the undeniable homosexual content of Caravaggio's paintings, but what critics most admired was Jarman's imaginative exploitation of the relationship between Caravaggio's pioneering use of dramatic light and dark contrasts, known as 'tenebrism', and the medium of film itself. As Mary Davies observed in the Turner Prize 1986 exhibition catalogue (p.11):

> Caravaggio ... could be described as the inventor of cinematic lighting. The dramatic lighting effects used for the first time in his painting are now the central concern of every cameraman and film-maker. With designer Christopher Hobbs and cameraman Gabriel Beristain, Derek Jarman has created a film in which the lighting progresses from the bright luminosity of Caravaggio's early paintings to the shadowy chiaroscuro of the later works. Many of the paintings are represented as stunning *tableaux vivants* as Caravaggio's low-life models pose as saints and virgins in the silence of the artist's studio.

Stephen McKenna

Stephen McKenna exhibited regularly throughout the 1960s and 1970s, but remained an isolated figure until the 1980s. During this decade it was possible, though somewhat erroneous, to view his realistic, figurative paintings, which excavate and transform images from ancient European culture, in the context of a post-modern preoccupation with the past. Whereas post-modernism favours quotation and pastiche, McKenna's aim has been to use the imagery of classical mythology to convey what he perceives to be enduring human concerns. To achieve this goal he has adopted a subtle poetic, even surrealist

Derek Jarman
1942 Born in Northwood, Middlesex
1960–2 King's College, London
1963–7 Slade School of Art, London
Died 19 February 1994

Stephen McKenna
1939 Born in London
1959–64 Slade School of Art, London

Derek Jarman
*Michael Gough as
Saint Jerome* 1986

Stephen McKenna
*Clio Observing the
Fifth Style* 1985

53

approach to subject matter, as J.C. Ebbinge-Wubben observed in 1985 (*Stephen McKenna*, Institute of Contemporary Arts, London 1985, p.7):

> What at first sight looks like historicism is on the contrary a transformation, a metamorphosis of it; what seems, superficially viewed, to be imitation turns out upon closer inspection to be imagination ... He sees it as the fundamental task of painting 'to attempt to see ourselves and our surroundings ... with an eye which can discern the poetic reality rather than the deceptive ... wrapping.

McKenna paints in a manner appropriate to his classical subjects using techniques derived from 'masters' of the Western tradition such as Titian, Poussin, Courbet and Böcklin. Commenting on his relationship to art of the past, the artist has written: 'If one sees our Western culture as a body of works, rather than as a progression of ideas determined by some inscrutable historicism, it becomes unnecessary to worry about one's distance from the last temporal marker' (*Turner Prize*, exh.cat., Tate Gallery 1986, p.13).

McKenna has embraced traditional genres such as allegorical figure compositions, still-life and mythological landscape. In the 1980s he also produced a series of urban landscapes depicting the ugliness and hostility of the man-made environment. According to Ian Jeffrey, one of these pictures, *Berlin, Havel See*, exhibited in the Turner Prize exhibition, seemed to illustrate McKenna's belief that: 'Landscape painting, dedicated for centuries to the glorification of God through nature ... is in our age more a tragic celebration of a departed wholeness: a lament for dying nature' (*Stephen McKenna*, exh.cat., Museum of Modern Art, Oxford 1983, p.9).

Bill Woodrow

Bill Woodrow established his reputation in the 1980s with sculptures made from discarded objects and materials, obsolete electrical appliances and domestic equipment, culled from junkyards and streets. In 1979 he began to unravel manufactured appliances by arranging their component parts in a line, or by exposing their insides. But his transformations always retained a link between the original and finished object. With his twin-tub sculptures, for example, begun in 1981, he reassembled the dismantled or partially dismantled elements of washing machines to form sculptures, while retaining evidence of the object's original identity and function. Thus, the form of a guitar, a gun, a saw or a bicycle frame emerged, fashioned as a three-dimensional object, from the body of a 'Hotpoint'. He has recycled thrown-away objects in his work, partly because he deplores the excesses of consumer society, but also for the more practical reason that they were readily available for use.

Summing up Woodrow's inventive recasting of the familiar in *New British Art in the Saatchi Collection*, 1989, p.156, Alistair Hicks commented:

> He is a narrative sculptor and speaks directly to those of his time in a manner similar to that of the painters and sculptors of medieval cathedrals ... In looking for a different way to present information he is forced to discover an added and emphatic grace in objects that often previously possessed little ... he has given new life to appliances and machines. With a turn of his wrist he cuts out an animal or instrument, and a washing machine becomes home to a squirrel or starts playing a guitar.

Although Woodrow's sculptures often appear comic, they nonetheless relate in a complex way to contemporary social, political and cultural experience. 'His sculpture is ironic and witty and employs a wide range of rhetorical devices; for example puns, paradox and inversion. They are critical and poignant, comic and grotesque, brutal yet subtle and stress the mortality of the object and the transitoriness of life' (*Turner Prize*, exh.cat., 1986, p.15).

Self-Portrait in the Nuclear Age (1986), shown in the Turner Prize exhibition, is one of several works representing Woodrow's meditations on nuclear power and nuclear war.

Bill Woodrow
1948 Born near Henley-on-Thames, Oxfordshire
1968–71 St Martin's School of Art, London
1971–2 Chelsea School of Art, London
1996 Became a Trustee of the Tate Gallery

Bill Woodrow
*Self Portrait in the
Nuclear Age* 1986

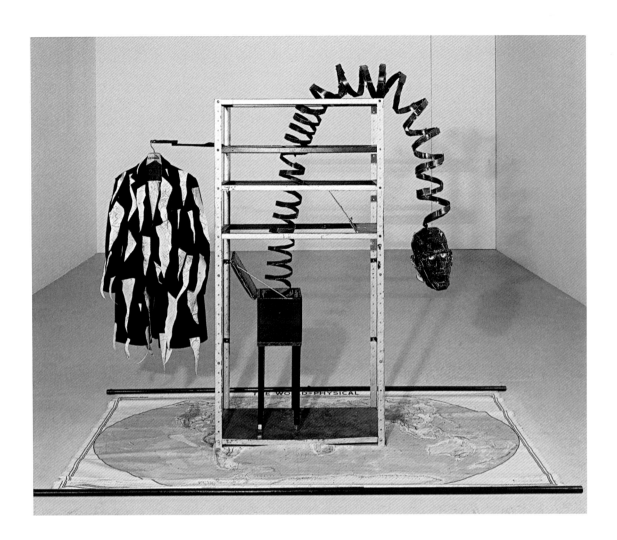

Richard Deacon
Troubled Water 1987;
Fish out of Water 1987;
Feast for the Eye
1986–7

In response to some of the criticisms voiced the previous year a number of modifications were introduced in 1987. The scale of the exhibition, for example, was enlarged to fill the Octagon and the North Duveen gallery. More importantly, the rubric was changed from 'the greatest' to 'an outstanding' contribution to British art, implying that the prize was not automatically awarded to Britain's greatest living artist but to the contender who had made the most impressive impact in any one year. But despite these attempts to hone the prize, the events of 1987 did not go smoothly.

From its announcement, the shortlist in 1987 puzzled and infuriated most critics. The favourite to win was Richard Long as he was the only artist with an international reputation comparable to that of previous winners. So the jury's choice of the younger sculptor Richard Deacon caused consternation, although most agreed that he was the only other contender on the shortlist who might have had a legitimate claim to the prize that year.

The shortlist was designed to draw attention to the diversity of contemporary British art, to give as many artists as possible greater exposure and recogition. Though worthy, this aim was self-defeating as the inclusion of so many implausible contenders proved demeaning for the artists and undermined the serious intentions of the prize. A highly esteemed senior artist such as Patrick Caulfield, who was shortlisted for the *The Artist's Eye*, an exhibition he had selected from the collection of the National Gallery, was a case in point. As he had not been shortlisted for his own paintings Caulfield's chances of winning the prize appeared slim and his presence on the shortlist humiliating. Equally, the continued inclusion of non-artists, in this instance Declan McGonagle, seemed tokenistic, as William Packer pointed out in the *Financial Times* on 26 November 1987 (p.25):

> The argument may be that nomination itself is a distinction to covet, as perhaps it is, though of a perversely patronising kind. Declan McGonagle is a particular victim of this doubtful honour, for he is the token artworld professional admitted to nominal consideration by the terms of the prize, yet tacitly understood to be in with no chance at all. How the form of critics, curators and dealers be fairly measured against that of working artists is a mystery still to be resolved.

Richard Dorment, writing in the *Daily Telegraph*, agreed that Long and Deacon aside, the contenders in 1987 seemed arbitrary, placed on the shortlist 'to lend a spurious suspense to the proceedings', or, as in the case of Helen Chadwick and Thérèse Oulton, selected in response to previous accusations of discrimination against women artists (*Daily Telegraph*, 26 November 1987, p.8). On the whole, the critics of the national newspapers agreed that the terms of the prize needed clarification. Packer expressed the consensus view when he wrote:

> It [the prize] faces a hard but simple choice: to address either recent or long-term achievement, to make that choice clear, and to confirm it by an infinitely more rigorous and consistent selection of the shortlist than has been so far. Each time, and this year is no exception, we have been presented with a choice that is no choice, a race in which any winner would be unthinkable – or at best bizarre – but for two or three, with the rest nowhere [ibid.].

Prior to the Turner Prize of 1987, Alan Bowness had been investigating the possibility of staging a winner's exhibition following the announcement, so that the public would have the opportunity of seeing an artist's work in depth. Drexel Burnham Lambert, the new sponsors of the prize, though keen to promote the event with leaflets, nomination forms and audio-visual presentations, declined to finance such an exhibition in their first year as sponsors. Nevertheless, in his foreword to the exhibition catalogue Bowness tentatively announced the Tate's intention to offer the winner a small exhibition in the summer after the award. This gesture later proved impractical as the winning artist was already committed to a conflicting exhibition at the Whitechapel Art Gallery. But in place of an exhibition

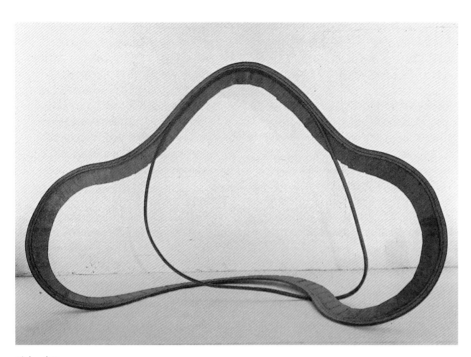

Richard Deacon
For Those Who Have
Ears No.1 1983

(1875–1926). The drawings reveal the important shift in his work from rectilinear, angular forms to a curvilinear, more organic visual language. Ostensibly abstract, the drawings also indicate a continuation of his interest in containers, suggesting such vessels as pots, sacks and pockets. Deacon subsequently made two versions of a large sculpture called *For Those Who Have Ears*, in 1982–3 and 1983 respectively, which share the same subject as the drawings. When questioned about the relationship between the drawings and *For Those Who Have Ears* (in the Tate's Patrons of New Art newsletter, 1985), he explained that their content had to do with a notion about song, or what Orpheus's song does to the world:

> In the story of Orpheus the trees and the rocks move and the wild animals lie down and ultimately he has the power to bring the dead back to life ... What I think is that song is the power of speech. I think of speech as being in between our private selves and the world. The power of speech is a social condition of being human. Language is one of the primary means which allow us to operate on the world, both to recognise and to give it shape.

The forms of the drawings and the sculpture were reminiscent of openings or apertures, like a mouth or an ear – the head of Orpheus singing or listening – or like Orpheus's lyre.

In other works, such as *Turning a Blind Eye*, he explored the relationship between the world and the eye:

> I think that one's sexual desires are projected primarily through vision and I think fairly incessantly, there are a number of works which try and make more sense of that. Taking *Turning a Blind Eye*, the work has several different things going on for it: The shape of the work is both an eye and the shape of a vulva and also it has a plough-like shape at one end ... the work itself is eye shaped, the drawing is like the exterior mount of an eye, the eyelids ... Turning a blind eye is the cliché for letting things happen which you know, but decide to ignore. The work itself in its eye shape is also blind, because it's empty.

Patrick Caulfield
1936 Born in London
1956–60 Chelsea
School of Art, London
1960–3 Royal College
of Art, London

Helen Chadwick
1953 Born in Croydon,
London
1973–6 Brighton
Polytechnic
1976–7 Chelsea School
of Art, London
Died 15 March 1996

Deacon was awarded the Turner Prize for similarly 'organic' and highly allusive works like *Fish Out of Water* and *Like A Snail (B)*, both of 1987.

Patrick Caulfield

Caulfield was included in the 'Young Contemporaries' exhibition of 1961 at the RCA, alongside a number of his peers at the Royal College of Art, such as David Hockney, Derek Boshier and Allen Jones. For many, these artists came to epitomise British Pop Art. Although Caulfield's work shares some of the characteristics of Pop, his images often convey a wistful or melancholic mood quite alien to Pop Art's typically upbeat style.

Since the 1960s he has produced pictures of interiors and still lifes that suggest the banality of everyday existence. Despite his reference to real things Caulfield has stressed that the environments he depicts are entirely fictitious: 'My paintings have always been imaginary; I create a non-existent space and give it a feeling of reality.' His use of light plays an important role in this process: 'I am conscious of formalising lighting effects which of course are imagined ... the way the light plays on the object painted from life seldom bears any resemblance to the way that the light works in the rest of the composition. I believe that my use of light makes objects twist and turn' (*Turner Prize*, exh.cat., Tate Gallery 1987, p.9).

Rather than for his own work, Caulfield was shortlisted on the basis of his selection of *The Artist's Eye* exhibition at the National Gallery, London. Unlike previous selectors who had focused on 'masterpieces', he surprisingly brought together relatively unknown works from a broad range of genres such as landscapes, cityscapes, interiors, still lifes and portraits. Marco Livingstone, in 'Patrick Caulfield: A Text For Silent Pictures', *Patrick Caulfield* (1992, p.11) nevertheless perceived some underlying relationships between Caulfield's paintings and the works chosen:

> *The Interior of the Brote Kerk at Harlem* by the seventeenth-century Dutch painter Pieter Saenredam, a precisely ordered and light-filled architectural view ... provides an admirable precedent for Caulfield's equally

serene interiors ... The presentation of light as a material substance, a concern for atmosphere in creating mood and the directing of the spectator's vision by means of variable degrees of finish – a characteristic of Caulfield's art that emerged in the mid-1970s – are, in fact, to be found also in many of the other pictures selected by him.

Helen Chadwick

Helen Chadwick was appropriately one of the first women to be shortlisted for the Turner Prize. Throughout her short but productive career she was known as a maverick innovator, and her influence, particularly on a younger generation of British women artists, has been considerable.

At the centre of her practice was a desire to extend our understanding of human existence. To this end she drew on a rich variety of sources from areas of knowledge such as anatomy, science and myth. From the 1970s she began to use her own body as the cardinal means of negotiating the subject of human identity. In her *Soliloquy to Flesh* of 1989 she wrote: 'My apparatus is a body × sensory systems with which to correlate experience.' It is therefore not surprising that her work typically provokes a mixture of physical sensations, as Marina Warner has observed: 'Neither exactly pain nor exactly pleasure, not exactly terror, not exactly tranquility, but all these exquisite sensations at one and the same time ('In Extremis: Helen Chadwick and the Wound of Difference', *Stilled Lives*, Portfolio Gallery 1996).

Often exuberant and given to excess, her photographs, sculptures and installations are remarkable for their highly imaginative and perturbing use of unusual materials, including lambs' tongues, furs, flowers, meat, urine, chocolate, household cleaning fluids and hair-gel. Chadwick enjoyed combining materials that would emphasise, yet simultaneously dissolve, the contrast between given opposites – the organic and the man-made, the visceral and the cerebral, the seductive and the repulsive. One example of this approach is *Wreaths of Pleasure* (1992–4), also known as *Bad Blooms*, a series of thirteen large, circular photo-pieces which depict arrangements

Patrick Caulfield
Interior with a Picture
1985–6

Helen Chadwick
Of Mutability 1986

of flowers floating on the surfaces of luridly coloured domestic fluids. As Louisa Buck has observed, the effect is 'a characteristically exquisite Chadwickian celebration of unholy alliances'(*Independent*, 18 March 1996, p.16).

Chadwick was shortlisted for *Of Mutability*, an exhibition of recent work held at the Institute of Contemporary Arts in 1986. Inspired by the baroque vanitas tradition the show was noted by the jury for its 'striking use of mixed media'. *Carcass*, for example, comprised a seven-feet-high transparent pillar filled with rotting vegetables. This unequivocal and pungent image of decay or *momento mori* was for Chadwick an attempt 'to find a resolution between transience and transcendence'. The show also included images of the artist appearing to float in a pond surrounded by fish, lambs and fruit, all in a state of decomposition.

Summing up Chadwick's achievement Marina Warner concluded (ibid.): 'Her art developed from the immediacy of experience gathered through her senses, but she tested this against an inherited set of values, encoded in images and formal standards. In Helen Chadwick's art, Mannerism meets Fluxus, the Rococo merges with Situationism – who could have ever dreamed such an imaginary fusion could happen?'

Richard Long

Long was shortlisted in 1984, 1987 and considered as a contender in 1988. A discussion of his work can be found under 1989 when he was awarded the prize.

Declan McGonagle

Declan McGonagle studied painting at the College of Art in Belfast. After a postgraduate year in 1976 he lectured part-time and exhibited his work throughout Ireland. In 1978 he was appointed by Derry City Council to set up and run the Orchard Gallery. In 1984 he joined the Institute of Contemporary Arts in London as Exhibitions Director. He returned to Derry in 1986 to initiate a series of new arts projects for the City Council. He also became responsible for the development of an Outreach/ Public Art Programme and the Foyle Arts Project (centred on a nineteenth-

century school building) as well as the Orchard Gallery programme.

When the Orchard Gallery opened in 1978, funded by Derry City Council with a subsidy from the Arts Council of Northern Ireland, it was the first professionally established public arts facility in Derry. Since opening it has developed a visual arts progamme that reflects contemporary art on an international as well as regional basis. Under McGonagle's directorship, the gallery staged over twenty-five exhibitions and initiated tours and collaborations with equivalent galleries and organisations in Ireland and abroad. McGonagle helped to forge relationships with local artists and communities whose involvement with the gallery led to a variety of successful installations, performances, public art projects and related events. An important aspect of the programme included the publication of monographs, catalogues, artists' books, recordings and other printed material.

In the late 1980s the Orchard Gallery's visual arts programme expanded in the context of the City Council's developing museum and cultural service. In 1987, for example, a team of four people started working with colleges, schools and other institutions and groups in the area. McGonagle left the Gallery in 1990 to become the first director of the Irish Museum of Modern Art (IMMA) in Dublin. In 1993 he served on the Turner Prize jury.

Thérèse Oulton

Thérèse Oulton's paintings received critical attention at her Royal College of Art Diploma show in 1983. Her large canvases seemed to suggest a Romantic feeling for landscape akin to that found in pictures by Turner, Watteau and Gainsborough. The complex tracery of paint, with its allusions to rock and plant formation, and the predominance of such colours as greens, blues and browns, all pointed to the landscape tradition. The rich colours, seductive textures and often dramatic impact of her paintings of the next few years also brought to mind other 'masters' of Western art, including Titian, Rubens and Velazquez. But the paintings also seemed undeniably contemporary. Oulton's handling of paint, for example, addressed twentieth-century concerns,

Richard Long
1945 Born in Bristol
1962–5 West of England College of Art, Bristol
1966–8 St Martin's School of Art, London

Thérèse Oulton
1953 Born in Shrewsbury, Shropshire
1979–83 St Martin's School of Art, London
1983–4 Royal College of Art, London

Declan McGonagle
1952 Born in Derry

Thérèse Oulton
Pearl One 1987

such as the flatness of the picture surface and the creation of a single field of paint. Writing in 1987, she explained that her intention was to distance traditional painterly elements such as form, light and colour from their usual descriptive role: 'Kinds of brushwork or a chosen palette, etc., conjure a selected heritage but, as examples, my re-usage of chiaroscuro doesn't describe a body receding into space. The pictorial device is adrift. Light is not used as an organising principle. Each brushwork is its own generator of light or lack of it. Colour concentrates or disperses undetermined by attachments to things or spaces' (*Turner Prize*, exh.cat., Tate Gallery 1987, p.19).

In the catalogue of Oulton's first solo exhibition in 1984 (*Thérèse Oulton: Fool's Gold*) Catherine Lampert described her particular method of applying paint to canvas:

> She prepares a coloured ground and on a palette-table sets out pools of turpentine-thinned oil paint. With a sable brush, or sometimes her hands, she pushes wet paint into wet paint, perhaps working and completing the whole area in one session. When this is possible the painted surface is only skin-deep. Nevertheless the variegated forms seem to have been caressed and battered into shape. Across the surface the flux, tempo and climaxes remind us of the coded messages an orchestra conductor sends. Oulton's musical sense of continuum lends credibility and beauty to the most melodramatic eruptions.

Richard Long
Red Walk 1986

RED WALK

A JAPANESE MAPLE IN AUTUMN LEAF
BERRIES 14½ MILES
A PLASTIC SHOE 17 MILES
A MUCK-SPREADER 21 MILES
SUNSET 22¼ MILES
ROSES 30½ MILES
A PLOUGH 37½ MILES
DRAINPIPES 38 MILES
COXCOMBS 39½ MILES
AN APPLE 44 MILES
FOXGLOVES 49½ MILES
A GYPSIES' FIRE 54 MILES
SUNSET 54¼ MILES
PAINT ON THE ROAD 63¼ MILES
A COAL LORRY 64 MILES
BLOOD OF A THRUSH 68 MILES
HOLLY BERRIES 71¼ MILES
A JET AIRCRAFT 72¼ MILES
A ROADMAN'S HAIR 75 MILES
A LETTERBOX 80 MILES
STONES 82¼ MILES
A PLOUGHED FIELD 90½ MILES
THE FACE OF A COCK PHEASANT 91¼ MILES
A SANDSTONE CLIFF 98 MILES

BRISTOL TO DAWLISH
ENGLAND 1986

Winner
Tony Cragg

Unpublished shortlist
There was no official shortlist in 1988. However, a number of artists, listed here, were discussed by the jury in the process of selecting a winner. Several of them were contenders for the prize on other occasions and their profiles can be found elsewhere in this book as indicated

Tony Cragg
for his exhibition as the British representative at the Venice Biennale
Lucian Freud for his exhibition at the Hirshorn Museum, Washington and tour to Paris, London and Berlin
Richard Hamilton for his exhibition of new work at the Fruitmarket Gallery, Edinburgh and Museum of Modern Art, Oxford
Richard Long for a continuing series of exemplary smaller exhibitions and publications, mainly abroad
David Mach for the exhibition of *101 Dalmatians* at the Tate Gallery, Millbank
Boyd Webb for his exhibition at the Whitechapel Art Gallery, London, Hanover, Los Angeles and Edinburgh
Alison Wilding for her exhibition at the Museum of Modern Art, New York and smaller exhibitions elsewhere
Richard Wilson for his contribution to Television South West Arts exhibition in Newcastle

Jury
Richard Cork
Art historian and critic for the *Listener*
Carmen Gimenez
Director, National Centre for Exhibitions, Madrid
Henry Meyric-Hughes
Director, Fine Arts Department, British Council
Jill Ritblat
Chairman, Patrons of New Art
Nicholas Serota
Director Elect of the Tate Gallery and Chairman of the Jury

Exhibition
Winner's exhibition held 26 April–25 June 1989
Prize of £10,000 presented by Alan Yentob, 22 November 1988

Tony Cragg
On the Savannah 1988

The arrival of a new Director of the Tate Gallery in 1988 provided the opportunity for a complete rethink of the terms and conditions of the prize. Nicholas Serota introduced a number of modifications: for example, from 1988 the prize would be given only to artists. But Serota's most radical change was the discontinuation of a published shortlist which in the past had caused 'anguish to artists without giving compensating edification to the public' (Letter from Nicholas Serota to Alan Bowness, 13 April 1988).

The disparity and size of the shortlist had also produced Turner Prize exhibitions that either disappointed or annoyed the art world and confused the public, who understandably believed that the quality of the work on view had some influence on the jury's final choice. As envisaged by Bowness, the shortlisted artists' display was replaced by an annual winner's exhibition staged during the summer following the presentation of the award. As things turned out, the winner of the prize in 1987, Tony Cragg, was the only artist to enjoy a one-person show of this kind.

But the abolition of the shortlist did little to encourage critical favour. For many its disappearance brought the entire *raison d'être* of the prize into question. Even a sympathetic critic such as Marina Vaizey, who lauded the winner as an 'outstanding sculptor' and an 'exciting original', bemoaned the opportunity that had been lost: 'Without the shortlist, there was no chance to survey the field, no peg for advance publicity, no public debate and hardly any gossip' (*Sunday Times*, 27 November 1988, p.8). Vaizey argued that all art prizes should be used to help art 'reach the public'. She concluded:

> There is room for more showbiz ... and greater public involvement, with national exposure of the group from which the final choices are made. Contemporary art is robust enough to take such scrutiny. The goal should not be a self-enclosed world congratulating itself but making art ever more accessible [ibid.].

Unfortunately, the Gallery's attempt in 1988 to give the prize more dignity by establishing a dinner at the Tate at which an artist, politician or celebrity would deliver a keynote speech, was interpreted in the absence of a shortlist as a self-congratulatory affair. Critics claimed that audience involvement had diminished. Ironically, the nature of Tony Cragg's work attracted an unusual amount of tabloid attention and engaged the public, however crudely. Following the announcement of the winner the Press Association dubbed Cragg a 'saucy' and 'controversial' sculptor 'whose works have included ... A bottle of tomato ketchup, beer, a bottle of wine, lemonade bottles, a jar of mustard, a variety of pickled vegetables and other sauce containers'. The correspondent gleefully continued: 'One exhibit on show last year, entitled *Wooden Muscle*, comprised seven lumps of rock, a tree trunk and four old scraps of wood, prompting one on-looker to comment: "I've seen a better pile in the back garden on bonfire night".'

Tony Cragg

Tony Cragg belongs to the generation of British sculptors who emerged at the beginning of the 1980s to achieve national and international acclaim during that decade. This generation, whose work was quickly though opaquely dubbed the 'New British Sculpture', includes Richard Deacon, Antony Gormley, Shirazeh Houshiary, Anish Kapoor, Richard Wentworth, Alison Wilding and Bill Woodrow. As students most of these sculptors experimented with conceptual art, installation and performance. But gradually they began to focus on making objects from mundane materials, and fabricated rather than crafted. Furthermore, their work tended to allude to meanings beyond the theories of art itself. Cragg recalled this turning point in 1987: 'For me, in the mid-seventies, the crucial question became one of finding a content, and from that came the idea that that might evolve through a more formal approach to the work' (*Tony Cragg*, exh. cat., Hayward Gallery 1987, p.24).

In 1977 Cragg moved to Wuppertal in West Germany where he has continued to live and work. His first large-scale exhibition in London was held at the Whitechapel Art Gallery in 1981. Cragg was shortlisted for the Turner Prize in 1985, but despite the rapid growth of his reputation in continental Europe and America, his work remained relatively

1988

Tony Cragg
1949 Born in Liverpool
1969–72 Wimbledon
School of Art, London
1973–7 Royal College
of Art, London
1977 Moved to West
Germany

Lucian Freud
1922 Born in Berlin
1933 Moved to Britain
Became a British
subject in 1939.
1938–9 Central School
of Arts and Crafts,
London
1939–42 East Anglian
School of Painting and
Drawing, Dedham
1942–3 Part-time study
at Goldsmiths'
College, London
1983 Created a
Companion of
Honour

Richard Hamilton
1922 Born in London
1938–40 Royal
Academy Schools and
Central School of Arts
and Crafts, briefly
continuing his studies
at the RA in 1946.
1948–51 Slade School
of Art, London
1952 Founder member
of the Independent
Group at the
ICA, London

unfamiliar to audiences in Britain until shown at the Hayward Gallery in 1987.

Cragg's work explores his relationship to objects both natural and man-made and is motivated by a sense of ignorance of the world, of such basic processes as electricity and molecular structure. Cragg is fascinated by the physical sciences – biology, geology, physics, chemistry – and what he has described as 'first-order experiences' – seeing, touching, smelling, hearing. Through his sculptures he constantly draws attention to our responses to both organic and artificial environments, and by formal means often suggests connections between these putatively opposing worlds. A sculpture such as *Citta* of 1986, for example, a structure of repeated units, resembles the growth patterns of particular crystals, implying that man-made ordering systems often instinctively echo nature's design solutions. Typically, this work also brings into question the assumption that nature is somehow more authentic than culture. But Cragg is champion neither of nature nor culture, preferring to invest belief in the power of the object. At root his art has been a quest to understand and improve the world that we inhabit. In the Hayward Gallery catalogue (1987, p.12) he states:

> I think that objects have the capability to carry valuable information for us, to be important to us, but the fact is that most objects are made in ways which are irresponsible and manipulative. Irresponsible because people – the makers of this or that – don't really consider in any metaphysical way the meanings of the objects that they're making; and manipulative because things are made for a variety of commercial and power-based reasons. My interest in the physical world, in this object world, is survivalistic at one level, but it will also lead me to dreams, to fantasy, and to speculation.

Cragg first became known for a series of sculptures made from found fragments of plastic which he began in 1978. These works gradually took the form of wall pieces, such as *Britain Seen From the North* of 1981 which is one of several works made in response to inner-city unrest that he witnessed on a visit to Britain at that time. Although Cragg uses

discarded material his main concern is to treat it as new, raw material rather than to appropriate or recycle. Lynne Cooke has observed: 'objects are not simply recuperated or reclaimed for the realm of art but instead are used in ways which he deems more consequential, to make propositions and statements' (Hayward Gallery catalogue, p.45). He has used an eclectic range of materials, including stone, wood, concrete, metals, rubber, plastic, glass, and he often incorporates existing objects into his sculptures. During the mid-1980s Cragg produced bodies of work dealing with the broadly interpreted themes of landscape and the city. Many of these works were shown at the Hayward Gallery in 1988. *Minster* of 1987, for example, comprises towers built from circular objects which recall chimneys, church spires, capacitors in early radios and the cell receptors of the eye. Similarly, *Capillular Landscape* of the same year draws comparisons between geological layers and cross-sections of human nerve tissue. Cragg commented in the Hayward Gallery catalogue (pp.34–6): 'In a sense it's obvious that in terms of the physical world scientists make more fundamental statements but artists and philosophers don't have a less important job. They humanise, they find out what the significance of science is for human beings ... I think you have to make images of objects which are like thinking models to help you get through the world.'

His interest has always been in the meaning of objects, whether they are organic or man-made. In 1984 he explained the underlying aim of his work, which was to explore connections between the laws governing nature and those invented by man in order to foster a more appreciative relationship between human beings and their increasingly alienating world (*Tony Cragg's Axehead*, Tate Gallery 1984, p.12):

> At one time the number of objects produced was quite limited. They were functional and there was a very deep relationship with these things. Because of industrial manufacturing techniques and commercial producing systems we are just making more and more objects and we don't gain. We don't have any deep-founded

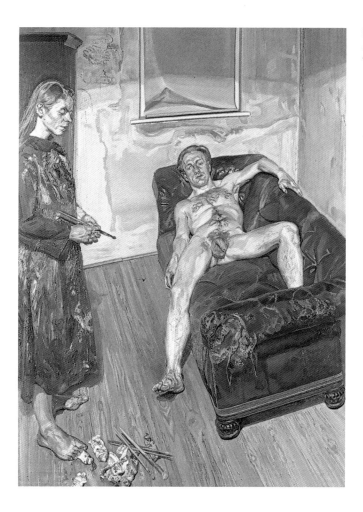

Lucian Freud
Painter and Model
1986–7

relationship with these objects, even those made of traditional materials like wood, as in the the case of *Axehead*. There are lots of familiar materials which are now produced in new ways through industrial techniques and we don't even have time to really reflect on these changes. If we work on the premise that the quality and nature of our environment and what we are surrounded with is actually having a very direct effect on us, on our sensibilities, perhaps even our emotions and intellects, then we have to be more careful with these objects and spend more time learning something about them.

In 1987 Cragg confessed that the motivation behind his work was to find a way of surviving in a visually hostile environment (Hayward Gallery, p.20):

> Perhaps I should be frank and ... say that I'm trying to improve the quality of my life. To find for myself a way of dealing with it.

Lucian Freud
For a discussion of his work see 1989.

Richard Hamilton
Through his activities with the Independent Group, Richard Hamilton was a key instigator of a Pop Art sensibility in Britain, producing a now famous definition of Pop's basic principles. Hamilton's work is perhaps best understood as an attempt to transform the tradition of Western art in the light of these principles, making him a contemporary history painter. His main subject, our complex relationship to the modern world, has led him to deal with a range of important social and political issues. In the early 1980s, for example, his memorable painting *The Citizen* (1982–3) initiated a series of paintings on the theme of the 'Troubles' in Northern Ireland.

Hamilton has been preoccupied with how the display of art contributes to its possible meanings since the 1950s, when he curated the exhibition *Growth and Form* at the Institute of Contemporary Arts in 1951. As much of his new work concentrated on the subject of 'interior' spaces, the

Richard Hamilton
Lobby 1985–7

1988

Richard Long
1945 Born in Bristol
1962–5 West of
England College
of Art, Bristol
1966–8 St Martin's
School of Art, London

David Mach
1956 Born at Methil,
Fife, Scotland
1974–9 Duncan of
Jordanstone College of
Art, Dundee
1979–82 Royal College
of Art, London

Fruitmarket Gallery exhibition was designed as a series of rooms each functioning as discrete installations in themselves. Bringing together his work of the 1980s for the first time, this exhibition confirmed for many that Hamilton was at the height of his powers, continuing to develop his ideas using a variety of media and technologies.

Richard Long

For a discussion of Long's work, see 1989, when he was awarded the prize.

David Mach

Through his sculptural installations David Mach has aimed to demythologise contemporary art for an unitiated public. To achieve this goal he has adopted a number of strategies: making temporary work in public spaces in order to undermine the commercial basis of the art world, using familiar consumer products such as bottles, books and tyres as his basic material, and collaborating with others so as to dispel the image of the artist as an alienated creative genius. His use of discarded manufactured objects and materials has aligned him with peers such as Tony Cragg and Bill Woodrow. However, his work is distinctive in that he transforms his materials visually and conceptually without changing their original physical or associative character. Through his sculpture he has attempted to extend rigid definitions of the theme of landscape in art.

In 1986 Mach installed *Fuel for the Fire* at Riverside Studios in Hammersmith. A curvilinear tidal wave created from old magazines surged from a fireplace, swallowing domestic objects lying in its path, threatening, like mass consumer culture, to engulf everything before it. Later in the decade he increasingly used objects for their potential meanings rather than primarily as raw material. In *101 Dalmatians*, for example, Mach addressed the theme of consumer desire by installing a 'chaotic nightmare of household furniture ... orchestrated by a pack of ornamental dogs, themselves the very objects of desire, works of art and commodities' (Frances Morris, *David Mach: 101 Dalmatians,* Tate Gallery 1988, p.11).

Richard Long
Untitled 1988

David Mach
101 Dalmatians 1988

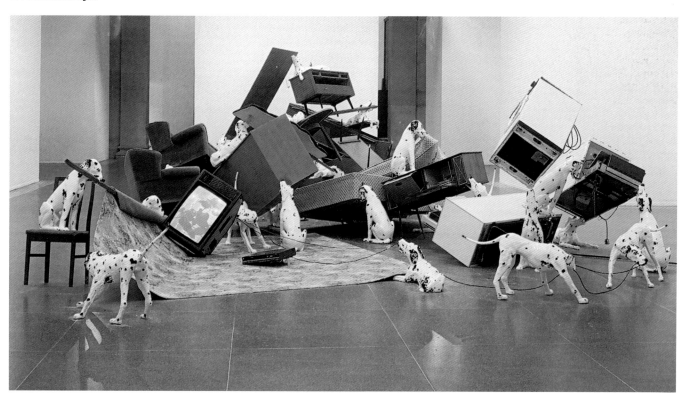

Boyd Webb
1974 Born in
Christchurch,
New Zealand
1968–71 Ilam School
of Art
1972–5 Royal College
of Art, London

Richard Wilson
1953 Born in London
1971–4 Hornsey
College of Art, London
1974–6 Reading
University

Alison Wilding
1948 Born in
Blackburn,
Lancashire.
Grew up in St Ives,
Huntingdonshire
1967–70
Ravensbourne College
of Art and Design,
Bromley, Kent
1970–3 Royal College
of Art, London

Boyd Webb

At the Royal College of Art Boyd Webb experimented with casting the human body in fibreglass. When documenting his work he discovered that taking photographs gave him a greater imaginative freedom and he began to take pictures of carefully staged tableaux comprising actors and props within dramatic settings. Drawing on Victorian genre painting and the sensibility of Surrealism, his works suggest elusive narratives that transform the everyday into a magical and marvellous place. In the words of Greg Hilty he has created 'a poetic experimental universe ... governed like our own world, by conditions which are at once self-perpetuating; stasis and migration, growth and decay, life and death' (quoted in *Spellbound*, Hayward Gallery, London 1996, p.125). An enduring feature of his work has been a concern with ecological issues such as pollution, nuclear war and the effects of technology, although his approach to these subjects has been discreetly subversive rather than overtly political.

In 1981 Webb began to make Cibachromes, high-quality photographs with excellent colour resolution, which enabled him to work on a larger scale with a new vibrancy. His fabricated environments became more fantastic, hinting at parallel universes where familiar objects are denied their logical properties or functions. Michael O'Pray has recently commented: 'Webb's work projects a sense of the "impossible", presented as solace for the disappointment of the world as it is' (*Spellbound*, Hayward Gallery, p.128).

Alison Wilding

See 1991 when Wilding was shortlisted for the prize.

Richard Wilson

See 1989 when Wilson was commended for the prize.

Boyd Webb
Pupa Rumba Samba
1986

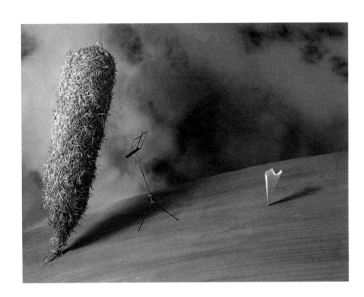

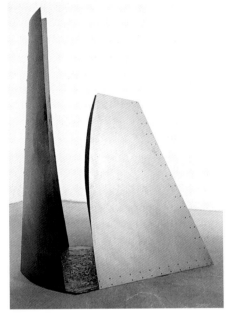

Alison Wilding
Stormy Weather
1987

Richard Wilson
20:50 1987

1989 will be remembered as the year in which Richard Long finally secured the prize. All five artists who had appeared on the first shortlist had now won the award, and agitation for further changes to the terms of the prize reached fever-pitch. The absence of a shortlist in 1988 had proved as contentious as any published list in previous years. So by way of concession, in 1989 the jury announced a review or 'highlights' from the preceding twelve months, commending seven artists from whom a winner would be chosen. The rubric of the prize now declared that the award would go to an artist 'for an outstanding achievement and contribution to art in Britain in the preceding twelve months' in deference to the increasing number of important and influential exhibitions by foreign artists taking place in Britain. This explains why for the first time a foreign artist, Giuseppe Penone, was considered for the Turner Prize. But these amendments pleased almost no one and critical reaction to the prize in 1989 was fiercer than ever. Geordie Greig in the *Sunday Times* (19 November 1989, p.C5) reported that discontent among artists and dealers had 'reached unprecedented levels' largely because: 'The competition is trapped fatally between those who believe art is not a competitive business and such prizes demean it, and those who support the idea of a Booker-like media extravaganza but accuse the organisers of half-heartedness in attracting coverage ... Whoever wins, it seems unlikely that the Turner Prize will emerge unscathed. The furore over Andre's bricks may seem minor in comparison with what happens this year.'

Most critics were still unclear about what the prize was actually for, as John Russell Taylor pointed out in *The Times* of 20 November (p.20):

> If the award is an accolade received on entry to the inner circle of the art establishment, then the choices are fair enough. But that is hardly going to generate the sort of excitement that the Booker Prize regularly achieves, because there is no chance of the prize being snatched by an untried youngster or a rank outsider.

After the announcement of the prize, several works by Richard Long in the Tate's collection were placed on display (*A Line in Bolivia – Kicked Stones* of 1981 and *Ten Days Walking and Sleeping on Natural Ground* of 1986) and a small winner's exhibition was planned for the following year. But Long's exhibition never took place (instead he became the first artist to participate in the Tate's series of annual exhibitions by contemporary sculptors in the newly renovated Duveen sculpture galleries, inaugurated in 1990). Drexel Burham Lambert had pledged to extend their sponsorship of the prize for a further three years at the enhanced level of £20,000. But in February 1990 DBL wrote to Serota reneging on their sponsorship. Furthermore, they were forced to withdraw expenses for the winner's exhibition. Drexel had gone bankrupt leaving the prize high and dry and non-existent during 1990.

Richard Long

Richard Long's work is about his relationship to the landscape. Since 1967 he has based his work on making walks in a variety of locations. He has undertaken solitary walks all over the world, often in remote areas, ranging from the Highlands of Scotland to the Alps, the Andes, the Sahara and Lapland. Using maps, words, and photographs he records things he has seen and evokes experiences he may have had on the walk, including those of time, space, movement, sight, sound, touch and taste. As part of his walk Long often creates a sculpture in the landscape, using elements readily to hand such as twigs, driftwood and stones. In remote areas these sculptures have remained anonymous, gradually returning to the natural environment. The impermanence of his sculptures is crucial, whether produced in the open air or installed in a gallery space: for Long their ephemeral quality suggests the reality of the human condition. Although he is often affected by the beauty of the landscape Long does not set out to depict this, or any other aspect of the natural scene. Instead, he aims to give the idea of the walk, recording facts such as the distance covered and weather conditions. Often physically demanding, the walks nevertheless give the artist great pleasure. In Rudi Fuchs's *Richard Long* (1986, p.74), he comments:

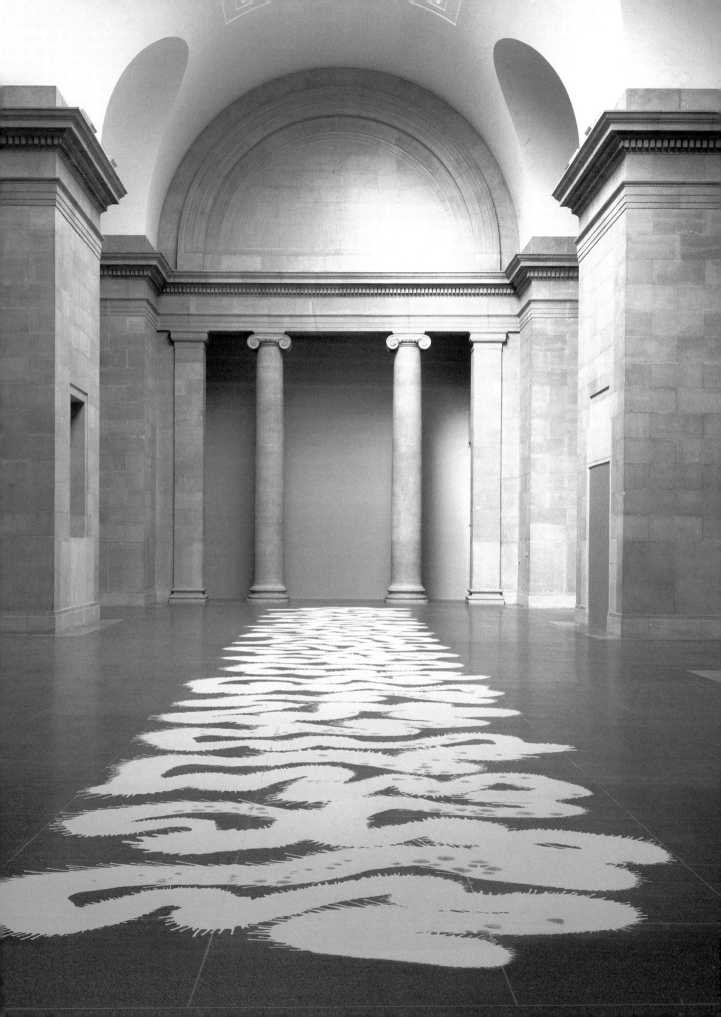

Richard Long
1945 Born in Bristol
1962–5 West of
England College
of Art, Bristol
1966–8 St Martin's
School of Art, London

Gillian Ayres
1930 Born in Barnes,
London
1946–50 Camberwell
School of Art, London
1981 Moved to North
Wales
1987 Moved to
Cornwall

Behind my work ... is the idea that I have seized an opportunity, won a fantastic freedom, to make art, lay down abstract ideas, in some of the great places of the world. So even with storms or bogs or blisters or tiredness, the way I can make my work is intensely pleasurable and satisfying. Even in the more modest ambience of a road walk, the labyrinth of country roads, the inns, the bed and breakfasts, the fabric of country life is still an enjoyable part of making the work and, although not specifically the subject of it, it is implicit in the idea of the work and the place of it.

Although Long has played down the romantic aspect of his art practice, his total involvement with the landscape and his often poetic responses to it place him in a particularly English romantic tradition that can be traced to Constable and Wordsworth. His relationship to the land is always based on personal experience, not just of the present but also of the past. He has talked, for example, of his art as carrying the pleasures of childhood – damming streams, throwing stones and building sand-castles – into adult life.

Often referred to as a 'land artist', Long has identified his work more closely with Italian Arte Povera and Conceptual Art. Although he works in and with the land, his method of working distinguishes him from North American land artists such as James Turrell and Robert Smithson who employ technological means to realise their work. In contrast, Long explores the relationship between man and nature on a human scale, indeed, he sees his work as a 'self-portrait, in all ways'. In an interview with Georgia Lobacheff, he commented: 'To walk across a country is both a measure of the country itself (its size, shape and terrain) and also of myself (how long it takes me and not somebody else). In other works, like my hand circles in mud, or waterlines, my work is more obviously an image of my gestures' (*Richard Long,* São Paulo Bienal 1994, British Council 1994, p.6).

Long has emphasised the primacy of his own experience as the source for his works and enjoys discovering new and original paths. In Fuchs' *Richard Long* (pp.72–3) he says:

I am interested in walking on original routes: riverbeds, circles cut by lakes, a hundred miles in a straight line, my own superimposed pattern on an existing network of roads – all these are original walks ... The surface of the earth, and all the roads, are the site of millions of journeys; I like the idea that it is always possible to walk in new ways for new reasons.

But alongside his insistence on the personal is a deliberate use of abstract, universal shapes and forms. In the interview with Georgia Lobacheff (p.5) he comments:

All my work is about my choices, my preferences. I like stones, so I use them, in the same way I make art by walking because I like walking. Stones are practical, they are common, they exist almost all over the world, they are easy to pick up and carry, they are all unique, universal and natural. But I also use other materials, like mud and water. My preference is always for simple, elemental and natural materials.

Long's sculptures always comprise universally recognisable geometric shapes shared by cultures all over the world. His sculptures might take the form of a straight line, a spiral, a cross, or more typically a circle. Geometric shapes provide the visual language of Minimal art, but in their natural setting his abstract sculptures suggest a more mystical interpretation. Writing about Long's work in his Palazzo delle Esposizioni catalogue (Rome 1994, p.17), Mario Codognato commented on the undeniable symbolism of the circle:

Ever since the dawn of civilisation human beings have produced abstract and schematic representations of the red disc of the sun and the image of the full moon and used them to express the notion of homogeneity, of absence of division. The circle has always been viewed as an indivisible totality. Circular movement is perfect in itself, unchangeable, it has no beginning or end. Hence its use as a symbol for time can be found in all

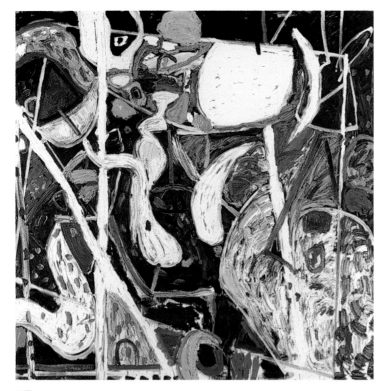

Gillian Ayres
Dido and Aeneas 1988

cultures, from the Babylonians to the Greeks ... and from the native peoples of North America to the modern wrist-watch.

The universal language of Long's sculptures and mud paintings was particularly noted in 1989 when his work was seen alongside artists from around the world in the controversial exhibition *Magiciens de la Terre*, held at the the Centre Georges Pompidou, Paris.

Gillian Ayres

Since the late 1970s Gillian Ayres has enjoyed the kind of critical reputation that few British women artists of her generation have achieved. Her large, abstract paintings have a distinctive exuberance created by a joyful celebration of colour and opulent forms. Although titles help to suggest a particular mood, her subjects remain elusive, deriving as they do from personal rather than theoretical imperatives, as Alistair Hicks has observed in his *Gillian Ayres* (exh. cat., Arnolfini Gallery, Bristol 1989, p.8):

> In many ways she is the existential heroine; she lives for the present. There is no sign of a theme, the paintings vary dramatically from one to the the next. She is honest enough to systematically report her feelings. One factor only unites her work, her deep commitment to painting, the momentum of her life.

In the 1950s, Ayres, like many of her peers, was affected by American Abstract Expressionism. In 1957 she was struck by a photograph depicting Jackson Pollock painting his canvas on the floor and for some years she also adopted this practice. Yet despite her admiration for Pollock, Ayres has, nevertheless, continued to place her own work firmly within a European tradition. She has said, for example: 'Titian, Rubens and Matisse are the greatest painters, unashamedly, of sheer beauty but they also used the medium to the fullest in every sense before or since'; and, 'I would like my paintings to have the same affect as Chartres or late Titian'. Monet's late paintings, such as his images of Rouen Cathedral dissolving in colour and light, have also inspired her search for the sublime.

Lucian Freud
1922 Born in Berlin
1933 Moved to Britain
Became a British
subject in 1939
1938–9 Central School
of Arts and Crafts,
London
1939–42 East Anglian
School of Painting and
Drawing, Dedham
1942–3 Part-time study
at Goldsmiths'
College, London
1983 Created a
Companion of
Honour

Giuseppe Penone
1947 Born in Garessio
Ponte, Piedmont, Italy
1966–8 Academia di
Belle Arti, Turin

Paula Rego
1935 Born in Lisbon
1952–6 Slade School of
Art, London
1956 Returned to
Portugal
1962 Began to divide
her time between
London and Portugal
until settling in
London in 1976

During the 1980s Ayres intensified both the substance of her paint and its colour. She exchanged her acrylic-based paints, plastics and resins, for oil and introduced sumptuous colours such as gold. Assessing the significance of her 1989 exhibition at the Arnolfini Gallery, Hicks concluded: 'The present exhibition reveals her desperately fighting to contain some of the force that she had previously allowed to disappear into thin air, to find new relationships between areas of paint. It has created an extra tension. She has become a painter for all seasons' (ibid. p.10).

Lucian Freud

In 1987 Lucian Freud's major retrospective exhibition opened in Washington, touring to Paris and finally London in February 1988. Writing in the exhibition catalogue, Robert Hughes declared Freud as 'the greatest living realist painter'. The show provided an occasion for the assessment of Freud's career and at the same time stimulated a wider critical debate about the role of figurative painting at the end of the twentieth century.

In the 1940s Freud painted with such stark clarity of line that Herbert Read was moved to call him 'the Ingres of Existentialism'. In the late 1950s, influenced by the works of his close friend Francis Bacon, he began to use a hog-hair brush enabling him to force the paint into raw equivalents for hair and flesh. For the depiction of flesh he began to use Cremnitz white, a heavy, grainy pigment with more lead oxide and less oil medium that other whites, which allowed him to convey the physical properties of skin, fat and muscle. Although his means of handling paint have changed, the intensity with which Freud scrutinises his subjects has remained a constant feature of his work.

Freud's sitters, usually relations or friends, are observed over a period of months or even years. Through this obsessive, interrogative looking he has striven to collaborate with them, to give his paintings a sense of his sitter's presence rather than mere likeness. He has said: 'In a culture of photography we have lost the tension that the sitter's power of censorship sets up in the painted portrait'; 'The painting is always

done very much with their co-operation' and 'I am only interested in painting the actual person; in doing a painting *of* them, not in *using* them to some ulterior end of art' (Robert Hughes, *Lucian Freud: Paintings*, exh.cat., British Council, South Bank Centre, London 1987, pp.18 and 20).

Freud's paintings, nevertheless, have a characteristic edginess. The lives that he depicts are shown against the familiar backdrop of his studio, a bare, shabby environment devoid of ornate props. Although seemingly brutal in their rendering of the human form, his paintings retain a sympathy with their subjects. As Robert Hughes observed: 'they bypass decorum while fiercely preserving respect' (ibid., p.21). For Hughes, Freud has addressed the crisis in the European tradition of the Ideal Nude which began in the late nineteenth century with the works of Degas and Rodin. Like these artists Freud has found a pictorial truth that has the power to disturb the audience of his own time.

Giuseppe Penone

Penone is the only non-British artist to have been a contender for the Turner Prize. This unique interpretation of the Turner Prize rubric in 1989 was intended to draw attention to the significant increase in exhibitions in Britain of work by foreign artists. Penone, who showed work at the Arnolfini Gallery, Bristol and at the Dean Clough Arts Foundation in Halifax, is an artist of international repute, having been associated with the Arte Povera movement in Italy since 1969. His work also relates to Land and Process art.

Paula Rego

Paula Rego is primarily a story-teller. Using collage in the 1960s and 1970s and since 1981 by painting directly, she weaves stories that deal with the darker side of human nature, with revenge, betrayal and desire. But her stories have no clear narrative: having no past or future they force the viewer to reach his or her own conclusions. Adrian Searle has commented that when confronting her pictures: 'We step into ... an enigmatic moment in which we have lost our bearings, and the only way to negotiate it is through a process of

Lucian Freud
Standing by the Rags
1988–9

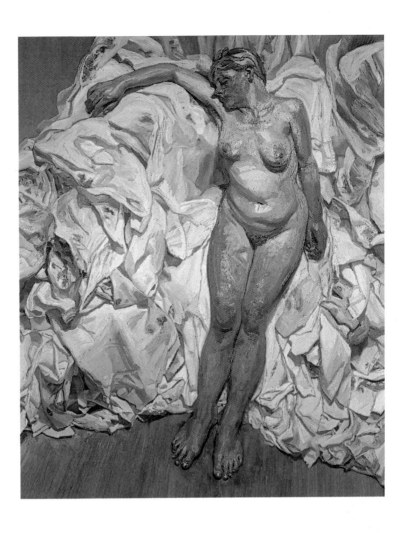

Paula Rego
The Maids 1987

1989

Sean Scully
1945 Born in Dublin; family moves to London shortly after
1965–8 Croydon College of Art
1968–72 University of Newcastle-upon-Tyne
1972–3 Harvard University, Cambridge, Massachusetts
1975 Moves to USA

Richard Wilson
1953 Born in London
1971–4 Hornsey College of Art, London
1974–6 Reading University

deduction, supposition, and an attendance to the hierarchical, psychological disposition of the composition. And, of course, through our own imaginations, our own private histories' (*Unbound: Possibilities in Painting*, Hayward Gallery, London 1994, p.84).

Rego's visual imagination and pictorial language have been nourished by a variety of sources, ranging from *Alice in Wonderland* and Disney films to Portuguese folk tales and the caricatures of Pluma y Lapis. But most important has been childhood experience, which she treats as an ever-present reality affecting adult life. The recurring themes of her work – nurturing and punishment, freedom and repression, power and impotence – are those which dominate childhood. Rego has likened her studio to the playroom where she spent hours in imaginative reverie. She even begins her paintings crouching on the floor as she did when drawing in her playroom.

Until the 1980s her stories were told primarily through pictures of animals, a conceit common to folk tales, fables, nursery rhymes and cartoons. Then humans, particularly pubescent girls, began to take centre stage. In her series *Girl with Dog* of 1986, Rego depicts themes such as punishment and domination with a new-found ambiguity. The dogs, like children, are shown subjected to the omnipotent care of their mistresses. Ruth Rosengarten has observed that for Rego: 'The dividing line between nurturing and harming – between love and murder – is always hair-thin, for the artist's concern is not with good and evil at their extremes, but with the area between, the acts of cruelty with which love is shot' (*Paula Rego*, exh.cat., Serpentine Gallery, London 1988, p.19).

Rego's retrospective exhibition of 1988 included a number of recent works depicting monumental, strong-faced girls. Although graced with such charm-ing attributes of girlhood as decorative clothes and hair, Rego reveals them to be intelligent, calculating and dangerous. In her appraisal of Rego's paintings of this period in *Modern Painters* (vol.1, no.3, Autumn 1988, p.34) Germaine Greer was unequivocal about their achievement: 'After the violation of Balthus's keyhole

vision, feminists hardly dared to hope that a woman painter could reassert woman's mystery and restore her intactness. Rego's paintings are full of shuttered windows, closed doors and vessels of ambiguous content. Her female types smile mirthlessly in a new version of the grin of the Maenads. Her paintings quiver with an anger and compassion of which we have sore need.'

Sean Scully
For a discussion of Sean Scully's work see 1993.

Richard Wilson
Richard Wilson's transformations of architectural spaces using industrial materials such as oil and metal, together with natural phenomena such as water and light, have often produced aesthetic effects that verge on the sublime. Elegant and deceptively minimal, his works destabilise established perceptions of architectural space and structure, heightening our awareness of mundane surroundings.

Perhaps his best-known work is *20:50*, first exhibited in 1987 at Matt's Gallery, London. Although site specific, this extraordinary installation can be adapted to almost any space: for example, it has been installed in 2003 at the newly-opened Saatchi Gallery in the former offices of the GLC, County Hall, London. On entering a room by means of a small corridor the viewer is momentarily unaware that the space has been partially filled with sump oil. The experience is physically disorientating and visually breathtaking: 'The rising and rapidly narrowing walkway that must be negotiated creates an unnerving sense of vertigo as the viewer is thrust out into space amongst an expanse of oil that reflects the surrounding architecture perfectly on its dark, faultless surface ... unlike water or mirrors, the reflection is contained entirely on the surface. It is impossible to see through even the first millimetre of the oil' (James Roberts, *Richard Wilson*, DAADgalerie, Berlin 1993).

In 1989 the Turner Prize jury was impressed by Wilson's four new installations which also dealt with architectural intervention: *Leading Lights* at Brandts Klaedefabrik, Odense,

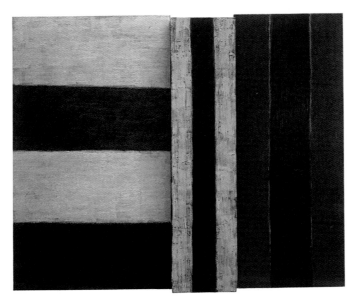

Denmark; *Sea Level* at the Arnolfini Gallery, Bristol; *High-Tec* at the Museum of Modern Art, Oxford and *She Came in Through the Bathroom Window* at Matt's Gallery, London. The last-named work involved suspending a window frame into the gallery space so that instead of being looked through it became an object to be looked at. The frame was still connected to its original position in the wall by panelling, so that part of the outside world appeared to have moved with the window into the gallery. James Roberts has eloquently described the effect:

> You become very aware of the air that has been displaced and is now a boxed and quantifiable volume with a very real presence. The view through the window somehow becomes pictorialised, as if it had become a schematic representation of the effects of perspective ... the physical projection into the space reminds you that viewing can be a two-way process and that, equally, windows allow the viewer inside to be viewed from outside [ibid.].

Winner
Anish Kapoor

Shortlisted artists
Ian Davenport for his powerful demonstration of the expressive possibilities of abstract painting, as seen in *The British Art Show*, in his debut exhibition at Waddington Galleries, and in exhibitions overseas
Anish Kapoor for the development of his sculpture as seen in his exhibitions in Grenoble, Madrid, Hanover and the XLIV Venice Biennale,
Fiona Rae for the impressive way in which she has extended the range of subject matter embraced by abstract painting, as seen in Aperto at the XLIV Venice Biennale, and in her recent London exhibition at the Waddington Galleries
Rachel Whiteread for her resonant sculptures of the spaces surrounding domestic objects and rooms, seen in the installation *Ghost* at the Chisenhale Gallery, East London, in exhibitions at the Arnolfini Gallery, Bristol, Karsten Schubert, London, and in various exhibitions abroad

Jury
Maria Corral
Director, Reina Sofia Centre, Madrid
Penny Govett
Representative of the Patrons of New Art
Andrew Graham-Dixon
Art critic of the *Independent*
Norman Rosenthal
Exhibitions Secretary, Royal Academy of Arts, London
Adrian Ward-Jackson CBE
Chairman, Contemporary Art Society
Nicholas Serota
Director of the Tate Gallery and Chairman of the Jury

Exhibition
6 November–8 December 1991
Prize of £20,000 presented by Robert Hughes, 26 November 1991

Anish Kapoor
Void Field (detail) 1989

From March 1990 the Tate Gallery worked towards reshaping the Turner Prize with its new sponsor Channel 4. Thanks to the enthusiasm of Channel 4's Commissioning Editor for Arts, Waldemar Januszczak, and an enhanced level of sponsorship, Nicholas Serota was able to effect significant improvements in the presentation and promotion of the prize, including the re-introduction of a shortlist exhibition. In the newly established broadsheet catalogue accompanying the Turner Prize exhibition of 1991 Serota took stock of previous failings and gave some explanation of the new-look prize, which now imposed an age limit of fifty years, and was to be awarded for 'an outstanding exhibition or presentation' during the preceding year:

The early history of the Turner Prize, established in 1984, has been in part a search for a format which is appropriate to the visual arts ... This year, after a lapse of one year, the Turner Prize is reinstated with terms which aim to give even greater focus. The decision to exclude artists aged over fifty is a recognition merely of the fact that comparisons are invidious between the achievements of artists of such differing ages as thirty and seventy. More significant, perhaps, is the decision to award the prize for 'an outstanding exhibition or other presentation' which has taken place during the year. This gives the prize a much clearer relationship to specific events, rather than being for an 'outstanding contribution', which carries with it the suggestion of an acknowledgement of a lifetime achievement.

The jury, in considering the exhibitions of the last twelve months, could not fail to note the impact of a younger generation of British artists both at home and abroad. Serota defended the jury's unprecedented inclusion of so many young artists on the shortlist:

Of course, there were doubts about the wisdom of singling out two or three artists from a generation that has not yet fully defined its position. However, the jury eventually decided that the shortlist, and therefore the exhibition

and Channel 4 film, ought to reflect passion rather than caution; better a shortlist which reflects conviction than a balanced end-of-term report.

But no such reasoning could placate the critics, many of whom were outraged by the youth of the contenders, and empathised with Kapoor's position as the only contender over thirty years old. Even more scandalous were rumours that the jury itself was at odds over the shortlist. On 26 November 1991, the eve of the award, Andrew Graham-Dixon replied to such accusations in the *Independent* (p.16):

I remember the first jury meeting in July as an amicable event which bore little resemblance to the descriptions of it that have subsequently appeared in the press. I do not recall the moment when, according to Roger Bevan, the 'other jury members, including the late Adrian Ward-Jackson and Maria Corral, protested this contentious shortlist' but were overcome by 'tactics of insistence'.

The shortlist was widely interpreted as an indulgent concession to fashion, a view summed up by Richard Cork: 'The short-list's trendiness amounts to a massive snub for the whole notion of working steadily towards well-earned maturity in middle age ('Young, Gifted and Rising too fast?', *The Times*, 8 November 1991, p.14). But like other critics, Cork was forced to acknowledge that considerable effort had gone into improving the presentation of the artists' work in the Gallery. The exhibition, traditionally held in the Octagon or North Duveens, now occupied six galleries in the 1979 extension. Furthermore, a video and information panels now helped to introduce visitors to the work on display. Richard Dorment was even moved to write: 'Despite everything you may have read, this is a calm, unassuming and really rather beautiful little exhibition of four thoughtful young artists' ('Winner in a Class of His Own', *Daily Telegraph*, 27 November 1991, p.18).
 Attempting to analyse why the prize continued to provoke controversy Marina Vaizey noted that in previous years sniping had been led 'by those critics and dealers who believe a romantic British

realism is the only genuine British art, and who confuse aesthetic evaluations with Colonel Blimp flag-waving'. But in 1991 the confused focus of the prize had been inadvertently perpetuated by the disparity in age and achievement of the contenders. Nevertheless, Vaizey was encouraging and endorsed the higher profile of the exhibition: 'The Turner Prize needs fundamental popularising ... It seems like a religion in which the public is barred not only from the priesthood but even from the congregation ... We need clearer explanation and demonstration of the marvels of contemporary art, of the way it makes us see and feel; we need more exhibitons of these artists, more television and radio coverage, and a piece of art any of us can potentially own for the price of a hardback book' ('No Wiser After the Event', *Sunday Times*, 1 December 1991, p.5).

The exhibition was clearly attracting new audiences and their apparent incomprehension of the work on display called for greater elucidation and serious critical discussion. Andrew Graham-Dixon, in summing up his experience as a juror in 1991, came to a conclusion that perhaps still holds true: 'The greatest problem facing the prize, now, may not lie within it but without. Its effectiveness depends on the willingness of others to address the contemporary art to which it seeks to call attention, and to do so with at least some of the seriousness with which that art was itself made' (ibid.).

Anish Kapoor

Anish Kapoor gained recognition as a sculptor in the early 1980s. Although appropriated under the term 'New Sculpture', he stands apart from the artists grouped under this label, with the exception of Shirazeh Houshiary and possibly Alison Wilding. His work is driven by a desire for self-knowledge, and to represent this quest he has developed a visual language dominated by archetypal images, including void, mountain, vessel, tree, fire and water. Powerfully evocative, beautiful and sublime, his art has been recognised as having universal spiritual resonance.

The son of an Indian father and an Iraqi Jewish mother, Kapoor's rich

cultural heritage has had a formative influence on his work. In 1979 a visit to India, together with his growing interest in Jungian psychoanalysis, contributed to Kapoor's development of distinctive forms and images. Curvaceous and sexual, these forms appear to symbolise different aspects of the feminine principle. Jeremy Lewison has argued that Kapoor's preoccupation with imagery suggestive of the female body can be understood as the artist's search for the Jungian 'anima', the unconscious female characteristics within man. One of Jung's followers, Eric Neumann, has examined female archetypes as represented in art and equates 'anima' or the 'transformative character' with creativity. Lewison has written in *Anish Kapoor: Drawings*, exh.cat., Tate Gallery, 1990, p.11):

> For Kapoor the interior of the body is an unknown area, a chasm or void which is both comforting and fearful, protective and restrictive, creative and destructive ... These binary oppositions ... are also key elements of Kapoor's images and, furthermore, of Indian, specifically Hindu, culture where the feminine deity (*shakti*) is perceived as the energising female counterpoint or consort of the male god. In cults which elevate the female principle above the male, the female is seen as the energising force which stimulates the masculine potential which is seen as dormant – even dead – without her.

The union of binary opposites – male and female, body and spirit, darkness and light – creates the sense of 'wholeness' that Kapoor seeks to invoke throughout his work.

Colour has played a key role in his art. Like many modern artists, including Yves Klein and Barnett Newman, he believes in its spiritual, symbolic value and transformative power: 'Colour has an almost direct link with the symbol-forming part of ourselves. That is something we have without formal education. It is just there' (ibid., p.21). Kapoor's early sculptures comprised groupings of enigmatic forms covered in pure pigments of red, yellow and blue. These pigments, inspired by the powders used in Hindu worship, leave no trace of

Anish Kapoor
1954 Born in Bombay, India
1973–7 Hornsey College of Art, London
1977–8 Chelsea School of Art, London

Ian Davenport
Untitled 1989

Ian Davenport
Untitled (Drab) 1990

the artist's hand so that the sculpture appears, in the artist's words, 'unmade, as if self-manifest, as if there by its own volition' (Germano Celant, *Anish Kapoor*, 1996, unpag.).

In the late 1980s and early 1990s Kapoor began to make works on a larger scale, many of which explore the theme of the void. Placing pigment, most often blue, inside the cavities of roughly hewn stone vessels he drew attention to the polarity between outside and inside, light and darkness. Kapoor has explained the sense of interior and exterior in terms of the human body:

> An essential issue in my work is that the scale always relates to the body. In the pigment works from 1979 to 1983, a sense of place was generated between the objects. This place has now moved inside the object so it has been necessary to change the scale. The place within is a mind/body space. A shrine for one person! [ibid.].

His aim with these new works was to create an object that did not really exist, a 'non-space', represented as a cavernous, ethereal space in the centre of the stone, as dark as the body's interior. Archetypally, this inner space is identified with the unconscious. The artist has said: 'Void is really a state within. It has a lot to do with fear, in Oedipal terms, but more so with darkness. There is nothing so black as the black within. No blackness is as black as that.' Kapoor's 'void' pieces attempt to produce a sensation of the sublime, a sensation that leads towards communion with God, or in Kapoor's terms, towards self-knowledge or 'wholeness' (ibid.).

Although a number of his works continued to comprise several pieces, notably *Void Field* shown at the Venice Biennale in 1990, in the Turner Prize exhibition Kapoor was represented by a single stone object. Writing in the accompanying broadsheet Sean Rainbird commented:

> In the urn form of the object displayed in this exhibition, there are echoes of an object made for everyday use: a receptacle for the storage of precious liquids. Its substantial height and girth ... hinder visual exploration of its less

accessible, incorporeal inner recesses. However, the coexistence of two such contrasting states of being within one sculpture intimates the potential in human experience for the spirit to unite with the body, part of a transformative process that lies at the heart of Kapoor's work.

Ian Davenport

During the late 1980s and early 1990s Ian Davenport was recognised as one of a number of younger artists who were confidently addressing and contributing to the post-war tradition of abstract painting. The sheer physicality of Davenport's paintings always suggests the importance of the process by which they were made. However, his paintings are not 'action paintings' in the manner of Jackson Pollock. As he points out in his 'Notes on Painting' (published in the catalogue for *The British Art Show* in 1990), Davenport clearly aims to exert an element of control over the medium: 'The structure of the painting is formed by the paint running into itself. Each of my paintings has evolved from a very deliberate process, not from intuitive marking.'

Davenport's paintings of the early 1990s were restricted to one colour. By dripping or manipulating different types of paint and varnish layers over an evenly painted matt ground he achieved contrasts, layers and a certain sense of depth. The apparently random flow of paint in rivulets down the surface of the canvas is in fact achieved by a number of precise techniques – tilting the canvas through one of four planes, adjusting the slant to influence the duration and flow of the paint, sometimes upending his canvases at the end of painting so the drips extend from the bottom to the top. At the same time, Davenport works with the innate properties of his materials allowing gravity and the viscosity of his paints and varnishes to determine the form of each trail of paint.

Although every channel or drip is potentially unique, Davenport subjects each painted trace to an overall structure, containing these individual elements within an organised whole. In the same way, he resists any kind of spiritual or transcendent reading of his paintings: his grounds and overlays do not stain the

Ian Davenport
1966 Born in Sidcup, Kent
1984–5 Norwich College of Art and Design
1985–8 Goldsmiths' College, London

Fiona Rae
Untitled (yellow and black) 1991

Fiona Rae
Untitled (yellow) 1990

Fiona Rae
1963 Born in Hong Kong (1970 moved to England)
1983–4 Croydon College of Art
1984–7 Goldsmiths' College, London

Rachel Whiteread
1963 Born in London
1982–5 Brighton Polytechnic
1985–7 Slade School of Art, London

canvas in the manner of Mark Rothko. The lines of paint are methodically released from the top of the canvas. Davenport deliberately attempts to control the paint, but his generous use of the material often produces sensuous, elegant and arresting surfaces.

Fiona Rae

When Rae emerged as a painter in the late 1980s her apparent virtuosity with the medium – her ability to move effortlessly from one type of brush mark to another – quickly won critical admiration. Since the late 1980s her work has explored the language of visual signs, challenging our expectations of paintings, of what they might be about or what they might contain. Rae appears to question why we probe a picture in search of a motif, almost as a visual reflex, like finding images in cloud formations. Her paintings ask why we suspend our critical awareness of the mechanics of painting and submit so eagerly to the illusion that something is actually depicted.

Her early paintings took the form of ordered rows of signs, each painted in isolation, suggesting the pictograms of hieroglyphic languages. But these signs did not correspond to any code or language. Rae's paintings of the early 1990s are more chaotic, containing disparate gestures or motifs that look out of place and disruptive. Characteristically, the paintings contrast vaguely recognisable motifs with grounds that are neutral or divided into fields of abutting or interpenetrating colours. Scrutinising the variety of painted marks on the surface of the canvas – drips, flourishes, lines, fields of colour – the viewer is uncertain which are deliberate, which accidental. In this way Rae invites a reconsideration of the relative importance of the different components within each work and the role they might play in relation to the composition as a whole.

In some canvases, certain lines and shapes resemble the visual language of cartoons and calligraphic line drawings, or of particular artists, for example, Brice Marden, Phillip Guston, Hans Hofmann and Picasso. In the context of Rae's paintings, how far do these recognisable marks retain their status? Most importantly, Rae's ambiguous marks encourage and yet frustrate any attempt to construct narratives for the painting. Since every viewer will identify the imagery differently, a universally agreed meaning seems impossible.

Rachel Whiteread

In 1991 Rachel Whiteread was represented in the shortlist exhibition by *Ether, Untitled (Amber Bed)* and *Untitled (White Sloping Bed)*. A discussion of her work can be found under 1993 when she was winner of the prize.

Rachel Whiteread
Untitled (Amber Bed)
1991

Rachel Whiteread
Untitled (Sink) 1990

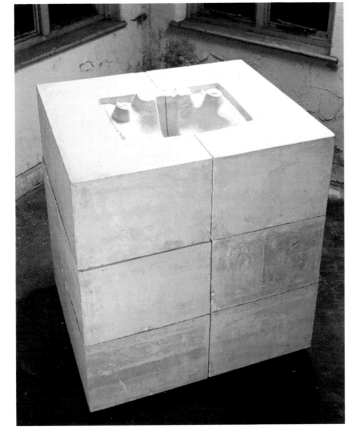

Winner
Grenville Davey

Shortlisted artists
Grenville Davey for the continuing development of his sculpture as seen in his exhibitions at the Kunsthalle, Bern and Kunstverein, Dusseldorf and also for his strong presence in *Confrontations* in Madrid
Damien Hirst for his exhibitions at the Institute of Contemporary Arts, London, his display at the Saatchi Collection, London and the work shown in *Made for Arolsen* at Schlosshof, Arolsen, alongside Documenta
David Tremlett for the many recent exhibitions of his work on the Continent, notably *A Quiet Madness* at the Kestner-Gesellschaft, Hanover
Alison Wilding for the subtle strength of her sculpture, seen in her exhibitions *Immersion* at the Tate Gallery Liverpool and *Exposure* at the Henry Moore Sculpture Trust Studio at Dean Clough, Halifax

Jury
Marie-Claude Beaud
Director of the Foundation Cartier pour l'art contemporain
Robert Hopper
Director of the Henry Moore Sculpture Trust
Howard Karshan
Representative of the Patrons of New Art
Sarah Kent
Art critic of *Time Out*
Nicholas Serota
Director of the Tate Gallery and Chairman of the Jury

Exhibition
4–29 November 1992
Prize of £20,000 presented by Rt Hon. Peter Brooke, Minister for the Arts, 24 November 1992

Grenville Davey
HAL 1992

Compared with the shortlist of 1991 this year's list was relatively evenly balanced, including two mature and two younger artists. But ferocious criticism continued unabated. Commenting on the jury's selection, the Director explained that there had been fewer exhibitions of younger British artists in Britain than in previous years but British art had 'continued to grow in reputation abroad through significant group and solo exhibitions'. This led critics to accuse the jury of not having seen all the exhibitions for which the contenders had been nominated. As in 1991, a number of critics argued that the selection was guided by fashionable international taste, only this year they drew attention to the overbearing influence of Goldsmiths' College and two of London's leading commercial galleries, the Lisson and Anthony d'Offay. This was a strange point to make, as 1992 marked the arrival of two young and distinctly radical dealers who represented artists on the shortlist, Karsten Schubert and Jay Jopling, both of whom challenged the dominance of the heavyweight galleries.

Frank Whitford's article in the *Sunday Times* (29 November 1992, pp.8, 13) typified local resistance to the rise of a new kind of conceptual art in the early 1990s. Lamenting the choice of artists, he concluded:

> The 1992 prize and its seven predecessors have been awarded by juries who manifestly take a narrow and blinkered view of the current state of art in this country, and their decisions have done less to initiate intelligent discussion than to confirm the ill-founded but widespread suspicion that most commercially and critically successful art is the product of self-delusion or a conspiracy cooked up by a coterie of self-appointed experts.

The dismissal by many senior critics of a new generation of artists whose thinking about art and art practice seemed to differ radically from their immediate predecessors proved too much for Waldemar Januszczak, who attacked his former colleagues (*Guardian*, 21 July 1992, p.34):

> As art critic of the Guardian for ten years I watched a lot of things come and go – fashions, art movements, artistic reputations, aesthetic priorities – everything except art critics ... They just stayed where they were, writing the same copy for the same magazine or newspaper, show after show, week after week, piece after piece, journalism's dullest baseliners ... Since when has being a good artist involved being an old artist? Since, I suppose, the moment that being an old critic first became confused with being a good critic.

Few of the more established critics were prepared, for example, to discuss such an artist as Damien Hirst with any seriousness. Richard Dorment was one of the exceptions: 'A 29-year-old avant-garde artist has created a work which in the popular consciousness has the instant recognisability of Whistler's Mother ... I've learnt not to dismiss Hirst. The creator of the shark possesses some kind of genius, whether for finding unforgettable visual images or for manipulating the press I'm not entirely sure' (*Daily Telegraph*, 26 November 1992, p.19).

The favourite in 1992 had been Alison Wilding, with Hirst as the wild card 'wunderkind', so Grenville Davey's win was utterly unpredictable, least of all for the artist himself. Davey later advised the artists shortlisted for the 1993 prize that 'Protective headgear, thick gloves, barrier cream, a length of rubber hose and definitely a sense of humour are objects an artist might need in order to survive the next few months leading up to the announcement of the the winner'. Davey's work was widely dismissed as 'boring', but his conversations with visitors to the exhibition proved more rewarding than reading reviews: 'Their attitude to the prize isn't a romantic view, it's very real; they come to the Tate's Turner show and get to grips with the work in a concrete way' (*Sunday Times*, 1 August 1993, p.9).

If winning brought mixed blessings, 'losing' was even harder. Sarah Kent, art critic of *Time Out* and one of the jurors in 1992, published candid accounts of her involvement in the Turner Prize following the announcement of the winner. In the Patrons of New Art Newsletter (Spring 1993, p.5) she commented on the pressures which the event placed on the shortlisted artists, but defended the principle of the prize:

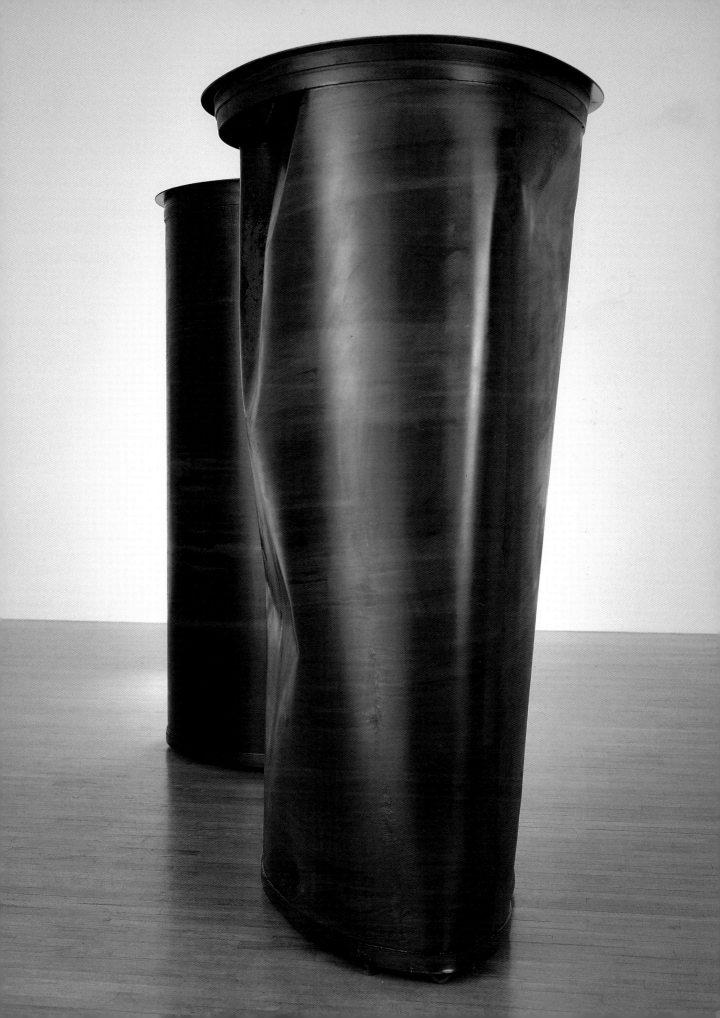

Of course, I expected the runner-up to be disappointed, but nothing had prepared me for the misery felt by the losers, nor for the sense of outrage amongst some of their supporters. Because the prize-giving is broadcast nationwide, their defeat was experienced as a public humiliation ... But in the long term I am convinced that the benefits of taking part far outweigh the pain. Several critics have called for the abolition of the prize, dismissing it as a media circus because of its high profile. This seems ludicrously misguided. The Turner Prize makes an important commitment to art as a living process, recognising that it is not enough for the Tate Gallery to venerate the dead ... The controversy generated by the event is not something to be feared; it is a healthy sign of interest. Fierce argument indicates intense feeling. Better to live in the spotlight, than to moulder in the gloom.

Had she won the prize Wilding would have been the first woman to do so. In 1992, a number of articles on the Turner Prize discussed the continued absence of a woman from the roll of honour, despite the increasing visibility of female artists in public and commercial galleries.

Grenville Davey

In the 1992 Turner Prize line-up Greville Davey was considered by many to be the outsider. But although relatively unknown to a wider public he had been successfully exhibiting work since 1987, when the Lisson Gallery gave him his first show, and had enjoyed subsequent solo exhibitions in Rome, Amsterdam, Paris, Bern and Düsseldorf.

At the centre of Davey's sculpture is an interest in the relationship between the art object and perceived reality. In the twentieth century the idea of the autonomy of the art object – its own reality as a structure of colour, texture, form and materials – has been fundamental to modernism, and led to the making of abstract art. At the same time, many artists, including Davey, have continued to explore reality and our relationship to it. During the late 1980s he was preoccupied with the form of the circle. At first glance his sculptures seem aligned to the tradition of abstract art that upholds Platonic ideas about the absolute beauty of pure forms. However, Davey quietly challenges these notions by subtly modifying geometric purity. On closer inspection, his cool abstract forms are reminiscent of domestic or industrial objects, oddly enlarged and out of context. His sculptures are invested with other contradictions: they appear to be manufactured but are mostly made by hand. They also imply an action which further enhances a narrative meaning such as screwing down, lifting off, welding or fitting. In an exhibition catalogue of 1989 Marjorie Allthorpe-Guyton commented:

> Davey's achievement is that his work is aligned to Minimalism in its refusal of the illusion of representation and yet he reveals simultaneously how and why representation works. He manages this by exploiting the simplest of sculptural language and makes us sharply in touch with our emotional and physical experience of the world.

Davey's reference to everyday objects is characteristically elusive. But though associations with the world of real objects and things are understated, it is possible to view the works, as Davey puts it, as 'objects with purpose', that is, they are not the outcome of exclusively aesthetic decisions. In *Ce & Ce* of 1989, for example, Davey casually places two large rusted steel circles overlapping one another against a wall. The informal positioning and steel lips of the circles suggest the lids of vats or giant paint pots, momentarily set aside. But the diameter groove also gives the circles the appearance of enormous nail or screw heads.

Davey seems to experience the world in terms of parallels or analogies: the noise of rainwater running in the drain in his studio is equivalent to the noise of electric cable shorting; amid the chaotic rattle of dropped metal he hears the sound of a telephone ringing. It seems that his sculptures begin life with a similar parallel or analogy with some object.

Titles play an important role in

Grenville Davey
1961 Born in Launceston, Cornwall
1981–2 Exeter College of Art and Design
1982–5 Goldsmiths' College, London

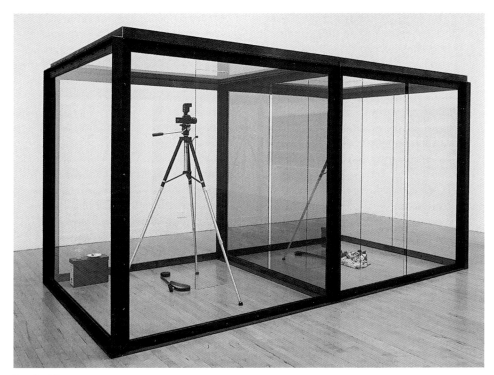

Damien Hirst
The Asthmatic Escaped
1992

Damien Hirst
*I Want You Because
I Can't Have You* 1992

suggesting possible insights to the viewer. In *Right 3rd and 6th* of 1989, undulating curves break the geometry of the basic cylindrical forms of the piece. The title gives the clue – dentists' notation for teeth. The curves were made by Davey bending sheets of hardboard between his knees and then fixing them in position while under tension. He found the title by phoning the first dentist he came across in the Yellow Pages and asking for the names of teeth. The circular forms of *Right 3rd and 6th* have smoothly finished painted surfaces. At this time Davey often painted industrial-sized objects in such domestic pastel colours, the colours of kitchens, bathrooms and bedrooms. *Drum* (1989–90), for example, comprises a pair of steel drums painted milky-white and cream, reminiscent of objects as banal as yoghurt pots.

Davey showed two works in the Turner Prize exhibition. *Common Ground* (1992) was the latest in a series of sculptures playing on the identity and functionality of industrial furniture. Like a number of Davey's sculptures, such as *Dry Table*, its form suggests a freestanding counter. But all of these sculptures are denuded in some way of their basic functionality. *Common Ground*, for example, is given an asphalt surface and its interior comprises a cage of steel mesh whose formal beauty coexists with its industrial references. The other piece included in the exhibition, *HAL*, also of 1992, suggests the generic cylindrical container found in a variety of contexts in the industrial environment.

Damien Hirst

In 1992 Damien Hirst was represented in the shortlist exhibition by two works of 1992, *I Want You Because I Can't Have You* and *The Asthmatic Escaped*. A discussion of his work can be found under 1995 when he was the winner of the prize.

David Tremlett

During the early 1970s David Tremlett was acknowledged as making a particular contribution to Conceptual Art. He was one of a number of British artists, such as Gilbert and George and Richard Long, whose work was recognised internationally and who were collectively seen as a distinctively British presence in avant-garde art.

A common thread in Conceptual Art was anti-materialism, favouring art that was unconventional, fragile or ephemeral in its physical forms. Tremlett shares this view, believing that 'the permanence of the work is in the idea'. A large part of his activity as an artist has been in the making of wall drawings which have a finite existence. Some of his wall drawings are never even seen in public, being made and left on site in the places where he has been moved to make work. More permanent are the large drawings on paper which, like the wall drawings express Tremlett's response to a particular place or thing seen. However, he emphasises that 'The drawing on paper has always had one purpose which is the dream to create a larger version on some interior/exterior surface'.

The tension between Tremlett's need to give monumental physical expression to his art and his feeling for the transience of existence extends to his medium – pastel. This he describes as 'a pigment dust both permanent and fragile'. He delights in the idea of 'the fragility of pastel used to create large structures'.

In 1970 Tremlett began to travel widely in pursuit of his art and has continued to do so: 'Much of my time as an artist has been spent working and travelling cheaply, in the Middle East, Asia, East Africa and the Southern States of the USA ... and naturally Europe ... Writing and drawing out of cheap hotels in towns and villages.' His subjects are 'bits and pieces you bump into, the unsavoury side of street life – dog shit, broken glass, tin cans'. Tremlett's work also deals with his vision of space, volume, time and distance. His sense of volume, space and proportion manifests itself most purely in the wall drawings, whose shapes refer sometimes to the floor plans, sometimes to other architectural details that appeal to him, of the buildings that have captured his imagination. He is particularly attuned to humble and everyday spaces – ordinary dwellings, bars and hotel rooms. In May 1990, for example, on the coast of Tanzania, Tremlett discovered Mjimwema, a group of ruined seaside villas built by sisal traders in the early 1950s. He speaks of their character as 'unpretentious domestic dwellings, not ruins of architectural value', of their

Damien Hirst
1965 Born in Bristol
1986–9 Goldsmiths' College, University of London

David Tremlett
1945 Born in St Austell, Cornwall
1963–6 Birmingham College of Art
1966–9 Royal College of Art, London

David Tremlett
Wall Drawings at
Abbaye de St Savin,
France 1991

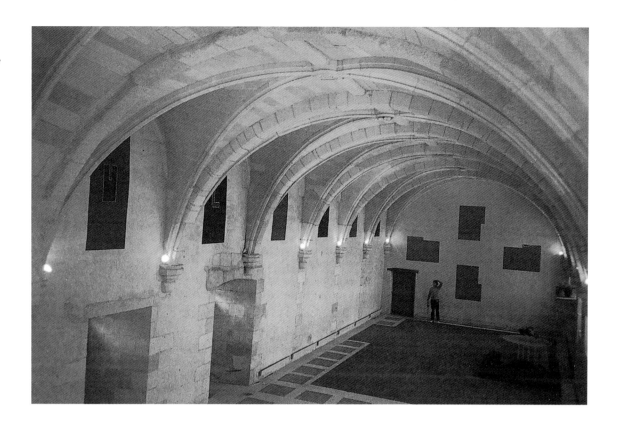

David Tremlett
Walls and Floors 91
1992

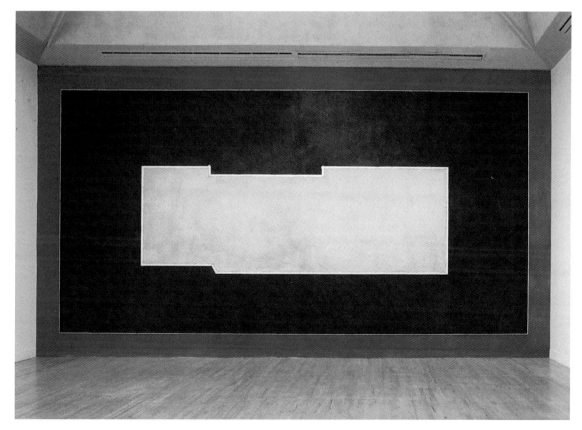

'feeling of a skeleton', and of poetry arising from their decay. The wall drawing included in the Turner Prize exhibition was based on his experience of this place.

Alison Wilding

Alison Wilding
1948 Born in Blackburn, Lancashire Grew up in St Ives, Huntingdonshire
1967–70 Ravensbourne College of Art and Design, Bromley, Kent
1970–3 Royal College of Art, London

Alison Wilding belongs to a generation of sculptors who were identified in the early 1980s as the instigators of a recognisable, if somewhat difficult to define, 'New British Sculpture'. After leaving the Royal College in 1973 she made installations incorporating everyday objects, but within a few years these ceased to be of interest to her and she gave up making work. However, by 1981 Wilding had established the basis of a vocabulary of sculptural forms which she continues to develop. She is also remarkable for a distinctly original and robust approach to materials.

One of Wilding's enduring sculptural preoccupations has been to explore the phenomenon of duality. Her sculptures often comprise two separate elements which interpret such elemental opposites as positive-negative, male-female, light-dark. Her use and understanding of numerous materials, including copper, brass, wood, beeswax, lead, galvanised steel, transparent plastics, silk, cotton, linen cloth, fossils, rubber and a variety of paints, pigments and chemical agents for patinating surfaces, has enabled her to set up unusual contrasts of form, colour and surface in ways that are often poetic.

In the summer of 1991 she exhibited ten years' work at the Tate Gallery Liverpool and five new works at the Henry Moore Sculpture Trust Studio at Dean Clough in Halifax. She chose to show one of the works from Dean Clough in the Turner Prize exhibition, *Assembly* (1991), made of two diverse and contrasting parts successfully brought together as a sculptural whole. According to Wilding one part is 'a steel tunnel with no light at the end' and the other is 'light, liquid and life'. The latter part is made of strips of PVC whose structure was carefully worked out in theory, although she had no idea what the final effect would be. It is typical of Wilding's working method to discover the finished sculptural form through the often slow and painful process of making the object.

Wilding also exhibited *Red Skies* of 1992 which belongs to a group of hollow upright forms whose veiled interiors are glimpsed through narrow slits or peephole-like apertures in their sides. The placing of one or more objects inside another was a recent development in her work. In *Red Skies* two sections, one inverted, of a darkly patinated steel cone, are placed to contain yet reveal a hollow column of transparent red acrylic. This is topped with a spun brass sphere, drilled with holes into which are inserted three different wires, two brass and one bronze, tightly coiled down on the surface, creating an effect, says Wilding, like 'worms cast on a beach'. She wanted the title to 'encompass an area of unease'. This work exemplifies key aspects of Wilding's achievement, namely her ability to produce formally resolved sculpture which alludes to some of the most basic elements of our psychology.

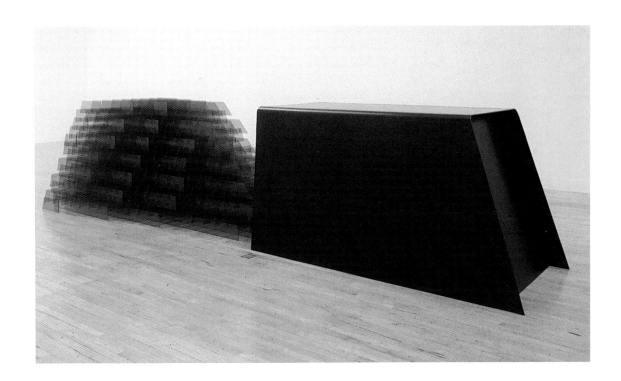

Alison Wilding
Assembly 1991

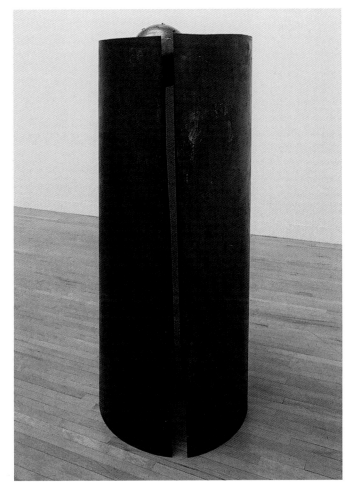

Alison Wilding
Red Skies 1992

Winner
Rachel Whiteread

Shortlisted artists
Hannah Collins for her strong representation at the Third International Istanbul Biennial, where she exhibited her series *Signs of Life*, and also for her retrospective exhibition at the Centre d'Art Santa Monica, Barcelona

Vong Phaophanit for his installation of *Neon Rice Field* at the Serpentine Gallery, London and at the Venice Biennale Aperto, and also for *Litterae Lucentes (Words of Light)*, an installation in the grounds of Killerton Park in Devon

Sean Scully for exhibitions of his work at Waddington Galleries, London, Mary Boone Gallery, New York, and for his major retrospective at the Modern Art Museum, Fort Worth

Rachel Whiteread for the continuing development of her work as shown at her retrospective exhibition at the Stedelijk Van Abbemuseum, Eindhoven, the Sydney Biennale, and Galerie Claire Burrus, Paris

Jury
Iwona Blazwick
Curator of exhibitions in Britain and abroad
Carole Conrad
Representative of the Patrons of New Art
Declan McGonagle
Director of the Irish Museum of Modern Art, Dublin
David Sylvester
Art historian
Nicholas Serota
Director of the Tate Gallery and Chairman of the Jury

Exhibition
3–28 November 1993
Prize of £20,000 presented by Lord Palumbo, 23 November 1993

Rachel Whiteread
House 1993

In retrospect, 1993 can be viewed as a watershed for the Turner Prize, a year that saw a significant increase both in visitors to the exhibition and audience appreciation of the works on display. The prize became firmly established as a newsworthy event of national and international interest, despite the persistence of negative critical coverage. A number of critics were completely wrong-footed by the public's response to the shortlisted artists. Giles Auty, for example, erroneously claimed in the *Spectator* (20 November 1993, p.56) that:

> As an exercise in poor public relations both by the Tate Gallery and Channel 4, the Turner Prize as handled at present would be hard to improve upon. By now probably the only people who care which of this year's shortlisted artists will carry off the cash are the contestants themselves. In spite of the enormous efforts made each year to drum up public support for the prize, scepticism has become deep-rooted even among those who can be bothered to take an interest.

Some critics continued to attack the terms of the prize and complained about the prevalence of conceptual and installation art. Ironically, it was *Neon Rice Field*, the installation piece by Vong Phaophanit that, despite critical jeering, most impressed the public with its serene sensuality. Writing in the *Daily Telegraph* (10 November 1993, p.21) Stephen Pile argued that contemporary art, as seen in the Turner Prize, was nowhere near as weird and incomprehensible as traditional art in the National Gallery. He conducted a vox-pop in the exhibition and discovered that nobody found the works difficult at all:

> In fact, my vox-pop showed that visitors universally liked all four shortlisted artists. A helpful video at the door shows them discussing their work in a clear, unpretentious way and who are we to disagree with them? ... The uniformed attendants felt that the warm, red glow gave a strong sense of the lifeforce in this simple white foodstuff which sustains half the planet. That was absolutely my own feeling. Everyone enjoyed the uncomplicated beauty of this piece,

which combines a very simple, Zen elegance with the rather Western energy of strident red neon.

Other critics concurred that the work on display was more appealing than in recent years. Sue Hubbard concluded: 'This year I detect a sea-change. There is a new cohesion. The show is balanced, thoughtful, organic. Painting, photography, sculpture and installation are all represented, and each artist speaks with eloquence in his or her chosen medium' (*New Statesman and Society*, 12 November 1993, p.33). David Lillington admired the exhibition but recognised that it made the jury's task even more difficult: 'This year the absurdity of the choice has been given a kind of formal structure which drives it home with extra force. The judges have to compare a painter, an installation artist, a photographer and a sculptor. It's crazy. Still, it gives us something to talk about' (*Time Out*, 10–17 November 1993).

Significantly, a number of writers attempted to explain why there seemed to be such an increasing disparity between critical condemnation of Turner Prize artists and public appreciation. Richard Cork in *The Times* (23 November 1993, p.31) observed that:

> Knocking modern art, as hard and frequently as possible, is fast becoming a national media pastime ... Focusing on what artists do, they never bother to ask themselves why ... This month, the rice in Vong Phaophanit's installation at the Turner Prize exhibition is the latest focus for those bent on proving that contemporary art suffers from terminal cynicism or idiocy. Many of those who delight in reviling him probably have not seen the work, let alone pondered the mulitple meaning it conveys.

Cork blamed this attitude on Britain's unhealthy adherence to 'heritage culture':

> While our appetite for the hallowed past swells to addictive proportions, our response to the new is invariably begrudging. We mistrust the unfamiliar, preferring instead to reserve our enthusiasm for art already sanctified by time. It is as if the crisis afflicting Britain's post-imperial

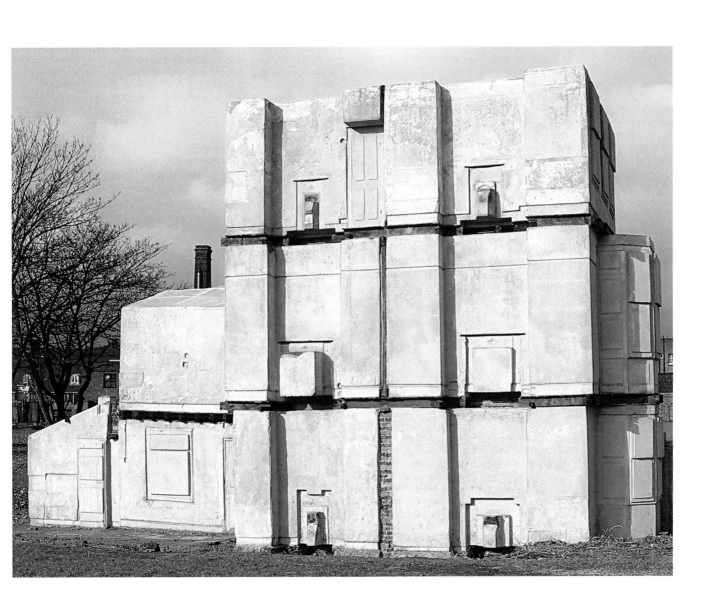

Rachel Whiteread
1963 Born in London
1982–5 Brighton
Polytechnic
1985–7 Slade School of
Art, London
1992–3 DAAD
Scholarship in Berlin

identity had made us seek reassurance in history, and shun contact with the disconcerting products of our own age.

For Andrew Graham-Dixon the problem was caused by the level of debate amongst critics writing on contemporary art:

> If I had a pound for every time the question 'But is it art?' had been voiced in newsprint and on the air since the 1993 Turner Prize shortlist was announced, I might have made more money than Rachel Whiteread did last night when she won it. Public discussion of art, it may be said, is the last thing that the prize has promoted. Vituperation, spleen, the widening of rifts between the various bitter factions that make up the British art world and the endless asking of that same old question, 'But is it art?': these are what it promotes. But is that a reason to get rid of it? Perhaps not. The Turner Prize does serve an extremely useful function even if it was not the one it was originally intended to serve. It focuses attention on how almost primevally backward, how dull, how embarrassingly narrow-minded and ill-informed most discussion of contemporary art in this country remains.

He puzzled over why, unlike people in the rest of Europe, Britains continued to doubt whether art was art, or not, and concluded: 'Perhaps because it enables them to conceal a very British fear; the fear of responding to art, the fear of feelings (yuk) and a corresponding reluctance to articulate them. If you decide that something is not art at all then (phew) you are safe from all that.'

Rachel Whiteread won the prize in 1993. Public response to her enormously successful public sculpture *House* proved impossible for the jury to ignore, although technically the piece fell outside the previous twelve months. Its profundity and ability to speak to a wide audience confirmed her stature as an artist. Ironically, Whiteread was also awarded a prize of £40,000 for being the 'worst' artist in Britain by erstwhile pop band the KLF, now the K Foundation, who spent £200,000 publicising their alternative Turner Prize which

supposedly comprised a public ballot. David Lillington pointed out the flaws in the K Foundation's efforts as self-styled art terrorists: 'They give all the evidence of believing in prizes, in artists, in comparisons of quality, in grading it and rewarding it – they use the same grammar as the thing they attack. The Turner Prize will survive because groups like the K Foundation will keep it there. Besides, what they do won't stop these four artists being excellent at what they do' (*Time Out*, 10–17 November 1993).

Rachel Whiteread

Rachel Whiteread's work is based on taking casts from the most commonplace objects, but the results are very far from literal representations. Her sculptures are vaguely familiar, yet they are puzzling, almost surreal. That her sculptures are not casts of the objects themselves but of the space above, below, adjacent or inside, creates this sense of mystery. The artist has commented: 'I wanted to use things that already existed. I wanted to get inside them or beneath them and try to reveal something previously unknown ... One of the first pieces I made in rubber was *Untitled (Amber Bed)* [1991]. The piece spent some time slumped up against the wall in my studio. It had a very strange, almost human presence.'

By casting the areas around objects Whiteread gives form to the spaces we have inhabited, the spaces that have contained our existence. The casts are often redolent of childhood memories: 'There are always scary places, like the space under the bed or inside the wardrobe or the space in the angle between an open door and the wall. These places are scary but also slightly erotic – secret, hidden. The stuff you don't really know about at that age.'

Materials such as plaster and rubber play a crucial role in the transformations and metamorphoses that take place in Whiteread's work: a bath cast in plaster becomes a sarcophagus; a kitchen sink a baptismal font; the inside of a hot-water bottle a torso that somehow echoes the Cycladic figures which stand at the very beginnings of sculpture. Beds and mattresses take on a life of their own. The plaster works, with their characteristically white, geometric block-like forms, have

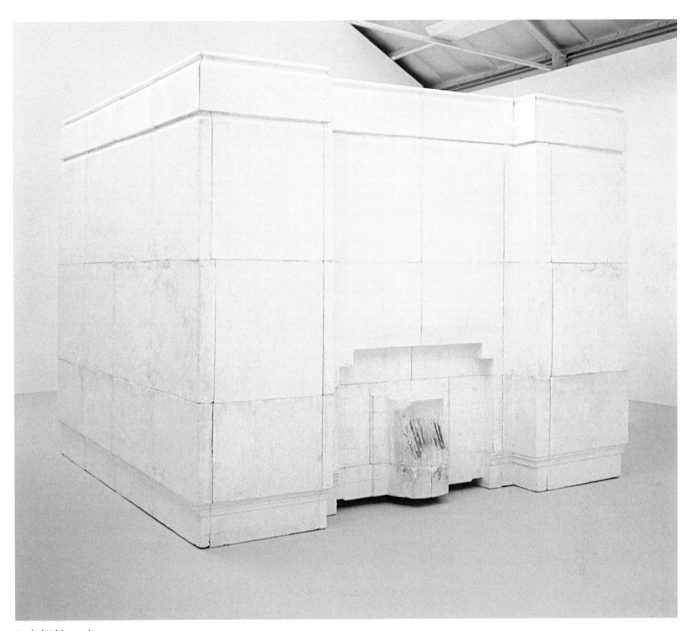

Rachel Whiteread
Ghost 1990

a visual severity that suggests the restrained aesthetic of Minimalism. Her work in rubber is more organic and sensual. In both media the response of the material to light is also important. Rubber in particular offers the artist a range of colours and degrees of translucency.

In the Turner Prize exhibition Whiteread was represented by *Untitled (Room)*, a new work shown for the first time. It was made in Berlin where she had been living and working on a DAAD (German academic exchange service) Scholarship. This sculpture was related to *Ghost* (1990), which first brought her to wide attention, but it also marked an important point of departure. *Ghost* was made from plaster casts of the four walls of the living room of a deserted 1930s terraced house in North London. Assembled with the positive side facing outwards they formed a room you could not enter, a room turned inside out. The new piece was also the cast of a room. However, it was not a found space but invented, constructed for the purpose in Whiteread's studio. Her aim was to create a room that was 'utterly standard ... just like a unit devised for people to survive in ... I wanted to make something fundamentally dull and basic'. *Ghost* was acclaimed for its monumentalisation of the mundane. Whiteread hoped that the effect of *Room* would be 'more monumental than *Ghost* – like a burial chamber or something you might find in an archaeological museum'.

Soon after she had been shortlisted for the Turner Prize in the summer of 1993 Whiteread commenced work on a project commissioned by Artangel in collaboration with Beck's beer. Preparations for the project, a public sculpture, had been in progress since 1991, although Whiteread had first conceived the idea when at art school. *House*, a cast of the interior of the last remaining house of a late nineteenth-century terrace in Grove Road, in London's East End, was completed on 25 October 1993. Although, strictly speaking, the work fell outside the year in question, the Turner Prize jury were unable to ignore the extraordinary impact of the piece, both nationally and internationally. From its completion to its demolition, and well beyond, *House*

became a focus for public debate about the role of contemporary art. Artangel summed up the artist's intentions: 'Like many public sculptures and memorials, *House* is a cast. But unlike the bronzes which commemorate triumphs and tragedies, great men and heroic deeds, this new work commemorates memory itself through the commonplace of home. Whiteread's *in situ* work transforms the space of the private and domestic into the public – a mute memorial to the spaces we have lived in, to everyday existence and the importance of home.'

Such was the level of public and media interest in *House*, particularly after the Turner Prize award, that Bow councillors revoked their decision not to extend the lease beyond November. The work was allowed to remain standing until the 12 January 1994, so that between five and eight hundred visitors per day could continue to experience the sculpture themselves. For many, *House* was a profoundly moving *momento mori* to individual lives and lost communities. It was praised by some critics as the most extraordinary and imaginative public sculpture made by an English artist this century. For others, it was a folly, another hoax in the style of Carl Andre's 'Bricks'.

Although she had fought to extend the life of *House*, at no point did Whiteread conceive of the project as an enduring monument: '*House* is to do with memory and ultimately it will become just that ... *House* makes a point about the smallness and fragility of the spaces we actually live in, worry about, decorate ... all those things that are a part of life.'

Hannah Collins

Hannah Collins is one of a significant number of artists who, since the 1960s, have adopted photography as their medium. She was represented in the Turner Prize exhibition by a group of works including several elements from a large installation made for the Third International Istanbul Biennial in 1992. Titled *Signs of Life* it continued her long-standing interest in the places occupied by those who exist on the margins or borders of society. In and around Istanbul she created a series of images focusing particularly on the city's role as a crossroads for refugees and economic migrants moving from East to West.

Hannah Collins
1956 Born in London
1974–8 Slade School of Fine Art, London
1978–9 Fulbright Scholarship in USA

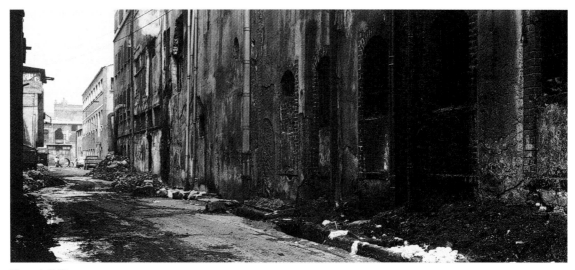

Hannah Collins
Signs of Life (section)
1992

Hannah Collins
The Truth 1993

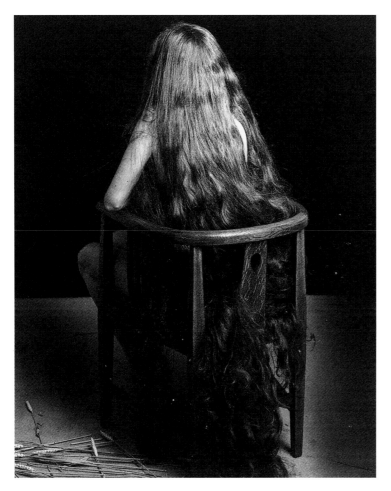

The artist was moved, for example, by the sight of an ex-Russian Army rubber boat being sold by Russian migrants in a street, 'an empty boat filled with air stranded on a dry city street' that evoked 'the edge of life and death'.

Collins has remarked that her work is 'both sculptural and pictorial'. It is often scaled to suit the environment, varying in size from one to thirty metres. The photographic images are mounted onto a variety of supports, including linen or cotton draped or hung like banners, and constructed metal panels are arranged as free-standing installations. The sculptural aspect of her work thus lies in its use of available space: 'I take into account space and there are different kinds of space at work: the space created by the piece, the space it occupies physically; how it relates to the public or private space in which it hangs.' This approach tends to produce a dramatic enhancement of the viewer's experience of the work, a dramatically enhanced realism.

Pictorially, Collins's work embraces the categories of traditional art: landscape and cityscape, interiors, still life, the figure. She frequently refers to the themes and imagery of the great art of the past. *The Truth*, for example, has connections with images of Mary Magdalen or Lady Godiva. But references of this kind are always secondary to the visual power and immediacy of her photographs, and to the meanings that they might suggest. Collins touches on many fundamental human issues: 'I am aware that social and political truths are embedded in my life and that these are reflected in the content of my work.' The artist has said that her art explores the interface between personal history and the specifics of the culture in which she finds herself, and she stresses that 'the work is dependent upon the cultural milieu from which it emerges ... the most important thing for me is that my work develops deep links with the environment in which it is made'.

Vong Phaophanit

Vong Phaophanit has said of his installation pieces: 'The work is based on ... no rules, except perhaps a new subjectivity ... if there is an object, an aim, it is to start from a point and lead outwards from there.'

The meanings of Phaophanit's art are inevitably related to his particular origins and background, but they are equally related to the traditions of art in his adopted culture and to his life as an artist living in Britain. He was born in 1961 in Laos, a former French colony. At the age of eleven he left to be educated in France and remained there after Laos ceased to be a constitutional monarchy and became the People's Democratic Republic of Laos in 1975. From 1980 to 1985 he attended the art school at Aix-en-Provence.

Phaophanit's art is immediately striking for its choice and use of such materials as rice, rubber and bamboo, and for the role played in it by light. All the elements of his works are bound together into a whole whose effect is purely aesthetic. But, produced on a large scale in South-East Asia, his materials are loaded with cultural, historical and economic significance. The artist neither denies nor asserts these meanings, using his materials, as modern sculptors have done from Brancusi onwards, to explore both their aesthetic possibilities and to create a potentially symbolic or metaphoric statement.

In the summer of 1993 he made a work outdoors at the National Trust property, Killerton Park, an eighteenth-century landscaped estate. On a long, red-brick wall of the kitchen garden, in front of which had been planted a grove of bamboo and palm trees, he placed nine Laotian words fashioned in red neon. He titled the work in Latin, *Litterae Lucentes (Words of Light)*, but deliberately withheld the meaning of the Laotian words. As well as emphasising the visual qualities of the piece this also drew attention to the politics of language. Phaophanit points to the annexation of the exotic plants, their importation into England where they are named in Latin. 'To name', he says, 'is to possess, to own, to control.' By denying us access to the meaning of his words he presents them deprived of that inimical power to name.

For the Turner Prize exhibition Phaophanit made a new variant of *Neon Rice Field*, one of a series of such fields that had impressed the jury during the previous year. Neon light placed just beneath the surface of translucent rice grains, arranged in furrows, produced a beautiful, seductive glow. Much of

Vong Phaophanit
1961 Born in Laos (since 1975 People's Democratic Republic of Laos)
1972 Educated in France (until 1985)
1980–5 Ecole des Beaux-arts, Aix-en-Provence
1985 Moves to Britain

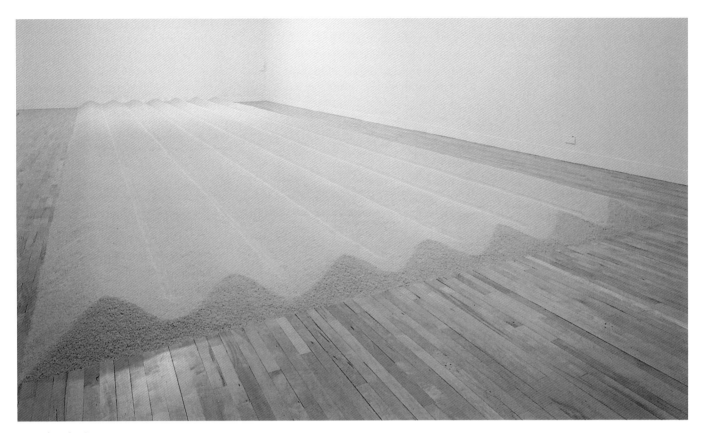

Vong Phaophanit
Neon Rice Field 1993

Vong Phaophanit
Litterae Lucentes 1993

Sean Scully
1945 Born in Dublin;
family moved to
London shortly after
1965–8 Croydon
College of Art
1968–72 University of
Newcastle upon Tyne
1972–3 Harvard
University,
Cambridge,
Massachusetts
1975 Moved to USA

Phaophanit's work depends on on the 'interactions of materials'. *Neon Rice Field* brings together two disparate things, one natural and organic, the other manufactured. The result is rich in both its physical presence and 'possibilities of meanings'.

Sean Scully

Since about 1980 Sean Scully has set out to make his own contribution to the tradition of abstract painting which aims to represent the spiritual. He has said: 'I am interested in art that addresses itself to our highest aspirations. That's why I can't do figurative paintings – I think figurative painting is ultimately trivial now.' He also believes strongly that abstract art can be more, not less, accessible than representational art: 'Abstraction's the art of our age ... it allows you to think without making oppressively specific references, so that the viewer is free to identify with the work. Abstract art has the possibility of being incredibly generous, really out there for everybody. It's a non-denominational religious art. I think it's the spiritual art of our time.'

Scully's spirituality is of the muscular variety. His earliest mature work featured grids of narrow stripes of brilliant colours. By the early 1980s the stripes had broadened out in the manner which he continues to use, and the paintings had become often very large constructions of separate panels, each in fact an individual canvas on a massively constructed stretcher. In some cases panels of different depths were brought together, creating effects of relief. With their combinations of vertical and horizontal striped elements these works have a powerful, almost architectural or sculptural presence, for some commentators even evoking ancient sacred monuments such as Stonehenge. The stripe is Scully's image; he sees it as a neutral form which can be made to carry various meanings. He uses stripes as the building blocks with which he can continue to explore the types of structure underlying some of the greatest art of the past, 'the large structures that represent us and our culture for all time'.

The origins of his paintings are deeply personal but, Scully emphasises, they 'are not just about me. I want them to address something larger. So I don't feel a painting is finished until it has a strong identity of its own, apart from mine. I'm not interested in self-expression'.

Around 1980 he began to change his application of paint, abandoning acrylic paint for traditional oil, mixing pure colours with old-fashioned earth hues – umbers, ochres and siennas. In this way he developed a distinctive palette of rich, brooding colour. Brushing his colours on in layers, using large Italian house-painters' brushes, he creates strongly textured surfaces. He usually uses a number of brushes on the same painting 'so the work is about different surfaces at different times'. Colours glow through from one layer to another, increasing the richness and complexity of the painting. For the lower layers the paint is mixed with a resin medium which speeds drying. But for the surface layers he uses the sumptuous medium of stand-oil – viscous heat-treated linseed oil. This, he says, 'makes the paint sexy', giving it a lot of body but also 'a slight translucency'.

Sean Scully
White Window 1988

Winner
Antony Gormley

Shortlisted artists
Willie Doherty for his video and photographic installations including work shown at Matt's Gallery, London, the Arnolfini Gallery, Bristol, the Douglas Hyde Gallery, Dublin and the Centre for Contemporary Art, Warsaw
Peter Doig for his exhibition of painting at the Victoria Miro Gallery, London, and for his strong contribution to a number of group exhibitions including *Unbound* at the Hayward Gallery, London, and John Moores Liverpool Exhibition 18 at the Walker Art Gallery
Antony Gormley for exhibitions of his sculpture including *Field* seen at the Malmo Konsthall, Tate Gallery Liverpool and the Irish Museum of Modern Art, Dublin, and for his contribution to several group exhibitions including *Ha-Ha* at Killerton Park, Devon
Shirazeh Houshiary for exhibitions of her sculpture and drawings, notably at the Second Tyne International, Newcastle upon Tyne, Camden Arts Centre, London, the Art Gallery of York University, Ontario and the University Gallery, University of Massachusetts, Amherst

Jury
Marjorie Allthorpe-Guyton
Director of Visual Arts, Arts Council of England
Roger Bevan
Representative of the Patrons of New Art
Jenni Lomax
Director, Camden Arts Centre, London
Milada Slizinska
Curator and art historian, Centre for Contemporary Art, Warsaw, Poland
Nicholas Serota
Director of the Tate Gallery and Chairman of the Jury

Exhibition
2 November–4 December 1994
Prize of £20,000 presented by Charles Saatchi, 22 November 1994

Antony Gormley
Testing a World View
(detail) 1993

It was widely reported that the shortlist for 1994 was relatively 'safe'. Antony Gormley won the award for his installations of *Field*, which had captivated the British public throughout the year. Sadly, the scale of *Field* prohibited its display in the Turner Prize exhibition. None of the artists was scandalously under the age of thirty, and none of them worked with tabloid-tempting materials such as rice or animal carcasses. But the public continued to visit the Turner Prize exhibition in their thousands, and although the press faithfully resorted to generating controversy about contemporary art, there was a notable trend towards more serious discussion of the artists' work. One critic even welcomed what he thought might be the end of controversy for its own sake: 'The adversaries supply the contempt and the copy that creates the 'controversy' which keeps the Turner Prize a hot topic ... But after years of watching the same clique slug it out, battle fatigue has set in. Sorry, boys, but we've been there and debated that one time too many. It's time to call a truce and cut out all the clapped-out talk about controversy. For once, let's see what's on show' (Cosmo Landesman, *Sunday Times/Culture*, 27 November 1994). Some critics found the inclusion of a painter, Peter Doig, the most 'deviant choice' on the shortlist because the last painter to win the award had been Howard Hodgkin in 1985. Painters had in fact been shortlisted almost every year since the inception of the prize.

A few critics noted that the exhibition had expanded by one room with an additional area given over to information including the profile films made by Illuminations for Channel 4, a reading desk and explanatory wall texts. Richard Cork in particular commented on the improved presentation (*The Times*, 8 November 1994, p.33):

> The 1994 exhibition deserves a welcome. As if to celebrate the coming-of-age of a prize now a decade old, this year's survey is given more space than before. The first room is devoted entirely to information about the artists, with the help of television monitors, relevant publications and seating for anyone who wants to linger and study. It establishes the right

mood for the show, where every exhibitor enjoys a handsome arena clearly separated from the other artists.

As well as providing more information for visitors to the exhibition in London, in a new initiative to engage audiences around the country, the artists' films were shown in seven regional galleries in conjunction with related public events.

On the night of the award ceremony a group of artists, designers and architects gathered at the gates of the Tate Gallery with placards bearing their own works. Taking advantage of media coverage of the event, this protest organised by FAT (Fashion, Architecture and Taste) aimed to display what was excluded from the Turner Prize and to convey frustration with the ways in which art is administered and promoted.

Antony Gormley

Antony Gormley has been widely credited with making a substantial new contribution to the western tradition of sculpture of the human body. Since the early 1980s he has used his own body to make sculptures that explore the human experience of being in the world. His work meditates on the relationship between our physical and spiritual selves, a duality that has preoccupied philosophers and artists since the beginning of civilisation.

In 1981, assisted by his wife, the painter Vicken Parsons, Gormley began to make moulds from his body which he used as the basis for lead body cases. The process is demanding as Gormley has to maintain a pose whilst he is first cast in plaster: 'I am trying to make sculpture from the inside, by using my body as the instrument and the material. I concentrate very hard on maintaining my position and the form comes from this concentration' (*Antony Gormley*, exh. cat., Tate Gallery Liverpool 1993, p.20). Although he continues to work with cases Gormley has since gone on to make solid forms, which aim to make physical the experience of the space within the body.

Between 1993 and 1994 Gormley's more recent work was shown in a touring exhibition involving Malmo Konsthall, Tate Gallery Liverpool and the Irish Museum of Modern Art, Dublin. Two works from this show, *Testing a World*

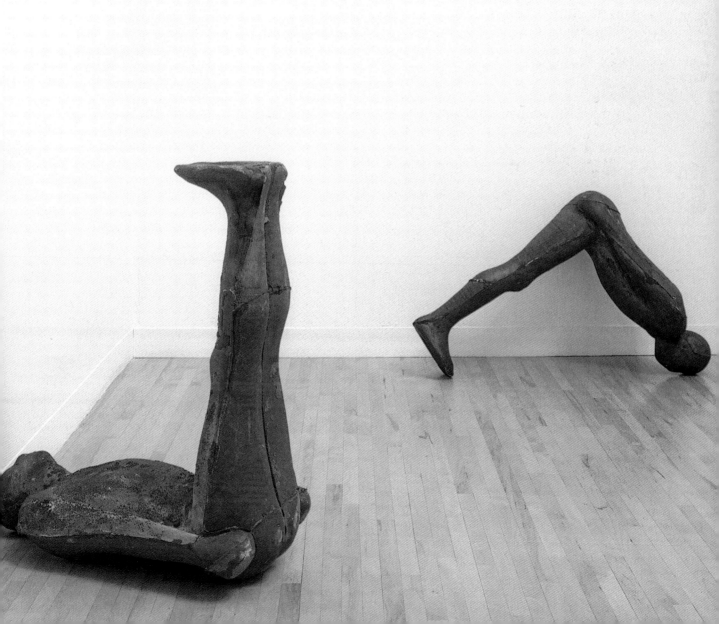

Antony Gormley
1950 Born in London
1968–70 Read archaeology, anthropology and art History at Trinity College, Cambridge
1973–4 Central School of Art and Design, London
1974–7 Goldsmith's College, London
1977–9 Slade School of Art, London

Willie Doherty
1959 Born in Derry, Northern Ireland
1977–81 Degree in Fine Art, Ulster Polytechnic

View and *Sense*, were displayed in adjacent rooms at the Tate Gallery for the Turner Prize exhibition. Gormley has described *Testing a World View* as a sort of 'psychological Cubism'. It comprises five identical, solid iron figures awkwardly bent at the waist to form right angles. Gormley arranges the sculptures in different configurations each time the work is installed, so that they seem to 'test' themselves against the architecture. In this way, 'the piece expresses the polymorphousness of the self; that in different places we become different. If Cubism is about taking one object and making multiple views of it in one place, this is a dispersion of one object into several cases for itself' (ibid, p.48). For the artist the right-angled pose of the body introduces a psychological dimension, suggesting the 'body in crisis'. 'Flung around the room' they demonstrate the current crisis of confidence in the Western world view (*Antony Gormley*, exh. cat., Museum of Modern Art, Ljublijana 1994, p.6).

The iron figures that make up *Testing a World View* are generalised representations of the human body, occupying an architectural space. *Sense* belongs to a series of concrete sculptures in which Gormley seems to have inverted this condition. Inside a concrete block he leaves the precise impression of his body, so that the block describes the space between the body and a compressed notion of architecture. The imprint of his body, seemingly once trapped or encased within the concrete, reminds the viewer of the vulnerability of flesh. On confronting these works several critics have called to mind the shadow traces of human bodies on the walls left standing at Hiroshima. But, for Gormley, they have more positive implications. *Sense*, for example, explores the experience of sensation which the artist defines as, 'an awareness of being and an awareness of being in space' (ibid., p.5). In this work the western concept of space, as something contained and quantified by geometry or measurement, is turned on its head: 'What *Sense* expresses is the way in which the imaginative space inside the body, the darkness of the body, connects with outer space – deep space' (ibid., pp.5–6). Gormley has expressed a concern for the fragility of the earth, particularly its 'living edge' or 'skin', the biosphere. In different ways both *Testing a World View* and the concrete blocks suggest the fundamental nature of our engagement with the earth and challenge our complacency towards it.

Perhaps the most notable of Gormley's works of this period was *Field*, an extraordinary installation first made in 1989. A recent version, *Field for the British Isles*, was made in collaboration with families and artists from the local community in St Helen's, and Ibstock, a local brickmaking company. Collectively they produced approximately 40,000 hand-sized clay figurines. The exact shape and scale of each figure were determined by the person making it. The artist has stressed the importance of the communal experience of producing the work: 'The makers are also the work's first audience and it is not like the audience of a spectacle. It's more like a collective experience of active imaginative involvement' (*Antony Gormley*, exh. cat., Tate Gallery Liverpool 1993, p.52). *Field* is viewed from the threshold of a room that cannot be entered. When we confront the work it returns our gaze. This has the uncomfortable effect of making us, and not the figures, the subject of the work.

There are many ways in which *Field* can be understood. Perhaps the most poignant interpretation is that this 'ocean of humanity' demonstrates our existence in the world both as individuals and collectively as the human race.

Willie Doherty

Willie Doherty is one of an increasing number of artists who work with the camera. From the late 1980s his main subjects have been Derry and its surrounding countryside. Derry, also still known by its 'colonial' name of Londonderry, was the site of some of the key events in the present phase of the Irish 'Troubles' – the 1968–9 protests by Catholics demanding civil rights, and the 1972 'Bloody Sunday' when thirteen civilians were killed by British troops at the end of an anti-internment rally. In 1991 Doherty commented: 'I am writing from a place with two names, Derry and Londonderry. The same place. Here things are never what they seem and always have more than one name. To understand this duality is to begin to

Willie Doherty
*The Only Good One is
a Dead One* (detail)
1993

Willie Doherty
Border Incident 1993

Peter Doig
1959 Born in
Edinburgh
1966–79 Lived in
Canada (moved to
London in 1979)
1979–80 Wimbledon
School of Art, London
1980–3 St Martin's
School of Art, London
1989–90 Chelsea
School of Art, London
1995– Trustee of the
Tate Gallery

understand how this place functions and how lives are lived here. Failure to recognise this duality is to miss the essential dynamic of what has been called a microcosm of the Northern Irish problem' (Willie Doherty, *Camera Austria*, 1991, no.37, p.11).

As a result of the 'Troubles' Derry has become one of the most photographed cities in Europe. But photographic documentation of the war in Northern Ireland has consisted largely of clichéd images. Picturesque photographs of victims and bomb-damaged buildings have only served to simplify events. In the late 1980s the introduction of media censorship made Doherty acutely aware of how opinions and events are influenced by media coverage. 'In this place with two names the paradox of difference easily collapses into misrecognition and is most easily described by the overdetermined language of "mindless violence" and "terrorism", which have become the only words available to the Press, in the absence of real political dialogue' (ibid). Doherty's work offers a critical response to such distorted documentation.

Doherty was represented in the Turner Prize exhibition by a double screen video installation *The Only Good One is a Dead One*, which toured several venues between 1993 and 1994. The phrase 'innocent victim' is much used in media reports of sectarian violence. In *The Only Good One ...* Doherty questions the meaning of this phrase within the particular context of Northern Ireland. In Derry, Catholics and Protestants have grown up in an atmosphere of mutual suspicion. Simply being a member of the opposite community somehow imputes guilt. Doherty comments on this 'war of the mind', but he does so without taking sides. Both videos were shot at night. One shows the view from a car parked in an urban street, the other the view from the windscreen of a car driving down an isolated country road. The videos were filmed in actual time using a hand-held recorder suggesting that the narratives at play are 'real'. A soundtrack comprising a monologue accompanies the work. In it a man imagines being both the victim and perpetrater of a terrorist act of violence. Thus Doherty illuminates the shared human experience of living in a state of

war. He also invites investigation of how this psychological condition is constructed through, for example, the constant presence of surveillance. Further discussion of Doherty's work can be found under 2003.

Peter Doig

Peter Doig's paintings first attracted attention in 1991 when he won the Whitechapel Art Gallery's Artist Award.

The tension between the narrative or representational content of painting and its purely visual, decorative and abstract qualities has remained a central issue for modern art. Part of the significance of Doig's work is that he has found a distinctive way of balancing these two elements.

The dominant subject of Doig's paintings has been the traditional theme of man in nature. But his works draw on diverse references ranging from paintings by landscapists in the western tradition, such as Edward Hopper and Claude Monet, to newspaper photographs, stills from films such as *Friday the Thirteenth*, banal postcards and travel brochures. Such sources act as 'triggers' for his memory and imagination. The surfaces of his paintings often comprise a fusion of intricate layers, skeins, and blobs of paint. The sheer visibility of the stuff of paint, which rarely translates in reproduction, serves to interrupt the narrative themes suggested by the image. This interplay of form and content produces a type of imagery that can evoke a strong response, bordering between attraction and repulsion.

In the Turner Prize exhibition Doig was represented by two snow scenes, *Pond Life* (1993) and *Ski Jacket* (1994), and three paintings from a series based on Le Corbusier's *Unité d'Habitation* at Briey-en-Forêt in France. The first *Unité d'Habitation* was completed in 1952 in Marseilles, an eighteen-storey block of flats which Le Corbusier hoped would become a standard type for postwar low-cost housing. The *Unité* in Briey, built in 1957, was vacated in the 1970s and narrowly escaped demolition. Doig was drawn to the building by its peculiar setting. Located in a wood, this monument to modernist aspiration is almost engulfed by the natural environment. The menacing power of

Peter Doig
Cabin Essence 1993–4

Peter Doig
Ski Jacket 1994

nature is strongly conveyed in Doig's paintings of this motif: for example, *Cabin Essence* of 1993–4 shows the building screened by a wall of impenetrable trees which recall the claustrophobic, prison bar trees depicted by the forerunners of the *fin de siècle* Symbolist movement, Edvard Munch and Vincent van Gogh.

Seemingly random splatterings of white paint are visible on the surfaces of these pictures. According to Doig these marks refer us back to the picture's beginnings, 'to the nothingness of painting – in just the same way as the whiteness of Corbusier's *Unité* represents negative space' (Paul Bonaventura, *Artefactum*, vol.11, no.53, Sept. 1994, p.15). The white paint could represent light reflected off the building, but it also visually disrupts the surface, preventing the depicted image from slipping into naturalism.

Doig constantly strives towards rendering the tension between the extremes of fact and fantasy. But, at root, his works emanate from an excitement with the substance of paint as a medium of visual expression.

Shirazeh Houshiary

For Shirazeh Houshiary imagination is the 'creative force of the universe'. Without it there is no existence. Art is an activity located in the realm of the imagination, and through art the artist documents his or her own path towards self-knowledge: 'An artist is someone who is capable of unveiling the invisible, not a producer of art objects' (Stella Santacatterina, Conversation with Shirazeh Houshiary, *Third Text*, no.27, Summer 1994, p.78). Her sculptures, paintings and drawings develop over a long period, informed by Sufi poetry and ancient writings from East and West on subjects including mathematics, philosophy, religion, art and astronomy.

Houshiary's world view is largely inspired by the poetry of Jalalu'ddin Rumi, the thirteenth-century Sufi mystic. 'Sufism' means 'the way' or 'the path', a way of being in the world and having contact with the centre of one's being. This quest for self-knowledge is common to most world religions. Houshiary believes that shared truths have been gradually clothed in a variety of external forms, which obscure the underlying unity of human experience. From the late 1980s onwards her work has gradually focused on geometric shapes, notably the square, circle, triangle and cross.

A five-part sculpture, *The Enclosure of Sanctity* (1992–3), and five recent paintings were Houshiary's contribution to the Turner Prize exhibition. The paintings were selected from a group of works depicting a square orbiting inside a circle. The delicate images were made by repeatedly drawing a Sufi chant in Arabic using pencil on matt black or white grounds. The squares are divided into patterns of light and dark. In many cultures the square symbolises the Earth and its four elements of earth, water, wind and fire, while the circle denotes Heaven. The union of the square and the circle therefore suggests the union of Heaven and Earth.

A belief in the interconnectedness of all life underpins *The Enclosure of Sanctity*, which hinges on the interplay between light and dark, the forms for the expression of the divine in Sufi writing. *The Enclosure of Sanctity* comprises five lead cubes installed according to precise measurements. The cubes evoke a planetary system, the central cube representing the sun, around which orbit Mercury, Venus, the moon and Mars. Planets, which we think of a spheres, are visualised as cubes. But the square, as Houshiary has demonstrated in her paintings, is fundamentally related to the circle: when it spins it creates a sphere in space. In this way the circle and the square demonstrate both the distinctiveness and the sameness of all life.

Inverse pyramids have been removed from each cube, and the remaining internal spaces divided by grids corresponding to numbers with which each planet is identified. Copper, gold and silver leaf, applied to certain segments of the grids, further enhance the uniqueness of each cube. Houshiary has written: 'Through studying these cubes, we can realise the multiplicity of the state of existence. We will understand that at every moment, our human individuality is only one of these states of existence, and to unveil these is to know the real centre' (statement accompanying Houshiary's exhibition at Camden Arts Centre, London, 1993).

Shirazeh Houshiary
1955 Born in Shiraz, Persia (Iran)
1976–9 Chelsea School of Art, London
1979–80 Junior Fellow, Cardiff College of Art

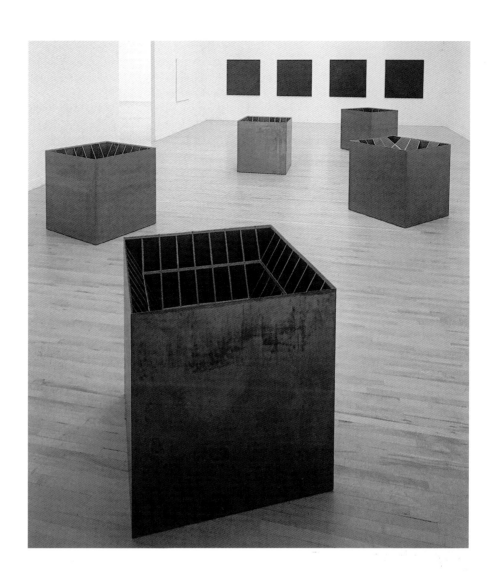

Shirazeh Houshiary
*The Enclosure of
Sanctity* 1992–3

Shirazeh Houshiary
*The Enclosure of
Sanctity* (detail) 1992–3

Damien Hirst 1995

Winner
Damien Hirst

Shortlisted artists
Mona Hatoum for her exhibitions at the Centre Georges Pompidou, Paris, and at White Cube, London, and her contribution to a number of group shows in Britain and abroad
Damien Hirst for his curatorship of and his own contribution to *Some Went Mad, Some Ran Away*, a touring exhibition which opened at the Serpentine Gallery, London, and for other presentations of his work in Britain and abroad
Callum Innes for exhibitions of new paintings at the Frith Street Gallery, London, the Angel Row Gallery, Nottingham, and most recently at the Galerie Bob van Orsouw, Zurich
Mark Wallinger for the exhibitions of his work at the Ikon Gallery, Birmingham, and the Serpentine Gallery, London

Jury
William Feaver
Art critic, *Observer*
Garry Garrels
Curator of Contemporary Art at the San Francisco Museum of Modern Art
George Loudon
Representative of the Patrons of New Art
Elizabeth Macgregor
Director of the Ikon Gallery, Birmingham
Nicholas Serota
Director of the Tate Gallery and Chairman of the Jury

Exhibition
1 November–3 December 1995
Prize of £20,000 presented by Brian Eno, 28 November 1995

Damien Hirst
Mother and Child, Divided 1993

The 1995 Turner Prize exhibition attracted unprecedented numbers of visitors who queued daily to see the work of the shortlisted artists. Many were curious to see Damien Hirst's *Mother and Child, Divided* which created a tidal wave of tabloid excitement: 'Have they gone stark-raving mad? The Turner Prize for Modern Art (worth £20,000) has gone to Damien Hirst, the 'artist' whose works are lumps of dead animals ... Modern art experts never learn. But, perhaps they are smart, since they make huge profits out of garbage – and now dead animals' (*Sun*, 30 November 1995). The notoriety of the piece was unwittingly increased when the exhibition opened temporarily without it.

There seemed to be no middle ground as far as critical response to Hirst's work was concerned: was he a contemporary genius or arch hoaxer intent on conning the public? John McEwen summed up the opposition in the *Sunday Telegraph* (3 December 1995):

> If Damien Hirst is anything, he is the ring-master of of his own career – on to his next trick, his next sensation, before the audience starts to think. There are the freak shows of the animals, the jolly paintings, his beaming self.

Whereas Richard Dorment in the *Daily Telegraph* (6 January 1996) articulated the relevance of Hirst's work for the present:

> Hirst's work acknowledges a buried sense of loss and longing for completeness that some psychoanalysts believe is universal. That this was the artist's intention seems to me clear from the title, which refers not to a cow and newborn calf, but to a mother and a child. Instead of sweeping aside our twin fears of being alone and of dying, Hirst makes it impossible to turn away from either.

Some acknowledged Hirst's claim to the prize, despite the calibre of the other contenders: 'Damien Hirst should have won the Turner Prize when he was nominated for it three years ago and I'm glad he's won it now. No one has done more to raise the profile of contemporary British art at home and abroad – and by his outrageously ambitious art works and energetic ease at dipping and dodging between the role of artist, curator, film director and media maverick, he's fired an entire generation with the belief that even in the frosty climate of the British art world, anything's possible' (Louisa Buck, *Independent*, 29 November 1995, p.3).

Members of the public were either moved or disgusted by *Mother and Child, Divided*: few remained indifferent and many voiced their opinions to the Tate Gallery and newspaper editors. One punter, for example, wrote passionately in Hirst's defence to the *Daily Telegraph* (Mark Sutton, letter to the editor, 2 December 1995):

> I was disappointed by your editorial on the award of the Turner Prize to Damien Hirst ('A Turner for the Worst', November 29). One of the briefs of the Turner Prize is to draw attention to artists who have best raised the profile of British art, whether at home or abroad. Hirst has clearly done that. His work is shown, respected and bought by art-lovers and collectors all over the world, and is one of the reasons why contemporary art is enjoying more attention now than it has in three decades. For that alone he deserves recognition.
>
> Art, like beauty, is in the eye of the beholder. Whatever my own opinion of Hirst's work, to say that it 'has the artistic merit of a bucketful of spittle' is to abrogate critical responsibility. I recently saw some of his work at an exhibition in the Serpentine Gallery, where it resulted in a great deal of interest, enjoyment, amazement, revulsion and argument from my fellow viewers. To fire up such a range of emotions – whether we like the work or not – is one of the primary functions of art; and the level of heated interest aroused by Hirst's work is a measure of his success at doing that. The point of the Turner is not to satisfy all tastes, which it could never hope to do. Its value is to stimulate debate and to encourage the public in this country to treat art as a serious issue about which we can hold serious opinions. As your Leader shows, this year it has at least done that. I suggest that your readers do not listen to the opinions of your paper, the art critics or myself,

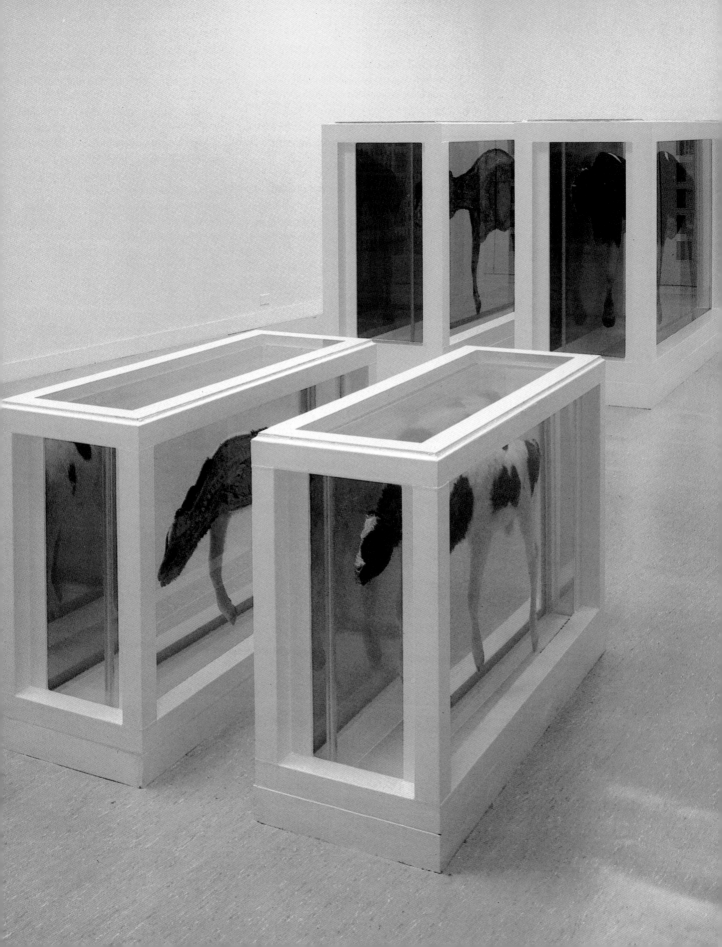

but go out and visit galleries and decide what type of art they like for themselves – since that ultimately is what art is about.

As one of Hirst's natural history pieces which make use of dead animals, *Mother and Child, Divided* enraged and upset animal rights protestors. When Hirst won the prize one protestor wrote in complaint to the *Evening Standard*: 'I must express my disappointment at the moral bankrupcty of the judges of the Turner Prize. However you view the exhibit, it increased the demand for dead animals by two, created unnecessary death and cheapened the life of a mother and child. Justice may yet be done should the artist be reincarnated as a dairy cow' (Paul Gaynor, *Evening Standard*, 1 December 1995, p.45). Hirst was himself in sympathy with the protestors as one of the aims of the piece was to provoke people into thinking about the way animals are treated. He had not slaughtered the animals in the name of art, but had acquired them from a knacker's yard where they had died of natural causes.

Hirst was not the only artist to excite the tabloid press. Mona Hatoum's video installation *Corps étranger* gained particular notoriety as it comprised an endoscopic and coloscopic film inside the artist's own body.

Damien Hirst

Since the late 1980s Damien Hirst has produced a body of highly memorable works which have intensified critical debate about the nature of contemporary art. The impulses driving his work derive from the dilemmas inherent in human existence: 'I am aware of mental contradictions in everything, like: I am going to die and I want to live for ever. I can't escape the fact and I can't let go of the desire.' One of his aims has been to 'make art that everybody could believe in' (Damien Hirst quoted in *Damien Hirst*, exh. cat., ICA 1991, p.7). This has sometimes involved using provocative materials – blood, flies, maggots, dying butterflies and dead animals. But he 'uses shock almost as formal element ... not so much to thrust his work in the public eye ... but rather to make aspects of life and death visible' (quoted in Jerry Saltz, *Art in America*, June 1995, p.83).

Hirst's most successful works have an immediate impact, physically communicating a thought or feeling. Brutally honest and confrontational, he draws attention to the paranoic denial of death that permeates our culture. His investigation into the traditional theme of mortality is not, however, intentionally nihilistic. On the contrary, recognition of the human condition allows life without fear: 'The horrible things in life make the beautiful things possible and more beautiful' (*Damien Hirst*, exh. cat., ICA 1991). Hirst is fascinated by systems: his own *oeuvre* is in fact organised into groups of work that address basic anxieties and desires. Most notable is a series of sculptures known collectively as *Internal Affairs*, which seem to consider the dichotomy between mind and body and the coexistence of life and death. Staging objects within steel and glass chambers or vitrines, the artist conveys a sense of human presence or narrative. One such work, *The Acquired Inability to Escape* of 1991 comprises two sections, the largest containing a table, chair, cigarettes, lighter, ashtray and stubs, the smaller remaining numbingly empty. For Hirst, the cigarette is a multi-layered symbol suggesting beauty, luxury, danger and death. Here, his addiction to smoking can be interpreted as a metaphor for decadence, a kind of bittersweet pleasure in hastening death.

The Acquired Inability to Escape marked the beginning of Hirst's interest in the division of space as a means of intensifying the emotional impact of his work. His steel and glass chambers refer to the aesthetic of Minimalism, established in the 1960s and reworked in the 1980s by artists such as Jeff Koons. At the same time they echo the claustrophobic, cubical frames depicted in the paintings of Francis Bacon, encasing nightmarish, fleshy images of man and beast. Hirst's chambers arose 'from a fear of everything in life being so fragile ... I wanted to make a sculpture where the fragility was enclosed. Where it exists in its own space. The sculpture is spatially contained' (*Minky Manky*, exh. cat., South London Gallery 1995). In more recent years he has divided and sometimes inverted these works, slicing the chambers in half, infiltrating the airtight vitrine with a band or gap of gallery space,

Damien Hirst
1965 Born in Bristol
1986–9 Goldsmiths' College, London
1992 Shortlisted for Turner Prize

Damien Hirst
Amodiaquin 1993

and turning the objects upside down.

Rigorously minimal structures and attention to spatial relationships are used effectively in Hirst's controversial *Natural History* series. *Mother and Child, Divided*, shown in the Turner Prize exhibition, unites the compelling power of the extraordinarily visceral *Natural History* sculptures with the formal concerns developed in other works. This piece comprises a cow and calf, each bisected, the four halves displayed in separate tanks of formaldehyde solution. The tanks are placed so that the viewer can pass between the divided animals, closely examining the exposed entrails and flesh pressing against the glass. For some, this is disturbing, even repulsive. For others it generates a melancholic empathy.

Mother and Child, Divided was first exhibited in 1993 at the Venice Biennale, where its subject was peculiarly poignant and provocative. Venice, in particular, is a treasure trove of High Renaissance images of the gloriously fecund Madonna nursing the holy infant. The relationship between mother and child remains sacred in Catholic culture and in Italy agitation surrounding the issue of birth control and abortion is highly charged. Characteristically devoid of sentiment, Hirst strips the closest of bonds between living creatures to its starkest reality. The title denotes the slicing of the animals, but also points to the the separation of mother and offspring. Isolation has been one of Hirst's abiding themes.

Hirst also exhibited two recent paintings from his series of 'spot paintings' – white canvases in a variety of shapes and sizes, covered with a slightly de-registered pattern or grid of coloured circles. Within each painting the spots are the same size, their colour arbitrary: 'The grid structure allows no emotion. I want them to look like they've been made by a person trying to paint like a machine ... I liked the way you could create this formal way of making a painting, and that I could do it for the rest of my life. I like this idea of a created painter, the perfect artist' (*Damien Hirst*, exh. cat., ICA 1991, p.9 and *Minky Manky*, exh. cat., South London Gallery 1995).

The coloured circles are reminiscent of sweets or pills, a likeness endorsed by the pharmaceutical stimulants or narcotics which give their name to each painting.

Hirst perceives medicine as a belief system: 'I can't understand why some people believe completely in medicine and not in art, without questioning either' (ICA, p.1).

Through his activities as artist and curator Hirst is one of the most influential artists of his generation. Gordon Burn has attempted to sum up his contribution: 'The fact that generosity of intention and dark energies can coexist in the same nature; the fact that individuals can – are fated to – live lonely, even desperate lives, within otherwise mutually sustaining partnerships. These are the great imponderables – the fundamental splits, dualities and twinnings – that ... it has come Damien's turn to investigate. That he brings to his inquiry such a brilliant, sordid, uncompromising and twisted imagination, is our good fortune' (Gordon Burn, *Damien Hirst*, exh. cat., Jablonka Galerie, Cologne 1994).

Mona Hatoum

Mona Hatoum first became known in the early 1980s for a series of remarkable performance pieces. Towards the end of that decade her practice had shifted from 'live' works to video, installation and sculpture, although these apparently disparate areas of her work continue to feed into one another. She has commented that 'in the process of developing a piece of work, I go through a rigorous paring down of all that is superfluous to arrive at a precise and contained form. Always in my work in all its manifestations ... formal considerations are of primary importance' (*British Art Show* 1990, exh. cat., South Bank Centre, London 1990, p.62).

Hatoum has focused on confrontational themes such as violence, oppression and voyeurism, often making powerful reference to the human body, its vulnerability and resilience. Paradox, or a sense of conflict, seems to pervade her work, arising from the juxtaposition of opposites such as beauty and horror, desire and revulsion. She has persistently aimed to engage the viewer, soliciting interpretation and eliciting emotional, psychological and physical responses.

In 1975 she settled in London after civil war broke out in Lebanon while she was on a visit to Britain. In the context of this war her early work was readily interpreted

Mona Hatoum
1952 British, born Beirut, Lebanon, of Palestinian origin
1975 Settled in London
1975–9 Byam Shaw School of Art, London
1979–81 Slade School of Art, London

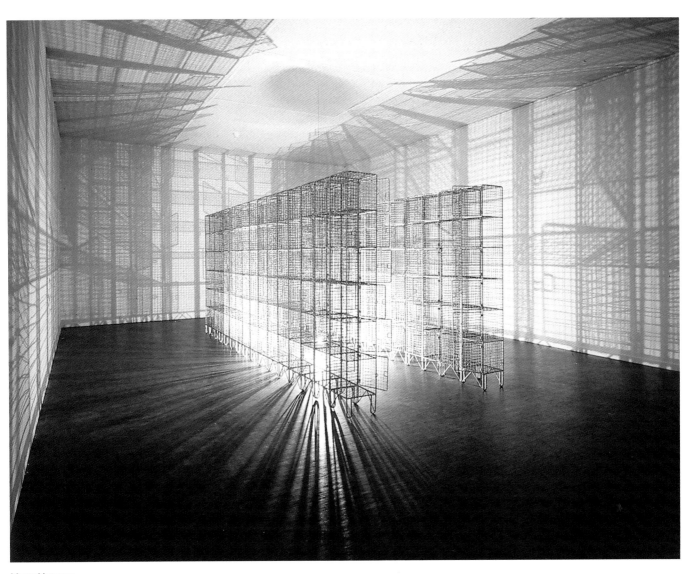

Mona Hatoum
Light Sentence 1992

Mona Hatoum
Corps étranger 1994

Callum Innes
1962 Born in
Edinburgh, Scotland
1980–4 Grays School
of Art, Aberdeen
1984–5 Edinburgh
College of Art
Lives and works in
Edinburgh, also works
in Glasgow

as a metaphor for universal conflict and resistance to oppression, although her achievement has been subtly to interlink aesthetic and political issues.

In the Turner Prize exhibition Hatoum was represented by two pieces, the earliest being *Light Sentence* of 1992, a U-shaped cage of wire-mesh lockers, stacked six-and-a-half feet high in a darkened room. In the centre, a naked lightbulb slowly moves up and down casting a web of shadows, which fully extend when the bulb touches the ground. The gentle swaying of the light sets the shadows in motion. The simplicity of the structure and the complexity of the linear forms are both beautiful and sinister. *Light Sentence* refers to imprisonment (confusingly suggesting both 'getting off lightly' and 'life sentence'). But the abstract nature of the installation suggests, as in other works by Hatoum, a generic type of institutional building associated with physical confinement.

The other installation on display was *Corps étranger (Foreign Body)*, a specially constructed tubular room containing a video projected onto a circular screen on the floor. With the help of medical technology (endoscopic and coloscopic examination of the full tract of the digestive system) the video charts the journey of the eye of a camera penetrating the artist's body. Travelling across the surface of Hatoum's body the camera then explores each orifice by turn. This 'fantastic voyage' is accompanied by a sound track made from an echocardio-graphic recording of the heartbeat as heard from different areas of the body.

Repelled and attracted, perhaps excited or intrigued by the sights and sounds of the inner chambers of the body, we imagine falling into these pulsating tunnels, propelled by peristalsis through our unfamiliar selves. As well as discovering the body as something alien, the viewer is at the same time invited to become the voyeuristic 'foreign body' inside the artist. On another level, the artist herself, as both woman and exile, could be regarded as 'foreign' by a patriarchal European culture.

Callum Innes

Following a stay in Amsterdam in 1988, Callum Innes abandoned his figurative approach to painting in favour of abstraction which seemed to offer a degree of detachment, allowing him to produce paintings that could exist beyond the limitations of his own experience or personality: 'My starting point is a desire to create an image that is somehow natural, that exists in its own right, holds a place for itself' (*Callum Innes,* exh. cat., Institute of Contemporary Arts, London 1992, p.18).

Innes's paintings are often admired for their enigmatic, meditative or even spiritual quality. Their quiet beauty is won from a tension existing between various elements. Starting with the monochrome, an established format of abstract painting favoured by minimalist painters since the 1960s, Innes etches away at the surface of the paint with a turpentine-laden brush.

His working method has been described as 'deliberately accidental' because he controls the amount and flow of turpentine, setting up a dynamic relationship between intention and intuition. Using this method he has established his own vocabulary in the form of distinctive groups of paintings, some of which were shown in the Turner Prize exhibition.

Prior to his nomination Innes began replacing his characteristic earthy palette with vibrant, dazzling pigments such as zinc yellow, cadmium red and cobalt violet. This departure was primarily stimulated by his *Resonance* or white paintings: 'Working with white is working with colour because of the fields of colour that open up when light hits the surface'.

Innes's monochrome grounds are painted from left to right with sweeping brushstrokes, the hog hairs creating a wall of horizontal lines. The impression of horizontality offers some resistance to the vertical lines of turpentine which transform the canvas. The vertical line or band became a highly significant pictorial element for American Abstract Expressionists working in the 1940s and 1950s. Barnett Newman, for example, used this line or 'zip' as a means of expressing the infinite: the vertical symbolically connects heaven and earth, unites spirit and matter, by splitting the canvas, imaginatively extending beyond its edges.

The vertical line is the starting point

Callum Innes
Monologue 1994

Callum Innes
Exposed Painting,
Cadmium Orange
1995

for each of Innes's *Exposed* paintings. Incising the monochrome ground with a line of turpentine the artist gently washes paint away from one side, gradually exposing an entire section of the canvas. The *Exposed* paintings seem rigidly geometric, but the line dividing solid colour from the cleansed area of the canvas betrays signs of human fraility – untrue, faintly wavering, sometimes slanting. Innes has commented: 'My approach is quite minimalist, but I'm not really interested in clean, clear-cut abstract paintings, pure formal exercises, I want emotion but also ambiguity' (ICA 1992, p.18). At its fringes the 'exposed' canvas retains traces of the paint previously covering the surface. For the artist, 'The most interesting part of the painting is the exposed part. That's the active part, where the painting actually exists' (quoted in Gill Roth, *List*, 27 Jan.–9 Feb. 1995, p.61).

Mark Wallinger

Since the mid-1980s Mark Wallinger has explored the complex theme of identity with imagination and irony. His primary concern has been to establish a valid critical approach towards the 'politics of representation and the representation of politics'.

Wallinger acknowledges that the pursuit of truth is subject to the anomalies and blind-spots of an artist's particular context and time. He adopts the strategy of parabasis which, as described by Jon Thompson, 'allows the author or artist to be both inside and outside of the action; to make comment before, during and after the depicted events. Like the Shakespearean chorus which is situated in an eternal present and yet is ... 'presumed' to know the pattern of events in advance, parabasis allows the writer or artist to expose him or herself as deeply implicated in the course of events, but to do so in the distanced voice of objective, critical commentary' (Jon Thompson, *Mark Wallinger*, exh. cat., Ikon Gallery, Birmingham and Serpentine Gallery, London 1995, p.12).

Wallinger's subjects stem from passionate interest or involvement, so that the critical edge of his work is twinned with the sensibility of an enthusiast or 'fan'. Horse-racing, for

example, 'has an extraordinary aesthetic frisson for me which covers everything from the gambling to the magical identification with the animal on which your money rides to the sheer beauty of the thoroughbred' (quoted in Paul Bonaventura, *Art Monthly*, no.175, April 1994, p.7).

In a series of paintings called *Half-Brother*, two of which were included in the Turner Prize exhibition, Wallinger portrayed four hybrid racehorses derived from the Jockey Club's official record of thoroughbred stallions. Each work comprises two panels, the left depicting the head and forelegs of one particular animal, the right depicting the tail and hindlegs of his half-brother (in racing terminology this term applies only to progeny sharing the same mother). A racehorse's pedigree multiples two-by-two-by-two in a kind of biblical symmetry. By the disruptive ruse of the child's game of consequences, Wallinger draws attention to both the cold financial calculations which prefigure equine unions, and the more sinister aspects of playing God in the perfection of a race. Wallinger's investigation of horse-racing culminated in 1994 when, with the support of a syndicate, he purchased a two-year-old filly which he named *A Real Work of Art*: 'In choosing a race-horse as the subject of the piece I am signalling the fact that the thoroughbred is already an aestheticised thing, its whole purpose being to give pleasure to its owners and followers' (ibid.). As the owner of a racehorse Wallinger was required to register his 'colours', (the distinctive livery worn by jockeys racing for a particular owner, with the Jockey Club. Wallinger felt that the very term 'colours' provided a 'poetic tie-in with the act of painting. If you mix up all of the colours on a palette you end up with brown' (ibid.). Wallinger made a series of forty-two paintings, each representing the registered 'colours' of owners with the surname Brown and titled simply *Brown's*.

Mark Wallinger
1959 Born in Chigwell, Essex
1977–8 Loughton College
1978–1 Chelsea School of Art, London
1983–5 Goldsmiths' College, London

Mark Wallinger
Half-Brother (Exit to Nowhere/Machiavellian)
1994–5

Mark Wallinger
Brown's 1993

123

Douglas Gordon 1996

Winner
Douglas Gordon

Shortlisted artists
Douglas Gordon for the presentation of his work at the Van Abbemuseum, Eindhoven; and for his contribution to a number of group shows, particularly *The British Art Show*, beginning in Manchester and touring to Edinburgh and Cardiff, and *Spellbound* at the Hayward Gallery, London
Craigie Horsfield for the continuing development of his work as shown in solo shows at the Antoni Tapies Fundacio, Barcelona, and at the Barbara Gladstone Gallery, New York, and for his contribution to the Carnegie International, Pittsburgh
Gary Hume for his solo exhibition seen at the Kunsthalle, Bern, and the Institute of Contemporary Arts, London, and for his contribution to several group shows, including *Wild Walls* at the Stedelijk Museum, Amsterdam, and *Brilliant!* at the Walker Art Center, Minneapolis
Simon Patterson for his solo exhibitions at the Lisson Gallery, London, and at the Gandy Gallery, Prague; and for his three separate solo exhibitions in Japan at Artium, Fukuoka, the Röntgen Kunstinstitut, Tokyo, and the Kohji Ogura Gallery, Nagoya

Jury
Bice Curiger
Editor-in-Chief, *Parkett* magazine, Zurich
Mel Gooding
Writer and critic
Edward Lee
Representative of the Patrons of New Art
James Lingwood
Curator and co-director of the Artangel Trust
Nicholas Serota
Director of the Tate Gallery and Chairman of the Jury

Exhibition
29 October 1996 – 12 January 1997
Prize of £20,000 presented by Joan Bakewell, 28 November 1996

Douglas Gordon
Something Between My Mouth and Your Ear 1994

The 1996 prize continued to draw visitors to the Tate Gallery despite the absence of an artist using 'shocking' materials and of tabloid hysteria. When the shortlist was announced, the most art correspondents could find to say about it was that it was 'boring' or 'sensible'. Brian Sewell's much quoted view was that: 'If the Turner Prize is trying to commit suicide by boring the pants off us, it is going the right way about it. These four are nobodies. They are not outrageous or a slap-in-the-face or whatever else Tate director Nicholas Serota wants to tell us, they are plain damned dull and boring' (*Independent*, 20 June 1996, p.9). Another critic suggested: 'You might just as well award the prize to the contestant with the nicest legs. With this tedious lot one is tempted to shout "Come back Damien all is forgiven"' (*Art Review*, September 1996). But this was not by any means the only response to the prize. Richard Dorment, for example, was both impressed by the artists selected for the shortlist – 'This is the strongest list in years, and what's more it has variety and feels fair, making it difficult to predict an obvious winner' (*Daily Telegraph*, 19 June 1996) – and by the exhibition: 'The exhibition of the shortlisted candidates for this year's Turner Prize opened last week at the Tate Gallery in London, and already the art press has dubbed it boring. I couldn't disagree more. For me the absence of artists such as Damien Hirst and the Chapman brothers from the list gives us a chance to ask a question that doesn't usually get asked in the brouhaha surrounding the Turner. If almost anything can be called art – and one of these artists works with video, another paint, a third with photography, a fourth with language – how do you determine quality? ... Whoever wins, this is a first class show and has become so popular that this year it has been extended until January 12' (*Daily Telegraph*, 6 November 1996, p.21).

Adrian Searle also commented on the public's commitment to the prize regardless of critical apathy: 'Public interest in the Turner extends beyond the handing out of big cheques, and despite the drearily predictable gor-blimey-they-must-be-bonkers tabloid knee-jerk, it is clear that many people in Britain actually like contemporary art. The enthusiasm

for younger British art has gone beyond a fad' (*Guardian*, 29 October 1996, p.6).

But Searle also expressed his view on the only controversial aspect of the shortlist. Women had been excluded in a year when young British women artists had been particularly visible: 'It is an all-male contest this year which doesn't say much for parity, let alone the perceived achievements of women artists these past twelve months.' William Feaver also criticised this aspect of the shortlist: 'There could well have been an all-bad-girl shortlist. Tracey Emin, Sarah Lucas, Georgina Starr, Gillian Wearing ... At the very least, Cornelia Parker should have been there at the Tate' (*Observer Review*, 1 December 1996, p.9). Many others shared this view, although some conceded that the omission of women had not been deliberate. Gallerist Laure Genillard, for example, concluded that: 'The strength of women's art in the last ten years has been overwhelming to the point of taking the art world by surprise. Therefore I don't think it is possible today to deliberately boycott women artists from the Turner Prize shortlist. If there are no women selected this year, I think this happened coincidentally in the shortlisting process' (*Make 72*, Oct.–Nov. 1996). Speaking about the issue of the all-male shortlist on behalf of the jury Nicholas Serota revealed that: 'At least one woman artist featured in the final discussion this year, but in the end, the collective decision of the jury was that those shortlisted had, this year, greater claims. Perhaps I should add that the jury rejected the idea of putting a woman artist on the shortlist simply because she was a woman.'

There was no clear favourite to win in 1996. When the prize went to Douglas Gordon a number of critics noted that this was the first time a video artist had received the award. Others also commented on the fact that it was extremely rare for an artist based outside London to achieve such an accolade.

Douglas Gordon
Douglas Gordon has worked in various media, mostly painting, installation and more recently film. In the broadest terms, his project has been to investigate how and why we establish meanings for our experiences, given that we live in an environment saturated by new

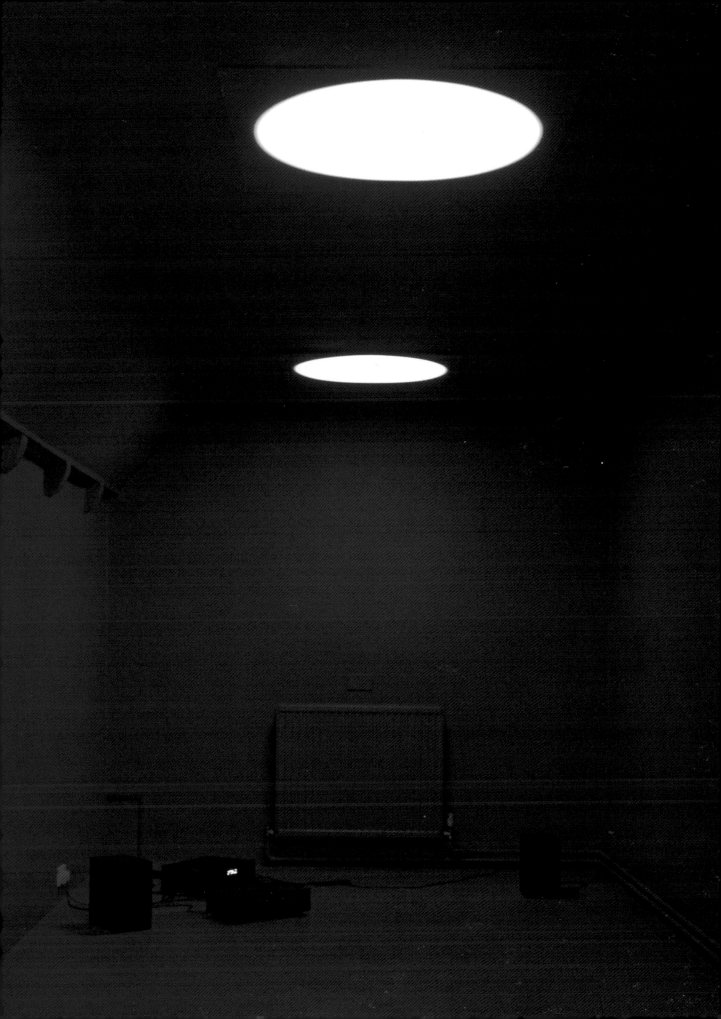

Douglas Gordon
1966 Born in Glasgow
1984–8 Glasgow
School of Art
1988–90 Slade School
of Art, London

information which constantly erodes any coherent sense of self. Gordon aims to tempt the viewer into becoming more aware of the shifting subjectivity of his or her perception of the world. But certain recent works also indicate disquieting discoveries about his own responses to certain pathological mechanisms underpinning mass culture; particularly the areas of voyeurism, sadism and eroticism.

Since the early 1990s he has been fascinated by such phenomena as perception, memory and amnesia. In 1990 he first produced *List of Names*, a wall text compiling 1,440 names of people he had met, but only those he could remember in the process of making the piece. A later work, *Something Between My Mouth and Your Ear*, explores the power of music as an identifying mechanism for various stages in life, evoking the past and marking the present. In an entirely blue room, the audience listens to thirty songs that were 'in the air' between January and September 1966, the months prior to Gordon's birth. The songs may have formed his earliest conscious or unconscious memories.

His preoccupation with memory, combined with a passion for cinema, led Gordon to work with films. His primary concern is with the viewer's psychological relationship with the moving image: 'We can be attracted to the spectacle of cinema while watching something completely repulsive' (Blocnotes interview with Stephanie Moisden, unpublished, 29 Dec. 1995, p.2). In 1993 he first exhibited the critically acclaimed *24-Hour Psycho*, now recognised as a pivotal work in his *oeuvre*. Using slow-motion he played Alfred Hitchcock's film so that it lasted an entire day. He chose this well-known film because most people would have some preconception of what they would be seeing. As the slow-motion frames set up tensions and narratives not previously visible, any memory or expectation of the film is perplexingly discredited. Gordon has commented on this 'schizophrenic' effect: 'The viewer is pulled back into the past in remembering the original, then pushed into the future in anticipation of a preconceived narrative that will never appear fast enough. In the middle of this is a slowly changing present – engaging

in itself, but "out of time" with the rest of the world around it' (unpublished letter from Douglas Gordon to Michael Newman, 27 July 1995, p.4).

In all of his film pieces Gordon manipulates the act of looking. *24 Hour Psycho*, for example, is rear-projected on a screen installed in the middle of the room, so that people can walk around and behind the moving images, an intimacy denied at the cinema: 'When I was younger, I always believed that another reality existed behind the surface of the screen. I wanted to use this childish idea as a device to move the viewer around the space and to avoid the traditional cinematic "fixed perspective"' (ibid., p.3).

Slow-motion has been used strategically by film-makers engaged in critical film theory. However, Gordon's use of this device reflects the way in which video cameras are used domestically. He has commented:

As a teenager, any girl or guy can sit in their bedroom and run and rerun a video of their current obsession and watch the whole thing in slow-motion. This is not an academic exercise. This is about sex. This is about a human drive of real desire to see what shouldn't be seen. It's like being taken from the academy to the bedroom, and then ending up somewhere else altogether' (Blocnotes interview with Stephanie Moisdon, pp.5–6).

Following *24 Hour Psycho* Gordon produced a number of works involving medical films recording psychological malfunction, in which he investigates sadism and voyeurism as perceptual responses. *Hysterical*, for example, is a fragment of a medical demonstration film of 1908 documenting techniques for the treatment of hysteria. In an unconvincing interior, two male doctors violently restrain a masked woman as she experiences an hysterical fit. Gordon hints that the film is phoney by projecting the image on two adjacent screens, one projected from the front and one from the rear, the latter in slow-motion. Mirroring the screens in this way creates the impression that things are not as they might first appear. The incident appears staged, reminiscent of early Hollywood comedy (as implied by the artist's title). But at the same time the brutality of the

Douglas Gordon
*Confessions of
a Justified Sinner*
(detail) 1995

Craigie Horsfield
1949 Born in Cambridge
1972–9 Lived in Poland
1979 Returns to Britain

footage is shocking. Gordon felt that the enacted scene became far more sinister when slowed-down.

In *Confessions of a Justified Sinner* (1995), which was the central piece in Gordon's Turner Prize display, the artist further explores the coexistence or 'hybridisation' of such apparent opposites as fantasy and truth, good and evil. *Confessions* comprises clips taken from an early film version of R.L. Stevenson's novel *The Strange Case of Dr Jekyll and Mr Hyde*, starring Frederic March as the doctor who attempts to liberate the human soul from its evil, bestial impulses. Unfortunately, his scientific dabbling has the reverse effect, with irrevocable and fatal results. Gordon amalgamates three clips enacting the fantastic transformation of saintly Jekyll into monstrous Hyde. Enlarged, slowed down and projected onto two separate screens, one negative, one positive, the selected clips emphasise and prolong the tortuous struggle between good and evil. But through slow-motion and video looping the expressions of the man turning into the monster are ambiguous – the distinction between good and evil is momentarily blurred.

The title of the piece refers to James Hogg's *The Private Memoirs and Confessions of a Justified Sinner*, published in 1824. Set in Scotland during a period of intense conflict within the Church, Hogg's chilling tale exposes the religious fanaticism that leads a devout youth to be seduced by the devil into killing his brother. The youth first meets the devil disguised as himself. In German folklore a meeting with one's own apparition or shadow soul, known as a *doppelgänger* (literally, 'double-goer') is a sign that death is imminent. In the book the narrative account of events is followed by the imagined confessions of the youth, which document his schizophrenic breakdown.

Gordon's work challenges us to be more conscious of how we perceive the world, and our place in it. We are frequently and uncomfortably prompted to play a game of 'truth or dare' in which we have to accept the rules and live with the outcome. As one critic has observed: 'Gordon's minimal means keep him at a distance, but he invites us – without pronouncing judgement or offering any

form of consolation – to plunge into some of the most difficult and distressing areas of the human psyche' (quoted in Angela Kingston, *Frieze*, no.21, March–April 1995, p.61).

Craigie Horsfield

Craigie Horsfield has said: 'The work I make is intimate in scale but its ambition is, uncomfortable as I find it, towards an epic dimension, to describe the history of our century, and the centuries beyond, the seething extent of the human condition' ('Craigie Horsfield: A Discussion with Jean-François Chevrier and James Lingwood', *Craigie Horsfield*, exh. cat., ICA 1991, p.28). His work is predicated on a philosophical position concerning the current crisis in European cultural, social and political life. In the late twentieth century we face the breakdown of rationalist and absolutist modes of thought which have dominated society since the Enlightenment. These omnipotent ideologies are now discredited – a belief in the idea of progress is no longer tenable. The notion that man could 'know all' and 'control all' has reached its threshold and we are crippled by a sense of an inability to act upon the forces of history which have brought us to this point of disintegration.

Through art Horsfield attempts to establish an understanding of history that involves the specificity of the present, challenging the notion of history as mythical past or inexorable future, divorced from human experience of the here and now. Using photography, with its residual trace of the real world, his work draws attention to the simultaneity and singularity of history.

Aware of the need to think and act new models of perceiving the world, Horsfield has based his project on human exchanges between individuals and communities. His black-and-white photographs record the environment around him and people he knows. The titles of his works record both the date of the photograph and the final print, emphasising the connectedness of past and present. He has written: 'It is an impossibly painful thing to realise that the lives, the very existence of people one loves are of the same matter as their fathers and mothers, and generations before. This is not

Craigie Horsfield
Carrer Muntaner,
Barcelona, Març 1996
1996

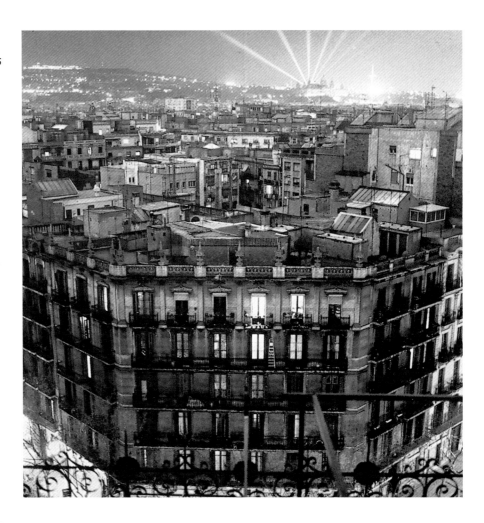

Craigie Horsfield
Pau Todó i Marga Moll,
carrer Muntaner,
Barcelona, Març 1996
1996

Gary Hume
1962 Born in Kent
1985–8 Goldsmiths'
College, University of
London

an easy thing to live with' (ibid., p.13).

The works shown in the Turner Prize exhibition were selected from a group of almost fifty images exhibited at the Fundacio Antoni Tapies in Barcelona. They were made as part of a collaboration over three years between Horsfield, Manuel Borja-Villel, and Jean-François Chevrier. The project involved several other groups working in and for Barcelona, and many individuals played an active part in its development. Within the project the city of Barcelona is seen not as different from other cities but as a paradigm of the changes occurring across Europe today. The collaboration was to describe this place and had a specific political purpose in developing an instrument and a model of communal action, and a sense of the network of relations that constitute a community. Horsfield has said: 'If we are to survive, if we are to resist death, [we] must work to understand the relation that we have at once to each other and the phenomenal world' (Craigie Horsfield, *Witte de With 1992: The Lectures*, Witte de With, Rotterdam 1993, p.83).

Gary Hume

In the late 1980s Gary Hume came to prominence with a series of sophisticated monochrome paintings which replicated the measurements of swing doors in St Bartholomew's Hospital, London. The paintings also incorporate the geometric features (circles, squares and rectangles) that are the windows and panels of hospital doors – they appear to be abstract, while literally representing real doors. Hume's use of gloss housepaint further enhanced the resemblance of his paintings to real doors. The resulting reflective surfaces of such paint also changed the experience of viewing the work. Hume continued to develop the series by using an increasing variety of colours and multi-panel parts until, at the end of 1992, he surprised the art world by abandoning them completely. Hume had felt trapped. The freedom afforded by critical and financial success was also stifling his creativity. He commented:

> I just wanted to continue to create. The limitations of abstract geometric paintings were of no interest. The

recent paintings are not so closed down and give you more to think about. The door paintings were solid, whereas now the subject matter is more fluid (Gregor Muir, *Vague Art + Text*, no.51, May 1995, pp.41).

In 1995 Hume exhibited his new work in solo shows at White Cube and the Institute of Contemporary Arts, London. The new paintings are often deliciously coloured and unashamedly sensual. His subjects, which he describes as 'embarrassingly personal', have included feet, flowers, animals, toys, women and such media celebrities as Tony Blackburn. They are chosen, Hume says, 'for their ability to describe beauty and pathos'. Derived from fashion magazines and other mass-media sources, the subjects are familiar, yet, transformed by the artist, who uses the mediated image as a starting point, they become volatile and confusingly evasive.

The new paintings are contoured with immaculately applied layers and ridges of gloss paint. Working on the floor, he first builds up the painting in white to produce a variety of surface levels. This determines the outlines of dominant motifs and defines which areas touch or overlap.

Innocence and Stupidity, included in the Turner Prize exhibition, comprises two large panels butted together, one echoing the image of the other. Layers of paint also sit side by side, forming pools of pastel colour suggesting an aerial view of a topographical terrain. This seemingly abstract painting depicts two rabbits, amoebic lilac shapes representing their eyes. Hume derived the image of the rabbit from a medieval French tapestry, *La Dame et la Licorne*. Although his images are usually appropriated from specific sources, Hume resists literal interpretation of his work. His primary concern is to give pleasure, rather than to explain or fix meanings. Ultimately he is 'searching for that art moment', a sublime moment of 'supreme humanity' that happens occasionally in front of art, the kind of moment he experienced on seeing an astonishing portrait of a girl by the fifteenth-century painter Petrus Christus.

Gary Hume
Whistler 1996

Gary Hume
*Innocence and
Stupidity* 1996

Simon Patterson

Simon Patterson
1967 Born in
Leatherhead, Surrey
1985–6 Hertfordshire
College of
Art and Design,
St Albans
1986–9 Goldsmiths'
College, London

Simon Patterson is fascinated by the information that orders our lives. Using a variety of media he humorously dislocates and subverts such sources of given information as maps, diagrams and constellation charts. By transforming authoritative data with his own associations he challenges established rationales. Patterson's seemingly random, personal logic suggests that there are many different ways in which systems can legitimately work, and even the most obscure reference can find an audience, since his own knowledge of history, science and culture is shaped within a social context: 'There is no code to be cracked in any of my work. Meanings may not be obvious, you may not get a joke, but nothing is really cryptic – I'm not interested in mystification. I like disrupting something people take as read' (Sarah Greenberg, *Tate: The Art Magazine*, no.4, Winter 1994, p.47).

Maps and diagrams function to convey reliable data about the 'real' world, translating putative 'fact' into abstract visual form. Patterson's best-known use of a map is *The Great Bear*. Within a few years of its making, this variation of the London Underground Journey Planner, or 'tube map', was lauded as 'an icon of Nineties art'. Patterson intended to print his version as a poster for the Underground. Understandably, as he had substituted station names with those of philosophers, film stars, explorers, saints and other celebrities, past and present, *The Great Bear* was deemed too confusing for commuters. Some new connections seemed appropriate, others nonsensical. Pythagoras as Paddington, for example, forms a neat triangle between the District and Circle, Metropolitan and Bakerloo lines. But what links Balham and Cher?

The relationship between language and objects was the focus of Patterson's work in the mid-1990s. At the Lisson Gallery in 1996 he exhibited a number of sculptures, including fabricated sliderules, kites and giant abacuses, which set out to explore the literal and metaphysical potential of three-dimensional things. The centrepiece of the show, later included in the Turner Prize exhibition, was an untitled work comprising three white yachting sails rigged on metal stands, each bearing the name and dates of a literary figure. Raymond Chandler (1888–1959), Currer Bell – the pseudonym of Charlotte Brontë (1816–1855) – and Laurence Sterne (1713–1768). In selecting these names Patterson implies a range of associations, not least the fact that as words they belong to the world of sailing, the ship's chandler, bell and stern. For Patterson the white sails suggest the artist's canvas: 'They are about the artist contemplating the blank canvas, and about the problems of making art' (Mel Gooding in Conversation with Simon Patterson at the Lisson Gallery, *Audio Arts Magazine*, vol.15, no.4, 1996). Indeed, the sails strain to race with the wind, to reach their destination, but the airless gallery denies them this satisfaction, perhaps suggesting the futility of competitions. On another level they refer literally to the traditional picturesque subject of marine painting.

Commenting on Patterson's lightness of touch in handling serious issues, David Lillington has written: 'His is a social art, addressing a society which puts faith in individualism. It sends the mind in several directions at once, and in this it is both funny and perceptive' (David Lillington, *Time Out*, 27 March–2 April 1991, p.43).

Simon Patterson
The Great Bear 1992

Simon Patterson
Untitled 1996

Winner
Gillian Wearing

Shortlisted artists
Christine Borland for her exploration of
the language of forensic science as seen
in her *From Life (Berlin)* project included
in *Material Culture* at the Hayward
Gallery and also in her solo exhibition at
the Lisson Gallery
Angela Bulloch for her inventive use of a
wide range of media and approach to
exhibition making, as seen in *life/live* at
the Musée d'Art Moderne de la Ville de
Paris and in her solo show at Robert
Prime Gallery, London
Cornelia Parker for her exhibition,
Avoided Object, at the Chapter Gallery,
Cardiff, in which she showed her
continuing exploration of the secret lives
of objects and materials both ordinary
and strange
Gillian Wearing for the sustained
development of her work in this year as
seen in *The Cauldron*, at the Henry
Moore Studio, Halifax; in *Full House*, at
the Kunstmuseum Wolfsburg; and most
recently for her video *10–16* at the
Chisenhale Gallery, London

Jury
Penelope Curtis
Curator at the Henry Moore Institute,
Leeds
Lars Nittve
Director of the Louisiana Museum,
Humlebaek, Denmark
Marina Vaizey
Writer, art critic and lecturer
Jack Wendler
Representative of the Patrons of New Art
Nicholas Serota
Director of the Tate Gallery and
Chairman of the Jury

Exhibition
29 October 1997–18 January 1998
Prize of £20,000 presented by the
Rt Hon. Chris Smith, Secretary of State
for Culture, Media and Sport,
2 December 1997

Gillian Wearing
60 Minutes Silence
1996

In 1997 the first all-woman shortlist
provoked accusations of political
correctness from some quarters. But
most acknowledged that the shortlist
genuinely reflected the achievements of
British women artists. Following the
presentation of the prize to Gillian
Wearing, Waldemar Januszczak wrote:
'Much has been made of the all-female
shortlist for 1997. But I honestly believe
it was inevitable. Young women artists
are making much of Britain's best work
at the moment and they are mainly
doing it in a new voice: the loud, boozy,
confident chatter of the single urban
female' (*Sunday Times*, 7 December
1997). The surprise for many critics,
however, was that the shortlist had not
included some of Britain's so-called 'bad
girl' artists such as Sarah Lucas and
Tracey Emin. When the exhibition
opened, Martin Coomer, writing in *Time
Out* (5–12 November 1997, p.48),
commented on what he felt was an
evenly matched competition: 'The jury
has done its job impeccably; four artists,
all worthy of individual merit, all well
known, but not too famous, all female –
yikes – but not the obvious choices.
Rumours that Sarah Lucas declined her
nomination, plus the omission of Tracey
Emin, Georgina Starr and Sam Taylor-
Wood have yielded a closer competition
than we are used to'.

The prize and the art on display
continued as in previous years to attract
criticism. Brian Sewell, for example,
declared: 'This year's Turner Prize is,
without doubt, the silliest yet' (*Evening
Standard*, 30 October 1997, p.29). Sewell
expressed the view that the Turner Prize,
which had not been won by a painter for
over a decade, was 'the disreputable
instrument of propaganda for the Serota
Tendency ... Soon, under its mephitic
influence, no one below the age of 40
will have the slightest notion of what
separates an art gallery from an infant
school, a freak show, a toy shop, and
boring television'.

Marina Vaizey, a juror in 1997,
commented on the criticism that the
Turner Prize inspired, from both
traditionalists and those supporting new
developments in art: 'Is the knocking
copy that the Turner attracts harmful?
Those prizes that are not much
criticised, or even scrutinised, are not

perhaps taken all that seriously either.
The non-reverential atmosphere does at
least engage some of the audience to
come and see what the fuss is about. It
also ensures an annual provision at the
Tate of a didactic exhibition of absolutely
current art. I do not think it is time to
stop knocking the Turner. Knock all you
want, but remember it is an open door.
Come and see for yourself what is within'
(*Sculpture*, Autumn 1997, p.10). Indeed,
more visitors attended the exhibition
than in previous years. One of the most
admired works on display was Cornelia
Parker's *Mass (Colder Darker Matter)*,
described by John McEwen in the *Sunday
Telegraph* (2 November 1997, p.12) as a
'show-stopper'. But for Richard Dorment,
also reviewing the exhibition, Gillian
Wearing's video *60 Minutes Silence* stole
the show (*Daily Telegraph*, 5 November
1997, p.22). The subsequent award of
the prize to Gillian Wearing, felt Colin
Gleadell, 'rammed home something that
was not fully grasped after last year's
award to Douglas Gordon. Like it or not,
accept it as art or not, video art is now
"institutionally correct"' (*Daily Telegraph*,
8 December 1997, p.18).

Gillian Wearing
Gillian Wearing is fascinated by people.
Using photographs and video she has
collaborated with members of the public,
young and old, to produce a body of work
that yields insights, both funny and
disturbing, into the complexities of
everyday life at the end of the twentieth
century. Her desire to scratch beneath
the surface of appearances was kindled
early on by fly-on-the-wall television
documentaries of the 1970s. She has
said (in *Brilliant!*, exh. cat., Walker Art
Center, Minneapolis 1995, p.81):

I think my most important influence
has been documentaries. I really
enjoyed the 1970s 'fly-on-the-wall'
documentaries that were made in
Britain. There was a programme
called *The Family*, where they went
in someone's home and filmed the
family. Documentary was still fresh
then, and these programmes felt
very spontaneous.

Wearing's subjects tend to highlight the
friction between public and private,

Gillian Wearing
1963 Born in Birmingham
1985–7 Chelsea School of Art, London
1987–90 Goldsmiths' College, London

between individual impulse and established norms of behaviour. Using carefully thought out methods and strategies, she presents a kaleidoscopic view of human experience, its pleasure, pain and ambiguities: 'There's elements of humour and then there's humility as well. I'm interested in every emotion being part of the work. Some of my work is very depressing, and then there's other stuff that's funny' ('Gillian Wearing interviewed By Ben Judd', *Untitled*, no.12, winter 1996–7, p.4).

All of her work involves a degree of complicity with ordinary people, mostly from South East London where she lives, an area that has become, in effect, her studio. In 1992 she began *Signs that say what you want them to say and not signs that say what someone else wants you to say*, a series of photographs of people holding placards upon which they had spontaneously written what they were thinking or feeling when the artist approached them on the street. The results are amusing, poignant and surprisingly honest for a nation noted for its lack of candour. In *Dazed & Confused* (no.25, 1996, pp.53, 54) the artist has commented:

> People gave so much of themselves, which is not expected of the British public, who are generally perceived as being reserved ... I wanted to find out what makes people tick. A great deal of my work is about questioning handed-down truths ... I'm always trying to find ways of discovering things about people, and in the process discover more about myself.

It has been noted that Wearing's work, which seems to depend on our 'vicarious voyeurism' for its effects, could be seen as exploitative of her human subjects (Adrian Searle, 'Gillian Wearing', *Frieze*, no.18, Sept.–Oct. 1994, p.62). But her collaborators are always consenting and Wearing, aware of her own fallibility, is never patronising or judgemental, often including herself in a work to prove the point. In *Dancing in Peckham*, for example, a video piece of 1994, she spent twenty-five excruciating minutes dancing in a shopping centre, the music of Gloria Gaynor and Nirvana playing only in her head, while a worryingly unperturbed

public trudged past her gyrating body and flailing limbs. Wearing has said (in *Dazed & Confused*, no.25, 1996, p.55):

> There are some things you can't ask of the public. For instance, the original idea for *Dancing in Peckham* stemmed from seeing this woman dancing wildly in the Royal Festival Hall. She was completely unaware that people were mocking her ... Asking her to be in one of my videos would have been patronising, so I decided to do it myself.

A method of eliciting collaboration consistently used by Wearing is that of placing an advert in the personal column of *Time Out* magazine. In 1994 she recorded the confessions of ten people who dared to respond to *Confess all on video. Don't worry you will be in disguise. Intrigued? Call Gillian* ... Aware of the confessional nature of many popular television chat shows, the artist offered participants the chance to confide their secrets to the camera, as if it were a modern Catholic confessional box. Besporting an array of wigs and masks and with varying degrees of relish or regret they disclose their 'perpetrations', which include betrayal, sexual perversion, stealing, and revenge. One man, the only victim, gives a desperately sad account of how witnessing his brother 'snog' his two sisters has subsequently destroyed his life.

Much of Wearing's work deals with the themes of deviancy and control. In *60 Minutes Silence* of 1996 the viewer is presented with what appears to be a life-size group photograph of twenty-six policemen and women. Suddenly there is movement within the frame. The picture is in fact a video projection: like a living sculpture it returns our gaze – we are being watched by the law. Wearing persuaded the participants to remain still for a punitive hour of silence under the scrutiny of her camera. Gradually, the shuffling increases, tension mounts. When the time is up, one officer releases a yelp of anger and relief. Lesley Garner (in the *Daily Express*, 2 August 1996) has commented:

> This video is not a photograph, and the longer I looked the more I saw other

figures move; nothing dramatic, just the normal shifts and coughs of people made to hold a silent pose for an hour.

It's mesmerising. There is a great sense of tension from all that suppressed energy, and the longer you looked the more individuals emerge. Gillian Wearing has made a career from using video to bring out humanity and individuality and this seemingly simple piece is compellingly effective.

As well as examining modes of behaviour in public spaces, Wearing has also attempted to unmask the ambivalent emotions underpinning personal relationships. *Sacha and Mum* of 1996 shows intimacies between a mother and daughter at home. But their embraces become struggles, the mother using a towel to mask and restrain the younger woman, clad only in bra and pants. Wearing has choreographed their movements, and by running the stark black-and-white film backwards, creates a disquieting scenario in which horseplay turns into coercion, bordering on violence.

A more recent film commissioned by the BBC, *Two into One*, records a mother and her two eleven-year-old sons talking about their relationship. Wearing met them through a friend and quickly realised that they had strong views about each other. They agreed to lip-synch edited interviews with the artist, so that the dynamics of their relationships are thrown into relief. This device, also used in *10–16*, exhibited at the Chisenhale Gallery in 1997, draws attention to the emotional and psychological realities belied by outward appearance. In *10–16* adults lip-synch to the recorded interviews of children aged between ten and sixteen. *Two into One* shows children lip-synching to their mother's voice, and she to theirs. As they speak, deadpan, to the camera, the shadowy borderlands between love and hate compellingly unfold.

Christine Borland

Christine Borland's work asks us to consider the ways in which social systems and institutions exploit and devalue life. She has said, for example,

'I think the ways that we are forced to be institutionalised or compartmentalised by the institutions surrounding the body – health, medicine, birth and death – is an important subject and one which we must try to repersonalise (unpublished interview, Kari J.Brandtzaeg, May 1997).

Her installations exploring the traditional theme of mortality are both seductive and repellent, exerting a morbid fascincation. Like an archaeologist or historian she conducts research, often seeking out expertise within a particular field of enquiry, opening doors that are normally closed.

The Dead Teach the Living, shown in the Turner Prize exhibition, points to how science has legitimised the dehumanisation of racial groups. On a visit to the Anatomical Institute in the faculty of medicine at the Westfälische Wilhelms-Universität in Münster, Borland was immediately struck by a display case of heads – death masks from people of different ethnic groups, shrunken heads, artists' portraits and fragments of heads. The department's records were mostly destroyed during the Second World War so Borland could only speculate as to whether these items had served as teaching tools. However, further research enabled her to establish a historical context for the specimens: she discovered that during the 1920s and 1930s the faculty had been an important centre for so-called Rassenhygiene ('racial hygiene') and eugenics. Many of its professors had promulgated National Socialist theories of race, a fact that Borland felt unable to ignore: 'Although I wanted the project in its eventual form to be historically non-specific, this knowledge provided a crucial perspective for me ... my struggle to deal with this history ... reflected the medical faculty's own desire to move forward while dealing with the past honestly and respectfully' (*Sculpture: Projects in Münster*, 1997, p.75). Borland made copies of these heads using the latest technology. The heads, she explains:

were scanned in many different positions by a laser and this information built up into computer data. In the next process the data was converted and painstakingly

Christine Borland
1965 Born in Darvel, Ayrshire
1983–7 Glasgow School of Art
1987–8 University of Ulster, Belfast

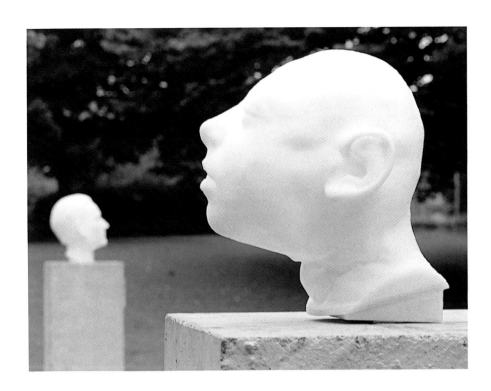

Christine Borland
*The Dead Teach the
Living* (detail) 1997

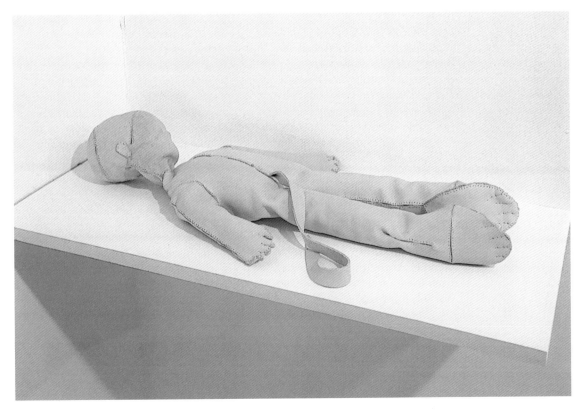

Christine Borland
Phantom Twins (detail)
1997

rebuilt in three-dimensionally molten ABS plastic, by machine. The resulting piece is necessarily removed from the emotive originals, the new material inviting curiosity and interaction [ibid., p.76].

On occasion Borland seems to be playing with the role of Mary Shelley's doctor-scientist, Frankenstein. In 1997, for example, she made *Phantom Twins* based on two leather 'dolls' used in the eighteenth century to demonstrate childbirth to medical students. The original 'dolls' contained real foetal skeletons –beneath the stretched leather their skulls are clearly visible. Although Borland used plastic replica skulls obtained from an osteological supplier, her 'dolls' nevertheless convey, at one step removed, the poignancy and uniqueness of the tiny lives buried under the leathery carapace.

Angela Bulloch

Angela Bulloch makes cool, immaculately fabricated mixed-media sculptures often including functional elements that are activated by the viewer, or modified by the passing of time. In an interview with Liam Gillick in *Documents sur l'art* (no.8, spring 1996, p.30) she has said:

I am interested in how things evolve, or shift their meaning when you move them into various different contexts. I am also involved in a consideration of time-scale as a framework, rather than assuming a fixed perspective ... I like the apparent contradiction of defining something which is always subject to change.

The human presence is crucial to the possible meanings of her work. Based on systems or structures that limit the parameters of human choice, her sculptures are nevertheless continually redefined in relation to those choices. As David Bussel has observed, 'The viewer becomes the activator, making an intervention of some kind through the structure provided by the work itself within the context of the gallery. As such, the work becomes a kind of democratic collaboration of action

and choice between Bulloch and her audience ('Angela Bulloch', *Frieze*, June–Aug. 1997, p.85).

Bulloch's real interest lies in how systems influence our preferences and exert control over our behaviour or potential for action. Using a variety of means, including modern technology, light, sound and fabricated 'furniture', her work effortlessly subverts such binary opposites as on-off, order-chaos, pleasure-pain, opposites that we might encounter in our daily experience of the world.

Since the early 1990s Bulloch has been making drawing machines, such as *Betaville* (1994). Typically, the artist sets up a system whereby the presence of the viewer, detected by infra-red sensors, sound- or pressure-sensitive switches, triggers the movement of a mechanically operated pen on the wall to produce a continuous line drawing.

Intrigued by the idea that sculptures can function as places of social interaction, Bulloch has more recently made sculptures that have potential use as furniture. A recurring type has been the comforting 'Happy Sack' which Bulloch uses as an individual piece or as an element in other sculptures. She has commented: 'If somebody wishes to view the work or to be part of it, s/he has to be more-or-less lying down, or together with other people on the same structure. Basically I see the 'Happy Sack' as a piece of furniture, but in another way it's a social structure (ibid.).

Another group of works, the *Rules Series*, begun in 1993, makes visible the rules and regulations that mechanise our behaviour. Displaced from their original contexts, and writ large on a gallery wall or some other location, her lists of rules, covering activities as diverse as bungy-jumping, stripping, and debating in the House of Commons, are themselves subjected to critical scrutiny. The *Rules Series*, like many of Bulloch's inventions, conveys the feeling that all life is interconnected, that individual action impacts on others and vice versa. As with all her works, one is left with the view that, for the individual, coerced by social convention, self-determination may be merely an illusion.

Angela Bulloch
1966 Born in Ontario, Canada
1985–8 Goldsmiths' College, London

Angela Bulloch
Betaville 1994

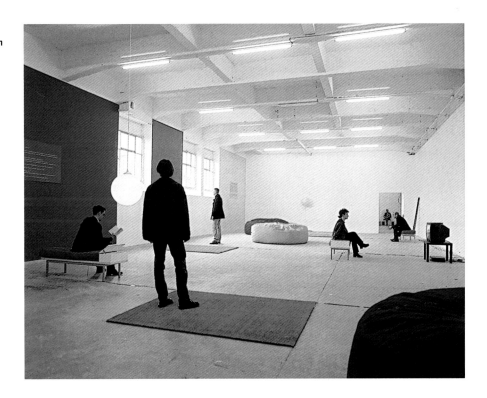

Angela Bulloch
Vehicles, an exhibition
at Le Consortium,
Dijon in 1997

Cornelia Parker
1956 Born in Cheshire
1975–8 Wolverhampton
Polytechnic
1980–2 Reading
University

Cornelia Parker

There are no absolute truths in Cornelia Parker's universe. Such is the intensity of her imaginative investigation into the nature of matter that 'She can convince you that the living room is the ocean, that buildings can breathe and that the universe can be turned inside out, like a glove' (Adrian Searle, *Cold Dark Matter: An Exploded View*, exh.cat., Chisenhale Gallery London 1991). Her approach to making sculpture has been described as that of a 'particle physicist', yet Parker's sensibility is poetic, shot through with an erudite and witty use of language and an understanding of the complexity of human experience. She tests the physical properties of substances and things, at the same time playing on their public and private symbolic meaning and value. Her methods of exploration have included suspending, exploding, crushing and stretching, and have involved the assistance of such unlikely collaborators as the Colt Firearms Factory in Connecticut and H.M. Customs and Excise.

Parker revels in the real and imaginative transformations wrought by destructive forces both natural and man-made. A pivotal piece in Parker's artistic career is *Cold Dark Matter: An Exploded View*, first installed at the Chisenhale Gallery in 1991. A garden shed, housing familar domestic objects culled from car boot sales, was blown up for the artist by the British Army. The residual scorched and mutilated fragments were then hung in a cluster around a single light bulb, where they appeared as a dematerialised form resembling an alternative solar system or eccentric 'parallel universe'. 'Cold dark matter' is a scientific term used to describe the substance that exists in the universe, yet remains mysterious and unquantifiable. For Parker it points to nature's resistance to being categorised, measured and fixed.

In 1997, during her residency at ArtPace in San Antonio, Texas, Parker produced a more ethereal installation, *Mass (Colder Darker Matter)*. Chunks and splinters of charcoal are suspended from the ceiling to form the illusion of a cube, dense at the centre, thinning at the edges. Parker had been in Texas for four days when she heard that a Baptist church had been struck by lightning. *Mass* is made from the charred remains. Parker reincarnated the pieces of charcoal, already resonant with meaning, as a formal arrangement of found objects. All of Parker's work is flush with linguistic and cultural associations. Here the church, symbolic of spiritual certainty and social order, has been 'killed off' by a natural force which could be interpreted by some as an 'act of God'.

The found object plays a key role in Parker's art practice. Two exhibitions have explored the idea of the found object in different ways. In 1995 she was invited by the actress Tilda Swinton to collaborate in the making of *The Maybe* at the Serpentine Gallery, London. From museums Parker selected curiosities associated with historical figures, all deceased, and displayed them alongside Swinton, who slept in a glass vitrine.

In a more recent exhibition held at the Chapter Gallery in Cardiff, Parker developed the idea of the 'avoided object' The idea grew partly out of the larger installations which always produced a discarded 'fall-out, a debris or a residue'. Parker began to focus on seemingly worthless by-products, that we 'avoid psychologically', such as tarnish, the swarf from grooves made in a lacquer 'master' record, or 'the negative of words – the little scraps left when somebody engraves a piece of silver'.

Cornelia Parker *Twenty Years of Tarnish (wedding presents)* 1996

Cornelia Parker *Mass (Colder Darker Matter)* 1997

Winner
Chris Ofili

Shortlisted artists
Tacita Dean for her solo exhibition at the Frith Street Gallery and other presentations of her work in the UK and Europe, in which she demonstrated her versatility in the use of a wide range of media, including drawing and film, to create imaginative narratives of her chosen themes
Cathy de Monchaux for the growing complexity and richness of her sculpture and for her sensuous use of materials
as displayed in her solo exhibition at the Whitechapel Art Gallery and her striking contribution to *Wounds* at the Moderna Museet, Stockholm
Chris Ofili for the inventiveness, exuberance, humour and technical richness of his painting, with its breadth of cultural reference, as revealed in his solo exhibition at Southampton City Art Gallery and in *Sensation* at the Royal Academy, London
Sam Taylor-Wood for her prize-winning presentation at the Venice Biennale and her solo exhibitions at the Kunsthalle, Zurich, and Louisiana Museum of Modern Art, Denmark, in which were seen her acutely perceptive explorations of human relationships through photography and video

Jury
Ann Gallagher
Exhibition Officer at the British Council
Fumio Nanjo
Curator and critic
Neil Tennant
Representative of the Patrons of New Art
Marina Warner
Author and critic
Nicholas Serota
Director of the Tate Gallery and Chairman of the Jury

Exhibition
28 October 1998–10 January 1999
Prize of £20,000 presented by agnes b., 1 December 1998

Chris Ofili
Afrodizzia (2nd Version)
1996

For many critics 1998 was a memorable year. Painters had always featured on Turner Prize shortlists; in fact, such celebrated artists as Sean Scully, Peter Doig, Callum Innes and Gary Hume had all been recent contenders. But this was the first time a painter had won the prize since 1985. However, odds-on favourite Chris Ofili, whose vibrant, gorgeous paintings, embellished with and propped up on resin-coated elephant dung, proved a problematic choice for critics who hankered after a more traditional mode of painting. Dubbed the 'Rembrandt of Dung', Ofili prompted the inevitable tabloid headlines – the *Express*'s 'Dung-ho art tops the Turner', for instance, and the *Sun*'s 'Artist dung great'. Brian Sewell, as so often, offered the strongest objection: 'If anything is to be said for these pictures it is only that all the damned dots and spots are mind-numbing triumphs of idiot industry, and their concentrated tedium is in no way relieved by the random application of pachydermal turds ... I am sick of shit in art: has no one in authority the courage to resist it and the infantilism that promotes it?' (*Evening Standard*, 8 October 1998).

There were also accusations of 'political correctness' when Ofili won the prize: not only was he the sole male artist on the shortlist, he also happened to be black. Following the announcement of the award, Adrian Searle defended the jurors' choice: 'Chris Ofili has proved popular with a black audience which, it is often assumed, feels alienated by contemporary art. Ofili is truly popular, and also highly respected among artists ... unlike an earlier generation of black artists in Britain, he is not interested in the polemics of political correctness, preferring beguilement and a self-consciously over-the-top exoticism to outright political statement ... Chris Ofili truly deserves the prize' (*Guardian*, 2 December 1998).

Raeka Prasad commented thoughtfully on the significance of Ofili's triumph for black Britons: 'Contemporary art galleries in Britain do not attract a large black audience. Visual art is still more clubby that contemporary music or even theatre. The Tate and National Portrait Gallery show work by black artists, but permanent displays are largely of European and western art. Most black artists are shown in temporary exhibitions – here, but not

forever and always. Ofili says: "I'm black and it's a very important part of what I am. I'm not embarrassed about it. I try to bring all that I am to my work and all that I experience. That includes how people react to the way I am – the prejudice and the celebrations. I now know I didn't win the Turner Prize only for me. I just hope that when black people look at me they don't see someone superhuman. They see themselves." ... Although art can touch people irrespective of race, the excitement at seeing someone who looks like you making art and featured in it, is still a novelty for black people in Britain' (*Guardian*, 5 December 1998). Ofili's *No Woman, No Cry*, a tribute to the family of murdered black teenager Stephen Lawrence, was widely admired by the press.

Judging by the amount of copy, many critics, whether for or against, felt compelled to analyse the success of the prize in the light of the huge audiences for the exhibition. In just one year attendance had increased by almost fifty per cent. Iain Gale, for example, queried the stated aim of the prize: 'The Turner may be a way of bringing "art" to a wider public, but it is equally dangerous for perpetuating the sad myth of art as outrage and playing into the hands of a dumbed-down press who happily prey upon the worst prejudices of a repressed and under-informed audience. The prize has now become more important than the art it shows. It has become a jamboree of indulgence, of opportunism and bigotry which may, in fact, be doing more harm than good to British art' (*Scotland on Sunday*, 15 November 1998). By contrast, Philip Hensher celebrated the spectacle engendered by the prize: 'From slightly fusty beginnings, it has turned into by far the most enjoyable and interesting of British prizes, and serves a genuinely useful purpose ... As all prizes should, the Turner gives the appearance of awarding achievement, when what it is really doing is luring in the unsuspecting audience with outrage, spectacle, fun and something amazingly new' (*Independent*, 30 October 1998). Others, including Adrian Searle, acknowledged the growing international reputation of the prize. Searle conceded that the Turner Prize had increased public awareness of contemporary art, but his guarded praise raised questions about the level of

engagement with the works of shortlisted artists: 'There's a danger that the British public is actually getting comfortable with contemporary art. Writers no longer feel obliged to explain what installations are, what conceptual art is, or why films and videos can be art. The Turner must take some credit for this accommodation to the avant-garde, but it's debatable whether familiarity is the same things as serious interest' (*Guardian*, 28 November 1998).

Chris Ofili

Chris Ofili's paintings are notable for their technical innovation and complexity, their vibrancy, funkiness, humour, irreverence and sheer delight in the act of painting. In his words: 'My work and the way that I work comes out of experimentation, but it also comes out of a love of painting, a love affair with painting.' Like the hip hop music that he listens to, Ofili samples and mixes a wide range of cultural and popular references, from the Bible to pornographic magazines, from 1970s comics to the work of artists like William Blake, producing work that challenges stereotypes of black culture, identity, exoticism and sexuality.

Ofili's approach to painting is characterised by a desire to experiment with the traditional confines of the medium, something which he does in part by incorporating seemingly extraneous elements, such as lumps of elephant dung, into his work. While at art school he gradually came to realise that 'you can do anything, there are no rules, and even the ones you set for yourself can be temporary – they're just for the moment'. For him, the introduction of elephant dung is a means by which to establish a dynamic between the increasingly beautiful paint surfaces of his paintings and the perceived ugliness of dung. He is insistent, however, that his use of dung is not intended as an assault on painting, rather a friendly challenge and an embellishment. To this end, he frequently adorns it with coloured map pins and uses it as the very means by which to support his paintings in the gallery environment, rather than hanging them on the wall.

Between 1993 and 1995 Ofili's paintings were essentially abstract, although there were suggestions of flowers, foliage and other organic motifs within the swirling traceries of dots and pools of colour that covered their surfaces. Ofili gradually extended his imagery to incorporate figurative elements, peopling his canvases with the tiny collaged heads of black personalities which he had cut out from magazines. The increasing technical complexity of the paintings, with their multiple layers of paint, resin and collage, provides a visual parallel for the ever-growing multiplicity of reference and meaning within Ofili's work as a whole. As his paintings became increasingly figurative, they also became increasingly urban in feel, rooting themselves more and more in the street culture of hip hop and the lyrics of 'gangsta rap'. Ofili has drawn an analogy between his painting technique, in which layer after layer is gradually built up until the overall picture is formed, to the 'laying down', one instrument at a time, of the different parts of a musical track.

It is in this context that his two versions of the painting *Afrodizzia* can be viewed. The title alludes to the stereotype of black sexual potency, while also describing the dizzying patterning and colours of the paintings. Ofili presents us with a pantheon of black celebrities from the worlds of music and sport, some of whom are singled out for special consideration by having their names emblazoned in coloured map pins across their own ball of dung. This is Ofili's own form of the 'namechecking' which is a characteristic feature of hip hop and rap performance. Ofili gives each of his characters a 1970s Afro hairstyle, a device which raises questions of black identity although in a highly ambiguous fashion. The Afro can be read both as a symbol of pride and unity, serving to highlight the individuality of each face it adorns, and as a means of sucking all that individuality out, sustaining the cliché that all black faces look the same. Typically, Ofili refuses to take a fixed stance: 'In some ways [the work] is a criticism of the absurdity of making work about identity, but in some ways it *is* about identity, to the point of overload'. *Afrodizzia* has both the exuberance and the sting in the tail that characterises much contemporary black music. This essential dichotomy in the work has been described by Terry Myers: '*Afrodizzia* is the perfect word to describe the hallucinatory celebration

Chris Ofili
1968 Born in Manchester
1988–91 Chelsea School of Art, London
1991–3 Royal College of Art, London

Chris Ofili
The Adoration of Captain Shit and the Legend of the Black Stars (Part 2)
1998

Chris Ofili
No Woman, No Cry
1998

at work in these paintings – art objects meaningfully labour-intensive yet mindful, it seems, of the thin line between dreams and delusions, or the large obstacles between dreams and the struggle to meet them' (*Art/Text 58*, 1997, p.38).

In 1996 Ofili began a series of paintings featuring Captain Shit, a 'slightly comical saviour of the day' (*Chris Ofili*, exh. cat., Southampton City Art Gallery, Serpentine Gallery, London 1998, p.8). Inspired in part by the character of Luke Cage Power Man from the 1970s Marvel comics, Captain Shit is a somewhat flawed superhero, whose red and yellow spandex suit, lipstick, nail varnish, and dungball belt-buckle seem to undermine his invulnerability. He does, however, appear to have been endowed with at least one superpower, namely the ability to glow in the dark thanks to the phosphorescent paint that Ofili has used in these paintings. In *The Adoration of Captain Shit and the Legend of the Black Stars (Part 2)*, Ofili presents us with one of his classic remixes of art-historical quotation, biblical reference and musical parallel. Just as the 'interludes' on hip hop concept albums make reference to the actual process of consumption of the music itself, so for Ofili this painting is as much an ironic comment on the 'adoration' of his paintings as an actual adoration of his superhero.

Captain Shit is typical of the humour that Ofili often brings to more serious issues of sexual and racial stereotyping. 'My project is not a p.c. project ... It allows you to laugh about issues that are potentially serious' (ibid., p.83). This refusal to censor himself is perhaps most evident in Ofili's use of pornography as source material. A recent portrait, *Rodin – The Thinker* (1997), takes inspiration directly from a photograph published in a pornographic magazine, as well as from Rodin's famous sculpture of the same title. The confrontation of base subject matter with sheer decorative beauty lies at the heart of much of his work. His is truly an 'irresolvable art that is intellectually provocative, visually luxurious and confounding' (ibid., p.13).

Tacita Dean

When she trained as a painter Tacita Dean was constantly dividing her

canvas into squares, unable to make just one image. This compulsion to resist the single viewpoint has found expression in her method of working, which often combines film, primarily 16 mm, with a variety of other media. Inhabiting the borderlands between truth and concealment, history and myth, her work takes the form of imaginative investigations, often triggered by chance encounters or discoveries. Typically documentary in style, her stories remain enigmatic, perhaps hinting at the various ways in which our experience of reality is filtered through knowledge, expectation and belief.

Dean is preoccupied with notions of time, and the relationship between history and the present is a recurring theme in her work. Many of her works also feature the sea, both as a backdrop for human drama and as a symbol of psychological and physical isolation. Her hypnotic and highly evocative film *Disappearance at Sea*, shown in the Turner Prize exhibition, records the fading light at nightfall refracted inside the St Abb's Head lighthouse beacon in Berwickshire. The rhythmic clunking of the rotating beacon, like the hum of the projector, contrasts with the atmospheric sound of seagulls and sea. Edited to fourteen minutes, the film cuts between a shot looking inwards to the bulb and a view out to sea, ending with the lighthouse beam panning the darkened coastline. The formal structure of the film, achieved using an anamorphic lens, seems to enhance the viewer's sense of space and the passage of time, notably in the way that the movement of the light itself seems to be progressively slowed as the film unfolds.

Disappearance at Sea is one of several works inspired by the tragic story of Donald Crowhurst, the amateur yachtsman who died in 1969 whilst participating in the first ever solo non-stop round-the-world yacht race. Realising that he could not complete the race, yet unable to admit his failure, Crowhurst began exaggerating his progress and concealing his real position. His anxiety about this huge deceit began to distort his sense of reality until, losing all sense of time and location, he drifted off course. His trimaran was found abandoned a few

Tacita Dean
1965 Born in Canterbury, Kent
1985–8 Falmouth School of Art, Cornwall
1989–90 Supreme School of Fine Art, Athens
1990–2 Slade School of Art, London

Tacita Dean
Still from
Disappearance at Sea
1996

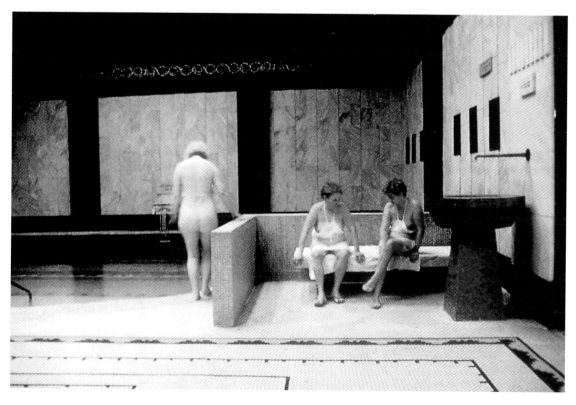

Tacita Dean
Still from *Gellért*
1998

hundred miles from the coast of Britain. For Dean, Crowhurst's story is 'about human failing; about pitching his sanity against the sea, where there is no human presence or support system left on which to hang a tortured psychological state'. In *Disappearance at Sea* image and sound induce a trance-like state, and a sense of disorientation that perhaps echoes Crowhurst's 'time-madness' (*Tacita Dean: Missing Narratives*, Frith Street Gallery, London 1997, p.17).

Alongside *Disappearance at Sea* the artist exhibited a new film, *Gellért*, shot in the thermal baths of the Hotel Gellért, Budapest, and *The Roaring Forties*, a series of blackboard drawings comprising a sequence of seven 8-feet-square blackboards which she completed in one week. Dean has produced such drawings since the early 1990s. In many ways they point to the relationship between the process of drawing and that of film-making, both of which rely heavily on editing. The Roaring Forties is a notoriously rough zone in the southern Atlantic. Using old photographs for reference Dean depicts what appear to be scenes from a maritime adventure. The luminous white chalk marks on black grounds give the boards the appearance of photographic negatives. The reference to cinematic storyboards is further emphasised by captions, hand-written in chalk as part of the drawing, such as 'Aerial view' and 'Out of frame'. Unlike a film still, which reads as a single moment, the cinematic storyboard, like a drawing, is full of potential, leaving interpretation more to the viewer's imagination.

Cathy de Monchaux

Cathy de Monchaux's world is a place of dreams and fantasies. Her sculptures have a highly individual visual language and yet seem strangely familiar. They appear to retain the vestiges of some functional object while having no identifiable practical application. As she describes it: 'They remind you of something you once saw somewhere else, as you passed it by in the street or in a dream.'

De Monchaux's work draws on a wide gamut of cultural references which she reinterprets within her own idiom. 'In a way I see all my work as a form of cultural plundering in an attempt to evoke a culture of my own. I suppose it's a kind

of world' (*Tate: The Art Magazine*, Summer 1997, p.61). Her work combines visual references that range from the religious to the secular, the sexually explicit to the chaste, the industrial to the domestic, the manufactured to the organic, the ugly to the beautiful. Frequently they are set against each other in a balance of opposites that attempts to act as 'a metaphor for the dialogue between all those opposing sides of the human psyche who are having their own shootout in your head all the time, as you struggle to appear to be a balanced human being'.

De Monchaux's earlier work seemed to hint at the darker side of eroticism. More recently she continues to investigate the contradictions of the human condition, and in particular of human sexuality and gender difference, but in a way which she describes as 'more psychologically dramatic, rather than sexually dramatic' (*Art Newspaper*, June 1997, p.14).

For the Turner Prize she combined a range of new and existing works to create a discrete world of objects within the gallery space. In her floor sculpture *Never forget the power of tears* rectangular, human-scale slabs suggested gravestones, cemeteries and human mortality. Twelve 'tombs' made of lead flanked a central 'backbone' composed of endlessly repeated organic-looking motifs. This exposed spine looked like an exotic *vagina dentata* or a giant Venus flytrap which, instead of feeding off insects, consumes human beings.

The arrangement of *Never forget the power of tears* was mirrored in a new work, *Fretting around on the brink of indolence*, comprising two lightboxes either side of an elaborate central section. Despite incorporating photographic images, which by definition have some roots in reality, the piece presented an ambiguous, dreamlike view of a world beyond the gallery. Like so much of de Monchaux's work it suggests anxiety, possibly about the state of the world we live in but also, in its combination of natural order and chaos, about all those 'irrational, emotional, repressed fears' with which our minds are clouded from time to time.

De Monchaux has also continued to work on a smaller scale in wall-mounted pieces like *Making a day for the dead ones*

Cathy de Monchaux
1960 Born in London
1980–3 Camberwell School of Art, London
1985–7 Goldsmiths' College, London

Cathy de Monchaux
*Never forget the power
of tears* (detail) 1997

Cathy de Monchaux
*Making a day for the
dead ones* 1997

(1997), *Cogent shuddering* (1997) and *Don't touch my waist* (1998). Many of her works have the feeling of quasi-religious artefacts, something which the artist encourages by distressing their surfaces and coating them with a unifying layer of chalk dust which gives them 'a patina of age and belonging'. It comes as little surprise that she cites among her visual sources Roman Catholic reliquaries and shamanistic ritual objects. While each work has a strong individual character, de Monchaux situates them within a larger whole, constructing an environment which conveys 'that sense of a very special place where the atmosphere is about the work and the viewer, a contemplative space' (*Make*, April–May 1997, p.21). This is her world with its own internal logic, but it is a world in which, as a viewer, one is given free reign for one's own imaginings.

Sam Taylor-Wood
1967 Born in London
1989–90 Goldsmiths' College, London

Sam Taylor-Wood

Using film, video and photography Sam Taylor-Wood has produced a body of work that focuses on a range of such fundamental human emotions and states of mind as expectation, desire, anger, loneliness and boredom. Working with professional actors, amateurs and friends, she loosely orchestrates scenarios, often lingering on the moments of tension created when opposites collide. Through her work she draws attention to the role of the mass media, particularly film, as an echo-chamber for all our expressions and gestures, both original and acquired. Even in works depicting more than one protagonist she seems to emphasise the solitary nature of human existence.

With a few exceptions, Taylor-Wood shoots her work on film rather than video. Although she draws on diverse sources from the history of art and popular culture, it is the cinema and the subversion of its conventions that has largely given her work its structure.

For the Turner Prize Taylor-Wood exhibited *Atlantic*, a highly acclaimed three-screen projection, in which the artist dwells on the well-worn subject of the breakdown of a relationship between a man and a woman. In the artist's words: 'On the wall in front of you is a panoramic projection of a restaurant. On the left-hand wall is a projection of a woman in her thirties ... She's angry,

yet resilient and calm. On the right-hand side there are a pair of man's hands ... He nervously fidgets with a pack of cigarettes or picks at the label of a wine bottle. The whole piece is synchronised ... and simultaneously you'll see the couple in the background in the panoramic view of the restaurant' (*Untitled*, no.13, Spring 1997, p.8). Shot in real time, the action is seen from three different vantage points. As in life, the viewer is faced with fragments of experience rather than the kind of narrative sequence constructed typically by film.

In this work Taylor-Wood concentrates on body language as key evidence for the viewer to decode. Perceiving the scene from a distance, the viewer is drawn to the spectacle. The intriguing dialogue, almost submerged in the ambient sound of the busy restaurant, sucks the viewer deeper into the action on screen. But as with much of her work, only shreds of the story are disclosed and we are left to make our own conclusions. Her interest seems to lie, as Michael O'Pray has commented, in 'the gesture of emotion itself, as an element of representation' (*Sam Taylor-Wood*, exh. cat., Chisenhale Gallery, London 1996, p.6).

Also shown in the exhibition were three works from *Five Revolutionary Seconds*, a series begun in 1995 in which the artist further explores the idea of dysfunctional narrative. In these extraordinarily elongated photographs she has succeeded in creating an almost cinematic effect. Shot with a camera that takes five seconds to pan the 360 degrees of a room, these panoramic images capture incidents of human interaction. Although an accompanying soundtrack records the conversations and background noise relating to the scene portrayed, the various plots remain ambiguous and unexplained.

Not unlike Renaissance paintings that depict sequences from the life of a saint in one continuous image, these photographs allude to the variety of states of being, the split persona of self, laid bare in one complete scene. Most of the lives portrayed appear to be unresolved and unfulfilled: the characters talk, argue, gaze out of windows, have sex, but ultimately seem oblivious to one another, dissipated by an atmosphere of ennui.

Sam Taylor-Wood
Atlantic (detail) 1997

Sam Taylor-Wood
*Five Revolutionary
Seconds XI* (detail) 1997

Winner
Steve McQueen

Shortlisted Artists
Tracey Emin for her solo exhibitions at Lehmann Maupin, New York, and Sagacho Exhibition Space, Tokyo, in which she exhibited works that showed a continuing vibrancy and flair for self-expression, a frank and often brutal honesty, and her versatility across a wide range of media
Steve McQueen for his exhibitions at the Institute of Contemporary Arts, London, and the Kunsthalle Zurich, which documented his original and uncompromising approach to film installation, including a major new piece *Drumroll*, and his innovative presentation of work in other media
Steven Pippin for his exhibition *Laundromat-Locomotion* originating at the San Francisco Museum of Modern Art, in which he transformed twelve laundry machines into cameras in an ambitious experiment exploring the relationship between vision and motion through photography
Jane and Louise Wilson for their exhibition *Gamma* at the Lisson Gallery, which documented the interiors of the decommissioned missile base at Greenham Common. The drama and intelligence of this work revealed the Wilsons' increasingly sophisticated approach to photographic and video installation

Jury
Bernard Bürgi
Director of the Kunsthalle Zurich
Sacha Craddock
Writer and critic
Judith Nesbitt
Head of Programming, Whitechapel Art Gallery
Alice Rawsthorn
Representative of the Patrons of New Art
Nicholas Serota
Director of the Tate Gallery and Chairman of the Jury

Exhibition
20 October 1999–6 February 2000
Prize of £20,000 presented by Zaha Hadid, 30 November 1999

When the shortlist for 1999 was announced, critics agreed that the artists selected had the potential to shock and excite the public as expected. There was enough material for journalists to have fun with their headlines; for example, Steven Pippin, who developed photographs in washing machines and toilet bowls, prompted *The Times* to report 'Turner Prize officially round the bend' (Dalya Alberge, *The Times*, 4 June 1995, p.5). For Richard Shone the list offered a comprehensive view of what was currently fashionable, with the exception of "Neurotic Realism", which had been 'rampant since the award of last year's prize' ('Turner Points', *Artforum*, September 1999, p.48). David Lee, Editor of *Art Review*, argued that the jury had concentrated on installation, film and video 'at the expense of anything one can normally recognise as art', concluding that: 'Any list with Emin cannot be taken seriously.' But quite the opposite proved to be true.

Once the exhibition opened, Tracey Emin's display sparked a violent critical response, creating a debate about accessibility versus elitism, which seemed to divide the art world. The debate was triggered by *My Bed* (1998), a sculptural installation of an unmade bed, accessorised with stained sheets, empty vodka bottles, soiled knickers and other ephemera suggesting squalor and despair. For some critics it represented a cynical move on the artist's part to steal the media spotlight.

Yet, Emin's media celebrity and confessional approach made her work instantly accessible to a non-gallery-going public, and she completely hijacked the event. Assessing her success, a critic in the *Financial Times* observed that she had become the 'people's choice'. But her media personality had serious implications for the other contenders, who by comparison seemed cold and remote, their work appearing 'relatively oblivious to the presence of its audience'. With her flair for self-expression and use of self-promoting strategies Emin was the exemplary Turner Prize artist, yet her participation in the prize pointed to some of the wider issues facing artists and museums in a culture dominated by mass communications and celebrity:

'If art is not necessarily a mass medium, high-profile exhibitions like the Turner Prize increasingly strive to turn the museum into one ... add a Media Personality to an art exhibition and you end up shining a glaring light on the contradictions underlying such shows' (Ralph Rugoff, 'Screaming for Attention', *Financial Times Weekend* November 20–21 1999, p.vii).

Tabloid coverage of *My Bed* prompted the then Secretary of State for Culture, Media and Sport, Chris Smith, to comment that the work of some young British artists was giving the country a bad name abroad, and he criticised the Turner Prize jury for concentrating on video and 'shock' installations. For conservative critics reluctant to accept video and installation art as valid art forms, this offered an opportunity to flag up the challenge facing Tate Modern, which was about to open in Spring 2000. The *Financial Times* editorial opined: 'The Tate justifies the Turner by pointing to the controversy that it arouses: it gets people thinking about contemporary art and it attracts big crowds ... It is ironic that so many new galleries should be opening at a time when contemporary art is alien and upsetting not only to most art collectors, but to the wider public, whose lottery dreams have financed what many will see as new temples to the meretricious' (Editorial, 'Art in the eye of the beholder', *Financial Times*, 28 December 1999, p.10). Yet such criticism seemed insignificant a few months later, when Tate Modern was launched to great critical and public acclaim.

Steve McQueen
Steve McQueen works in a variety of media – film, photography and sculpture – but the language of film is the essence of his work. He made his first films at Goldsmiths' College and after graduating he was awarded a place at the Tisch School of the Arts in New York, a forcing ground for independent American film directors. However, once there he soon realised that learning to be a professional film-maker was too prescriptive and he left after a year, frustrated by the lack of freedom to experiment. He later commented, 'they wouldn't let you throw the camera up in

Steve McQueen
Deadpan 1997

Steve McQueen
Drumroll
1998

Steve McQueen
1969 Born in London
1989–90 Chelsea
School of Art, London
1990–3 Goldsmiths'
College, London
1993–4 Tisch School of
the Arts, New York
University

Tracey Emin
1963 Born in London
1983–6 Maidstone
College of Art
1987–9 Royal College
of Art, London

the air', and since that time he has amply demonstrated that there are no limitations on what can be done with a camera.

Until recently McQueen worked only in black and white, using 16 mm or 35 mm film, without sound. In all his work he uses the rudimentary elements of film language, distilling film to its most basic form to gain a greater sense of immediacy and impact. McQueen deliberately shuns any elaborate narrative structure or character development, but chooses extremely simple filmic propositions. This pared-down approach gives the films an elegant, highly formal, uncluttered quality.

The use of extreme and unexpected camera angles has become a trademark of McQueen's films. 'The idea of putting the camera in an unfamiliar position is simply to do with film language ... Cinema is a narrative form and by putting the camera at a different angle ... we are questioning that narrative as well as the way we are looking at things. It is also a very physical thing. It makes you aware of your own presence.'

For McQueen, the choice of black and white film was a means of working as directly as possible with his medium without the distraction that the use of colour might involve. In *Deadpan*, McQueen uses a famous stunt from the film *Steamboat Bill Jr* of 1928, where comedian Buster Keaton remains standing as a house collapses around him. In its original form it was a slapstick, throwaway moment, but McQueen's version is humourless, and completely deadpan. We see McQueen standing in front of a timber house, a simple A-frame structure with a single window frame. The camera focuses first on his feet, and then the window frame, and we watch from various angles as repeated shots of the wall fall, but never touching him since he is standing directly in the path of the open window. He hardly flinches, staring straight ahead. The artist has taken a moment of silliness, a cinematic cliché, and given it powerful resonance.

It is easy to be absorbed by McQueen's films, to be gripped by the content while equally captivated by the rich, sensuous quality of the film: the bold, chiaroscuro

light effects, and the graininess of the projected image. However, McQueen's films have a stronger effect on us by way of their presentation. McQueen has a clear strategy for their installation. The image is projected in an enclosed space, on a scale way above human proportions. 'Projecting the film onto the back wall of the gallery space so that it completely fills it from ceiling to floor, and from side to side, gives it this kind of blanket effect. You are very much involved with what is going on. You are a participant, not a passive viewer.' This is particularly effective in *Deadpan*, one of the films shown in the Turner Prize exhibition, where the enclosed space makes the viewer feel as if the wall will fall in on them as well as the artist. The silence is also key: 'The whole idea of making it a silent experience is so that when people walk into the space they become very much aware of themselves, of their own breathing ... I want to put people in a situation where they're sensitive to themselves watching the piece.'

McQueen is attracted to the physical dimension of film-making, and the theme of travelling and movement – particularly its disorienting and dislocating effects – links many of his works. In *Drumroll*, the first work where he combined colour and sound, McQueen installed video cameras at either end of an oil drum, with one in its curved surface, and rolled it through the streets of Manhattan. A microphone recorded the ambient sounds of the journey, a cacophonous accompaniment to the whirling, circular images that show his route along New York's busy streets and sidewalks. The resulting films are innovatively presented in triptych format.

Tracey Emin
The art of Tracey Emin embraces the full range of media available to the late twentieth-century practitioner: painting, drawing, printmaking, sculptural construction, performance, installation, film, video, embroidery, appliqué, neon and written text. In addition, she has devised for her art, and incorporated as part of the work itself, some unusual marketing strategies.

Emin has become notorious as one of the so-called bad girls of contemporary

Tracey Emin
Turner Prize
Installation,
1999

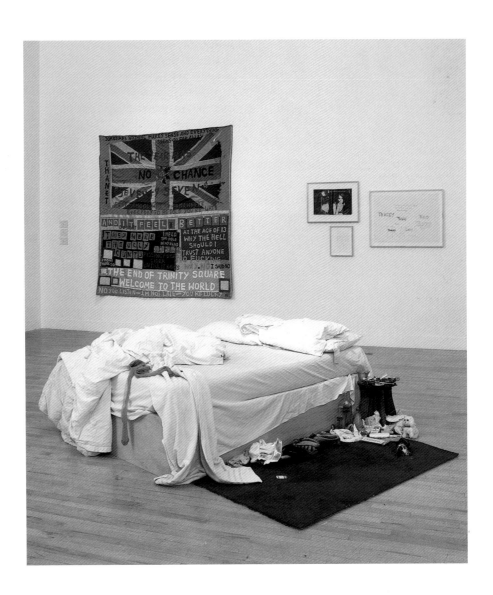

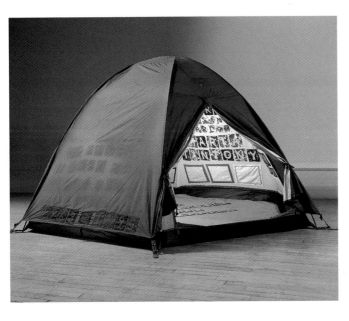

Tracey Emin
*Everyone I have Ever
Slept With 1963–95,*
1995

Steven Pippin
1960 Born in Redhill
1982–5 Brighton
Polytechnic
1987 Chelsea School of
Art, London

British art, but commentators have also noted the wistfulness, poetry, humour and honesty that underpin the harrowing frankness of her obsessively confessional oeuvre. Although she deals so relentlessly with the minutiae of her own life, she touches largely on issues that are common to all, not least sexuality, mortality and the creation of meaning in life. She also shares with prominent artists of the past a preoccupation with what it is to be an artist.

Tracey Karima Emin was born in London in 1963 and grew up in Margate, where her mother and father ran a hotel. At twenty she gained a place at Maidstone College of Art. Graduating in 1986, she went on to study at the Royal College of Art. At this stage, she was a painter and printmaker. In 1990 she had an abortion, after which 'the whole meaning of creativity changed. I gave up art completely in 1991.'

She emerged from this crisis period in 1992, when she invited around eighty people to invest in her future as an artist: in return for £10 they each received three letters from her. Then, in 1993, she teamed up with the artist Sarah Lucas to open *The Shop* in the East End of London, where they sold small works directly to visitors. One of these customers was the gallerist Jay Jopling, owner of White Cube, who offered her a solo show. Emin titled her exhibition *My Major Retrospective* because she thought she would never have another.

Emin's marketing of herself and her art continued in 1995 with the *Tracey Emin Museum* at 221 Waterloo Road in London. Until the venture ended in 1998 she was artist and gallerist, creator and curator of this living interactive artwork. Also in 1995, Emin produced *Everyone I Have Ever Slept With 1963–95*, which has become an icon of contemporary British art. This igloo-shaped tent, a testimony to intimacy, is embroidered on the inside with the names of everyone Emin had slept with, including her twin brother in the womb, parents and comatose friends, as well as lovers.

My Bed (1999), shown in the Turner Prize exhibition, is an installation based on her own bedroom. It graphically illustrates themes of loss, sickness, fertility, copulation, conception and death – almost the whole cycle of human life has its locus in this place, where we all spend what are ultimately our most significant moments. Emin has said: 'There should be something revelatory about art. It should be totally new and creative, and it should open up doors for new thoughts and new experiences.'

Steven Pippin

Between 1982 and 1991 Steven Pippin's work consisted of photographs. These were not taken with conventional cameras, but optical devices converted from pieces of furniture, architectural spaces and diverse objects. A characteristic of these 'cameras' is that their function relates closely to the artistic subject each depicts. For example, a fridge is used to photograph food, and a wardrobe takes pictures of clothes. Since 1991 Pippin has also made sculptural machines. Most of these have interconnected moving parts that spin, flip or rotate on different axes, like a gyroscope, around a stable central point that houses an image or object.

Among Pippin's most celebrated photographic works are those taken with washing machines. After his first experiment in 1985, in 1991 he made a series of works, *Laundromat Pictures*, in which he converted machines in public laundromats into cameras. After making an exposure through a shutter device placed in the recessed glass door of the washing machine, he used the wash, rinse and spin cycles to develop, fix and dry the photographic negative, thus drawing an analogy between the technical processes of cleaning clothes and developing photographs. Operating in public, Pippin noted the embarrassment felt by people as their dirty washing was exposed to public view. The attention he drew to himself through his eccentric activity was countered by donning a suit. For him it provided, 'a means of protection, an acceptable uniform' behind which he felt 'secure and respectable, even in the most squalid of situations'.

Pippin's *Laundromat-Locomotion*

Steven Pippin
The Continued Saga
of an Amateur
Photographer 1993

Steven Pippin
Laundromat-Locomotion
(Horse & Rider) 1997

photographs of 1997 mark the ambitious culmination of his washing machines project. Using a bank of twelve machines triggered by trip wires, the artist created sequences of images of himself. In a homage to Animal Locomotion, the pioneering photography of Eadweard Muybridge, which analysed motion for the first time, he also photographed a horse and rider, moving along in front of the line of machines. Pippin's sequences of a naked woman, and another of a nude man walking with a full erection, make a wry comment on Muybridge's less scientific studies of naked women getting in and out of bed.

Cosmological investigations and the laws of physics are subjects of fascination for Pippin. They are central to several of his machines, which he began making in 1991. A group, made in the late 1990s, were based on models of the solar system. For the Turner Prize exhibition Pippin's photographs and sculptures were shown together for the first time.

Jane Wilson
1967 Born in Newcastle
1986–9 Newcastle Polytechnic
1990–2 Goldsmiths' College, London

Louise Wilson
1967 Born in Newcastle
1986–9 Duncan of Jordanstone College of Art, Dundee
1990–2 Goldsmiths' College, London

Jane and Louise Wilson

Using film, photography and sculpture, Jane and Louise Wilson have created a series of highly theatrical and atmospheric installations, that investigate the darker side of human experience. Since they first began working together in 1989 – the year they famously produced identical degree shows – the Wilson twins have been fascinated by the power of the unconscious mind, creating a body of work that probes collective anxieties and phobias, arouses unwanted memories, and seeks to reveal that which is usually repressed.

The Wilsons explore this subterranean world in highly charged psychodramas, acted out using the tools of the mass media: film and photography. They create environments of moving image, sound and space where reality and artifice collide. Although moving images take prominence in their work, these are characteristically exhibited with large-scale, filmic photographs and physical props that allude to, and are relics of, the unfolding drama.

Increasingly sensitive to the powerful emotional effects generated by certain kinds of architecture, the Wilsons have filmed in locations made notorious by events in recent political history, 'buildings where there is a pathology attached'. *Stasi City* (1997), the first of these works, was filmed in Berlin, in the abandoned headquarters of the former German Democratic Republic Intelligence Service, the Staatssicherheitsdienst, and in a former Stasi prison. In this work and more recently in *Gamma* (1999), filmed at the decommissioned American missile base at Greenham Common, the Wilsons probe the architectural uncanny.

Through swift camera movement and sharp editing a powerful tension is achieved in these films, a drama heightened by the complex devices employed within the installation itself. The images are presented on two sets of double corner projections placed opposite each other in the same room. These twin projections offer similar perspectives on the unfolding action, sometimes only slightly out of sync, but occasionally completely at odds with each other. This has a disorientating effect on the viewer. The scale of the images, projected floor to ceiling, is also crucial – there is an elision between real and depicted space.

The Wilsons went on to film in other locations where the architecture is saturated with meaning, such as the Palace of Westminster, and Caesar's Palace in Las Vegas. For *Las Vegas, Graveyard Time* (1999), shown in the Turner Prize exhibition, they chose to film inside the very public spaces of casinos. Shot in the early hours of the morning, at 'graveyard time', the film conveys a sense of emptiness that makes the casino interiors sinister and alienating. The work demonstrates how certain emotions are not purely the property of self-evidently sinister sites, such as those found in *Stasi City* and *Gamma*, but are also present in places supposedly associated with pleasure.

Jane and Louise
Wilson
Stasi City 1997

Jane and Louise
Wilson
*High Roller Slots,
Caesar's Palace*
1999

Winner
Wolfgang Tillmans

Shortlisted artists
Glenn Brown for his exhibitions at Jerwood Space, London, Max Hetzler, Berlin, and Patrick Painter Gallery, Los Angeles, which revealed the growing complexity of his paintings and sculptures, referencing and reworking such diverse sources as the works of Old Masters and popular science-fiction illustrations
Michael Raedecker for presentations of his work at The Approach, London and the Stedelijk Van Abbemuseum, Eindhoven, which revealed his fresh and original approach to painting, and his unusual use of materials in depicting beautiful yet disquieting interiors and landscapes
Tomoko Takahashi for her installations that create a unique tension between chaos and order, combining a diversity of found materials in complex and original ways, as seen in *New Neurotic Realism* at the Saatchi Gallery, London, and her ground-breaking internet project *Word Perfect* with Chisenhale Gallery and e-2
Wolfgang Tillmans for his exhibitions at Interim Art, London, Stadlische Galerie, Remscheid, and Andrea Rosen Gallery, New York, and for his numerous publications, all of which demonstrate how his work engages with contemporary culture while challenging conventional aesthetics and the established genres of portraiture, documentary and still life

Jury
Jan Debbaut
Director of the Stedelijk Van Abbemuseum, Eindhoven
Keir McGuinness
Chairman of Patrons of New Art
Julia Peyton-Jones
Director of the Serpentine Gallery, London
Matthew Slotover
Publisher of *Frieze* magazine
Nicholas Serota
Director of Tate and Chairman of the Jury

Exhibition
25 October 2000–14 January 2001
Prize of £20,000 presented by Paul Smith, 28 November 2000

Wolfgang Tillmans
I don't want to get over you
2000

The first shortlist of the new millennium was universally recognised as being unusually 'sensation-free' (Laura Cumming, *Observer Review*, 18 June 2000, p.10). Instead of being dominated by video and installation, as in the previous year, it boasted two painters, seemingly suggesting a return to more traditional forms of art. But the jury's choice nonetheless took the critics by surprise, since it included only one native-born artist. The history of the Turner Prize is peppered with examples of 'foreign' artists who have made Britain their home, for example Lucian Freud, Paula Rego and Anish Kapoor. But, significantly, the shortlist for 2000 appeared to signal the demise of the 'YBAs', the loosely associated group of young British artists, who had come to dominate contemporary art both at home and abroad.

At the press meeting to announce the shortlist, Nicholas Serota explained the presence of artists from Japan, Holland and Germany in a competition set up to celebrate and promote contemporary British art. Asked whether the jury had dismissed the 'YBAs' as past their prime he replied: 'They are no longer young British artists. They are in their late thirties and early forties now – individuals doing their own thing – and no longer a movement ... It was not a question of not being up to scratch. The Turner Prize has never been predictable. The culture here is richer because we have never confined the idea of British art to those who have been born in this country. At a time when there is a great deal of public debate about migrants, we should be in the forefront of those pointing out the huge contribution they have made to this country. If the Turner Prize had been around in the 1740s, I hope that Canaletto [whose scenes of London are in Tate Britain] would have been on the shortlist.'

Most broadsheet critics found the choice of artists refreshing, and welcomed the Prize's recognition of the many non-native artists working in Britain. As the *Guardian*'s critic Adrian Searle argued: 'Britain, particularly London, has been a great place to make art over the past decade, and the art world has seen waves of incoming artists from abroad, all but eclipsed in the

public eye by the media fascination with the YBAs and the spurious promotion of cool Britannia' ('Foreign creativity pierces Brit art bubble', *Guardian*, 15 June 2000, p.9).

Following the extraordinary media coverage of the previous year, centering on Tracey Emin, the absence of anything easily branded as 'shocking' came as a relief to those weary of tabloid sensationalism. With its story heading 'No sheep, no beds, no dung – just fine art' the *Daily Telegraph* summed up the pleasure many critics took in reviewing the exhibition (Richard Dorment, *Daily Telegraph*, 25 October 2000, p.23). Yet some critics concluded that in sidelining the 'YBAs', the jury had perhaps foregrounded artists who weren't quite ready for such mass exposure.

It came as no surprise that Wolfgang Tillmans was awarded the prize – it seemed remarkable to art-world insiders that it had taken so long for an artist working with photography, long established as a fine-art medium, to be honoured in this way by the establishment.

Wolfgang Tillmans
In a world already saturated with images, Wolfgang Tillmans uses photography to question conventional aesthetics and codes of representation. He creates images of great resonance from unlikely sources – a half-naked man urinating on a chair, rats rummaging through city rubbish, snow melting on the pavement. Through them, Tillmans reaches beneath the surface of contemporary culture and prompts us to do the same.

It was his images for cult magazines like *I-D* in the late 1980s and early 1990s that initially won Tillmans acclaim. He photographed his friends and peers in the world they inhabited – at raves, protest rallies and festivals. 'I put all my love and energy into taking these pictures of people that I thought were beautiful and worth taking pictures of.' His seemingly casual and direct style went against the sleek aesthetics of conventional magazine photography. It suited the contemporaneity of his subject matter, and gave the resulting images a powerful sense of reality.

By challenging mainstream perceptions and practices, Tillmans promoted a compelling alternative to accepted ideas about beauty and sexuality.

Tillmans's images frequently appear artless and improvised. However, appearances can be deceptive: he knowingly adopts a 'language of authenticity' and many images are carefully staged. Tillmans explains his motives: 'I want people to accept my aesthetics as valid and what is most valid is what is perceived as real.' Thus, we have an 'authenticity of intention', which means that Tillmans often works to conceal his art, lighting each picture evenly, suppressing shadows, so 'there appears to be very little between me and my subjects'.

The content of Tillmans's photographs is so diverse it resists easy classification. The themes of landscape, portraiture and still life are parallel and persistent concerns. Indeed, he invokes the term 'parallelism' to describe life's complexity, the way in which it has so many diverse aspects which we often experience simultaneously, and this explains his ever shifting viewpoint: 'my perception constantly shifts from the micro to the macro ... to the personal and to the public and back'. But Tillmans blurs the boundaries between private and public, personal and universal, transforming the people, places and objects that surround him into something more universal and emblematic in character.

When photographing people, Tillmans ensures that his subjects are always at ease before the lens, and through them he creates scenarios that are rich in possibility, summoning 'possible ways of being, of togetherness, of behaviour, of sexuality'. The image of Lutz lying naked in the sand dunes laughing mischievously is testimony to this. Tillmans's stance is inquisitive and provocative: 'These scenarios might appear strange to some people, but I try to ask through them, what is so strange here, the scenario in the picture, the world around you, society, your ideas about beauty or my ideas about beauty.' When photographing landscapes or objects, his view is equally particular. Much has been written of his ability to elevate the unexceptional, and find

beauty in the everyday, but he ventures: 'I'm sometimes surprised at the notion of the everyday in my work, because I feel that the things I photograph aren't that everyday to me. I don't have a beautiful bunch of tulips on my table every day of the year, a pair of jeans are not always lying about in a way that draws my attention, only in rare moments does the nature of a person or of a cityscape reveal itself visually to me ... that is a special and rare situation which I look or wait for ... to transform simple things around me into something unique.'

Tillmans acknowledges that the simplest images often are the most powerful. This is something we see time and again, in single images, and equally in bodies of work such as *Concorde* (1997) and *Total Solar Eclipse* (1998). In these projects, the artist adopts a matter-of-fact viewpoint. He almost underplays the power and presence of the phenomena he records. We are not given a privileged view of Concorde's flight, but glimpse it from a distance, soaring above drab West London suburbs, disappearing into a stream of vapour. The eclipse series is again an accurate and unpretentious visual record. We might expect an aestheticised view, but once again Tillmans defies expectations.

Prior to being shortlisted, Tillmans had pushed his art in different directions, manipulating his photographs in the darkroom to create abstract effects: 'While printing there are always mistakes that happen and from early on I took great pleasure in them. Once I notice something has gone wrong I use that as an opportunity to experiment or to play.' Using his own customised light tools and colour filters, he often adds to images, as with *I don't want to get over you* (2000), where a gestural stroke of green counters the vivid blue of an empty sky. He has also created purely abstract works, like the series of *Blushes* (2000), where pink and grey flecks and threads of colour emerge from and fade into pale backgrounds. These fragile impressions strike directly at the most commonly held assumptions about photography and its role in image-making.

A questioning of appearances and

Wolfgang Tillmans
1968 Born in Remscheid, Germany
1990–2 Bournemouth and Poole College of Art and Design

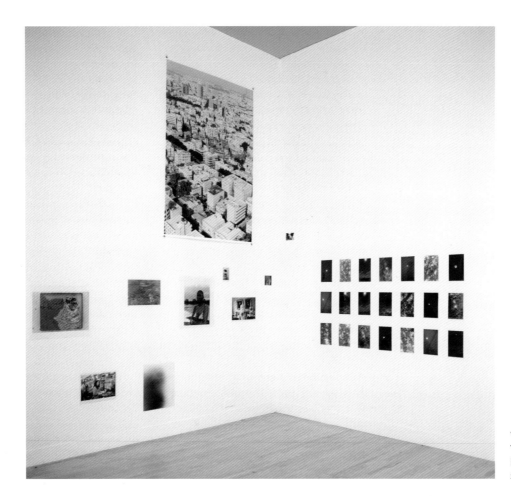

Wolfgang Tillmans
Turner Prize
installation shot
2000

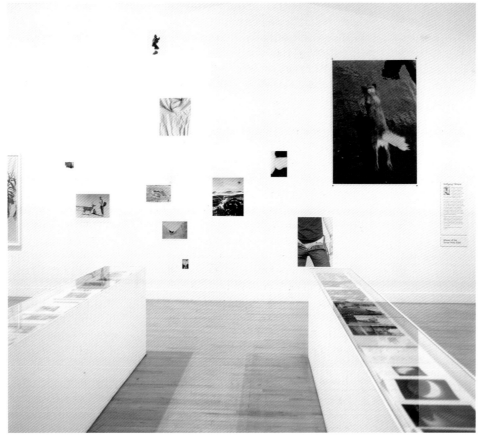

Wolfgang Tillmans
Turner Prize
installation shot
2000

expectations is at the core of Tillmans's work, and integral to this is the way he presents his images. They exist as posters and postcards, in magazines and artists' books, and he views each as an equally valid means of communicating his view. In a gallery installation, he defies the predictable, linear presentation of standard formats that characterises photography displays, and instead brings together an array of images, pinning or taping them to the wall in a rich variety of combinations. He mixes different types and surfaces – small C-type prints, postcards, magazine pages, and large inkjet prints – preferring the purity of the unframed image. He also combines old images and new, often rediscovering photographs taken years earlier. This seemingly informal, ad-hoc presentation is again highly deceptive, for each juxtaposition is rigorously thought through. The connections and networks Tillmans constructs with each collage across a gallery wall summon different narratives and meanings, reflecting his own trains of thought and inviting the viewer to project their own.

That the same images exist in multiple formats and contexts ensures there can be no one way of reading them: Tillmans's work is continually changing. This diversity also suggests that he is concerned less with the material or medium used, and more with the actuality of the image he has created. He is an artist first and foremost, he uses photography to convey his view of contemporary life, but ultimately, he wants us to peel away this framework to feel the purity of direct experience.

Glenn Brown

Glenn Brown deftly and thoughtfully mixes fine art with popular culture, reanimating the historical within the contemporary to create paintings and sculptures of baffling complexity.

Head of JYM (1973), a portrait by Frank Auerbach, first caught Brown's attention in 1991 and marked a turning point for the artist. Brown made a work based on it, entitled *Atom Age Vampire*, in which he captured Auerbach's expressive impasto in an ingenious *trompe-l'oeil* manner: the effect was

immaculately smooth. The glossy finish obliterated Auerbach's brushwork so that the painting resembled a photograph, which was in fact the source from which Brown had worked.

Brown's lengthy process of working from reproductions reflects how we often experience an artwork second-hand, through photography. He has adapted the styles, palette and imagery of such varied artists as Georg Baselitz, Jean-Honoré Fragonard and Salvador Dalí. But for Brown, the original image is merely the point of departure. He adds further twists by selecting reproductions that are not always faithful to the original in colour or tone, and by distorting, manipulating, rotating and cropping the image as he desires. 'I re-enliven it into something completely different. Something that makes personal allusions to my own life.'

In any one painting, centuries may collide. This is demonstrated by *The Marquess of Breadalbane* (2000), for example, one of the works in the series of heads based on that original Auerbach portrait. The figure is set against an empty sky, within an oval. Both features situate the work firmly in the tradition of historic portraiture. The colour scheme adds another layer of history, having been inspired by Edwin Landseer's *The Monarch of the Glen*, dating from 1851 (a painting originally commissioned by the Marquess of Breadalbane, hence the title).

In *The Tragic Conversion of Salvador Dalí (after John Martin)* (1998), Brown brings together his interest in the imaginative distortions of Surrealist imagery and the fantastical representations found in science-fiction illustrations. He inverts John Martin's nineteenth-century vision of the apocalypse, transplanting a futuristic city onto the horizon. The act of placing an airbrushed fantasy within a vast history painting is more than a little ironic, although it is difficult to identify whether the irony is directed at the source from popular culture or at the high-art style in which it is reconfigured. Characteristically, the title of the painting adds another layer of meaning, with its reference to Dalí and his conversion to Catholicism, which for Brown signalled the demise of his painting.

Glenn Brown
1966 Born in Hexham
1984–5 Norwich School of Art
1985–8 Bath College of Higher Education
1990–2 Goldsmiths' College, London

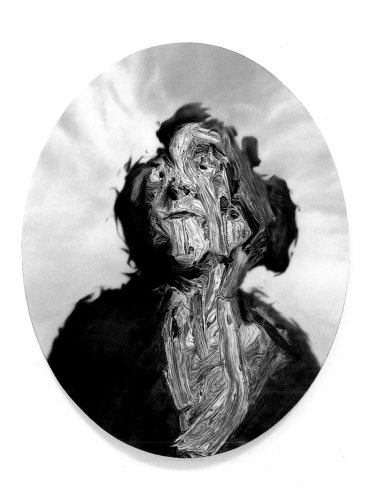

Glenn Brown
*The Marquess of
Breadalbane* 2000

Glenn Brown
*The Tragic Conversion
of Salvador Dalí (after
John Martin)* 1998

Michael Raedecker
1963 Born in Amsterdam
1985–90 Gerrit Rietveld Academie, Amsterdam
1993–4 Rijksakademie van Beeldene Kunsten, Amsterdam
1996–7 Goldsmiths' College, London

In the Turner Prize exhibition Brown included some of his sculptures, which evolved in parallel with his paintings. Typically, none of his works offers a single reading or fixed viewpoint – their painterliness is continually deceptive. Brown's strategy is deliberately subversive, often idiosyncratic and highly individualistic, and this ultimately ensures that the works he creates are very much his own.

Michael Raedecker

Michael Raedecker's haunting, deserted landscapes and sparse interiors are at once familiar and unsettling. They depict marginal places, dry and arid plains or valleys, barren woods, lone buildings smothered in thick blankets of snow or half-glimpsed through the gloomy twilight. Carefully avoiding any kind of explicit narrative in his paintings, Raedecker creates evocative images that have a dreamlike, cinematic quality, or resemble dramatic stage sets awaiting players.

A Raedecker painting is the result of a carefully orchestrated layering of unusual techniques and media. In addition to paint applied in both thin washes and thick impasto, he also attaches thread, embroidery, sequins and textiles to the canvas, and his work skilfully blurs the distinctions between fine art and craft. Working initially with the canvas laid flat he begins by 'drawing' the image using loose thread, which is then glued down to the canvas. He subsequently applies as many as ten washes of dilute acrylic paint, allowing chance to influence it as it dries and thickens around the thread. As successive washes are placed onto the canvas he scatters fake-fur fibres into them. These create texture and suggest a patina of wear and age. This is the ground upon which he then builds his image.

While Raedecker's landscapes are imagined, they frequently incorporate imagery of modernist houses and cabins drawn wholly, or in part, from popular magazines and American ideal-home brochures. Certain themes recur in his work. One is the juxtaposition of interior and exterior, clearly articulated in *echo* (2000). This work, which depicts the inside of the mouth of a cave draped with woollen creepers, was inspired by an episode in a 1989 Paul Auster novel, *Moon Palace*, in which an artist hides out in a hermit's cave and has a revelation about the nature and role of art: 'The true purpose of art was not to create beautiful objects, he discovered. It was a method of understanding, a way of penetrating the world and finding one's place in it.' In *ins and outs* (2000) we see a single-storey building. It is twilight, or night, and the only light comes from a brightly lit window. Yet we cannot see inside, and can only imagine what may be going on within.

Raedecker talks about painting as a search for 'truths', yet understands that painting alone cannot provide answers: 'It's only a painting. It can give clues but not real truths.' Thus his work is suggestive of dreams, of reveries, or of stages onto which we must project our own narratives. Ultimately it is only completed with the involvement of us, the audience.

Tomoko Takahashi

Tomoko Takahashi has become well known for installations in which she transforms reclaimed rubbish and detritus into crazy, complex and beautiful arrangements. She originally trained as a painter, but later swapped her brushes and paint for these scavenged materials. Nevertheless, she describes herself as an 'abstract artist' and her installations as 'landscapes'.

Takahashi left Tokyo in 1990 and came to study at Goldsmiths' College in London. Her early works were mainly collages or assemblages, but gradually the scale of her work became more ambitious. Developing an interest in site-specific installations, she began to focus on large-scale works occupying rooms, or even whole buildings.

Takahashi has created installations in schools, galleries, offices and even a police station, spending many months excavating the site, and even sleeping in situ, as she slowly gathered together material for the work. Her fascination with recycling seems to raise questions about social and economic waste, and the unquenchable thirst of capitalist consumerism. While acknowledging these issues, however, Takahashi's interest lies more in the history revealed

Michael Raedecker
echo 2000

Michael Raedecker
ins and outs 2000

by these objects, their relationship to time and place, and their ability to act as symbols of a collective experience.

The completed installations are the result of a painstaking process of selection and arrangement, despite the characteristic impression of chaos. In fact Takahashi places great emphasis on order. Even though her works often appear anarchic, closer scrutiny usually reveals the carefully structured relationships she has set up between apparently random objects.

In 2000 Takahashi created a spectacular installation in a tennis court in Clissold Park, North London, as part of the Stoke Newington Festival. Assorted bits of sports equipment were suspended, stacked, piled and balanced in a playful and precarious arrangement. Working against the existing grid lines of the tennis court, she mapped out new boundaries and connections, freeing the objects from any predetermined relationships. Systems, Takahashi seemed to suggest, are arbitrary and some rules are made to be broken.

Her work for the Turner Prize exhibition, *Learning How to Drive*, also examined social systems and structures. During the preparation for this installation, she found the restrictions of working with a museum both intriguing and frustrating. The guidelines that govern exhibitions within a large organisation, such as visitor flow or health and safety considerations, sparked Takahashi's interest in some of the broader rules and regulations that govern everyday life. The installation conjured up the world of symbols, signage and logos that are part of our daily landscape, and yet with typical irreverence, she managed to undermine and tease the rigidity of civic life and its codes.

Takahashi is an idealist who hopes that in her works she can release objects from their usual straitjackets of meaning and context, and by extension release us from our conditioned expectations of the world around us. Her work is about playing with rules. While she is respectful of order, ultimately, she states, 'it's about freedom'.

Tomoko Takahashi
1966 Born in Tokyo
1985–9 Tama Art University, Tokyo
1990–4 Goldsmiths' College, London
1994–6 Slade School of Fine Art, London
1997–8 Goldsmiths' College, London

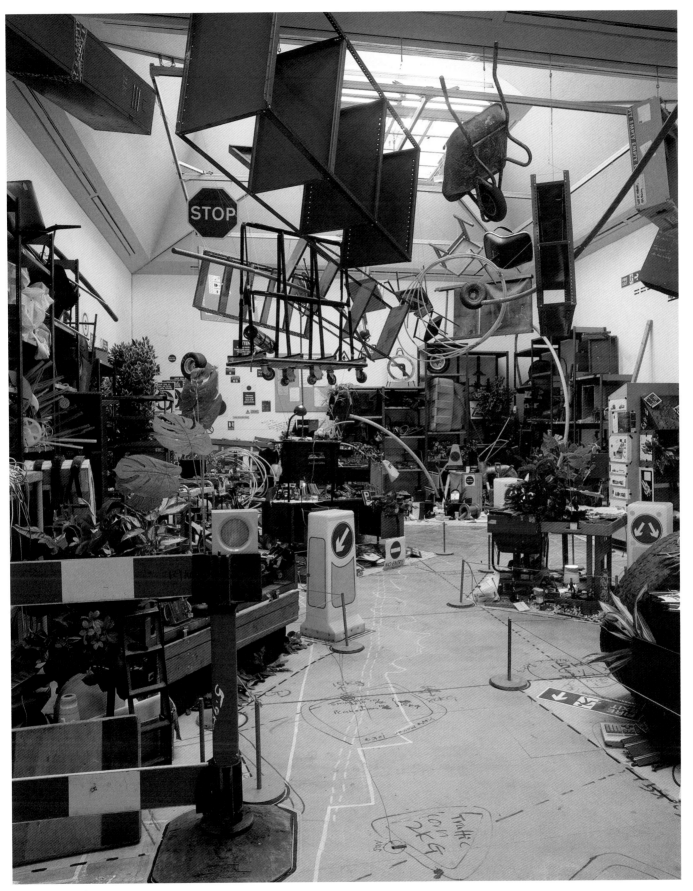

Tomoko Takahashi
Learning How to Drive
2000

Winner
Martin Creed

Shortlisted artists
Richard Billingham for his solo exhibition of photographs at the Ikon Gallery, Birmingham, and for his contributions to *The Sleep of Reason* at the Norwich Gallery and to *Scène de la vie conjugale* at Villa Arson, Nice, in which he showed both new video work and his recent photographs featuring his poignant return to the places of childhood memory
Martin Creed for his solo exhibition *Martin Creed Works* at Southampton City Art Gallery, Leeds City Art Gallery, Bluecoat Gallery, Liverpool, and Camden Arts Centre, London, and *Art Now: Martin Creed* at Tate Britain, London, in which he reaffirmed the rigour and purity of his work and its characteristic mixture of seriousness and humour
Isaac Julien for his complex, poetic film installations, which combine a theoretical sophistication with visual beauty and sensuality, seen in exhibitions of his work at Cornerhouse, Manchester, the South London Gallery and Victoria Miro Gallery, London, in collaboration with Film and Video Umbrella, and in *The Film Art of Isaac Julien* at the Center for Curatorial Studies, Bard College, New York (and tour).
Mike Nelson for the haunting resonance of his architectural installations, which juxtaposes a diversity of found objects, fusing numerous references and creating open-ended narratives that suggest a sense of threat, danger, or life on the edge, as seen in his contributions to *The British Art Show*, National Touring Exhibitions and to *Another Place* at Tramway, Glasgow

Jury
Patricia Bickers
Editor of *Art Monthly*
Stuart Evans
Representative of the Patrons of New Art
Robert Storr
Senior Curator of Painting and Sculpture, The Museum of Modern Art, New York
Jonathan Watkins
Director of Ikon Gallery, Birmingham
Nicholas Serota
Director of Tate and Chairman of the Jury

Exhibition
7 November 2001–20 January 2002
Prize of £20,000 presented by Madonna, 28 November 2000

Martin Creed
Work No. 227 The lights going on and off
2000

Disgruntled and increasingly agitated media discussion about the nature of the Turner Prize dominated coverage in 2001. The tone was set by the *Evening Standard's* critic, Brian Sewell, who two weeks in advance of the shortlist announcement in May, invited readers to nominate their own contenders, in an attempt to expose the undemocratic selection process. 'Has any working artist who is not in the charmed circle of Sir Nicholas Serota, chairman of the judges, any chance of being chosen above those who are?' he asked ('Is this your idea of art?', *Evening Standard*, 11 May 2001, p.3). Sewell was later accused of fixing the results of his public poll in collusion with the Albemarle Gallery (Nick Fielding and Richard Brooks, 'Turner Prize Poll "fixed" by gallery', *The Sunday Times*, 27 May 2001).

For most critics the all-male shortlist seemed obscure, difficult and even boring. But for some, its non-starry nature proved that the prize was not attention-seeking for its own sake, as Iain Gale commented: 'If the prize's selection procedures are still suspect to some, this shortlist deserves to dispel cabalistic conspiracy theories ... In its seventeenth year the Turner Prize has finally come of age' ('The Turner Prize – What a turnaround', *Scotland on Sunday*, 4 November 2001, p.13).

Martin Gayford commented on the relationship between the prize and its opponents, which, he felt, ironically, had contributed to the success of the event: 'The higher blood pressure and the raised public profile are, of course, closely connected. It is largely its detractors, I suspect, who have made the Turner Prize as prominent as it is. Hearing that something is new and radical and under attack, people throng along to see what all the fuss is about' ('Nothing Ventured', *Spectator*, 8 December 2001, p.60). But in 2001, the success of the prize in reaching a wider audience seemed to work against it: on the whole there was a demand for less elitism in the selection process, in the mediation of information about the artists, and a plea for less 'conceptual' art.

A number of critics felt that the prize had reached a plateau, and called for its demise. Writing in the *Daily Telegraph*,

John McEwen asked: 'Has the Turner Prize come to the end of its natural life? The lack of fizz certainly suggests it. And why not? It has been going almost twenty years and the vibrant era of Thatcherite competition which gave it birth has long gone' ('Grave Time for Turner', *Daily Telegraph*, 11 November 2001, p.6). More seriously, it appeared that the prize had become so successful in engaging the media machine that overexposure was now causing it to implode.

One of the most interesting issues to arise in 2001 was that of art-world language, which came under attack as elitist and obscure. As Mark Irving commented: 'The problem is that art is becoming so much like the fashion world, with artists taking over as the new celebrities, that few people are prepared to give the language spoken by the in-crowd a thorough dressing down. It really is about time we challenged their perceived notions and explored new ways in which to transgress the boundaries of art and language' ('How to speak Modern Art', *Independent on Sunday*, 9 December 2002).

More pointedly, Matthew Collings, presenter of Channel 4's live Turner Prize television programme, accused Tate of failing in its efforts to communicate with a mass audience: 'The Tate people ... are masters of putting on the aura. This stuff is indefinable. It's absolutely impossible for someone untrained to read the voodoo aura stuff, or to write the vacuous prose they put in the press release' ('The Knack: How to win the Turner Prize', *Independent*, 9 November 2001).

In 2001 the most column inches were engendered by Martin Creed's *Work No. 227: The lights going on and off*, whose title describes the simple content of this piece about perception. For those opposed to conceptual art, it provided a classic example of 'the Emperor's new clothes', while many supporters of the artist felt it was the wrong work to show in a Turner Prize exhibition.

But generating almost as much coverage as the art, was the choice of pop superstar Madonna to present the award. For Rosie Millard this reflected the international status of the prize: 'While

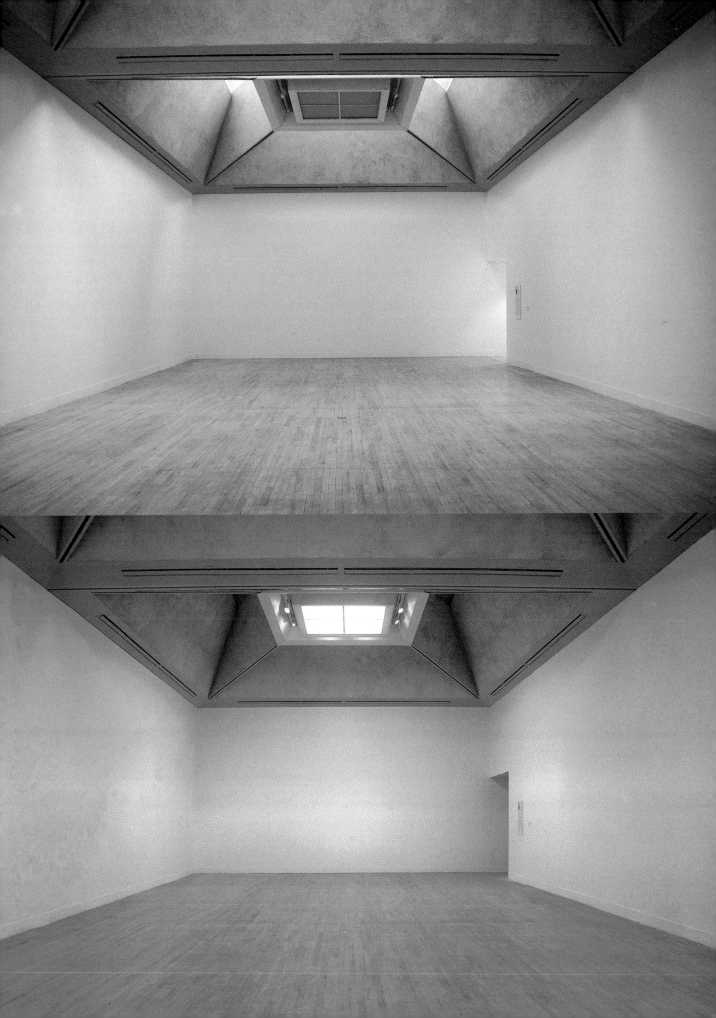

Martin Creed
1968 Born in
Wakefield
1986–90 Slade School
of Fine Art, London

Madonna has become gradually more British, the Turner has grown more international ... Its style has gone from village dog show to global trophy with live coverage on national television. Meanwhile British contemporary art has become so associated with popular culture that to have La Ciccione presenting art's biggest prize is wholly appropriate' ('Don't Worry ... it's only art', *Independent*, 28 October 2001, p.7).

For others it suggested a cynical marketing strategy, as Janet Street-Porter commented: 'How do they top this next year? The Tate has embarked on a rollercoaster ride in its desperate attempt to be bigger, better and more controversial every time. Even second rate art is worth better treatment than this' ('Editor-at Large', *Independent*, 9 December 2001, p.2). Madonna further bumped up media coverage, when in an act of defiance, she used obscene language before the nine o'clock watershed during the Channel 4 broadcast of the event.

Martin Creed

Martin Creed uses a multitude of materials, often from urban daily life, to fulfil his compulsion to make 'things'. His work emerges from an ongoing series of investigations into commonplace phenomena. By challenging notions of display and enhancing that which is usually taken for granted, he delicately reintroduces us to elements of the everyday and allows us a moment for reflection.

Creed typically works with paper, music, air, light or text to create a systematic series of comically slight yet earnest works: objects, songs, statements, gestures and interventions. It is significant that each of his works is not titled; identifiable only by number, each piece is added to Creed's system with equal status regardless of its medium. Creed's diverse output defies categorisation within traditional genres of artistic production. However, a subversive wit is present in all his works, teasing a dramatic effect from a formal elegance and minimal simplicity.

His idiosyncratic stance is born out of acute indecision and a playful preoccupation with the conundrum of wanting to simultaneously make

something and nothing: 'the problem was to attempt to establish, amongst other things, what material something could be, what shape something could be, what size something could be, how something could be constructed, how something could be situated ... how many of something there could be, or should be, if any, if at all.' Pragmatic in approach, Creed's cross-examination of the motivation behind every decision reveals a personal anxiety about 'making something extra for the world'. This noncommittal manner is central to his particular rationalisation and is also symptomatic of his insistence upon equilibrium. When exhibited, the three metronomes in *Work No. 223*, for example, are set to beat one quickly, one slowly and one neither quickly nor slowly. Furthermore, Creed's wall protrusions exist as sculpted forms, yet, 'happened upon' through a series of non-choices in being made of the same materials that constitute the wall surface upon which they are displayed, they simultaneously cancel themselves out and remain part of the wall. There is no join separating the protrusion from its support and it exists in the world without Creed having to create something new.

Creed's creative motivation is spectacularly visualised in his neon sign, *Work No. 232: The whole world + the work = the whole world*. Displayed on the façade of Tate Britain in 2000, the specific context lent by the gallery served to advocate the interpretation that art is inextricably part of life. At the same time, however, the equation could imply the redundancy of artistic enterprise, and particularly Creed's, in leaving no impression upon the world. Both sentiments are readily embraced by Creed in making his work, but it is the economy of means symbolised by this equation that he strives to adopt, a goal that is realised when a work is achieved as a result of doing nothing at all.

For the Turner Prize exhibition, Creed decided to show *Work No. 227: The lights going on and off*. Nothing is added to the space and nothing is taken away, but at intervals of five seconds the gallery is filled with light and then subsequently thrown into darkness. Realising the premise set out in *Work No. 232*, Creed celebrates the mechanics

Martin Creed
*Work No. 200: Half the
air in a given space*
1998

Richard Billingham
1970 Born in
Birmingham
1991–4 University
of Sunderland

of the everyday, and in manipulating the gallery's existing light fittings he creates a new and unexpected effect. In the context of Tate Britain, an institution displaying a huge variety of objects, this work challenges the traditional methods of museum display and thus the encounter one would normally expect to have in a gallery. Disrupting the norm, allowing and then denying the lights their function, Creed plays with the viewer's sense of space and time. Our negotiation of the gallery is impeded, yet we become more aware of our own visual sensitivity, the actuality of the space and our own actions within it. We are invited to re-evaluate our relationship to our immediate surroundings, to look again and to question what we are presented with. Responding to the actual condition in which he has been asked to exhibit, Creed exposes rules, conventions and opportunities that are usually overlooked, and in so doing implicates and empowers the viewer.

There are precedents in the history of art from which one can draw certain similarities with *Work No. 227*. Yves Klein's exhibition *The Void* (1958), for example, presented viewers with an empty, white gallery. Creed, however, rejects the idea of absence in his space, as he believes that his work quite literally fills the gallery with light and darkness. The dynamic that occurs as a result of his event perhaps recalls the influence of the chance 'happenings' of the Fluxus movement of the 1960s and 1970s, which opposed artistic tradition. Similarly the concerns of Conceptual artists of the same period is evident in Creed's work: he continues the enquiry into the notion of authorship, the role of the artist and the value of the art object, yet there is something characteristically democratic about his exercises in awareness. Formulated like musical compositions, Creed's works exist as certificates or sets of instructions. These fact sheets allow anyone to make or install his work but, as Creed points out, 'you can put it where and how you choose and like a musician playing a piece of music, you can do it well or badly'. Creed, strongly influenced by music, orchestrates scenarios that exist with

little certainty yet are often arresting and powerfully resonant.

While he tackles questions about the nature of art and explores its links with life and reality, Creed resists presenting a world-view. Like the experimental musician John Cage, who in staging his silent piece of music forced the audience to listen to the ordinary, ambient noises that they might otherwise ignore, Creed offers up a pause for observing the minutiae and nudges us towards greater contemplation. His realist agenda suggests a range of possibilities and, more importantly, highlights that it is the inconsequential that often means most in real life. There is a genial accessibility to Creed's work, and its sociability is corroborated by the artist's honesty: 'I want to make things and I want to communicate with people.' His balloon piece, for example, *Work No. 200: Half the air in a given space*, provides genuine pleasure in a shared experience, setting up relationships between those who participate. Creed never forgets that there has to be a viewer, someone to sustain the work, someone to counterbalance the questioning that brought it about in the first place. As he asserts in a typically measured fashion: 'My work is 50% about what I make and 50% about what other people make of it.'

Richard Billingham

Richard Billingham is best known for his candid and intimate photographs of his family, taken at their home in the West Midlands between 1990 and 1996. A selection of these photographs was published to much acclaim in the book *Ray's a Laugh* (1996). They feature his alcoholic father Ray, his mother Liz and his younger brother Jason. Underlying the narratives of conventional family album photographs is an unspoken code that Billingham's work brings to light: images such as that of Ray lying in a drunken stupor next to the toilet contravene traditional taboos about which aspects of family life should be made public.

While they document working-class poverty, Billingham's photographs are not self-consciously political, and the artist asserts that they were not

Richard Billingham
*Tony Smoking
Backwards* 1998

Richard Billingham
Hedge 2001

intended to shock. Instead they address identity in personal terms through family relationships; they are about love and beauty. They were originally intended as studies for paintings, and Billingham has explained that he aimed to produce domestic scenes, as much about figures in interiors, in their environment, as the lives being led. He has also said that the influences behind this body of work came from painting rather than photography, and he acknowledges his particular admiration for Walter Sickert, Frank Auerbach and Leon Kossoff.

Two recent video works relating to Billingham's family photography were included in the Turner Prize exhibition, in addition to *Untitled* (1999). This triptych comprised photographs of a television screen showing Billingham's video footage of his father, focusing on his hands and the surface of his skin. The camera was held so close to the television that the resulting images are blurred and grainy. On both levels proximity adds to the abstract qualities of the work, and renders it a powerful study of the un-idealised human body.

Between 1992 and 1997, Billingham produced a series of landscape studies of Cradley Heath in the West Midlands. He frequented this place during his childhood, and the photographs were an attempt to re-familiarise himself with it. His most recent works in the exhibition were photographs of landscapes taken in Europe and Pakistan. He had just begun using a medium-format camera rather than traditional 35mm, thereby giving the images greater detail and an almost hyper-real quality. For Billingham, this work represented an intuitive, unselfconscious response to the landscape, informed by a love and respect for nature and an appreciation of landscape painting. He commented that the Cradley Heath photographs were 'about looking into myself', whereas the new work was about 'looking forward ... feeling the landscape for the first time' and then responding through photography.

Isaac Julien

Isaac Julien's films are about memory, fantasy and desire, addressing absences and omissions in accepted historical narratives. Featuring as writer, director and occasionally actor in his films, Julien has combined these roles with those of theorist and teacher. His work has been shown in various contexts from television and cinema to art gallery. These facts reflect both the diversity of his practice, and his refusal to accept the confines of a given genre or discipline – he has often sought to challenge traditional divisions between film, literature, dance, music and art.

While his work is clearly related to cinematic film, in the 1990s Julien began to explore the possibilities of film as art by producing installations specifically for gallery display. This allows him certain freedoms; for instance, although narrative remains a constant in his work, it is frequently enigmatic and open-ended. The gallery context has also enabled him to move away from single- to multiple-screen works, making possible, as in *The Long Road to Mazatlan* (1999), the representation of 'many different "looking" relationships at the same time'.

This film, shown in the Turner Prize exhibition, was made in collaboration with the choreographer Javier de Frutos. Shot in lavish colour in San Antonio, Texas, it explores white masculinity, longing and repressed desire in the context of mythologies surrounding the American West, and the place of the cowboy as a gay icon.

Also exhibited was *Vagabondia* (2000), set in Sir John Soane's Museum in London. Described by the artist as a Pandora's box, the museum is a treasure-trove of artefacts collected by Soane in the late eighteenth and early nineteenth centuries, with many of its objects contained in secret spaces, niches and compartments. These are gradually explored during the film, focusing on the processes of collecting and archiving, and revealing the ways in which the museum embodies both a subjective history created by Soane and dominant Western culture. The film is structured in the form of two mirroring images, which unfold to produce the effect of a kaleidoscope as sculptures and architectural fragments glide past the camera. A slight lapse in timing between the two images at the end of the piece disrupts the flow, splintering the narrative and suggesting the presence

Isaac Julien
1960 Born in London
1980–4 Central St Martin's School of Art, London

Isaac Julien
Vagabondia 2000

Isaac Julien
*Untitled (from
Mazatlán)* 2001

Mike Nelson
1967 Born in
Loughborough
1986–90 Reading
University
1992–3 Chelsea
College of Art and
Design, London

of many divergent accounts or voices within history.

Julien uses the Soane Museum to intensify the visual luxury of his film. His formalist play on composition, mise-en-scène and strong contrasts in lighting relates his work to that of Orson Welles, Jean Cocteau and Luchino Visconti. Such filmic devices are used to create a powerful poetic and symbolic framework for the representation of alternative and often overlooked histories.

Mike Nelson

Mike Nelson creates large-scale architectural installations, transforming space with meticulous constructions of found materials. Working with the historical and geographical specifics of the site, he fuses an encyclopaedic range of references into three-dimensional narratives. Elements from cultural, socio-political, film and literary sources are borrowed to form an open-ended hybrid. Littering his works with pertinent objects, he aims to provoke us into questioning our individual standpoints, and thus relies on our involvement to continue or complete the scene.

Viewing Nelson's work is an active experience; one must move around, through or into his installations to survey them entirely. Scale and detail are fundamental to his artifice, and Nelson manipulates both with great precision in order to seduce and implicate viewers in his narratives. Like cinematic sets, his works are overwhelming in size and content. His arrangement of materials is never arbitrary, but is carefully organised in an idiosyncratic and provocative way. Furniture, magazines, clothing and memorabilia anchor the work in a half-recognisable reality, rendering the piece more intimate.

Themes of cultural transference,

physical trespass and survival can be teased out of Nelson's work, but it is a consistent exploration of society's belief systems – capitalist, spiritual, artistic, nationalistic – that lies at the heart of his art. He alludes to alternative truths and ways of thinking that challenge current ideologies.

Trading Station Alpha CMa, shown at Matt's Gallery, London, in 1996, was the first of the labyrinthine works for which Nelson is best known. Strongly influenced by a post-apocalyptic survival movie, and by the site-specifics of the gallery, the installation comprised a warehouse space of catalogued detritus and cast-offs. For the Turner Prize display, faced with the task of summing up his practice in one show, Nelson presented an exaggerated idea of the 'signature' exhibition. Borrowing from his own repertoire, he exhibited three works simultaneously: he recreated parts of *Trading Station Alpha CMa*, incorporated objects from *The Coral Reef* of 2000 and presented, in a new installation entitled *The Cosmic Legend of the Uroboros Serpent*, exactly what those familiar with his work might expect to see – an intricate network of corridors and rooms.

Typically, Nelson included dingy lighting to evoke claustrophobia, the mirroring of entrance and exit spaces to create confusion, and doorways that offer choice to the visitor, but simultaneously imply that a wrong turn has been taken into unauthorised, private territories. The space he used was in fact a storeroom, perhaps referring to Tate's store, where various works of art are reduced to a collection of catalogued objects. By cataloguing his own works into his own system, Nelson parodied those who try to classify what he does, aiming to deflect such linear interpretations.

Mike Nelson
*The Cosmic Legend of
the Uroboros Serpent*
2001

Winner
Keith Tyson

Shortlisted artists
Fiona Banner for her exhibitions at the Neuer Aachener Kunstverein, Aachen and Dundee Contemporary Arts, in which she displayed her new large graphite drawings, and where she interwove graphic, sculptural and sound works, as well as extending the sources of her film-based text works
Liam Gillick for his outdoor installations at Tate Britain, London, and his exhibition at the Whitechapel Art Gallery, London, in which he reaffirmed his ability to create complex works of art that set up the possibility of dialogue, often achieved in collaboration with other artists internationally. His writings and curatorial projects were also noted
Keith Tyson for his exhibitions at the Venice Biennale, the South London Gallery, and the Kunsthalle Zurich, where the playful energy, richness and breadth of content of his large graphic works, as well as their relationship to his machine sculptures, were vividly apparent
Catherine Yass for her exhibitions at the Indian Triennial and at aspreyjacques, London, in which she furthered her photographic explorations of architecture as well as portraiture (notably in the works resulting from her recent stay in India) and extended her practice into film

Jury
Michael Archer
Critic and lecturer
Susan Ferleger Brades
Director of the Hayward Gallery, London
Alfred Pacquement
Director of the National Museum of Modern Art, Georges Pompidou Centre, Paris
Greville Worthington
Representative of the Patrons of New Art
Nicholas Serota
Director of Tate and Chairman of the Jury

Exhibition
30 October 2002–5 January 2003
Prize of £20,000 presented by Daniel Libeskind, 8 December 2002

Keith Tyson
Turner Prize
Installation, 2002

In 2002, nomination forms were made widely available to the public for the first time, appearing in a national newspaper, the *Guardian*, rather than just in art magazines and venues. *Guardian* critic Jonathan Jones reported: 'It's a Tate initiative and reflects, says Serota, an attempt to increase public involvement in selecting the four artists shortlisted for the prize ... "The Turner Prize shortlist has always been partly compiled as a result of public nominations, and we want to broaden the range," explains Serota ... "It has frequently been the case that nominations from the public have affected the judges", ('Everyone's a critic', *Guardian*, 9 April 2002, p.12). But Serota was quick to point out that the awarding of the prize was not an objective process. Its purpose was to champion the new, rather than to promote all aspects of contemporary art.

Those opposed to this aim took action in 2002 by launching a number of alternative prizes. For example, the Traditional Art Association announced the TAA prize in Edinburgh in September 'to create an academic alternative to the Turner Prize' (Matthew Beard, 'Traditionalists launch £20,000 annual prize', *Independent*, 20 September 2002). November saw the birth of the Lexmark European Prize in Paris, which aimed to revive contemporary painting (Marianne Brun-Rovet, 'Turner artists "self-publicists"', *Financial Times*, 2 November 2002). Earlier in the year the children's Barbie art prize, sponsored by Mattel, was launched, also offering a £20,000 prize. Leading its judges was Ivan Massow, former Chairman of the Institute of Contemporary Arts, sacked for commenting that British 'concept' art was 'pretentious, self-indulgent, craftless tat'. He publicly admitted that through the Barbie prize he sought to 'make mishchief' for the Turner.

Yet, it was not these rival prizes, nor indeed Fiona Banner's potentially tabloid-titillating billboard text piece *Arsewoman in Wonderland*, that whipped up the biggest controversy for the Turner Prize in 2002. This was supplied by a government minister, Kim Howells, whose harsh note on a public comments board in the exhibition appeared in newspapers across the country: 'If this is the best that British artists can produce then British art is lost. It is cold, mechanical, conceptual bullshit', adding the postscript: 'The attempts at contextualisation are particularly pathetic and symptomatic of a lack of conviction.'

Tate refused to comment on the minister's outburst, taking the view that the ensuing news story was about Howells, rather than about the quality of the exhibition or of contemporary British art. The story ran and ran. While some welcomed Howells's personal remarks as refreshing evidence that Labour ministers were not merely party drones, most felt such intervention was inappropriate, as the *Daily Telegraph* editorial pithily remarked: 'As a junior minister at the Department for Culture, Media and Sport, he is one of the few people in the country who is not entitled to air his opinions about art. Even if the Turner Prize were paid for by the taxpayer, rather than sponsored by Channel 4, as it is, Mr Howells would still be trampling all over the principle on which state subsidies for the arts have been based ever since Keynes created the Arts Council in 1946 ... Ministers may flatter themselves that they are in touch with public opinion, but most people would prefer them to mind their own business' ('The artless minister', *Daily Telegraph*, 1 November 2002).

For others, the minister's response was positively reassuring. As Adrian Hamilton wrote with some irony in an *Independent* editorial: 'Mr Howells may or may not be right about the current crop of the Turner shortlist. Great art, or even good art, is not produced year on year. But the past twenty years – the two decades Howells dismisses as having produced nothing worthwhile –which have thrown up Rachel Whiteread, Antony Gormley, Anish Kapoor, Gilbert and George and the Chapman brothers, are not short of things to say or a willingness to find new means to do so. But, on second thoughts, perhaps it would be more worrying if a government minister did appreciate them' ('British art is in rude health, Mr Culture Minister', *Independent*, 1 November 2002, p.21).

What was clear from the public comments board in the Turner Prize exhibition was that visitors to the show were looking and deciding for themselves. The comments were wide ranging, but

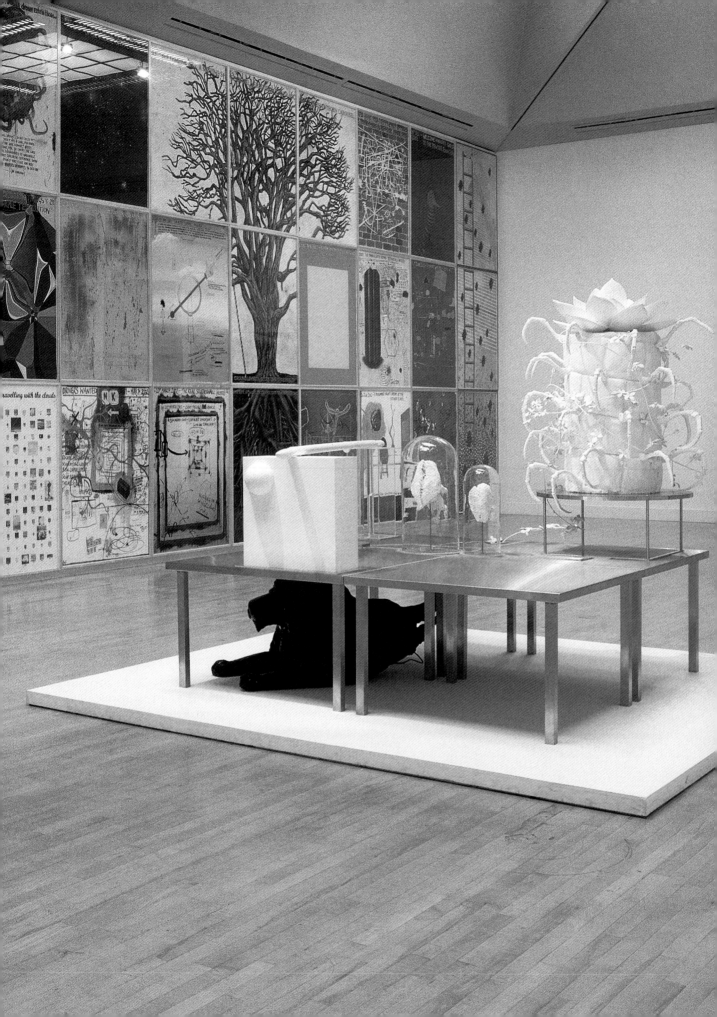

Keith Tyson
1969 Born Ulverston, Cumbria
1984–9 Barrow-in-Furness College of Engineering
1989–90 Carlisle College of Art
1990–3 University of Brighton

all of the exhibiting artists found public support, most of all Keith Tyson. It came as some surprise to the press when Tyson, the bookies' outsider and the public's favourite, won. Tyson's unpretentious, mechanical-engineering background and apparent modesty seemed to signal the end of the artist-as-celebrity, as Rachel Campbell-Johnston opined: 'The Brit art which has dominated the past decade of Turner debate has been characterised by an air of ironic detachment ... But Tyson brings a rush of fresh blood to the head ... Tyson's works are like experiments, made not to prove facts but to promote creativity. This is why he was the right winner this year' ('Artist plugs enthusiasm into decade of irony', *The Times*, 9 December 2002, p.4).

An interview with the winning artist appeared in *The Times* the next day. When quizzed about the issues raised by Kim Howells, he replied: 'The Turner is an important prize precisely because it keeps interest frothing way at the top end ... And to ask "Is that art?" is pointless. If you went to a Mercury Music Prize, you wouldn't say: "Is a country-and-western album better than a punk album?" You wouldn't ask: "Is it music?" You would just think: "It's not my kind of music. What do I feel? How do I respond to it? Is it interesting?" Those are the questions to ask' (Keith Tyson interviewed by Rachel Campbell-Johnston, 'The Shock of the Now', *The Times*, 10 December 2002, p.17).

Keith Tyson
Keith Tyson describes his practice as a form of experimentation, likening his studio to a laboratory and his works to a series of simultaneous research projects. Fervently believing that no one prescriptive method is complete, Tyson moves with ease between the scientific, the philosophical and the fantastical in his monumental quest to provide insight into the perplexing questions underpinning human existence. His investigations culminate in an extraordinary array of objects, machines, drawings and paintings that seek to locate us in space and time and, ultimately, reflect the complexity of the world we inhabit.

At the root of Tyson's projects is an insatiable curiosity about how things come into being and the nature of origin. He states, 'I'm fascinated by science's dogmatic determinism: the belief that any event or action, however complex – a Mozart concerto, a terrorist attack – arises from hydrogen atoms bashing together after the Big Bang.' Although stemming from such profound conceptual concerns, his works are infused with an energetic playfulness and self-effacing humour that acknowledges the immensity and quixotic nature of his undertaking.

Tyson first came to prominence with a series of works made using the Artmachine (1991–), a name embracing an elaborate methodology comprising flow charts, books and computer programmes that generates random artistic proposals for him to implement. These ranged from *AMCHII – Give us this day in Life* (1996–7), for which he was instructed to decorate the surfaces of 366 breadboards, to *AMCHII – the KFC Notebooks and the UCT* (1995), which involved casting the entire Kentucky Fried Chicken menu in lead. In part a reaction to the obsession with signature styles and high production values prevalent in art schools in the early 1990s, his aim was to eliminate all traces of autobiography from his work.

Using the Internet as its sourcebook, the Artmachine's creative possibilities are unpredictable and potentially infinite, giving Tyson the freedom to work in the widest variety of styles and media. He has commented, 'The idea of failure, or the impossibility of achieving – or even managing – [what I am instructed to do] are all part of what's fascinating about working with Artmachine. I'm experimenting on myself, my own thinking and my own hand like a scientist would experiment on a frog.' Although the Artmachine currently lies dormant, allowing Tyson to embark on more concrete paths of enquiry, his work has continued to encompass a variety of forms. Encountering an installation of his work can be an overwhelming experience, and can include anything from eccentric interactive games to models of the universe and works awesome in their graphic intensity.

Fundamental to Tyson's output are his large studio drawings. Operating as his sketchbook, they are the genesis of

Keith Tyson
*Bubble Chambers: 2
Discrete Molecules of
Simultaneity* 2002
(detail)

all his manifold lines of enquiry. Layering image and text to offer vivid transcriptions of the artist's frenetic mental activity, they comprise preparatory sketches for Artmachine proposals; devices that may or may not be realised; conversations; questions; statements and expressions of the artist's emotional and physical state. As such, they have been described by curator Kate Bush as collectively representing a sort of 'hard disk of the Self'. Each dated and titled, the drawings exist as independent artworks whilst forming a heterogeneous journal of Tyson's reactions to internal and external influences at the time of their making. It is the subtle formal and conceptual patterns Tyson identifies between the drawings that dictate their placement on the gallery wall, allowing chronology to be ignored and, thus, time to be restructured.

Random elements inspire creativity in many of Tyson's works. The most recent work included in the Turner Prize exhibition was *Bubble Chambers: 2 Discrete Molecules of Simultaneity* (2002), a painting on two aluminium panels. At first glance, each panel appears identical, containing lines of text densely layered over a network of circles varying in size and colour. On closer inspection we realise the circles form a molecular structure of the kind found in chemistry textbooks, with each circle or 'bubble' representing a specific moment in time. Various poetic phrases spiral off each circle evoking scenes or events from life occurring simultaneously, from the commonplace to the monumental: '4.11 pm 6th Aug 1986, A lugworm pierced by a fishing hook is launched into the salty air... 4.11 pm 6th Aug 1986, A warm breeze gently massages the leaves of a London Birch tree.'

Bubble Chambers is a landscape of sorts which attempts to represent the many parallel experiences occurring at any one moment in the same universe: a slice through centuries, continents, dimensions. If studied carefully, a subtle narrative thread can be found weaving through the work, varying in tone from panel to panel, suggesting an association between apparently isolated incidents. The narrative is not conclusive, however, and it is not essential that we identify it;

rather we are encouraged to free-associate from the prompts given, adding our own reality and the references we bring with it to the many realities depicted.

Tyson's preoccupation with the mysteries of the universe and his efforts to give form to the metaphysical world have led him to insist that, despite his idiosyncratic production, he is fundamentally a 'traditional' artist. *The Thinker (After Rodin)* (2001), belongs to the recent body of works he made under the title *The Seven Wonders of the World*, each a manifestation of a particular line of enquiry into phenomena the artist finds 'wondrous'. Here, Tyson's curiosity stems from the knowledge that something as abstract and staggeringly complex as consciousness originates from and is contained within brain matter. *The Thinker (After Rodin)* is a monolithic hexagonal structure containing a bank of powerful computers that generates its own artificial universe. Described by Tyson as a 'comatose god', it is entirely self-sufficient and impenetrable, the only indication of its hidden activity being a barely audible electronic hum and two tiny LED lights at its summit. Like Auguste Rodin's *The Thinker*, a bronze statue of a figure hunched in deep thought, it is inert and mute, yet Tyson suggests that it moves beyond a mere representation of human thought to embody the phenomenon itself within its aluminium walls.

Like many of Tyson's works, *The Thinker* requires a leap of faith from the viewer, asking us to suspend our disbelief. Yet while he frequently stretches the limits of the imagination, his results have usually been arrived at from a position of logic. Nevertheless, Tyson is quick to point out that he is not a scientist. Rather, his works operate as a location for the real and imaginary to meet and, as such, offer a site for new possibilities. Unlike the scientist looking for consistent results to define a hypothesis, Tyson's practice embraces infinite variety and unpredictability, spiralling off in unlimited directions. His art is not prescriptive; all interpretations are equal and true, and evidence of the pluralistic nature of the world we inhabit. For Tyson, the great advantage of art over rigid paradigms is that it is 'tolerant of contradictions'. 'Loose parameters,' he comments, 'always lead to more interesting results.'

Fiona Banner

Fiona Banner explores the seemingly limitless possibilities of language, yet at the same time demonstrates how words can often fail us, exposing our inability to convey internal thoughts, emotions and experiences.

Since 1994 Banner has created compelling handwritten and printed texts – 'wordscapes' – that retell in meticulous detail the entire narratives or particular scenes from feature films. The vast scale of these works often echoes the cinematic format and nature of their subject matter. Banner also investigates the formal components of written language, giving fresh significance to the symbols that punctuate sentences. From 1997 she has recreated full stops in various typefaces as magnified abstract forms in a striking, yet playful, series of drawings and sculptures.

From early 2000, Banner began using pornographic film as a basis for an exploration of our obsession with sex, and the extreme limits of written communication. In large, densely filled works she transcribed the sexual activities taking place in an X-rated version of Alice's fictional adventures, *Asswoman in Wonderland*, directed by and featuring Tiffany Minx. Banner's *Arsewoman in Wonderland* (2001), a 4 × 6 m printed description of the film, pasted and layered sheet after sheet onto the wall like an overladen billboard, was included in the Turner Prize exhibition. The overwhelming size of the work – which was covered with continuous lines of lurid pink text – combined with the excessive use of words, made it impossible to read the 'story' line by line.

The film has no dialogue; like most pornography it is reliant on the power of images. By trying to trace in words the visceral experience of watching the film, Banner attempted to find a verbal equivalent for this spectacle of sexual activity. Yet, as we absorb the initially shocking words, the verbal devices for capturing the lewd actions quickly deteriorate, exposing the estrangement of language from this task. 'It reveals the innocence of language,' says Banner.

Fiona Banner
1966 Born Merseyside
1986–9 Kingston Polytechnic, London
1991–3 Goldsmiths' College, University of London

Fiona Banner
Turner Prize
Installation, 2001

Liam Gillick
1964 Born in
Aylesbury,
Buckinghamshire
1983–4 Hertfordshire
College of Art
1984–7 Goldsmiths'
College, University of
London

In 1997 Banner published THE NAM, a 1,000-page book containing a blow-by-blow description of six Vietnam films. She then made a tiny full stop out of neon, marking an end to this mammoth project. This led to the series of sculptures in which Banner enlarges full stops, presenting them as physical objects, literally punctuating the space. In the Turner Prize exhibition, they also functioned as objects to lean against or sit on, allowing visitors to pause, paralleling their role within language.

Visual imagery has become more prominent than the written word in mainstream culture. Banner uses language or punctuation to negotiate imagery that she finds too powerful or complex to process in any other way. It is this crucial role of words in releasing our thoughts and fantasies, despite their inherent limitations, that Banner seeks to explore.

Liam Gillick

'I absolutely believe that visual environments change behaviours and the way people act. I'm not prescribing certain thinking – it is a softer approach than that – I'm offering an adjustment of things, which works through default. If some people just stand with their backs to the work and talk to each other, then that's good.'

Through interventions into specific architectural spaces, whether a gallery, public housing estate or airport, Liam Gillick encourages people to negotiate and experience differently the environments he has manipulated. Gillick's practice is underpinned by rigorous theorising: he is as much a writer as a maker of objects. However, his work is shaped by a very visual awareness of the way in which different properties of materials, structures and colour can affect our surroundings and therefore influence the way we behave. His work employs the formal vocabulary of an updated Minimalism, recalling the sculptures of Donald Judd, for example, in its use of bold colours, off-the-shelf industrially produced materials, and repetitive, geometric forms. Amongst Gillick's visually seductive abstract and semi-functional elements might be a screen, a room divider, a large work table, a display case, a ceiling panel,

a vinyl wall text, or a floor sprinkled with glitter. Through combinations of these he endeavours to create an intellectual dialogue with the viewer as much as a physical one.

In the work *Coats of Asbestos Spangled with Mica* (2002), created specially for the Turner Prize exhibition, Gillick pursued this desire to inform both our bodily perception of a space, and our intellectual response to an altered environment. The large suspended ceiling of brightly coloured Perspex panels, held in place by an anodised aluminium framework, dominated the room, transforming it into a glowing array of coloured reflections bouncing off the walls and floor. The title of the work refers to *The Underground Man*, by Gabriel Tarde, published in 1905, which describes a world in which 'the sun has gone out', and people have gone underground to create a new society of art and culture.

Gillick has consistently extended his practice into other disciplines, acting as designer, critic, author and curator. For the Turner Prize exhibition he designed a display case to contain computer plans for recent public art projects and design work. His commitment to dedicated research and the energetic generation of new, interlinked ideas and proposals lies at the root of understanding his work. This belief in speculative thinking means that there will inevitably be some lines of enquiry that do not go anywhere, or will reach a dead end. Yet Gillick is not looking for conclusions or resolution, but opportunities to experiment and play.

Catherine Yass

Catherine Yass is best known for her arresting photographic lightbox portraits of people and architectural spaces. Using colour and light to manipulate her subject, she aims to probe beneath the surface of the visible world, presenting an intensified reality that verges on the supernatural.

Yass is acutely aware of the ambivalent status of her chosen medium and denies the camera its role as an impartial recording mechanism. Her desire to 'acknowledge that there's someone behind the camera' is manifest in the trademark method she employs in the majority of her photographic works.

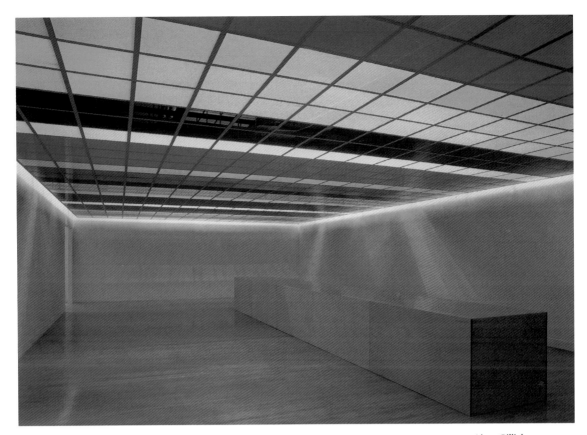

Liam Gillick
*Coats of Asbestos
Spangled with Mica*
2002

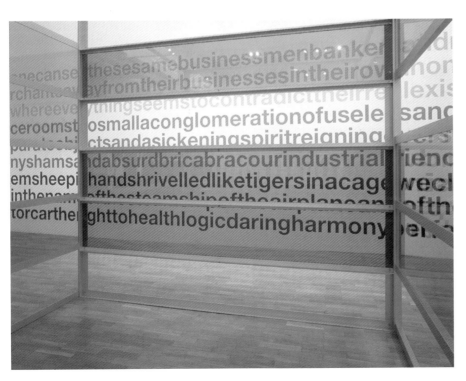

Liam Gillick
The Wood Way
2002

Catherine Yass
1963 Born London
1982–6 Slade School
of Art, London
1988–90 Goldsmiths'
College, University of
London

The technique has its origins in a chance occurrence that took place shortly after Yass left art school, when a colour slide film was loaded incorrectly and processed as a negative, revealing its creative possibilities. Using a large-format camera, she shoots first a positive colour transparency and then a negative one of the same scene a few moments later. The two are overlaid and further tonal adjustments are made during the printing of the composite image. This suffuses even the most mundane of scenes with an uncanny charge, heightening colours and translating areas of strong light into gradations of intense blue.

Corridors (1994), a series of eight lightbox works, gives a familiar institutional feature a discordant resonance, so that it appears both beautiful and frightening. Foreground and background planes merge, and fields of polarised colour lend a hallucinogenic atmosphere to the scene. The process of overlaying negative and positive exposures marks a passage, or compression of time, fusing two parallel realities, imbuing her work with an otherworldly quality. Yass is interested in the way in which the viewer shifts between the pictorial image and its surroundings, thus caught in a no-man's-land between the two, mirroring the duality of her technique.

Yass's more recent venture into the time-based medium of film developed the concerns of her photographic works, opening up new possibilities. In *Descent* (2002), included in the Turner Prize exhibition, a camera lowered from a crane tracks steadily down the full length of a tower block under construction at Canary Wharf, East London. Yass comments, 'I loved the idea of shooting something from a temporary viewpoint that didn't really exist and wanted it to be about the dreamlike seduction of falling.' On the day of filming, an unexpected carpet of mist lent a mesmeric quality to the footage, which Yass enhanced by screening the film in reverse. The imagery is beautifully meditative and melancholic; we are not so much falling as drifting, dislocated, through an unfamiliar landscape.

Yass's photographic and film works are meticulously constructed, yet she relinquishes an element of control to allow her subject matter to guide her subtly to new territories. She thus moves the photographic medium beyond the documentary and into the realms of painting, presenting a reality that is highly subjective and transformed by her imagination.

Catherine Yass
*Descent: HQ5: 1/4s,
4.7˚, omm, 40 mph*
2002

Catherine Yass
Corridor: Chaplaincy
1994

Grayson Perry 2003

Winner
Grayson Perry

Shortlisted Artists
Jake and Dinos Chapman for their exhibitions at Museum Kunst Palast, Dusseldorf, White Cube, London and Modern Art Oxford, in which their striking sculptural installations and graphic works investigated society's taboos with humour and provocation, appropriating imagery from diverse sources including art history and consumer culture
Willie Doherty for the continuing strength and relevance of his film installations and photographic worksin addressing the complexities of living in divided societies, as demonstrated in his exhibition at the Irish Museum of Modern Art, Dublin, and his contribution to the XXV São Paulo Biennial
Anya Gallaccio for solo presentations of her work at Tate Britain and the Ikon Gallery, Birmingham, in which she furthered her innovative exploration of the tension between organic and traditional sculptural materials, such as sugar, wax and bronze, to create poetic works that encapsulate the passing of time
Grayson Perry for his unique work exhibited at the Stedelijk Museum, Amsterdam, and the Barbican Art Gallery, London, which combined the traditions of fine and decorative arts, including drawing, embroidery and ceramics, to explore compelling personal and social themes

Jury
Richard Calvocoressi
Director of the Scottish National Gallery of Modern Art, Edinburgh
Frank Cohen
Representative of the Patrons of New Art
Chrissie Iles
Curator of Film and Video, Whitney Museum of American Art, New York
Andrew Wilson
Critic and Deputy Editor, *Art Monthly*
Nicholas Serota
Director of Tate and Chairman of the Jury

Exhibition
9 October 2003–18 January 2004
Prize of £20,000 presented by
Sir Peter Blake 7 December 2003

Marking twenty years of the event, the 2003 Turner Prize provided an occasion for reflection on the impact of the Prize on British culture. But the strength of the 2003 shortlist convinced even long-serving journalists that, despite its longevity, the Turner Prize still had the capacity to surprise and impress.

Unlike recent shortlists, which had tended to favour the relatively young and unknown, 2003 showcased artists mostly in their forties with well-established careers. One of them, Willie Doherty, had even taken part in the Prize almost a decade earlier. Many commentators welcomed the list as the most serious in years, concurring with *Guardian* critic Adrian Searle, who acknowledged the maturity and accomplishment of the contenders: 'I like this year's Turner Prize shortlist. It isn't glib, it is well balanced, the artists have all in their ways developed a singular approach ... Those who complain at how today's art lacks traditional artistic values and enduring subjects shall have to take a deep breath. Model-making, etching, pottery and woodcarving are among this year's skills (Adrian Searle, 'Pots, carvings, candles, jokes – they're all here', *Guardian*, 30 May 2003).

Yet, paradoxically, the presence of the notorious Chapman brothers, dubbed 'the Brothers Grimm' in the popular press, and Grayson Perry, the so-called 'transvestite potter', meant that the 2003 Turner Prize could hardly fail to deliver – or even exceed – the expected dose of outrage and controversy. For many critics and correspondents of the broadsheet papers the shortlist seemed to contain the right ingredients for success. *Daily Telegraph* critic Richard Dorment, for example, observed: 'The Turner Prize has been very dull lately – more for the critics and other professionals than the public. This list takes into account that the prize should be communicating with the public. There is no painting but, on the other hand, these artists are good at strong imagery' (quoted by Nigel Reynolds, 'Transvestite potter in frame for Turner Prize', *Daily Telegraph*, 30 May 2003, p.7).

Coinciding with the announcement of the shortlist, the *Daily Mail*, in an effort to champion anti-modern art sensibilities, staged their 'NOT the Turner Prize' exhibition at The Mall Galleries, comprising four hundred paintings. The winner, Gerard Burns, received £20,000 for a hyper-realistic painting of a girl leading a bull.

For many critics, across different media, the Turner Prize exhibition staged that autumn didn't disappoint. Reviewing the show for the *24 Hour Museum* website, Richard Moss reported that: 'Despite celebrating its 20th year, this year's Turner Prize exhibition ... shows no signs of retiring into the venerable recesses of the art establishment' ('Death, Decay and Pots – the Turner Prize 2003 at Tate Britain',www.24hourmuseum.org.uk/12/1/03). Even perennially unsympathetic critics, such as Martin Gayford, were pleasantly surprised: 'Skeletons, worms, dreadful crimes, mortality and frenzied flight are among the subjects chosen by the four very different artists on the shortlist this year. Paradoxically – and I never thought I'd find myself writing these words – this is rather a good Turner Prize display, not mind-bendingly dull as some recent years have been' (Martin Gayford, 'They only do it to annoy', *Sunday Telegraph*, 2 November 2003, Review p.9).

Despite the obvious 'shock' factor of some of the works included, the show as a whole was praised for its tautness and coherence. For Searle it was one of the best Turner displays he had seen: 'There is an air of calm and seriousness, almost a terseness about the show – however volatile some of the subject matter and content' (Adrian Searle, 'States of Decay', *Guardian*, 29 October 2003, p.13). Though convinced that bookies' favourites, the Chapmans, deserved to win, *Sunday Times* critic Waldemar Januszczak was nevertheless forced by the exhibition layout to reconsider the work of Grayson Perry: 'By offering one good thing after another, the 2003 Turner show raises the stakes as it progresses, then pulls off an excellent double bluff at the end by placing the Chapman brothers in the penultimate slot and following them with the exceptionally effective Grayson Perry. It is a dashed cunning move. The natural dynamics of the show force you into believing that Perry must win. He's so good' (Waldemar Januszczak, 'He might not be Mystic Meg ...', *The Sunday Times*, 7 December 2003).

Grayson Perry
Coming Out Dress
2000

Grayson Perry
Golden Ghosts
2001

Grayson Perry
1960 Born in
Chelmsford
1978–9 Braintree
College of Further
Education
1979–82 Portsmouth
Polytechnic

As might have been expected, media coverage was dominated by images of the Chapman brother's tabloid-friendly sculptures *Sex* and *Death*, with such headlines as 'The Stomach Turner Prize' (*Sun*, 29 October 2003, p.21) and 'Modern Ar*e' (*Daily Mirror*, 29 October 2003, p.27). But opinion about these new works was divided. For Richard Dorment, normally appreciative of the Chapman's oeuvre, the inclusion of *Death*, a 'deliriously, comically silly' work was a mistake, since it both misrepresented the Chapman's real achievement and hijacked attention away from what was otherwise a worthwhile show. He observed: 'In their different ways [the artists] all share a pessimistic view of nature, history, sex and society, expressed in work that is often beautiful, always compelling' (Richard Dorment, 'Ignore the naughtiness', *Daily Telegraph*, 29 October 2003). He was not the only critic to note the conspicuous absence of *Works from the Chapman Family Collection*, a series of sculptures that the Chapmans might have been expected to show, or that it was concurrently on display down river in the Saatchi Gallery.

Although the artists were addressing such major themes in their work as sex, death, politics and the transience of existence, concern was expressed about the value of 'shock art'. Tired of the tactics associated with 1990s Brit art, a few observers noted that the least shocking aspect of the show was the desire to shock itself. For some, even the institution's warning to visitors of sexually explicit content represented a cynical ploy. Writing in the *Daily Telegraph*, Neil Tweedie commented: 'The gallery no doubt hopes that the sign advising parents with children under the age of sixteen to avoid the exhibition will prove to be an immediate crowd-puller. The blow-up dolls will certainly be a must for schoolboys' (Neil Tweedie, 'Maggots, skeletons, fear and death. The Turner is back as healthy as ever', *Daily Telegraph*, 29 October 2003).

By December, it seemed a *fait accompli* that the Chapmans would walk off with the prize. Grayson Perry's win was all the more surprising since it seemed unlikely that a jury of art-world professionals would favour the people's choice (as revealed by public comments left at the exhibition). The jury commended Perry not for his shocking subject matter or headline-grabbing transvestism, but for 'his use of the traditions of ceramics and drawing in his uncompromising engagement with personal and social concerns'. As usual, the award ceremony was widely reported, the press revelling in such headlines as 'Prize goes to Pot' and 'Transvest-Art' (*Daily Mirror* and *Sun*, 8 December 2003), accompanied by colourful photographs of Perry dressed as his alter ego Claire, resplendent in a puff-sleeved, Shirley Temple-style, purple satin dress, embroidered with rabbits, hearts and the names 'Sissy' and 'Claire'.

Apart from the odd objector, for instance David Lee, who concluded that the art world's 'Widow Twanky' would be 'remembered as an artist who was a transvestite, not for the quality of what he achieved', Perry's success was almost universally welcomed (quoted by Geoffrey Levy, 'Frocky Horror Show!', *Daily Mail*, 9 December 2003, p.11). Speaking the morning after the announcement Perry revealed that he had not expected to win, commenting: 'Some people say my pots are beautiful, and beauty can be a bit of a swear word in contemporary art. It is as if we are shocked by it' (quoted by Rachel Campbell-Johnston, 'He's not as potty as he looks', *The Times*, 9 December 2003, T2, p.6).

Grayson Perry

Grayson Perry has commented: 'A lot of my work has always had a guerilla tactic, a stealth tactic. I want to make something that lives with the eye as a beautiful piece of art, but on closer inspection, a polemic or an ideology will come out of it. Not so that it destroys the intrinsic pattern and beauty of it … but so that there is a frisson' (*Grayson Perry: Guerilla Tactics*, Stedelijk Museum, Amsterdam 2002, p.24). His choice of ceramics as a primary medium for making quietly subversive art was largely influenced by his involvement in the early 1980s with the Neo-Naturist Cabaret, which promoted an ethos of honest self-expression and disregard for fashion. Appearing on vases, the conventional carriers of flowers rather than ideas, the impact of his more disturbing subject matter – murder, war, sexual deviancy, obscenity, violence –

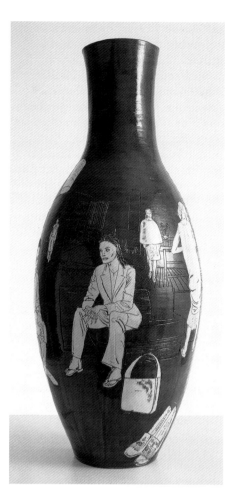

Grayson Perry
Boring Cool People
1999

has been all the more profound.

Echoing the English tradition of social satire, established in earlier centuries by painters such as William Hogarth and caricaturists like James Gillray, Perry has exposed hypocrisy and pretension at all levels of the social strata – from the mores of the suburban petit bourgeois, to the laddish materialism of Essex man. The smug posturing of the fashion world and self-designated cultural elite have also come in for ridicule. For example, the elegant vase, *Boring Cool People* 1999, depicts the faux ennui of chic, gamine figures in classic white, against a minimal Yves Klein-blue ground. Perry has commented: 'The blankness of fashion models, their lack of narrative. They are the frontline troops of western consumerism, a dead pretty face selling white goods' (ibid., p.41).

Despite their increasingly sumptuous and sophisticated appearance, Perry's pots are still made using the basic amateur's technique of coiling – building up the shape of the pot from a coil of clay. The lowly status of ceramics dovetails with his own characteristic self-effacement: 'I like the whole iconography of pottery. It hasn't got any big pretensions to being great public works of art, and no matter how brash a statement I make, on a pot it will always have a certain humility'(ibid., p.38). This humility, or self-criticism – humorously exemplified by his signature stamp of a 'W' combined with an anchor, thus spelling 'Wanker' – prevents his critique from becoming self-righteous.

Although typically confrontational, the implications of Perry's tabloid-style narratives are by no means black and white. The chilling imagery on Perry's pot *We've found the Body of Your Child* (2000) draws on a range of sources, from Pieter Breugel's painting *Hunters in the Snow* (1565) and Tom Waits's song *Georgia Lee*, in which a parent laments his murdered child. Perry depicts a man walking away from a distressed woman, beside her the body of a child. Yet confounding expectation and prejudice, he takes issue with the demonisation of paedophiles by the media, pointing to statistics suggesting that parents are the most likely perpetrators of violence towards children. Society's ambivalent sentimentalisation of childhood is

also explored in the nostalgic imagery of *Golden Ghosts* (2001), a delicately decorated pot, layered with drawn figures of Victorian dolls and children dressed-up in doll-like costumes. An aeroplane flies overhead, and this sickly-sweet, chocolate box image is disrupted by a barefoot child with amputated hands. On closer inspection, the decorative motif peppering the surface of the pot reveals itself as a tiny coffin, a symbol of the artist's sympathy with the universal suffering of children.

In recent years Perry's work has become more overtly autobiographical, exploring his troubled upbringing in Essex, and his transvestite alter ego Claire, who emerged out of his oppressively macho childhood environment. Although part of his identity from an early age, and a significant influence in his work, Claire has only recently 'come out', appearing on his pots, in photographs and at art events, wearing costumes embroidered with his own designs. One such costume, worn by Perry for Claire's Coming Out, a performance staged in October 2000, was included in the Turner Prize exhibition, together with a selection of pots and photographs. What distinguishes Perry's use of an alternative self-identity from that of most other artists is that Claire is a poignantly real rather than imaginary figure, occupying a crucial role in his life and work: 'One of the reasons I dress up as a woman is my low self esteem, to go with the image of a woman being seen as second class. It is an outsiderish stance ... It is like pottery: that's seen as a second class thing too' (ibid., p.33).

Perry's fearless engagement with the more disturbing effects of our culture has been summed up by Andrew Wilson: 'What Perry enacts ... throughout his work is an opposition between an orthodox world of conventions and values, and a perverse grotesque world which calls accepted hierarchies into question' (ibid., p.86).

Jake and Dinos Chapman

Working together since the early 1990s, the Chapman brothers have developed a 'terrorist' aesthetic, with which they have shocked and provoked. Their use of obscene imagery, ironic, inflammatory statements and scatological humour

Dinos Chapman
1962 Born in London
1979–81 Ravensbourne
College of Art
1988–90 Royal College
of Art, London

Jake Chapman
1966 Born in
Cheltenham
1985–8 North East
London Polytechnic
1988–90 Royal College
of Art, London

has caused some critics to dismiss them as misanthropic, puerile pranksters. However, as Stuart Morgan has observed, like the American artist Jeff Koons, the Chapmans make art precisely in order to excite critical response, which subsequently becomes part of the work (Stuart Morgan, 'Rude Awakening', *Frieze* issue, 19 November –December 1994, p.32).

Taking their lead from the work and writings of the Surrealists – particularly Hans Bellmer and Georges Bataille – they have confronted the viewer with artworks that, by any normal codes should be abhorrent and repulsive. Forcing the viewer to experience both disgust and pleasure, the artists aim to shatter any complacency regarding interpretation of aesthetic experience. A consistent strategy to this end has been the opposition of offensive subject matter with a highly-crafted, visually seductive technique.

In autumn 2002, the brothers exhibited *Works from the Chapman Family Collection* at White Cube in London. Aping the dimly lit, hushed conditions of an ethnographic museum, they displayed what appeared to be an extraordinary array of tribal sculptures. These were in fact exquisitely crafted, fake 'primitive' artworks, based on free plastic gifts or embellished with McDonald's logos. As one might expect, the artists perversely claimed that their aim was to turn McDonald's into a religion, rather than to comment on the oppressive and exploitative nature of cultural and economic globalisation.

Though drawing on mass-consumer culture for much of their imagery and materials, the Chapmans have often referred to the history of art. A key source has been the work of the nineteenth-century Spanish artist Francisco Goya, particularly his series of etchings *The Disasters of War*, depicting human cruelty. In one of their best-known works, *Great Deeds, Against the Dead* (1994), they realized one of Goya's gruesome etchings as a life-sized sculpture, using mutilated retail mannequins. Yet they rendered his horrific image of castrated figures unsettlingly absurd by means of a slick, airbrushed finish and high-street wigs.

The Chapman's Turner Prize display included *Insult to Injury* (2003), shown in their exhibition at the Museum of Modern Art, Oxford, 'The Rape of Creativity' (a title taken from a book by Bataille). For art lovers, it is perhaps their most shocking work, since it comprises a mint-condition set of Goya's *The Disasters of War* etchings, which the artists have defiled, or, in their words 'rectified', by drawing clown or puppy heads over those of the victims. Such defacement of a work of art has a precedent in the mid-twentieth century, when American artist Robert Rauschenberg erased a drawing by Willem de Kooning, an eminent artist of the previous generation. However, the Chapmans have not destroyed Goya's prints, but twisted and perhaps intensified their impact. As one critic commented: 'What the Chapmans have released is something nasty, psychotic and value-free; not so much a travesty of Goya as an extension of his despair ... The Chapmans have remade Goya's masterpiece for a century which has rediscovered evil' (Jonathan Jones, 'Look What We Did', *Guardian*, 31 March 2003).

The Turner Prize exhibition also featured two new sculptures, *Sex* (2003), a reappropriation of their earlier *Great Deeds Against the Dead*, and *Death* (2003), its companion piece. *Sex* is a bizarre, gothic representation of death – a lurid assemblage of joke-shop props and medical skeletons cast in bronze, the mutilated bodies crawling with carefully painted flies and maggots. *Death* is a life-size bronze cast of two inflatable sex dolls lying on a lilo engaged in oral sex. As a representation of pleasure for its own sake, it perhaps relates to the artists' desire to produce a series of works to 'be consumed and then forgotten' (quoted by Lizzie Carey-Thomas, *Turner Prize* broadsheet, 2003, n.p.).

Describing themselves as anti-humanist, the Chapmans have produced a body of work that is morally ambiguous, a visual manifestation of their opposition to the pervasive notion of art as redemptive. They have commented, 'we are intensely pessimistic about the job of being an artist and about what art does socially. But our cynicism translates into humour ... when someone laughs at something we've opened an abyss. Everything falls in' (ibid.).

Jake and Dinos
Chapman
Insult to Injury 2003

Jake and Dinos
Chapman
Sex 2003

Willie Doherty
1959 Born in Derry, Northern Ireland
1977–81 Ulster Polytechnic
1995 Glen Dimplex Artists' Award, Irish Museum of Modern Art, Dublin
1999 DAAD Scholarship in Berlin

Willie Doherty

From the outset of his career in the early 1980s, Doherty's works have usually referred in some way to his native Derry and the surrounding area. Yet, increasingly, his photographs and video installations have achieved a level of detachment that gives them a relevance beyond the specifics of his own experience and community.

Experimenting with a variety of familiar photographic and cinematic devices and techniques, Doherty has continued to produce work that subtly critiques the ways in which film and photography contribute to the shaping of personal and public 'reality'. He has said: 'Photography continues to point to aspects of the "real" subject, whatever that subject is (a landscape, a person, etc.), but there is a whole layer of that subject's activity that photography just can't represent or get to adequately. Photography is thus an inadequate tool, inadequate to the role it has been assigned by society' (quoted by Carolyn Christov-Bakargiev, *Willie Doherty: False Memory*, exh. cat., Irish Museum of Modern Art, Dublin 2002, p.11).

Doherty's retrospective exhibition at the Irish Museum of Modern Art, Dublin, highlighted his fascination with the themes of memory and identity. He has been particularly interested in the impact of the media on individual and collective memory, as revealed by false-memory syndrome, in which memories of past events and experiences – distorted by photography, advertising, television and cinema – are confused or inaccurate. In the slide projection *30 January 1972* (1993), Doherty researched memories of Bloody Sunday – a traumatic and defining event in the history of the troubles in Northern Ireland, when thirteen protestors were shot dead by British soldiers – by comparing eyewitness accounts with those remembered through media reports and documentation.

In such recent works as *Retraces* (2002) Doherty has continued to consider the ways in which media conventions might shape memory. On seven monitors installed at varying heights, the artist presents related video sequences – all shot using a static camera position – of locations in Derry, Belfast and the Derry–Donegal border. Each sequence carries a subtitle, indicating a specific date, time or place. The subtitles echo the cinematic convention of establishing a change in location. Used here, they draw attention to our own attempts to classify and verify experience by fixing it in a specific time and place.

A human presence in Doherty's work has often been implied through devices such as a voiceover, or a hand-held camcorder moving through an environment. In recent works the figure has become more explicit, no more so perhaps than in *Re-Run* (2002), which represented Britain at the XXV São Paulo Biennial in 2002, and was shown in the Turner Prize exhibition. A man in a suit and tie is the dynamic focus of the work. He runs along the middle of a bridge at night, the sense of urgency and threat amplified by the dramatic contrast of his glowing white shirt with the red light surrounding him. The piece is presented on two suspended screens positioned at opposite ends of a dark space: on one, the man is shown running towards the viewer; on the other he is running away. Each sequence is a compilation of wide, mid or close-up shots of the figure, edited so quickly that he appears to be running continuously. He is caught in an endless loop, so that he appears to be running continuously, destined never to escape, or to reach his destination. Although set on the Craigavon Bridge across the River Foyle, which literally and symbolically divides the opposing Catholic and Protestant communities in Derry, *Re-Run* – and the existential moment it conveys – could easily be taking place anywhere.

Doherty has subtly yet rigorously challenged the objectivity of the visual and verbal language that articulates our subjective experience. His achievement has been summed up by Carolyn Christov-Bakargiev: 'Doherty has effectively laid the ground for an art that explores the relationship between personal experience and social reality, individuals and collectives, individual memory and collective memory' (ibid., p.17).

More information about Doherty's work can be found under 1994, when he was also shortlisted for the Turner Prize.

Willie Doherty
Re-Run 2002

Anya Gallaccio

Since the early 1990s, Gallaccio has been committed to exploring the physical and metaphorical properties of natural materials. She has commented: 'I see my work as being a performance and collaboration ... there is unpredictability in the materials and collaborations I get involved in. Making a piece of work becomes about chance – not just imposing will on something, but acknowledging its inherent qualities' (quoted by Rachel Tant, *Turner Prize* broadsheet, 2003, n.p.). A combination of visual drama and formal simplicity often belies the many elements of meaning she draws into the work – art-historical, social, mythical, political and personal.

Her work usually emerges from the specifics of a particular location and the unpredictability of such materials as fruit, flowers, sugar and ice, which transform over time through a natural process of decay. Her fascination with process, akin to the work of Italian Arte Povera artists of the 1960s, has been part of a strategy to develop an aesthetic that proposes an alternative set of values to those of museum culture, based on natural, rather than man-made systems.

Gallaccio's recurring themes of loss, beauty and femininity coalesced in works comprising cut flowers, left to rot under a sheet of glass. One such work, *preserve beauty* (1991–2003), made of 1,600 red gerberas, was shown in the Turner Prize exhibition. The exquisitely formed, carefully cultivated gerberas also function as a ready-made, the basic unit for art promoted by Minimalist artists of the 1960s such as Donald Judd and Carl Andre. Perhaps drawing on the example of Eva Hesse (1936–70), Gallaccio has further re-interpreted Minimalism and pursued Arte Povera's 'aesthetic of the organic' in other works, notably in *intensities and surfaces* of 1996. Exhibited in a former pump station in Wapping, East London, this thirty-four-tonne block of ice was constructed from slabs, each weighing 200 kilos, giving it a typically minimal, geometric shape. Yet, at its heart was a lump of rock salt, which hastened the sculpture's erratic transformation and demise.

More recently, and perhaps surprisingly, Gallaccio has cast natural objects such as trees in bronze, a medium traditionally favoured by artists for its durability. However, she has made the material her own. Using the 'lost-wax' method of casting, which in this case involves burning the wood of the tree out of a plaster shell, Gallaccio introduces an element of chance and explores her interest in cycles of transformation. In *because I could not stop* (2002), included in the Turner Prize, a tree cast in bronze is adorned with real apples, then left to rot gradually and fall to the gallery floor. By contrast, the cast tree remains, the process of growth and decay frozen in time by the metal.

In 2002, the Duveen galleries – Tate Britain's cavernous architectural spine – provided Gallaccio with a venue rich in historical associations. In response to landscape paintings in adjacent galleries, and the centrality of landscape to traditional notions of Britishness, the artist installed seven English oak trees, which were felled and cut from the Englefield Forestry Estate in Berkshire. Durable and powerful, the oak is an exemplary signifier of British heritage and character. Austerely presented, Gallaccio's forest of trunks echoed the verticality of the gallery's columns. In this location the trees, planted at the time of the French Revolution, were transformed into magnificent cultural artefacts, testifying to both the power and fragility of nature. She also exhibited slabs of solidified sugar syrup, made from Norfolk-grown sugar beet. In a museum founded on a colonial sugar fortune, this material was particularly resonant. But the wider context of the museum in general seems to have prompted Gallaccio's exploration of sugar, which is used for preservation.

Heidi Reitmaier has commented on the distinctive sensibility underlying the artist's approach: 'Gallaccio's ... ability to oscillate between the personal and the art historical, from the avant-garde (and its conventions) to the experimental, and from the factual to the fictional means you can't pin the work to a particular genre or school of practice. For her, discovering the new is more important than inscribing or building on a legacy' (ibid., p.43).

Anya Gallaccio
1963 Born in Paisley, Scotland
1984–5 Kingston Polytechnic
1985–8 Goldsmiths' College, London

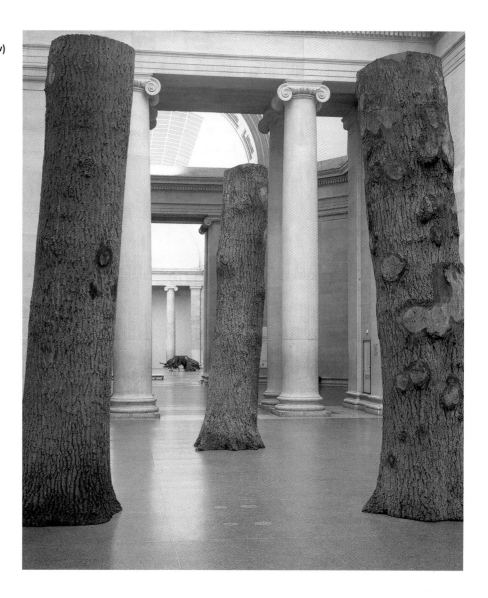

Anya Gallaccio
beat (installation view)
2002
Foreground:
As long as there were
any roads to amnesia
and anaesthesia still
to be explored

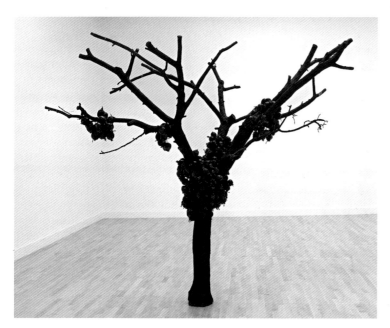

Anya Gallaccio
because I could not
stop 2002 (detail)

Winner
Jeremy Deller

Shortlisted Artists
Kutluğ Ataman for his poignant and
incisive video installations, which
describe the lives of individuals, creating
intimate portraits while addressing
broader social concerns, as shown
at the Istanbul Biennial and other
European venues
Jeremy Deller for *Memory Bucket*,
a mixed-media installation at Art Pace,
San Antonio, documenting his travels
through the state of Texas. This
continued Deller's personal investigation
of the social and cultural make-up that
defines different societies
Langlands & Bell for *The House of Osama
bin Laden*, an exhibition first shown at
the Imperial War Museum, London,
featuring photographs, digital
animations and video works made
following their visit to Afghanistan,
which extended their interest in
buildings, their histories and how we
relate to them
Yinka Shonibare for his sculptural
installations in which he continues
to use African fabric to subvert
conventional readings of cultural
identity, as seen in his exhibition
Double Dutch at the Museum Boijmans
Van Beuningen, Rotterdam, and
in his solo show at Stephen Friedman
Gallery, London

Jury
Catherine David
Director of the Witte de With Centre for
Contemporary Art, Rotterdam
Adrian Searle
Art critic, *Guardian*
Robert Taylor
Representative of the Patrons of New Art
David Thorp
Curator, Contemporary Projects, Henry
Moore Foundation
Nicholas Serota
Director, Tate and Chairman of the Jury

Exhibition
20 October–23 December 2004
Prizes of £25,000 to the winner and
£5,000 each to the other shortlisted
artists presented by Jon Snow,
6 December 2004

By 2004, Channel 4's remarkably
successful sponsorship of the Prize had
come to an end. But new sponsors,
Gordon's Gin (owned by Diageo plc),
seemed keen from the outset of their
three-year sponsorship to outdo their
predecessors by introducing some
significant improvements, notably by
doubling the prize money to £40,000.
With this increase it was now possible
not only to up the winner's prize from
£20,000 to £25,000, but to acknowledge
the achievements and contribution of
all shortlisted artists with a prize of
£5,000 each.

The aims of the Turner Prize were
clearly attractive to the new sponsors.
Speaking for Gordon's Gin in May 2004,
Mark Sandys commented: 'We are
delighted to be associated with the
Turner Prize which is one of the most
prestigious awards in the arts world ...
Our aim is to encourage the British
public to embrace new ways of thinking
about and making art. In turn we hope
to raise the awareness of the
craftsmanship, skill and creativity that
goes into producing a work of art'.

The shortlist for 2004 comprised
artists who worked mostly with film and
photography, which led to some critical
discussion about the nature of
contemporary art practice. For example,
Nigel Reynolds, arts correspondent for
the *Daily Telegraph*, noted: 'There is not
a single painter on the list but it is heavy
with artists who make films and videos –
the consequence, one of the judges said,
of art students buying digital cameras
instead of learning to draw' (Nigel
Reynolds, 'Digicians wipe out paint for
the Turner generation', *Daily Telegraph*,
19 May 2004, p.10). Some critics
welcomed the shortlist as an accurate
reflection of current trends in art
practice. Writing in the *Independent*,
Michael Glover observed, '... what this
year's shortlist makes evident ... is that
artists now tend to be multi-disciplinary,
readily shifting from video to sculpture,
to drawing to painting and back again,
and often creating hybrid works from
several different disciplines at once
(Michael Glover, 'Video visions that
turn', *Independent*, 19 May 2004, p.14).

But the real surprise for most
commentators was that the jury had
selected 'substance over shock'. The

artists were mature, all in their late
thirties or forties, and their work – in stark
contrast to that of the 'Young British
Artists' (YBAs) – showed a strong interest
in sociological, anthropological or political
themes. Many journalists found a news
angle in the fact that Ben Langlands
and Nikki Bell had been shortlisted for
an exhibition held at the Imperial War
Museum, including a work comprising
a virtual tour of the putative former house
of Osama bin Laden.

The shortlist was either praised as
'strong, uncompromising, intellectual'
(Rachel Campbell-Johnston, 'From Shock
and Awe', *The Times*, 19 May 2004, T2,
p.12), or condemned as serious but 'dull',
lacking the excitement aroused by the
YBA generation (Nick Hackworth,
'BritArt's new yawn', *Evening Standard*, 18
May 2004). Although a self-confessed fan
of Jeremy Deller's work, *Guardian* critic
Jonathan Jones concluded: 'The Turner
Prize traditionally upsets the *Daily Mail*
by making Britain a land unfit for water-
colourists. This year it has found a new
way to annoy – by selecting a shortlist of
political artists ... The exhibition can be
guaranteed to make you vomit' (Jonathan
Jones, 'It makes you think – but virtue
can be a bore', *Guardian*, 19 May 2004).

Such divided opinion was, if anything,
reinforced when the show opened in
October. For Richard Dorment, who as art
critic of the *Daily Telegraph* had frequently
defended some of the more radical Turner
Prize artists, the exhibition for 2004
was a disappointment. He commented:
'Tate Britain has mounted the Starbuck's
of art exhibitions: a show of almost
interchangeable artists all working with
film and video and all politically engaged
in exactly the same, wholly predictable
way' (Richard Dorment, 'Tell me
something new', *Daily Telegraph*, 20
October 2004, p.18). His view was echoed
by many commentators. Craig Burnett,
for instance, quipped, 'Well, let's face it:
this is not a memorable Turner. Heavy-
handed, dull, this is art as a sociology
lesson' (Craig Burnett, 'Picks of the Week',
Guardian, 29 November 2004, p.18). But
Tate Britain's director, Stephen Deuchar,
hoped that the exhibition would refute
the British public's perception that
contemporary art was self-absorbed:
'I think the public is inclined to think that
the art world is very self-referential and

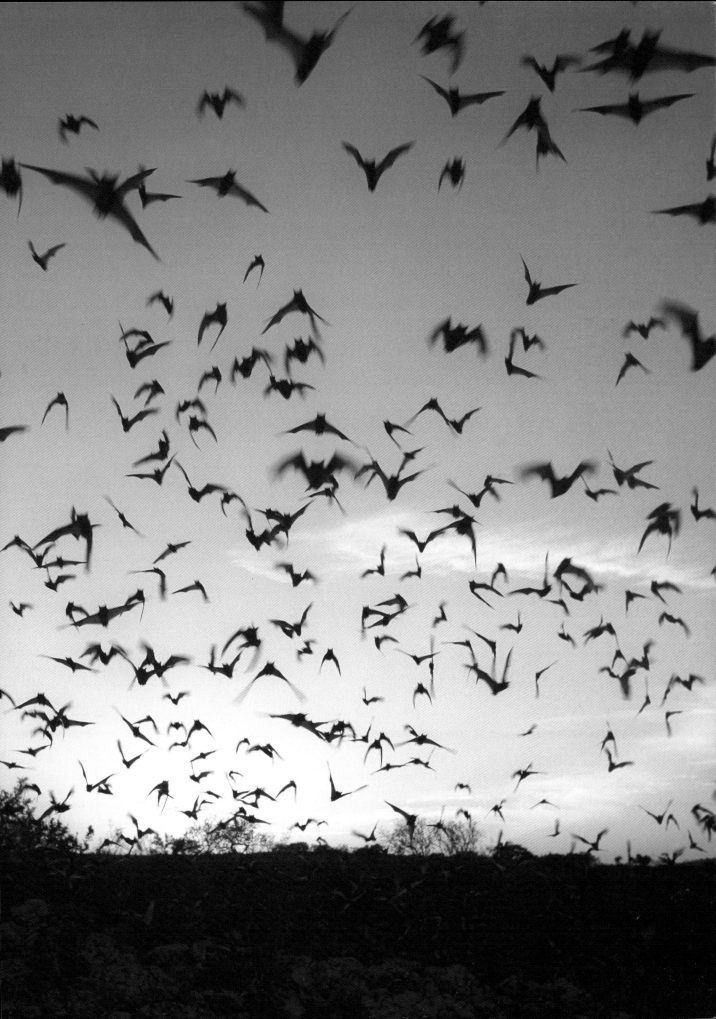

Jeremy Deller
1966 Born in London
1985–6 Courtauld
Institute of Art

that artists don't think beyond their own lives. But this show demonstrates a very committed engagement with subjects that are way beyond the art world and are much more about the human condition in an international context' (quoted by Louise Jury, 'Turner shortlist sees artists turn political', *Independent*, 20 October 2004, p.20).

That the artists were engaged in 'real' political issues was confirmed when, a few days prior to the opening of the exhibition, Langlands & Bell were forced to remove a politically sensitive work from the show on the advice of Tate lawyers. Their film *Zardad's Dog* was shot in Afghanistan in October 2002 and comprised footage of the trial of notorious assassin Abdullah Shah at the Supreme Court in Kabul. In the autumn of 2004 the contents of the film were considered to have a bearing on the trial of Shah's alleged employer, Afghan warlord Faryadi Sarwar Zardad, then taking place at the Old Bailey in London. Despite the difficulty and disappointment at having to remove a third of their exhibition, on the withdrawal of their work Langlands & Bell commented: 'We fully support the laws and the reasons for them. It's not a matter of censorship; it's a matter of justice and security for the witnesses who are giving evidence' (quoted by Louisa Buck, 'Langlands & Bell for law and justice', *Art Newspaper*, no.152, November 2004, p.32). In place of the work in the gallery they were obliged to project the statement, 'Due to the trial of Faryadi Sarwar Zardad currently in progress at the Old Bailey this work has been temporarily removed following legal advice'.

On the whole, public comments tended to reflect those of the critics confounded by the apparently documentary style of much of the work on display. Waldemar Januszczak devoted his review of the exhibition to tackling this issue, pointing out that from Trajan to Raphael, artists have traditionally engaged with social and political concerns. He concluded: 'This is ... an excellent Turner prize selection – one of the best I've seen. The award should go to Deller, for holding up such a pin-sharp mirror to the poor cut of our times' (Waldemar Januszczak, 'Does the Turner Prize annoy you? It should', *The Sunday Times*, Culture, 7 November 2004, p.7).

Januszczak was vindicated when bookies' favourite Jeremy Deller won the prize. The *Guardian* reported that Deller, describing himself as 'not a technically capable person', was a popular choice, being 'almost unnaturally well-liked both by the art world and general public' (Maev Kennedy, 'Turner prize shock: out of four serious competitors, the best artist wins', *Guardian*, 7 December 2004). But some papers chose to squeeze a story out of Deller's comment that he was glad his teacher had deterred him from taking art 'O' level, with the *Daily Telegraph* for example running this under the headline 'Can't paint, can't draw ... meet the Turner Prize winner' (Nigel Reynolds, *Daily Telegraph*, 7 December 2004, p.5), while the *Evening Standard* opted for 'Turner prize winner was rubbish at art, says teacher' (News in Brief, *Evening Standard*, 9 December 2004). In an interview with the artist the day after the award ceremony, Stuart Jeffries quizzed Deller: 'You can't draw, you can't paint – how do you get the nerve to call yourself an artist?' To this Deller replied: 'The thing is – the world has moved on. You're not writing with quills on parchment. Why is art the only thing that can't progress in terms of the means of production?' (Stuart Jeffries, 'It was really, really horrible', *Guardian*, 8 December 2004, p.6).

Jeremy Deller

Jeremy Deller acts as a catalyst for a broad spectrum of creative projects, yet he rarely locates himself at the centre of the action. Instead, he adopts the role of mediator, director, publisher or curator, instigating collaboration in others as a way of engaging with specific historical, social and geographical subjects. Deller's aim is to draw attention to activity taking place on the fringes of the mainstream, from forms of self-expression linked to vernacular or folk culture, to overlooked events that he feels warrant a reappraisal.

The performative nature of Deller's practice and its reliance on participation ensures that it is only truly activated in the public realm, either through covert intervention in the form of fly-posters, signs or billboards intercepted by the

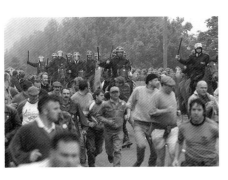

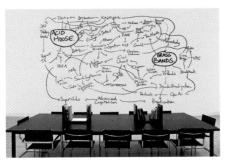

Jeremy Deller
The Battle of Orgreave
2001

Jeremy Deller
*The History of the
World* 1997–2004

unsuspecting passer-by, or through orchestrated events that bring together different cultural traditions and social groups according to his own idiosyncratic logic. With *Acid Brass* (1997), he invited a traditional brass band to play reworked acid-house anthems, at once operating within as well as subverting existing genres to create something wholly new. The political and historical connections between the two apparently oppositional musical styles are mapped out diagrammatically in Deller's key work *The History of the World* (1997–2004), presented as a large-scale wall painting in the Turner Prize exhibition. Both types of music were representative of northern working-class communities and, for the artist, indicated a staunch form of resistance to Thatcher's government in 1980s Britain.

Part alchemist, part social-anthropologist, Deller is often concerned with recontextualising the recent past to reveal hidden histories that deviate from a prevailing view. *The Battle of Orgreave*, commissioned by Artangel in 2001, brought together veteran miners and members of historical re-enactment societies to restage as accurately as possible one of the most violent and controversial clashes between miners and police during the 1984–5 strike. This audacious project, which resulted in a film directed by Mike Figgis, a book and an audio recording, hinged on the trust and co-operation of the thousand or so people involved, many of whom had taken part in the original conflict. Deller describes the project as the 'exhumation of a corpse', resurrecting the raw emotions of the period and attempting to uncover a fresh account of an event notoriously distorted by the media. *The Battle of Orgreave* functions as a piece of 'living history', a postscript to the event rather than purely a restaging.

What characterises Deller's approach is his obsessively demotic drive: not only his inclusiveness but also the sincerity with which he approaches all his subjects, no matter how playful or trivial they may appear. His commitment to a project, once initiated, is unwavering. Most of his projects take his own enthusiasms as a starting point and rapidly gather momentum to incorporate an ever-widening circle of communities and situations.

In his recent work Deller has moved away from excavating British cultural heritage to looking at specific geographical locations. To mark the opening of the international art biennale Manifesta 5 in 2004, he organised a parade on San Sebastian's central boulevard comprising a cross-section of the city's low-profile social groups, from fencers to surfers to members of the gay community. It was a celebratory affair, producing an extraordinary aural and visual cacophony and flamboyantly exposing the diverse social fabric of the city.

The relationship between private and public, personal experience and collective history, weaves through all Deller's work and is particularly pertinent to two projects charting the cultural landscape of the United States. *After the Goldrush* (2002) is a guidebook of sorts to Northern California. It was shaped by the people whom Deller met during his year-long residency in San Francisco, from the director of the Exotic World Museum of the Burlesque to an ex-Black Panther turned gallery director. Their personal narratives reflect a wider American history and, combined with various cultural landmarks highlighted by Deller, present a complex portrait of a state traditionally associated with tolerance and liberation and yet equally notable for its proliferation of prisons.

In his documentary-style film *Memory Bucket* (2003), featured in the Turner Prize exhibition, Deller turned his attention to recent events in Texas, focusing on two politically loaded locations, Waco and President Bush's home town of Crawford. Collaging together interviews and archive footage, the work juxtaposes the public face as presented through the media with first-person accounts. These include interviews with a survivor of the Branch Davidian siege, the owner of Bush's local diner, and an elderly Quaker woman, who quietly but cogently presents her motivations for attending an anti-Bush rally. Deller's decision to linger in the closing moments of the film on the extraordinary evening ritual of three million bats emerging from a cave illustrates the resilience of the rhythms

of the natural world over thousands of years, in contrast to the transience of current socio-political events.

Deller often delves unashamedly into controversial territory. Yet his emphasis on empowering people to represent themselves through their genuine passions serves both to avoid mawkish sentimentality and to deflect accusations of cultural tourism. Underpinning all his work is the belief that art cannot and should not be segregated from the world at large, or severed from the conditions of its making. He is aware of the power he holds as an artist, and uses it to gain access to sources, people and the media. His art could be viewed as both celebratory and shot through with melancholy; it is at once an affirmation of the ways in which self-expression can instil life with value and meaning, and a memorial to life's passing.

Kutlug Ataman

Kutlug Ataman's work is poised on the boundary between documentary and fiction. It explores the fragility of personal identity and the possibility of its change and reconstruction through simple acts of storytelling. His films are deliberately modest in technique, but reveal the complex texture of memory and imagination, truth and fantasy, fact and reality from which our understanding of everyday life is composed. Ataman uses a hand-held camera and shoots from a close, sometimes even claustrophobic, single viewpoint. The films retain an immediacy reminiscent of home movies, but are presented as multi-screen and multi-layered installations to accommodate the density of the narratives he records.

Ataman's subjects are individuals who, through circumstance or choice, have become dislocated from conventional social or behavioural categories, and feel compelled to reinvent themselves. They reveal their personalities with a disarming frankness and their extraordinary narratives are always allowed to take centre stage. Ataman focuses on their use of language to communicate who they are, to elicit emotions, to create narratives and to fix meaning. Their speech becomes the primary action. He believes that, 'Identity

is not something that you possess, but something that people make you wear' and that, 'Talking is a form of rebellion, because you can work against these perceptions ... Talking is the most meaningful activity we are capable of.'

In the Turner Prize exhibition Ataman was represented by *Twelve* (2003), a multi-screen installation made in response to the political situation in the Middle East. It was filmed in south-east Turkey, near the border with Syria, in an Arab community that believes in reincarnation. *Twelve* shows one of the ways in which this community makes sense of horrific loss. Its members believe that everyone is reborn, but that only those who have suffered violent or untimely deaths can remember their past lives. Significantly, beliefs similar to this are often held in communities with recent histories of war or persecution: if the soul never dies, death need not be so feared – and conversely, life can, if necessary, be sacrificed. Memory takes the social form of a suture, a wound-healing.

In *Twelve*, six individuals talk about the impact of their past lives on their present one. Each is shown at life size and in portrait format, on a separate projection screen suspended in the gallery. The viewer sits facing them, like listeners in a storytelling culture. Ataman's subjects range in age from their early twenties to their sixties, and are filmed in their own home or place of work. For them, reincarnation is not a belief, but a certainty. In a totally matter-of-fact way they recount their deaths in their previous lives, their experiences after death and their rebirth. Some show the scars they believe they still carry from their deaths.

Sometimes the subjects have sought out their past-life families, and it is quite usual for them to be accepted by these strangers. As they talk about these relationships, where they may have past-life children who are the same age as they are, or a wife who is twice their age, the narratives become confusing. It is sometimes hard to keep track of which family and which life they are talking about as they move between 'then' and 'now' and past and present parents, spouses, siblings and offspring, sometimes referring to themselves with

Kutlug Ataman
1961 Born in Istanbul
1983-8 University of California

Kutlug Ataman
Stills from *Twelve*
2003

different pronouns in the same sentence.

To Ataman, it is this quality that differentiates this work from his previous pieces, because it highlights a particular limit of language. In earlier films, he revealed the mechanism of the narrative construction of identity by documenting the activity of speaking. But as the subjects of *Twelve* attempt to tell their stories, language becomes strained. As Ataman explains, the grammar of any language deals with 'one type of reality – which is life ... In *Twelve*, since they switch between talking about present and past lives in such a natural way, language becomes insufficient, and slowly one succumbs to a state of confusion – which is also very interesting, because reality as we understand it becomes slowly modified and irrelevant.'

Compelling as these films are when seen as documents of social and personal history, it is the process of that documentation that is most significant in this work. Ataman's films reveal how all narratives are to some extent fabricated: 'All documentary is a narrative and all narrative is constructed. All narratives, hence all lives, are in the end created as art by the subject.'

Langlands & Bell

The diverse collection of works by Langlands & Bell that makes up *The House of Osama bin Laden*, for which they were shortlisted, resulted from an intense two-week stay in Afghanistan, commissioned by the Imperial War Museum, London. On first encounter the works appear restrained, given the extremity of the situation experienced, yet each serves to question our expectations and understanding of the aftermath of war in the twenty-first century.

Whereas the British tradition has been to commission artists to record events on the front line, Langlands & Bell were dispatched in October 2002 to consider the post-war environment. The complete lack of any military presence in the works is conspicuous; they focus instead on what happens once most of the international forces, and therefore the majority of the world's media, have moved on. A further contrast is that these artists, who have worked together

Ben Langlands
1955 Born London
1977–80 Middlesex
Polytechnic

Nikki Bell
1959 Born London
1977–80 Middlesex
Polytechnic

since the late 1970s, emphasise a conceptual rather than purely narrative or figurative approach. Their previous work has tackled subjects such as the physical and symbolic layouts of corporate and civic architecture and the coded matrix of international air travel: themes that were unexpectedly thrown into sharp relief by the tragedy of September 11 2001, and the resulting global events that continue to unfold.

Arriving in Afghanistan, the artists were immediately struck by the number of non-governmental organisations (NGOs) operating there – approximately 120 international NGO and UN agencies and 160 local Afghan NGOs in Kabul alone. The logos of these supposedly independent NGOs were displayed in the exhibition as a series of flags, the age-old props of war. The accumulative effect of these is to encourage the viewer to question the roles of these ubiquitous international charities: do they actually serve the interests of the destitute Afghan civilians?

In an accompanying work, *NGO (Part 1)*, the acronyms of these organisations were presented as an eloquent digital sequence of images that multiply, transform and dissolve into each other. Both formally and conceptually, this piece relates closely to *Frozen Sky* (1999), a digitally controlled neon sculpture that randomly links the acronyms of airports around the world. The city codes were chosen both for the range of their distribution and for their formal qualities, rather than making any specific connections between the locations, and the font, Avenir, was selected for its aesthetic attributes. As with the subsequent work using NGO acronyms, the formal quality of these strange languages exercises a powerful fascination for Langlands & Bell.

During their visit, the artists made a dangerous expedition to an isolated house briefly occupied by Osama bin Laden in May 1996, when he arrived in Afghanistan from Sudan. Partially bombed by American B52s when the Taliban refused to surrender bin Laden to the United States, this building becomes as symbolic as the Twin Towers. After their return to London, the artists recreated it as an interactive virtual animation, in collaboration with

Tom Barker's V/Space LAB. Much has been written about modern warfare as a media event, with bombing raids sometimes said to be influenced as much by the need to make captivating television images as by military strategy. There is also a great deal of literature about the influence of video games on violent behaviour. *The House of Osama bin Laden* occupies ground in between these two thoroughly contemporary visual experiences. Viewers can navigate their own route and may be keen to invest meaning in the eerie but mundane surroundings, but they will gradually become frustrated by the experience. There are no weapons provided and no target, none of the thrills found in a conventional video game or modern warfare.

In the work, as on the world stage, bin Laden remains elusive, his absence symbolising the inconclusiveness of the ongoing 'war against terror'. Langlands & Bell comment: '*The House of Osama bin Laden* explores ways in which evidence of the identity of the presence of a person may be discovered, revealed or projected in a locality after their departure ... Architecture is one of the most tangible records of the way we live. Buildings tend to encapsulate our hopes and fears at many levels while also reflecting the persistent human will to plan events.'

Yinka Shonibare
Yinka Shonibare's art is visually spectacular, a decadent fusion of unrestrained colour and pattern. In media ranging from painting and sculpture to photography, installation and film, he playfully opens up to question the categories and stereotypes that society has adopted in order to 'make sense' of the modern world. It is the grey areas of human experience that interest Shonibare. Accepting nothing at face value, his art engages with social, cultural and political issues that shape our histories and construct our identities.

Shonibare grew up in both London and Lagos. He considers himself 'truly bi-cultural' and embraces the variety of experience offered by global living. When faced with pressure to produce 'African' work at art school, his response was wilfully to subvert any attempt to categorise him. He adopted his now

Langlands & Bell
The House of Osama bin Laden 2003

Due to the trial of Faryadi Sarwar Zardad currently in progress at the Old Bailey, this work has been removed temporarily following legal advice.

Langlands & Bell
Zardad's Dog 2003
Substitute projection 2004

Yinka Shonibare
1962 Born in London
1984–9 Byam Shaw
School of Art, London
1989–1991
Goldsmiths' College,
London

trademark 'African' Dutch-wax or batik fabric as a substitute for conventional art materials, finding in this textile a metaphor with which to tackle the complex notion of authenticity. Originating in Indonesia, the batik printing technique was industrialised by Dutch colonisers in the mid-nineteenth century before being copied by the British, who then exported the printed fabric from factories in Manchester to West African markets. Since the 1960s the fabric has been synonymous with the postcolonial celebration of African independence and national identity. By juxtaposing this fabric with Western objects and images in his art, Shonibare reveals it to be both genuine and fake; by making use of its questionable origins he brings about a transformation of perception.

In the 1990s Shonibare started to produce vivid and richly textured paintings that questioned the role and function of painting itself and challenged the heroic gestures of modernist, abstract art. Substituting the canvas with small, regimented squares of 'African' fabric, he makes reference to the restrained, grid-like compositions of Minimalist art but then subverts it by introducing excessive colour and organic patterning. Creating 'high' art from commonplace, non-Western cloth bought at Brixton market, he pushes the boundaries of taste with a uniquely political edge. *Maxa* (2003) continues his attempt to reinvent painting as a place for public discussion but in a more joyful and informal way. Numerous disks covered with cloth, and decorated on both front and sides like icing on a cake, are placed on a vibrant blue ground. Typically, however, sensual pleasure is subtly undercut. Shonibare plays with the decadence of the pattern and the problematic history of the fabric, finding metaphors for excess and its flipside, exploitation.

Social stereotypes and cultural icons are frequently used by Shonibare as a way of questioning accepted values. In his flamboyant installation *The Swing (after Fragonard)* (2001) he takes an icon from eighteenth-century European art and recreates the flirtatious scene of an elegant young woman kicking out her legs from a froth of petticoats, while lounging on a swing. But Shonibare

is selective with the elements he extracts from the original painting. For example, by excluding the priest who pushes the swing and the reclining gentleman gazing up the woman's skirts, he paradoxically draws out the 'naughtiness' of the rococo composition and implicates the viewer in the voyeurism of his sensuous pastiche.

In his first film, *Un Ballo in Maschera (A Masked Ball)* (2004) – presented together with *Maxa* and *The Swing (after Fragonard)* in the Turner Prize exhibition – Shonibare pushes his emblematic style of narrative to a new level, playing with the movement, sound and structure of the medium. The film depicts the assassination of King Gustav III of Sweden at a masked ball in 1792. Set in a rococo theatre in Stockholm, the film's action is played out through the medium of dance; unaccompanied by music or dialogue, the choreography and costume conjure up a visual feast.

Yet once again, nothing is straightforward. By splicing together different takes of the same scene, Shonibare rejects the notion of editing to achieve perfection, and references the structure of modernist film. His dancers act out the idea of the loop, traditionally employed in artist's video, and the idiosyncrasies of each re-run complicate the viewer's point of entry into the film. Conventional narrative is further undermined by a reversal of the performance; in undoing every action, the film's beginning, middle and end become indistinguishable. This masquerade parodies period costume dramas and provides a dramatic and open-ended metaphor for disguise and deception and the politics of representation. But typically, Shonibare refrains from moral statement by upholding the notion of play in his work. He engages the viewer on a visceral level and entertains us with a subtle humour that pricks our consciousness to open up debate.

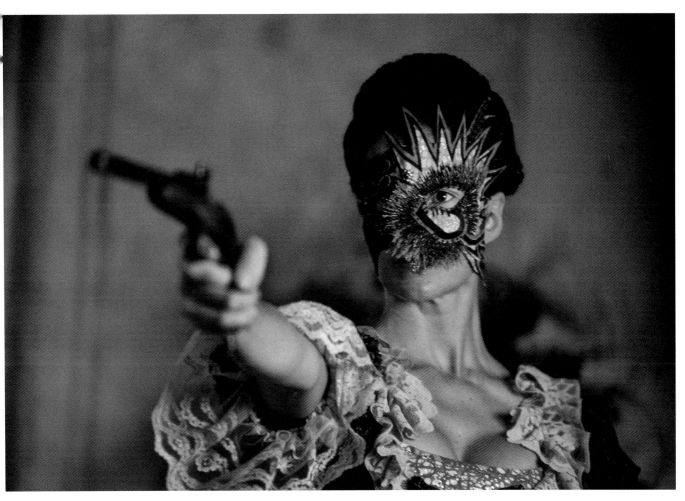

Yinka Shonibare
Un Ballo in Maschera
(A Masked Ball) 2004

Yinka Shonibare
The Swing (after
Fragonard) 2001

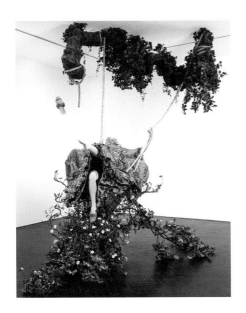

Winner
Simon Starling

Shortlisted Artists
Darren Almond for his exhibition at K21, Kunstsammlung Nordrhein-Westfalen, Düsseldorf in which he continued, through a range of media including film, photography and sculpture, to address the themes of time, space and memory, and their effects on both social and private histories
Gillian Carnegie for her solo exhibition at Cabinet, London, in which she continued her exploration of the properties of painting. Working within the traditional genres of landscape, still life, the nude and portraiture, she has incorporated a wide variety of subjects and techniques
Jim Lambie for solo presentations of his work at Sadie Coles HQ, London and Anton Kern, New York, in which he continued to produce exuberant installations and sculptures with reference to pop music and youth culture, transforming objects with such everyday materials as glitter and coloured tape
Simon Starling for his solo exhibitions at the Modern Institute, Glasgow, and the Fundacio Joan Miró, Barcelona. He transforms and reframes existing objects using a rigorous process of research, and through sculptural installations creates poetic narratives by drawing together disparate cultural and historical references

Jury
Louisa Buck
London-based contemporary art correspondent, *The Art Newspaper*
Kate Bush
Head of Art Galleries, Barbican Art Gallery
Caoimhín Mac Giolla Léith
Art critic and lecturer, Modern Irish Department, University College Dublin
Eckhard Schneider
Director, Kunsthaus Bregenz
Nicholas Serota
Director, Tate and Chairman of the Jury

Exhibition
18 October 2005–22 January 2006
Prizes of £25,000 to the winner and £5,000 each to the other shortlisted artists, presented by David Lammy, Minister for Culture, 5 December 2005

Simon Starling
Shedboatshed (Mobile Architecture No.2),
Turner Prize Installation,
2005

Media coverage of the announcement of the 2005 shortlist in June centred on the jury's inclusion of Gillian Carnegie, a young, figurative painter, exploring such traditional genres as landscape, still-life and the nude. That Carnegie was the first artist exclusively using paint to be shortlisted in five years provided the kind of headlines exemplified by the *Daily Telegraph*'s 'Turner Prize Shocker: the favourite is a woman who paints flowers. Whatever next?' (3 June 2005, front page). Carnegie was immediately made the even-money favourite by bookies William Hill. For once, it was felt, the prize accurately reflected the diversity of styles current in British art (see for example Peter Aspden, 'Shortlist reveals an eclectic landscape', *Financial Times*, 3 June 2005, p.15).

While the shortlist continued to be praised for its representation of differing practices, when the exhibition opened in October, most critics noted that with exception of Carnegie's ongoing series of 'bum paintings', there was little of shock-value to report. The exhibition was widely dubbed the 'Tame Turner'. Most scathing was Tom Lubbock's review for the *Independent* 'The Good, the Dull and the Bland', in which he dismissed the show as 'boring', with even his favourite Jim Lambie failing to produce his best work (18 October 2005, p.12). But not all critics were unmoved. Richard Dorment wrote enthusiastically: 'Jim Lambie should win this year. He is just such an original, unclassifiable artist. There is no one remotely like him working in Britain today – a great artist, a star' ('Flowers in a vase vs blood on the floor', *Daily Telegraph*, 18 October 2005, p.25). Others noted a wistful, nostalgic mood pervading the exhibition, with all the artworks conveying a sense of loss (Charles Darwent, 'The winner? Please place your bets now ...', *Independent on Sunday*, 23 October 2005, p.12).

Many of the tabloids scented a story in Simon Starling's *Shedboatshed*, which to the 'casual observer' appeared to be simply 'a shack' (Tom Kelly, 'The shed that became a boat that became a shed again ... and could win the Turner Prize', *Daily Mail*, 18 October 2005, p.19). But on the whole, critics seemed to admire Starling's craftsmanship and what they perceived as the eccentricity of his project.

While many Scottish critics were quick to celebrate the presence of two Glasgow-based artists in the Turner Prize as evidence of the continuing 'Glasgow miracle', *Scotland on Sunday*'s Iain Gale wrote enthusiastically about the entire show as, 'the most inspiring, intelligent and modest I can remember ... At a time of worldwide catastrophe and conflict it is significant that this year's show, while less overtly political and topical than the last, should be as eloquent, moving and reflective as I have ever seen it. I defy you to leave feeling less than jubilantly hopeful about the future of British art' ('Small but perfectly formed', *Scotland on Sunday: The Review*, 23 October 2005, p.2).

In the three weeks leading up to the award in December, as part of an ongoing commitment to encourage debate about the Turner Prize, sponsors Gordon's Gin initiated a 'Judge for yourself' tour. Launched at London Victoria railway station by Minister for Culture, David Lammy, and subsequently travelling to Manchester Piccadilly and Edinburgh Waverley, the tour aimed to take the Turner Prize to the public. It provided an estimated three million commuters across the length of Britain an opportunity to view a six-minute walk-through tour of the exhibition at Tate Britain, hear vox pops from visitors attending the show, use a screen-sized comments wall and enjoy a convivial complimentary G&T. Tate Britain's director, Stephen Deuchar commented, 'A pioneering initiative such as this will give many more people the chance to express an opinion ... We also hope it will inspire more people to take a trip to Tate Britain to visit the exhibition' (quoted by Shan Ross in 'Is it art? Here's a platform for you to have a say', *Scotsman*, 23 November 2005, pp.8–9).

Commenting on Starling's win – the bookies' even-money favourite prior to the award – the jury declared its admiration for his 'unique ability to create poetic narratives which draw together a wide range of cultural, political and historical references'. Not everyone agreed, notably the Stuckists, who annually exploit media coverage of the Prize to promote the cause of traditional artistry. The views of Charles Thomson, co-founder of the group were widely reported: 'The Turner should be renamed

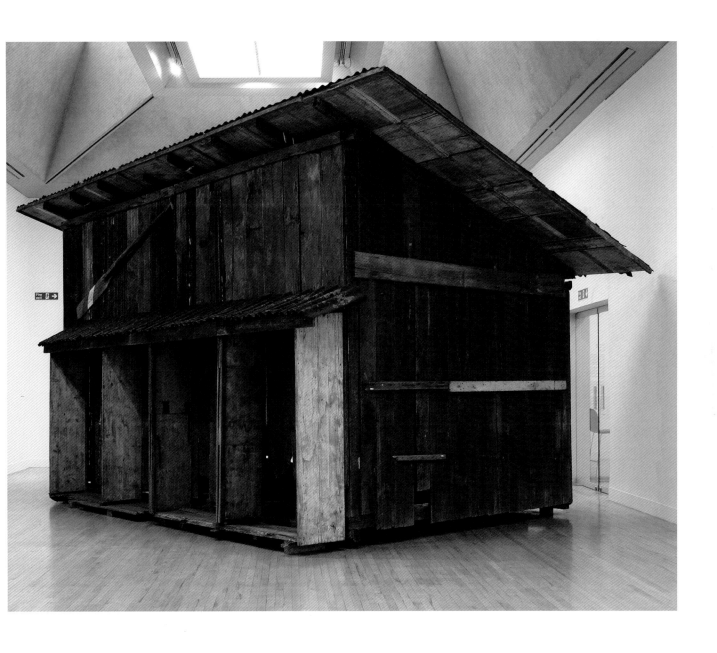

Simon Starling
1967 Born in Epsom
1990–2 Glasgow
School of Art

the B&Q DIY prize ... Starling should get his Craft Badge, 1st class, but not the Turner Prize' (Dalya Alberge, 'One man and his boat shed sail into a storm over the Turner', *The Times*, 6 December 2005, p.3). On the evening of the award, the Stuckists also protested outside Tate Britain against the purchase of Chris Ofili's series of paintings 'The Upper Room' while serving as a Tate Trustee, a purchase firmly defended by Tate director, Nicholas Serota.

Responding to accusations that the story behind the making of his work was more interesting than the end product, Starling commented, 'Some people will come to the work with a lot of knowledge, some not. That's true of any work of art ... Art for me is a free space to explore things. The things I do don't always come out looking like conventional works of art. But then I'm like any artist these days working in relation to a long history of art' (Starling interviewed by Stuart Jefferies, 'I've got a lovely poem from a lady in St Albans about sheds', *Guardian G2*, 7 December 2005, p.18).

Simon Starling

Simon Starling's work is usually triggered by a commonplace object, man-made or natural, that he rebuilds or reframes using a process of rigorous investigation. His painstaking research unravels a kind of convoluted narrative, a complex network of multi-layered relationships – cultural, historical, economic, political, geographical, ecological – that reveal the ways in which these often contradictory relationships shape the contemporary world. Francis McKee has observed that the 'skewing of time lies at the heart of many of Starling's projects – opening channels to the past and cutting across historical boundaries. By instigating a kind of perpetual motion, these works forestall the deadening of ideas and constantly modify experience' ('Chicken or Egg? Francis McKee on Simon Starling', *Frieze*, Issue 26, Jan–Feb 2001, p.76).

Like a number of artists of his generation, Starling has been particularly attracted to modernist design of the early twentieth century, his constructions often mimicking the aesthetic qualities of high-modernist style. Yet the imperfections of his hand-made, amateurish copies of

manufactured designs suggest a sympathetic and interested reconsideration of modernism, which, from the vantage point of the twenty-first century, can also encompass its failures (see Charles Esche, *Simon Starling*, Galeries für Zeitgenössische Kunst, Leipzig, 1999).

Making and remaking objects is central to Starling's practice, as he comments: 'The investment on a physical level energises the work and draws people in. It is the physical manifestation of a thought process' (quoted in Turner Prize broadsheet 2005). Remaking an object allows the artist to expose both the concealed processes of its construction and the cultural and economic systems that produce its value and meaning. For his project *Work, Made-Ready* at Kunsthalle Bern in 1997, Starling hand-built a bicycle using aluminium parts from a Charles Eames chair, a classic of modernist design, and reconstructed the chair using aluminium from a Marin bicycle. This laborious process resulted in a sculptural installation that played on Marcel Duchamp's idea of the ready-made, and on the relationship between the unique and the mass-produced: the iconic chair was transformed into an everyday commodity, yet at the same time became a unique hand-crafted work of art more valuable than its illustrious original. In the gallery, Starling displayed the two objects on either side of a glass wall, each with an explanatory text. As with many of his works, these texts or extended titles report the process or journey behind their making, what Starling has described as 'not the name of the dish, but the recipe' (Daniel Birnbaum, 'Simon Starling', *Art Forum*, Vol. XLI No.6, Feb 2004, p.105).

A key work for Starling in 2005 was *Shedboatshed (Mobile Architecture No.2)* (2005), which was represented in the Turner Prize exhibition. For this project, Starling transformed and re-transformed a shed from Schweizerhalle on the Rhine. The first stage was to dismantle the structure and then rebuild it as a local-style boat. Carrying the remains of the original building, the boat was subsequently paddled down river, before being reconstructed into a shed and displayed at the Museum für Gegenwartskunst in Basel. The economy

Simon Starling
Shedboatshed (Mobile Architecture No.2),
Production Stills, Basel,
Switzerland 2005

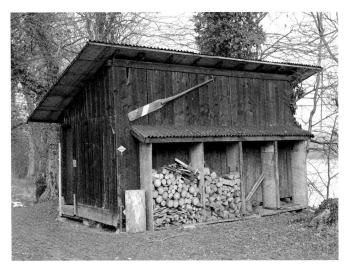

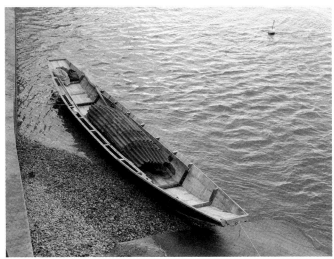

Simon Starling
Tabernas Desert Run
2004

2005

Darren Almond
1971 Born in Wigan
1990–93 Winchester
School of Art

suggested by the structural compatibility of building and boat, and the efficient transportation of the shed to its final destination are offset by Starling's labour-intensive process and the sheer poetry of his endeavour. Commenting on the work, Starling told one journalist: 'Spending a month turning a shed into a boat only to turn it back into a shed seems wilfully absurd ... Hopefully that has some resonance in a world at which everything happens at such high speed' (quoted by Alice O'Keefe, 'Is it a shed? ... No, but it could be the Turner Prize winner', *Observer*, 6 October 2005, p.9).

In recent years, journeys – both imagined and real – have become an integral part of Starling's work, with the movement of objects across political borders and between different continents providing a narrative springboard. The relationship between journey and idea is most lucid in a series of projects involving plants. *Kakteenhaus* (*Cactus House*) (2002), entailed transporting a Cereus cactus by car from the Tabernas Desert in Andalusia, Southern Spain, for an exhibition at Portikus in Frankfurt. The history of Tabernas, regarded as Europe's only true desert, reveals much about the modern world. Although cacti from the New World were introduced by the conquistadors in the seventeenth century, the type used by Starling was probably related to those imported to Tabernas in the 1960s and 1970s by film director Sergio Leone, specifically to add an authentic touch to 'spaghetti westerns' filmed in the region. More recently, mass cultivation under plastic has transformed the landscape, although inefficient irrigation has led to depletion of the groundwater table. At the same time, the Solar Platform of Almeria, Europe's leading solar-energy research centre, is desalinating sea water in an effort to combat the rate of desert expansion.

Starling's *Kakteenhaus* teased out some of these disparate histories and layers of association. To keep the cactus alive in Frankfurt, he rigged up a makeshift greenhouse system using the heat produced as waste by the engine of his car. Placed in the gallery, the engine remained connected by pipes to the disembowelled car parked outside. The juxtaposition of a cactus – the thriftiest plant of the desert – and a highly inefficient combustion engine playfully yet poignantly highlighted the absurd profligacy of contemporary life and its wide-reaching global implications.

In September 2004, Starling returned to Tabernas as the starting point for two new projects, both described as 'a kind of process painting', one of which, *Tabernas Desert Run* (2004), was represented in the Turner Prize exhibition ('Simon Starling: Tabernas Desert Run', exhibition press release, The Modern Institute, Glasgow, October 2004). Recalling American artist Chris Burden's *Death Valley Run* of 1977, a ride across the 'wild west' on a bike improbably powered by a minuscule petrol engine, Starling undertook *Tabernas Desert Run*, his own forty-one-mile ride across the desert on an improvised electrical bicycle. The bike was equipped with a portable fuel cell run solely on desert air. Some of its only waste product, pure water – produced by the reaction between hydrogen and oxygen – was collected in a bottle attached below the fuel cell. Referring back to the location and its history, Starling used the water to make a 'botanical' painting of an Opuntia cactus. Displayed in a Perspex vitrine at The Modern Institute, Glasgow, the project took on the properties of 'a kind of closed, symbiotic system' (ibid.).

Darren Almond

Using a variety of media, including photography, film, sculpture and installation, Darren Almond makes work that reconfigures ideas about time and place, and explores human responses to them. Recollection and remembrance are also recurring themes, which the artist explores through subjects that engage with social, political and personal histories.

Contemporary perceptions of time are fraught with contradiction. Time can be said to quantify existence, yet for each individual it remains a subjective experience. While scientists have questioned the idea of linear time, technological developments have served to reinforce it, splitting the smallest unit of time into ever-decreasing microseconds and nanoseconds. By disorienting, intensifying or slowing down our experience of temporality, Almond's work offers the possibility of imagining an alternative view. Restrained

Darren Almond
If I Had You
2003

and elegant, his work is nevertheless emotionally charged, often combining romantic and scientific responses to questions about the nature of time.

In his first well-known work, *A Real Time Piece* (1995), he broadcast a live image of his own studio in West London via satellite to an abandoned shop in Exmouth Market on the other side of the city. During the twenty-four-hour transmission, the only action was the emphatic sound of an amplified flip-clock, positioned on the wall above his desk. In place of the artist, object, time and space become the main protagonists, in an understated yet powerful demonstration of the possibility of being in two places at once.

In *A Real Time Piece*, lack of action had the effect of slowing down the experience of time. In subsequent works, the artist has decelerated time in a rather more literal way. In his installation *Oswiecim* (1997), Almond displayed two black and white films showing the two bus stops outside the concentration camp museum at Oswiecim (also known as Auschwitz) in Poland. Snow falls, an anonymous group of people wait in vain for a bus. Slowed down, the films make the experience of waiting even more drawn out, as Daniel Birnbaum has commented: 'Like many of Almond's works, this is a piece about duration, delay, and it affords an intensified experience of time. Where nothing happens, temporality itself is felt. Time hurts' (Daniel Birnbaum, 'Darren Almond', *Art Forum*, Vol. XXXVIII No.5, January 2000, p.102). In a related work, *Bus Stop* (1999), Almond borrowed the actual bus stops to display in a Berlin Gallery, providing newly made replacements for the street. For him, the ordinary, yet unavoidably real, street furniture functioned as a powerful symbol of the Holocaust, capable of connecting the viewer to an event fast fading from living memory.

As well as addressing collective memory, Almond has explored personal remembering to equally poignant effect, most strikingly in his four-screen video installation *If I Had You* (2003), featured in the Turner Prize exhibition. Shot in the seaside town of Blackpool, where his grandparents honeymooned, the work focuses on the themes of nostalgia,

Darren Almond
Until MMXLI.II
2002

love and loss. One screen lingers on the artist's widowed grandmother, lost in bittersweet reverie, while another focuses on the feet of a couple dancing around a ballroom to a slightly off-key piano melody. The other screens depict two features from the Lancashire resort: a windmill with whirring sails and a luminescent garden fountain. Almond's sophisticated use of image and sound strongly evokes the intensity of nostalgic longing, exposing human vulnerability – both physical and emotional – in the face of passing time.

In his ongoing 'Fullmoon' series, Almond has used the medium of photography to record the passing of time in the natural world. These long-exposure photographs of landscapes at night, for example *Californian North Star* (2005), produce beautiful yet eerie records of passing time, tracking the movement of the stars in a single image. In 2003, he also produced a series of photographs and two films as a result of trips to the Artic and Antarctica. Still regarded as the last real wildernesses, the polar regions have fascinated romantic writers and artists for centuries. In his series of photographs *Until MMXLI*, the endless spaces of Antarctica, devoid of any points of perspective, are compressed and flattened. The title of this series refers to the fact that Antarctica will remain a protected preserve until 2041, and that Almond's endeavour contrasts with that of the heroic nineteenth-century explorers, whose aim was to conquer nature. Here he reminds the viewer that establishing and understanding our place in the universe can prove to be 'a slippery business' (Brad Barnes, 'White Fever', *Darren Almond: 11 miles ... from Safety*, exh. cat., White Cube, London 2003, p.7).

Gillian Carnegie
1971 Born in Suffolk
1989–92 Camberwell School of Art, London
1996–8 Royal College of Art, London

Gillian Carnegie

Gillian Carnegie's response to the idea that painting has been played out, with all possibilities exhausted, is to centre her practice at the heart of the European tradition. Paradoxically, her emancipated exploration of the fundamental properties of painting takes place within the confines of the medium's traditional genres: still-life, landscape, portraiture and the nude. Rather than limiting her

choices, this has opened up an endless range of subjects, which she is at liberty to execute in a variety of painterly styles.

Typically, Carnegie sets up a tension between her subject and the medium. Using a sophisticated variety of brushstrokes, she produces contrasting textures and built-up areas that fracture the relationship between paint and subject, celebrating the sheer materiality of the medium. Carnegie's virtuoso style is often conspicuously old-fashioned. Her muted, drab palette of browns, in particular, recalls a pre-Impressionistic, old-masterly concern with modelling form to suggest real volume and substance. However, she uses such 'fusty hues' not to depict solidity, but to confirm the 'ultimate evanescence' of her representations (Barry Schwabsky, 'Gillian Carnegie', *Art Forum*, Vol. XLIII No.8, April 2005, p.201).

Carnegie's approach to painting has been linked to the work of Edouard Manet (Ben Tufnell, *Days Like These: Tate Triennial of Contemporary British Art 2003*, exh. cat., Tate Britain, London 2003, p.48). By the late 1860s, some critics conjectured that for Manet painting was primarily an arrangement of colours and forms, and that even his most contentious subjects had been put together to satisfy formal concerns. Yet at the same time, Manet's paintings represent the world of his class, his radical paintwork becoming emblematic of the pleasure-oriented values of the upper bourgeoisie (James H. Rubin, *Manet's Silence and the Poetics of Bouquets*, Reaktion Books, 1994, p.197). Although perhaps taking Manet's approach as a starting point, Carnegie's work seems to play with expectations of visual pleasure, resisting any contemporary desire for an aesthetic coherence that might be indicative of shared values. This is perceptible in a series of still-life paintings of flowers. *Fleurs d'Huile* (2001), for example, depicts a flower arrangement against a white ground. At first glance, the shadow dappling the surface and background wall convinces the viewer of the solidity of the flowers. The 'reality' of the picture is further evidenced by the exquisitely painted vase – a humble cut-down plastic water bottle, depicted as lustrously as cut glass. Yet the flowers at the centre of the spray collapse

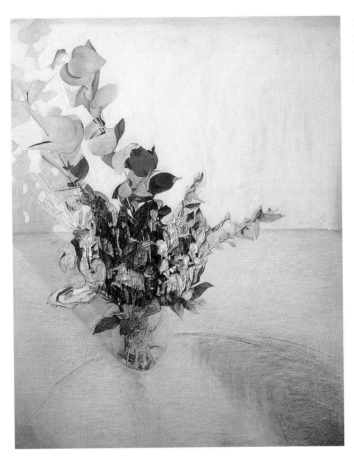

Gillian Carnegie
Fleurs d'Huile
2001

into a molten mass of viscous paint, reminiscent of the alluvial surfaces of paintings by Leon Kossoff or Frank Auerbach. But unlike these artists, who use paint as a possible equivalent or substitute for matter, Carnegie seems to want her paintwork to exist independently of what is pictured, casting doubt over painting's powers of representation, denying the viewer the pleasure of any easy recognition.

On one level, Carnegie's flower works might be understood as a metaphor for painting itself. In the nineteenth century, this modest still-life subject allowed artists to concentrate on the medium of paint, to the point where the theme of floral arrangement came to represent a shift from a narrative approach to a 'visual poetics'. As symbols of mourning and celebration, they could signify both pain and pleasure, 'for remembering reality and for the desire to transcend it' (ibid., pp.159, 163). Carnegie's flowers seem to do both. Their colours – drained and putrid – suggest decay and death. Yet, in defiance of any potential symbolic meaning, two small disks of yellow paint, too flat to be read convincingly as flower stamens, return the eye to the surface of the canvas, and to the insistently abstract, material quality of paint.

In *Section* (2004), Carnegie portrays a tree in browns, reds and ochres, the unremittingly earthy hues alleviated in places by patches of blue sky. Yet, as Barry Schwabsky has suggested, 'the sky does not breathe. Instead, the eye is caught up in the dense tangle of branches and disoriented by the way the foreground has been thrown out of focus by a series of seemingly arbitrary smears of paint ... Somehow there is endless space caught up among those branches but precious little around them' (Schwabsky, p.201). Perhaps the pervasive sense of claustrophobia in many of Carnegie's canvases is a metaphor for the closed-in nature of painting, which on one level can only be about itself. What is certain, however, is that Carnegie has the ability to deploy a range of techniques to make paintings that are richly elusive, subversive and perceptive.

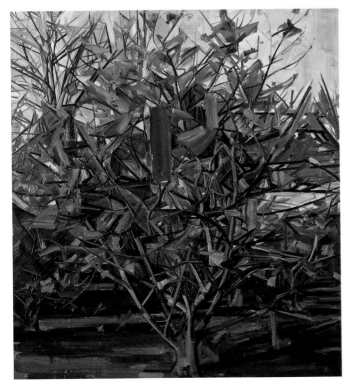

Gillian Carnegie
Section
2005

Jim Lambie

Using such everyday materials as glitter, vinyl tape, buttons and wool, Jim Lambie makes sculptural assemblages that

Jim Lambie
1964 Born in Glasgow
1990–4 Glasgow
School of Art

beautify and customise mundane objects, most typically the accessories of 1970s and 1980s pop culture such as record decks and album covers. He has also animated spaces by covering floors with vinyl tape to create hypnotic grounds for his sculptures. His choice of materials and familiar objects that happen to be 'lying around' points to aspects of his own life and enthusiasms, but more importantly, it reflects his desire to offer the viewer a way in to the work.

There is a transformative, almost alchemical element in all of Lambie's work. He is primarily interested in transporting the viewer into a psychological or imaginative space, the kind of non-visible space occupied when listening to music. For Lambie, art works best when it stimulates such inner experience: 'You put a record on and it's like all the edges disappear. You're in a psychological space. You don't sit there thinking about the music. You're inside that space that the music's making for you' (Jim Lambie, in *Tailsliding*, exh. cat., The British Council, London 2001, p.11).

Glasgow School of Art's Environment Department nurtured Lambie's understanding of the importance of context and placement in shaping both the physical manifestation and possible meanings of a work of art. Hence his work usually evolves in relation to a specific space. He also tends to work intuitively, creating sculptures in the gallery, which gives them an improvisatory feel. He is best-known for a series of floor pieces, collectively titled *Zobop*, which use the perimeters of a given room to create an overwhelming visual echo of that space. Working from the edges of the room, vinyl tapeis stuck to the floor in alternating lines of vivid, shiny colour that gradually ripple towards the centre until the entire floor is covered, accentuating even the slightest irregularity in the room's outline. The pulsating lines utterly transform our sense of the space, which seems both to expand and contract, in Lambie's words, 'creating so many edges that they all dissolve' (Jim Lambie interviewed by Andrea Tarsia, *Early One Morning*, exh. cat., Whitechapel Art Gallery, London 2002, p.111).

The formal qualities of some of Lambie's work, and his choice of throwaway materials, give his pieces a superficial resemblance to such art-historical movements as Minimalism, Op Art and Arte Povera. But as a DJ and musician he is connected to the Glasgow music scene, and references to that world, and to pop culture more generally, permeate his work (Lizzie Carey-Thomas, *Days Like These: Tate Triennial Exhibition of Contemporary British Art 2003*, exh. cat., Tate Britain, London 2003, p.100). *Graffiti* (1999), for example, is one of a group of kinetic sculptures made from record decks that the artist has remodelled, in this instance by coating the record deck with a thick layer of blue glitter, while a mess of tangled safety pins and pearls cascades from its underside to the floor. Suspended on the wall, the humble deck becomes both a glamorous trophy and a transmogrified, ritualistic object. While the purpose of this mysterious, made-over item remains elusive, the artist suggests that 'covering an object somehow evaporates the hard edge off the thing, and pulls you towards more of a dreamscape. The hard, day to day, living edge disappears' (*Early One Morning*, p.111).

Lambie clearly enjoys making theatrical environments that alter mood as powerfully as any soundtrack. For *The Kinks* (2005), the artist's Turner Prize installation, a dramatic black, white and silver tape floor functioned as a backdrop for a group of brightly coloured sculptures comprising blown-up versions of knick-knack statues of birds, adorned with casually dripped paint, and handbags covered in fragments of mirrored glass. On the wall, a silhouette of the 1960s band The Kinks in the form of a Rorschach ink blot echoed the viscous pools of paint gathering around the sculptures. As in other recent installations, Lambie used shorter strips of tape arranged in a cross-hatch pattern, resembling 'shading' or 'drawing'. His playful contrast of spatial illusion through a kaleidoscopic collision of sculpture and ground produced a gloriously giddying, visually overloaded experience, as critic Adrian Searle observed: 'Looking at the installation is like sticking your finger in a power socket … the sliver tape throws shards of light up the gallery walls and makes the whole floor float' ('The house that Simon built …', *Guardian*, 18 October 2005, p.20).

Jim Lambie
Zobop 2003

Jim Lambie
The Kinks 2005

Winner
Tomma Abts

Shortlisted Artists
Tomma Abts for her solo exhibitions at Kunsthalle Basel, Switzerland, and greengrassi, London, that revealed her rigorous and consistent approach to painting. Through her intimate and compelling canvases she builds on and enriches the language of abstract painting

Phil Collins for solo shows at Milton Keynes Gallery, Tanya Bonakdar Gallery, New York, and his presentation in British Art Show 6 in which he showed engaging photographic and video installations involving diverse social groups. By instigating unpredictable situations, he encourages people to reveal their individuality, making the personal public with sensitivity and generosity

Mark Titchner for his solo exhibition at Arnolfini, Bristol in which his hybrid installations furthered his exploration into systems of belief. Working across a wide range of media, including light boxes and extraordinary hand-carved contraptions, his work continues to interweave a vast array of references from pop lyrics to philosophy

Rebecca Warren for her exuberant sculptural installations as seen in her solo exhibitions at Matthew Marks Gallery, New York, and Galerie Daniel Buchholz, Cologne, and for her contribution to the Tate Triennial 2006. Her works combine a wide range of sources with a strong formal awareness, injecting conventional materials with a sensual physicality to create something wholly new

Jury
Lynn Barber
Writer, *Observer*
Margot Heller
Director, South London Art Gallery
Matthew Higgs
Director and Chief Curator, White Columns, New York
Andrew Renton
Writer, and Director, Curating, Goldsmiths College, University of London
Nicholas Serota
Director, Tate and Chairman of the Jury

Exhibition
3 October 2006–14 January 2006
Prizes of £25,000 to the winner and £5,000 each to the other shortlisted artists presented by Yoko Ono 4 December 2006

Tomma Abts
Mino 2006

Inevitably, coverage of the 2006 shortlist announcement focused on the more titillating aspects of Rebecca Warren's sculptures, for example, 'Clay genitalia? It must be the Turner Prize' in *The Times* (Jack Malvern, 17 May 2006, p.27) and *The Sun*'s 'Show us your arts' (17 May 2006). But on the whole, critics concurred that the new shortlist was strangely lacking in controversy, and that the Turner Prize had ceased to be interesting.

When the show opened in October, reporters struggled to generate provocative headlines, finding some joy in Warren's use of dust and discarded objects, which prompted such captions as 'Entry really is a load of old rubbish' (*Shropshire Star*, 3 October 2006, p.15). Phil Collins's fully functioning office, *shady lane productions* – installed as part of his Turner prize exhibition to investigate people's experiences of being involved in reality TV – proved newsworthy, but column inches mostly revealed a genuine interest in his project. Turner Prize juror, curator Andrew Renton, suggested that the absence of controversy lay in the growing sophistication of Turner Prize audiences, commenting: 'Perhaps the Turner has grown up and the public has grown up with it ... They know enough about art not to be shocked or offended any more, and they don't have a problem with an artist who makes videos or sweeps up the floor and puts it in a vitrine' (quoted by Hephzibah Anderson, 'The "faking it" Turner Prize judge', *Jewish Chronicle*, 1 December 2006, p.36).

Ironically, the only whiff of controversy in 2006 was caused not by the artworks in contention, but by Renton's fellow juror, *Observer* writer Lynn Barber. Reviewing the exhibition, Adrian Searle mused on the potential of *shady lane productions* as a metaphor for the process of the prize itself: 'There may well be those who feel their lives have been ruined by their participation in the Turner Prize, which itself includes a modicum of television exposure. Will the Turner contenders be queuing, in the full gaze of visitors to the show, to tell the stories of their ruin for Collins's project?' ('Car batteries, clay nipples, reality TV and a glimpse of the future', *Guardian*, 3 October 2006, p.20). But it was Barber, not shortlisted artists, who produced the kind of raw material that Collins might have been seeking for his project, when, breaking with convention, she publicly revealed the disappointment and humiliation she had experienced as a juror.

Barber had already made waves in the spring, when under the aegis of the Freedom of Information Act, the content of email correspondence between her and Tate was reported in the press, exposing her dissatisfaction with aspects of the selection process, particularly the lack of resources available to jurors to visit exhibitions, forcing them to rely on exhibition catalogues for reference to particular shows (see Chris Hastings, 'Shows missed by judges, questions over artists ... It must be the Turner Prize', *Sunday Telegraph*, 30 April 2006). Then, a few days before the exhibition opened in October, Barber detailed her complaints and the workings of the jury in 'How I suffered for Art's sake', a feature for the *Observer Review* (1 October 2006, p.5). Barber's misgivings, however, proved short-lived. Following the announcement of the winner, she concluded that she was in the end 'very proud to have been a Turner Prize judge' (Lynn Barber, 'My Turner's over. Phew!' *Observer*, 10 December 2006).

In 2006, Tomma Abts became the first woman since Gillian Wearing in 1997 and the only painter since Chris Ofili in 1998 to receive the award. Predictably denounced by Stuckist, Charles Thomson as a painter of 'silly little meaningless diagrams', Abts was widely acclaimed as a worthy winner, as Charlotte Higgins reported: 'There are no flashing lights this year, literally or metaphorically; no scandal, manufactured or otherwise, in the form of elephant dung or pornographic pots. This year's Turner Prize has been won by the deeply serious abstract painter Tomma Abts' ('German-born painter wins Turner Prize', *The Irish Times*, 5 December 2006, p.10).

Tomma Abts

Tomma Abts's intense, densely wrought paintings in acrylic and oil possess a formal definition and coherence that suggests that they could never have existed any other way. However, closer scrutiny reveals a complex vision in which relationships between colour, form

and ground are at once established and fluid. Abts achieves this quality of momentary stasis, of elements held in a magnetically charged balance, through a rigorous, lengthy working method that is both precise and unplanned. Within a defined set of parameters that pitches the rational against the intuitive, Abts seems to find endless possibilities for investigating the language of form in painting.

Since 1998, Abts has worked consistently to a modest format of 48 x 38 centimetres. She uses no source material and has no preconceived notion of the final composition. Instead, she begins by freely covering the surface of the canvas with loose, thin washes of bright, almost lurid, acrylic paint in gradated colour fields or splodges of multicoloured camouflage. This creates an activated platform onto which oil paint is applied, layer after layer, enabling forms to emerge and mutate through a gradual process of accrual. Thus, starting from a point of abstraction, the internal logic of each composition unfolds to guide a series of decisions in which shapes are defined, buried and rediscovered. Hues are gradually subdued to a range of off-key tones but are no less artificial; colour not only helps to establish the emotional landscape of each work, but equally functions as an integral compositional element. Abts works 'inside out', blocking in areas around delineated forms. Where corresponding areas of paint accumulate at differing speeds, rifts and seams appear, extending outwards from the shapes' edges as if marking their own trajectory beneath the surface. Baring the visible traces of their construction, the finished pictures are described by Abts as 'a concentrate of the many paintings underneath', each former state remaining undisclosed yet integral to the result (Tomma Abts in conversation with Peter Doig, 'Painting in the real world', *The Wrong Times*, exh. cat., The Wrong Gallery, New York 2004, p.15).

A curious tension is maintained between the painting's physical topography and the form that it describes, between surface material and pictorial illusion. The plank-like struts zigzagging across the surface of *Mino* (2006) almost demand to be plucked from their ochre ground, the shadowy pools beneath

enhancing the optical illusion. However, planes that appear to be located in the foreground reveal flashes of the translucent first stain of acrylic, the texture of the canvas clearly visible, creating a window back in time through numerous subsequent strata to a former manifestation.

A sense of multi-directional movement, of every inch of the canvas having been scrutinised and charged, is common to all Abts's paintings with varying degrees of complexity. *Teete* (2003) is one of several works in which we are initially pulled to a vanishing point at the centre of the image from which blades shoot out, starburst-like, towards the edges of the canvas. A jagged path of darker orange and greenish tones dissects the nicotine-stained palette and follows the contours of the blades in a circular direction. In *Heeso* (2004), a wriggling red line meanders from top-left corner to bottom right and back again. This fluidity echoes the evolution of forms below the surface, but also Abts's ambition for the works to inhabit a space that is both ambiguous and recognisable. Fuelling her approach is the drive to push the personal and arbitrary to a communicable point of objectivity. Abstract elements might occasionally hover on the periphery of representation – at times alluding to objects situated within a semi-defined landscape, for example – but are then disrupted by the artificial tonal scale or incongruous perspective. Abts is engaged in a constant game of push and pull, of abiding by and testing out her own self-imposed restrictions, until the painting becomes 'congruent with itself' (email exchanges between the artist and Tate curator Lizzie Carey-Thomas, 8 August 2006).

Abts's paintings seem to achieve what only painting can, inhabiting both this reality as an object or 'thing', and a parallel world with its own set of rules and relationships that demand to be judged on their own terms. Varying dramatically in mood and tone despite the strict focus of Abts's enquiry, each is the product of an individual and idiosyncratic journey, an extended thought process made concrete (Abts has pushed this idea to an extreme by casting a painting in aluminium). The artist preserves a sense of the work's autonomy – from each other and from anything outside the parameters of the

Tomma Abts
1967 Born in Kiel, Germany
1989-95 Hochschule der Kunste, Berlin
Lives and works in London

Tomma Abts
Teete 2003

Tomma Abts
Heeso 2004

Phil Collins
1970 Born in Runcorn
1990 University of
Manchester
1998–2000
University of Ulster

painting – through their adamantly non-descriptive titles, which are derived from a sourcebook of first names; she appears to select those that are least familiar sounding, but which strike a phonetic resonance with the work. When they are installed together in the gallery, one is aware of formal and tonal correspondences between paintings, reflecting the fact that Abts works on many canvases simultaneously, allowing ideas to migrate from one to another in an ongoing dialogue. Acting as a counterpoint to the methodical progression of the paintings, her pencil and colour-pencil drawings operate as accelerated exercises in composition. In these, she decides upon a limited set of formal components and a reduced colour scheme, and allows arrangements freely to unfurl across the page in one sitting.

Abts's paintings and drawings embody a quality of self-evidence that cannot easily be transcribed or translated into any other format. Existing in parallel to much recent work by her contemporaries, Abts's paintings refer neither to specific art-historical movements, nor to avant-garde modernist agendas. Each functions as an autonomous object containing all the thoughts, feelings and crises worked through to a resolution that is fundamental to its making. As she explains: 'The forms don't stand for anything else; they don't symbolise anything or describe anything outside of the painting. They represent themselves' (ibid., exh. cat., *The Wrong Times*, p.16).

Phil Collins

Phil Collins exploits, exposes and indulges our obsessive love of the camera, operating within modes of representation usually occupied by reportage and low-budget television. He both uses and disrupts their codes of conduct to examine the interface between the portrayal of people as individual subjects and as symbols of an often troubled political situation.

how to make a refugee (1999), a film revealing the cold-hearted treatment by journalists of a young Kosovan war victim, introduced many recurring themes within Collins's practice. By recording a press photographer's private conversations about how to frame the photo-shoot, the artist reveals how the media manipulate their depictions of the world's tragedies to make neat sound-bites for remote audiences. He has commented: 'There's something very brutal and ugly about the total disregard for the subject and a complete lack of understanding of the reasons why he won't expose nor describe his wounds' ('Who said an Artwork Shouldn't Be and Imposition? A Conversation between Phil Collins and Jeremy Millar', *Deutsche Borse Photography Prize 2006*, exh. cat., The Photographer's Gallery, London 2006, p.77).

Unlike the documentary style of film-making prevalent in recent art, Collins often removes his subjects from their day-to-day reality, with the unexpected reverse effect of representing them as ordinary people. In *they shoot horses* (2004), young Palestinians earned eight days' wages in one day by taking part in an exhaustive dance marathon. With little reference to geographical location, Collins's film highlights how Palestinians are usually defined by the media in terms of their social, economic and political circumstances, rather than as normal young people. The artist comments: 'The backdrop to *they shoot horses* resembles those of cheap reality shows, which we have a surfeit of on British TV. I was interested in applying these forms to places where we imagine they don't formally exist, and also seeing how they might create platforms that might articulate not difference, but in fact a threat of resemblance' (quoted in *British Art Show 6*, exh. cat., Hayward Gallery, London 2005, p.151). The work harnesses the levelling force of pop culture to question our preconceptions, yet at the same time, it inevitably becomes a metaphor for the relentlessness of the fraught political situation in this region of the Middle East.

Collins's Turner Prize exhibition featured a video installation *return of the real / gercegin geri donusu* (2005) and a related live project specifically conceived for the Turner Prize, *shady lane productions* (2006), a fully functioning office installed in the gallery. Commissioned in 2005 by the 9th Istanbul Biennial to make work in the city, Collins invited people who believed their lives had been ruined by appearing

Phil Collins
*the return of the real /
gercegin geri donusu*
2005

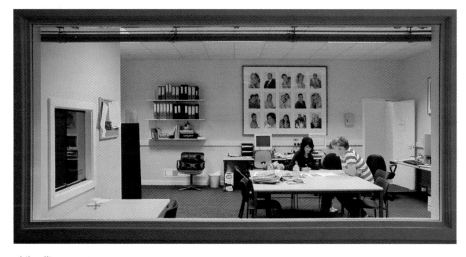

Phil Collins
*shady lane
productions* 2006

on reality TV shows to attend a press conference at a well-known hotel, the Mamara. Fifteen participants told their stories to a captivated press audience, later broadcast on the evening news. Collins subsequently hired the director of a Turkish extreme make-over show to conduct a series of hour-long interviews with ex-participants in a TV studio. The artist is occasionally seen in the background, checking the image and sound levels, making explicit his role as artist and producer. *return of the real* foregrounds the ethics of further exploitation, yet in contrast to reality TV, its compelling personal narratives are unedited and uncensored, and the interviewees clearly enjoy taking command of the camera.

Through *shady lane productions*, Collins enacted the media's working methods. For the exhibition's duration, it became the operational hub of his next set of projects dealing with the influence of the camera on the behaviour it seeks to record, and the impact that new modes of realism and entertainment have on lived experience. Staffed by the artist, an office manager, researchers and receptionists for public enquiries, the office organised a British episode of *return of the real*. Neatly encapsulating the layered and complex approach of Collins's work, this project investigated the relationship between the production of art and its wider social context, acknowledging and utilising the mechanism of the Turner Prize itself as the ultimate, artworld media spectacle. An examination of the camera's forceful ability to seduce and manipulate lies at the heart of Collins's practice; he makes us aware that as viewer, subject or photographer, we are all complicit in the mediation of representations of the world.

Mark Titchner

Mark Titchner describes his work as 'a dialogue about how you receive thought and ideas'. He focuses on belief, on the tangled web of ideas that run through and inform our society; but equally he investigates the problems of knowledge and communication – the fallible ways in which we perceive our ideologies.

The form of Titchner's works varies immensely. He is best known for the billboards, lightboxes and posters that

have been displayed in Gloucester Road Underground station, London, and in various cities around the United Kingdom and abroad. Designed on a computer and presented through the equipment used for advertising, these large-scale images scream for attention. Miscellaneous slogans in Titchner's trademark blunt font are written in abrasive colour schemes on top of over-wrought backgrounds that rattle the senses. In extreme contrast to his digitally designed works, Titchner also makes sculptures that have been chiselled by hand. His carved objects are dark and clunky, contrasting superficiality against ungainly physicality, ease and speed against labour. Through the effort and time invested in their making, the sculptures possess a devotional quality, whereas the similarity of computer-drawn images to advertisements makes their messages feel like empty slogans.

The messages adorning Titchner's works are scavenged from song lyrics, philosophical tracts, scientific treatises and occult religions. Proclaiming a wealth of philosophies, these texts cajole or heckle the viewer with an evangelical idealism. Rapture and its flip-side, doubt, are the twin poles of Titchner's undertaking – irreconcilable opposites that effect the schizoid character that runs through all his works.

How to Change Behaviour (Tiny Masters Of The World Come Out) (2006), included in the Turner Prize exhibition, is a complex installation in which notions of science, spirituality and authorial instruction collide. Using such unorthodox theories as 'Psionics' (the art of manipulating psychic ability by means of physical instruments), Radionics (a spiritual healing technique) and Sigils (magical signs that seek to control the world), the installation attempts to harness man's psychic potential. A wall text in an institutional font asks the viewer to engage with quasi-magical wooden machines, which are chiselled with zealous statements derived from Trade Union banners. Titchner's installation turns on an absurd proposition: that its viewers' willpower be directed towards the improvement of the contraptions that are supposedly fulfilling their wishes. Short-circuiting the system, Titchner creates a situation where, as

with religion, belief becomes its own proof. Blind faith in technology is put into question, and so, too, is trust in the instructions given by authority.

Titchner also exhibited a more recent work *Ergo Ergot* (2006), which menaces and bedazzles the viewer on a grand scale. A whirling kinetic sculpture at the centre of the work exposes the unreliability of human perception. Part crude experiment, part sensual operation, its arrangement of spinning disks tests two scientific hypotheses: the Ebbinghaus Illusion (also known as 'The Titchner Illusion'), which maintains that the size at which we see things is dependent on what surrounds them, and the 'perception-versus-action hypothesis', which states that visual information is processed in two different streams, one for visual awareness and one for movement.

Recalling 'rotoreliefs', the optical illusions designed by Marcel Duchamp in the 1920s, as well as the logo for the 'Vertigo' record label, the rotating disks induce a dizziness in the viewer akin to the moment before a fall. Information is presented amongst all this spin, in the form of dates that flicker hypnotically amidst a pulsating sequence of lurid patterns. These silhouettes are in the shape of the Rorschach psychological test, Ink Blot No.4, which is supposed subliminally to suggest male authority, whilst the speed at which they flicker is designed to stimulate the brain's Alpha wave activity, lulling the viewer into a trance-like state. The twenty-two dates depicted derive from Liberty's 'Human Rights Legislation Audit' – a public record of all the acts passed by parliament since 1999 that have had worrying implications for human rights. Titchner's installation suggests that, like our perceptions, our civil rights are not a given but are vulnerable to manipulation.

Rebecca Warren

For Rebecca Warren, precedent, process and form, as well as her own position within the lineage of a predominantly male sculptural tradition, are in continual dialogue. Her practice can be likened to a form of associative collage in which a wide variety of references are amalgamated to create an ever-evolving visual language. A regular strategy has

Mark Titchner
1973 Born in Luton
1992–5 Central
St Martins College
of Art and Design,
London

Mark Titchner
*How to Change
Behaviour (Tiny Masters
of the World Come Out)*
(detail) 2006

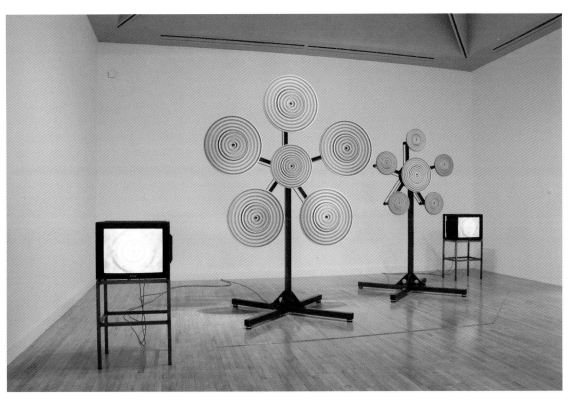

Mark Titchner
Ergo Ergot 2006

Rebeca Warren
1965 Born in London
1989-92 Goldsmiths
College of Art, London
1992-3 Chelsea School
of Art, London

been to revisit works by the accepted masters of expressive figurative sculpture – Degas, Picasso or Rodin, for example – deftly reworking and mistranslating identifiable motifs. Her relationship to her influences is a complex one; rather than attempting to counter or redress existing depictions of the female form, she appears to push them to an extreme. With wit and a characteristic lightness of touch, she both pays homage to her heroes and questions their true motivations.

Warren is best known for her series of unfired clay figures, roughly sculpted into giant approximations of oversexed females. Reduced to their essential physical attributes they stride forth with ecstatic abandon in their trademark oversized shoes. Their heads, where they appear, are shrunken or dissolve into a tangled mass of entrails. Yet for all their overbearing physicality, there is something inherently unstable about Warren's sculptures. The material appears barely modelled and it is unclear whether forms are exploding out of or submerged back into the clay. Opposing the position of mastery and authority assumed by her predecessors, Warren draws attention to the arbitrary nature of the creative process, questioning the very feasibility of self-expression and representation through sculptural means.

Gregorio Magnani has noted 'a suggestion of failure and inability to perform' running through the artist's work (Magnani, 'Dark Passage', in *Rebecca Warren*, exh. cat., Kunsthalle Zurich, 2004, p.47). Such qualities are particularly evident in her series of wall-mounted vitrines, some of which featured in the Turner Prize exhibition. Contrasting dramatically with the rough-hewn vitality of the clay sculptures, these take the form of seemingly haphazardly constructed MDF boxes with ill-fitting Perspex fronts displaying collections of abject detritus: bits of wood, twigs, fluffy pom-poms, a coiled hair, a squiggle of lit neon. Each box, containing a miniature drama with a quietly persuasive emotional charge, elevates the discarded leftovers – the fallout of 'real' activity in the studio – to the status of art object, while flouting the conventional hierarchies of display.

In a recent series of plinth-top clay sculptures, including, for example, *The Garden of My Spouse I* and *II* (2006), both shown in the Turner Prize exhibition, Warren harnesses the nebulous properties of her material to play a game of hide-and-seek with the viewer. At times, these are so crudely formed that on first appearance they resemble nothing more than chewing-gum gobbets, partially painted and glazed in candy-floss colours. Closer inspection reveals surprisingly graphic, erotic tableaux or references to specific artworks.

The gradual distortion and degradation of an established form is a persistent theme in Warren's work. For the Turner Prize, Warren also displayed a number of bronzes. Cast from clay originals, they retain the lumpy texture of their former incarnation, as well as traces of rubber from their extraction from the moulds. Warren's disregard for the conventional treatment of the material is further suggested by areas of acrylic paint, which give description to the forms beneath. After the original clay works returned from the foundry, bashed and misshapen from the casting process, the artist set about revising and adding to them before sending them back for recasting. This process enabled her to divorce herself one step further from both the source image and her position of ultimate responsibility. Such working methods seem commensurate with her desire to produce forms that exist first and foremost as physical things in the world, rather than as vehicles for the articulation of an idea.

Warren performs a precarious balancing act in her works. Loaded with a complex chain of associations, they are emphatically non-didactic, even at times wilfully misleading. Their shape-shifting properties nevertheless belie a powerful materiality that shoots directly to the gut.

Rebecca Warren
*2001, 2002,
2003, 2004 or 2005*
2006

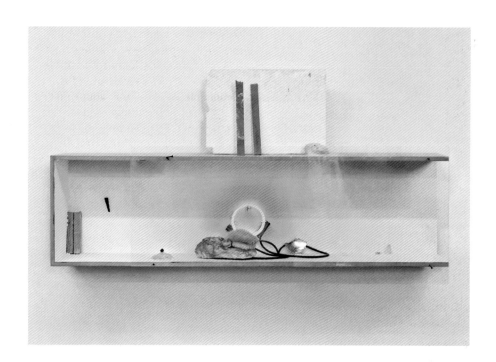

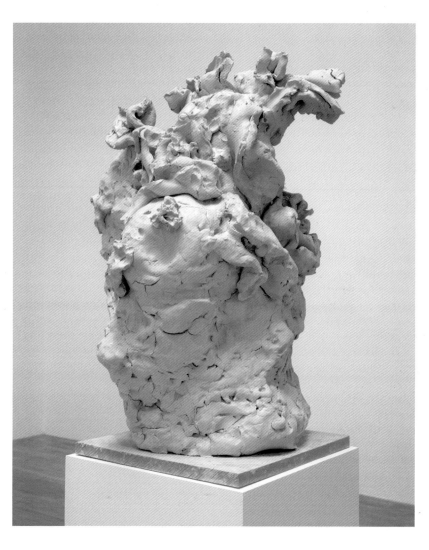

Rebecca Warren
*The Garden of My
Spouse I* 2006

Shortlisted Artists
Zarina Bhimji for her solo exhibitions at Haunch of Venison, London and Zurich, featuring work engaging with universal human emotions such as grief, pleasure, love and betrayal using non-narrative photography and film-making. Through atmospheric and poignant imagery, Bhimji's recent work demonstrates a new approach to her long-standing preoccupations and research
Nathan Coley for his solo exhibition at Mount Stuart, Isle of Bute, the public installation *Camouflage Church*, Santiago de Compostela, Spain, and his contribution to the group exhibition *Breaking Step – Displacement, Compassion and Humour in Recent British Art* at the Museum of Contemporary Art, Belgrade, Serbia. Through a variety of media, Coley's work makes manifest the belief systems embedded in society and its architectures
Mike Nelson for his solo exhibitions *AMNESIAC SHRINE or Double coop displacement*, Matt's Gallery, London, and *Mirror Infill* (2006), Frieze Projects, Frieze Art Fair, London, in which his immersive installations transported the viewer to imaginary, yet plausible worlds. For the Frieze Art Fair he created an installation of a photographic studio that brought the site of creativity to the heart of the commercial environment in which it was embedded
Mark Wallinger for his solo exhibition *State Britain* (2007) at Tate Britain. Wallinger's powerful installation demonstrates art's unique ability to engage with contemporary political issues. The direct representation of Brian Haw's banners and paraphernalia creates a force and conviction unmatched by the representation of the Parliament Square protest in the media

Jury
Michael Bracewell
Writer and critic
Fiona Bradley
Director, Fruitmarket Gallery, Edinburgh
Thelma Golden
Director and Chief Curator, Studio Museum, Harlem
Miranda Sawyer
Freelance broadcaster and writer
Christoph Grunenberg
Director, Tate Liverpool and Chairman of the Jury

Exhibition
Tate Liverpool, 19 October 2007 – 13 January 2008

Zarina Bhimji

Since the 1980s, Zarina Bhimji has used a range of media, including sculptural installation, photography, film and sound, to explore human identity, often in the wider context of the politics of power and history. Never didactic – her choice of materials and imagery is governed by a poetic sensibility and a lightness of touch – she creates haunting visual metaphors for human emotion, experience and memory. Such metaphors enable her to articulate otherwise hidden aspects of shared human experience, to 'speak the unspeakable that wants to be spoken' (the artist, exhibition press release, Haunch of Venison, Zurich, 2007).

Bhimji's work evolves through a process of rigorous research and information gathering, allowing her to 'put certain myths and realities to the test' (the artist, www.zarinabhimji.com). Yet the results are far from documentary, taking the form of highly aesthetic, carefully composed narratives, which – engaging the viewer on many levels – appeal to universal, human truths. Bhimji's ability to combine such contradictory realities as beauty and horror, cruelty and love through imagery devoid of sentiment or certainty can be seen in a positive light, as Marina Warner has observed: 'When Zarina Bhimji reproduces conflicts of identity, she is growing another culture in the process' (Marina Warner, *Zarina Bhimji*, exh. cat., Kettle's Yard, Cambridge, 1995, unpag.).

Although her work transcends the specifics of its personal or historical beginnings, Bhimji's early exposure to the turbulent aftermath of Britain's imperial debacle has played a role in shaping her artistic preoccupations. Born in Uganda to parents of South Indian origin, she grew up in the shadow of dictator General Idi Amin, who in August 1972 expelled large numbers of Asians and Africans, many of them British passport-holders. Bhimji's family decided to stay in the country, spending two years in hiding from Amin's regime before finally leaving to settle in Britain.

For Bhimji, who hardly spoke English when she arrived, 1970s Britain was in many ways a threatening and hostile environment. Enoch Powell's notorious 'Rivers of Blood' speech was still fresh in many people's minds, the National Front was highly active and Asian youths were frequently the targets of attacks by racist gangs. In early works, such as *I will always be here* (1992) – a mixed-media installation including a series of glass shoe boxes containing such fragments as hair and red tulip petals – Bhimji addressed ideas of cultural classification, while in the same piece, white, child-size Indian shirts (*kurtas*), singed and burnt, quietly evoked the atrocities occurring around the world in the name of racial purity.

In 1998, Bhimji returned to Uganda for the first time. A series of works emerged from this, notably an ongoing group of photographs *Love* (1998–2006), and *Out of Blue* (2002), a 16mm film commissioned for Documenta XI. *Out of Blue* is a filmic narrative, which, using both sound and image, explores the potential of art as universal mode of representation, in this instance as a metaphor for grief and loss. Bhimji's portrayal of the countryside in *Out of Blue* might be seen in the context of traditions of British landscape painting, particularly, for example, in relation to the intensity of J.M.W. Turner's sublime nature, conveyed through both historical sense of place and range of atmospheric effects. Opening with languorous shots of beautiful landscape, the film moves quickly to a bush fire and abandoned locations: decaying interiors with stained walls, prison cells, fences, empty streets – places suggesting 'elimination, extermination and erasure' – juxtaposing the harmony of nature with human cruelty and vulnerability (the artist, www.zarinabhimji.com). Neglected graveyards, objects such as shoes, and even shadows and silhouettes, accentuate the absence of human life. A mesmerising soundtrack – featuring, for example, the high-pitched drone of mosquitoes, exhaled breath and the haunting voice of Sufi singer Adiba Parveen – serves to reinforce the sensation of terror and the bittersweet feeling of love and loss (see Clare Loenen, 'Zarina Bhimji', *British Art Show 6*, exh. cat., Hayward Gallery Touring, 2006, p.158).

Bhimji uses the formal elements at her disposal – colour, tone, texture and sound – to create an overwhelming sensory

232

Zarina Bhimji
Forgotten Us 2006

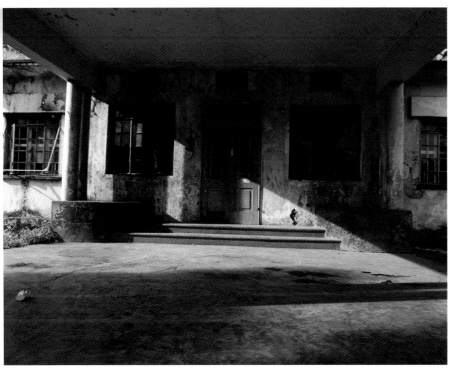

Zarina Bhimji
This Unhinged Her
2006

experience. Although based on factual research, for Deepali Dewan, *Out of Blue* 'follows an emotional process without knowing where it is leading ... There remains an ambiguity, which like a mirror, deflects the focus of the work on to the viewer. The enduring effect is one of tenderness and beauty, conveying the complexity of human experience and emotion' (Deepali Dewan, 'Tender Metaphor: The Art of Zarina Bhimji', *Fault Lines: Contemporary African Art and Shifting Landscapes*, eds. Gilane Tawadros and Sarah Campbell, 2003, pp.131–7, p.134). For the artist, the project was about 'learning to listen to difference, the difference in shadows, microcosms and sensitivity to difference in its various forms ... It attempts to link to similar disturbances that have taken place in Kosovo and Rwanda. The work is not a personal indulgence; it is about making sense through the medium of aesthetics' (the artist, www.zarinabhimji.com).

In her series *Love* (1998–2006), Bhimji further explores the themes of love and loss. Devoid of human life, these eloquent images of landscapes, interiors and architectural spaces, allude to the utter ruination caused by betrayal. The interior scenes (composed using props) enable the artist to create images of abandonment that, 'evoke a timeless realm occupied by the human psyche' (Dewan, p.136). Bhimji achieves an almost alchemical transformation of the physical into the psychological by subtly exploiting formal differences. For example in another photograph, *Forgotten Us* (2006), the artist creates an almost abstract picture of geometric forms through tonal contrasts. Casting a shadow under the porch, strong sunlight diagonally splices the frontal image of a house into areas of light and dark, while on the red, earthy ground, merging with the shadows, darker stains are visible.

Nathan Coley

Driving Nathan Coley's investigative practice is a curiosity about the meanings or values – private, public, social, political, religious – that shape our surroundings, influencing daily life and how we see ourselves. Acknowledging that public space is never value-free, Coley researches the specifics of an urban context to unpack the complex

Zarina Bhimji
1963 Born in Mbarara, Uganda
1974 Moves to Britain
1982–3 Leicester Polytechnic
1983–6 Goldsmiths College of Art, London
1987–9 Slade School of Art, London

Nathan Coley
1967 Born in Glasgow
1985–9 Glasgow School of Art

relationships between often competing claims. Through his work, which has taken various forms including slide projection, film, architectural modelling, drawing, photography and installation, he throws light on the built environment – experienced physically, mentally and through memory – as 'an illustration of who we are' (the artist, quoted by Helen Luckett, *British Art Show 6*, exh. cat., Hayward Gallery Touring, 2005, p.182).

Although Coley's projects have included a diverse range of built structures and public spaces, from pigeon lofts, demolition sites and show homes, to the temporary court set up at Kamp van Zeist in 2000 to accommodate the Lockerbie bombing trial, a number of works have focused in differing ways on places of worship. *Fourteen Churches of Münster* (2000), for example, is a video shown on a monitor accompanied by a drawn flight plan, which, shot from a helicopter, maps a route encompassing all the churches in the centre of the German city. The work recalls the targeting of the city's churches by Allied bomber pilots in the final stages of the Second World War, a strategy designed to lower civilian morale. Here, Coley re-creates the detached view of the pilots on their destructive mission, so that the churches appear as objects, rather than as powerful expressions of faith, cultural aspiration or places of potential sanctuary (Katrina Brown, 'Fourteen Churches of Münster', *Nathan Coley: There Will Be No Miracles Here*, Fruitmarket Gallery, Edinburgh/ Locus+, Newcastle Upon Tyne, 2004, p.62).

The Lamp of Sacrifice, 161 Places of Worship, Birmingham (2000), created for *As It Is*, an exhibition at the Ikon Gallery, Birmingham, comprised cardboard models of all the places of worship listed in the city's central-area *Yellow Pages*. Part-performance, part-sculptural installation, the work entailed Coley's transformation of the gallery into a workshop for the duration of the exhibition, in order to construct 161 four-foot-high models, which might be viewed as 'actualisations' of the diverse and shifting religious profile of a community. Regarding this and a subsequent work, *The Lamp of Sacrifice, 286 Places of Worship, Edinburgh* (2004), Fiona Bradley has commented: 'By rebuilding cities from one particular

perspective, Coley brings experience as well as scrutiny to bear. This is his method: to describe by remaking so that he, and by extension the viewer, has a physical as well as mental relationship to the space in question' (ibid., Fiona Bradley, 'Building the Imagination', p.10).

In 2006, Coley produced new work for an exhibition at Mount Stuart, a neo-gothic mansion on the Isle of Bute. Aspects of the historical narrative attached to Mount Stuart provided a poignant context for his continuing preoccupation with the physical manifestation of political and religious ideas. The exhibition included *Camouflage Church*, *Camouflage Synagogue* and *Camouflage Mosque*, three models of buildings specifically associated with Christianity, Judaism and Islam. They relate to a work of the previous year, *Jerusalem Syndrome* (2005), a film based on the artist's research into the rare, religious psychosis triggered by visits to the Holy City, the centre of these world religions. Here, denuded of their symbols – cross, Star of David, crescent – and emblazoned with optically disorienting, horizontal bands of colour, the identity of each building is partially disguised. While evoking religious architectural decoration, the stripe-pattern derives from 'dazzle' camouflage used for battleships during the First and Second World Wars. As Andrea Schlieker suggests, Coley's camouflage works might be read as 'subtle metaphors' for the declining authority – invisibility even – of established religion in Western, secular society. At the same time, their link to wartime tactics perhaps alludes to 'geo-political conflicts' fuelled by conflicting religious beliefs, giving them a particular contemporary resonance (see Schlieker, 'Negotiating the Invisible: Nathan Coley at Mount Stuart', *Nathan Coley*, Mount Stuart Trust, Isle of Bute, 2006, pp.12–13).

Questions of authority – namely of the rival religious and secular claims to public space – are differently posed by a strident, illuminated text, *There Will Be No Miracles Here*, installed on scaffolding in Mount Bute's romantic, eighteenth-century landscaped grounds. Placed in view of the Burges Chapel (a basilica commissioned by the devout Catholic and medievalist John Patrick Crichton-Stuart

Nathan Coley
*Camouflage Church,
Camouflage Synagogue,
Camouflage Mosque*
2006

Nathan Coley
*There Will Be No
Miracles Here* 2006

(1847–1900), 3rd Marquess of Bute), the text's seemingly unequivocal denial of the power of God refers to a historical anecdote concerning the French village of Modseine in Haute Savoie, purportedly the site of many miracles. A notice bearing the text was erected there in the seventeenth century by order of the king, suggesting that temporal law regards itself as capable of controlling even God's actions. Yet, in this setting, the intended meaning of the text remains ambiguous, as much an expression of the rationalist's right to be free from superstition as an indictment of the absolute power of the state (ibid., pp.14–16).

As part of his exhibition, Coley engineered the first public display of a small, highly charged object, the silver casket that carried the heart of the 3rd Marquess of Bute to the Holy Land, where it was buried on the Mount of Olives in accordance with his dying wish. The quiet disclosure of one man's fervent conviction, seen in conjunction with Coley's other exhibits, highlights the tensions between faith and reason that continue to shape our environment, and our lives.

Mike Nelson

Since the late 1990s, Mike Nelson has realised large-scale, labyrinthine, architectural installations that transform the spaces they inhabit into open-ended scenarios for the viewer to investigate. Influenced by the specific context of the site, layers of literary and cinematic sources, and using meticulously assembled found materials and artefacts, Nelson immerses the viewer in convincing, often disquieting environments – abandoned hotel rooms or offices, places of refuge or retreat – that in the broadest sense raise questions about society's belief systems.

Typically, Nelson allows viewers to find their own way through the space – physically, psychologically and metaphorically. As Jeremy Millar has noted, Nelson's installations are frequently constructed as a 'series of baffles', of confusing doors and corridors, often leading to transitory spaces such as foyers or ante-chambers, places we might pass through on our way to somewhere else. 'The transitional space', Millar concludes, 'allows for seemingly

Mike Nelson
1967 Born in
Loughborough
1986–90 Reading
University
1992–3 Chelsea
College of Art and
Design, London

opposing elements to be maintained without any form of simplistic resolution or synthesis' (Millar, 'Ordo Ab Chao', *Mike Nelson: Triple Bluff Canyon*, Modern Art Oxford, 2004, unpag.). The awkward, clandestine quality of these spaces, which place the visitor in the role of detective or intruder in some hidden world, seems to work against the current emphasis on 'access' as a marker of artistic success (see Richard Grayson, 'In A Secret Service', *A Secret Service: Art, Compulsion, Concealment*, exh. cat., Hayward Gallery Touring, 2006, p.13).

A number of Nelson's recent works have engaged directly with the interpretative context of the art spaces and galleries in which they are sited. For example, when shortlisted for the Turner Prize in 2001, his installation *The Cosmic Legend of the Uroboros Serpent* was hidden in a storeroom at Tate Britain, perhaps parodying the collection, classification and interpretation of artists and their work by museums. Another work, made for the São Paulo Biennale in 2004, comprised a perfect extension of the curved white spaces of the exhibition, in which intrepid visitors could discover concealed areas containing evidence of rituals performed by a people long since departed. Typically, despite the elaborate plausibility of Nelson's imaginary *mise-en-scène*, the viewer, cast in the role of archaeologist, was left to piece together clues (see Grayson, pp.19–20).

More recently for *Mirror Infill* (2006), commissioned by Frieze Art Projects at London's high-profile, international Frieze Art Fair, Nelson secreted an imaginary, parallel environment in the heart of the commercial gallery space, presenting a palpable and conceptual counterpoint to the mechanisms of an art fair, where the commodity value of art is exposed in its rawest state. Entry to the installation through one of three unmarked doors situated between gallery booths was almost serendipitous, at odds with the ready availability of art works typified by commercial gallery showrooms.

In utter contrast to the brightly-lit, well-heeled social setting of the art fair, Nelson's series of deserted, claustrophobic rooms and corridors conjured up a dingy photographer's darkroom. Furnished with aged and worn

fittings, and smelling authentically of photographic chemicals, the installation seemed to offer a Dorian Gray-like reflection of the world outside. Hanging from the ceiling in rows were hundreds of pictures documenting the building of the fair in Regent's Park, representing a kind of triumph of culture over nature. Nelson has commented: 'As a phenomenon the art fair is interesting – things are taken from their habitats, displayed and jumbled in a new purpose-built home to be consumed in every sense and elevated to another tier of mythology. It was a long time before I could think of an appropriate work, something which both adored and abhorred in equal parts, to become as a mirror held up and to expand the vacuum beyond. There also seemed to be an urgency to the project, as if there was a limited period in which outdated darkroom technology could speak of memory and reflection without being quaint' ('Mike Nelson: *Mirror Infill*', www.friezeartfair.com).

Occasionally, themes, narratives or fictional characters in Nelson's work resurface in a new guise, allowing the artist to reveal – if only metaphorically – an underlying critique of his own work, and perhaps to suggest a way forward. In *ANMESIAC SHRINE or Double coop displacement* (2006), commissioned by Matt's Gallery, Nelson revisited an imaginary biker gang, the Amnesiacs, through whom in the mid-1990s he created a new world derived from a splintered image of their own (and his) past, as a means of coming to terms with loss. Here, the Amnesiacs help him to build a shrine. But as the title suggests, their scrambled memories interchange personal history and received imagery. As the gallery's press release concludes: 'Selecting and mixing motifs in the same way that a voodoo shrine might co-opt an everyday object and elevate it to a new totemic status the Amnesiacs attempt to offer a devotional alternative to the artist within the cul-de-sac they perceive he is in' ('Mike Nelson: *ANMESIAC SHRINE or Double coop displacement*', www.mattsgallery.org).

The idea of a dead-end or trap is perhaps enhanced by the work's formal reference to Bruce Nauman's *Double Steel Cage* (1974), a sculptural installation

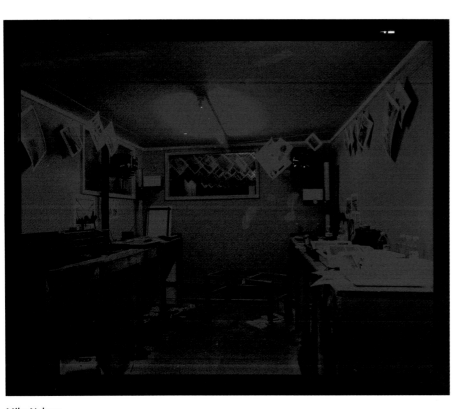

Mike Nelson
Mirror Infill 2006

Mike Nelson
AMNESIAC SHRINE or Double coop displacement (detail) 2006

sandwiching viewers in a corridor between an outer and inner mesh cage, which in the context of Nauman's oeuvre might be interpreted as a playing out of the limitations that artists face when making their work. A network of passages and doors leading off a number of small triangular spaces, *ANMESIAC SHRINE* – made from chicken wire and wooden frames – was unusually transparent. However, the viewer's journey through the installation remained deceptively – even frustratingly – complex, with false doors and dead-ends impeding any direct route. Yet, eventually, a way out is discovered.

More information about Nelson's work can be found under 2001 (see pp. 180–1).

Mark Wallinger

Perhaps the most striking aspect of Mark Wallinger's work is its sheer inventiveness and visual ingenuity. Since the mid-1980s, he has made work in a diverse range of media, including painting, drawing, video, photography, sculpture, installation and appropriated objects – most spectacularly a race horse named *A Real Work of Art*. Avoiding a signature style, Wallinger has explored such themes as identity, spirituality and death, often using irony or humour to engage the viewer. His work characteristically holds in balance a richness of content with a critique of the formal tools of representation.

Although it stems from personal interests and is informed by an enquiring moral and political conscience, the meanings of Wallinger's work remain elusive and open-ended. Adopting a critical position that aligns him in the widest sense to traditions of 'reasoning' and 'generous scepticism', the artist has commented: 'As soon as art becomes didactic, I'm not interested. I'm more interested in art that is genuinely ambiguous, in which the preconceptions of the viewer are imperilled' (Ian Hunt, 'Protesting Innocence', *Mark Wallinger: Credo*, exh. cat., Tate Liverpool, 2000, p.17; the artist, quoted by Lewis Biggs, ibid., p.11).

In the mid-1990s, following his acclaimed series of works exploring the social structure and practice of that very English obsession – horse racing – Wallinger began to produce a number of

Mark Wallinger
1959 Born in Chigwell, Essex
1977–8 Loughton College
1978–81 Chelsea School of Art, London
1983–5 Goldsmiths College of Art, London

works in which reversal is used as a destabilising device, throwing perceptions and beliefs into question. In a series of videos, *Angel* (1997), *Hymn* (1997) and *Prometheus* (1999), known as the *Speaking in Tongues* trilogy, the artist explored the limits of perception through the theme of religious belief.

In a significant public sculpture of 1999 he combined his interest in transcendental themes with earlier concerns about the relation of the individual to wider social and political structures. In situ from July 1999 to February 2000, *Ecce Homo* (Behold the Man) was the artist's contribution to a series of sculptures commissioned to occupy the fourth plinth on the north-west corner of Trafalgar Square. It captured the nation's imagination. Cast from a real man, this life-size white marble-resin sculpture representing Christ interprets the moment from St John's Gospel when Jesus – persecuted victim and political prisoner – was held up before the crowd to decide his fate. Wallinger's manifestation of an ordinary man facing death, yet possibly on the threshold of immortality, might be seen as embodying a question mark over the power and legitimacy of all permanent public art, which represents values that aspire to endure forever (see David Burrows, 'Beyond Belief: Mark Wallinger's *Ecce Homo*', *Mark Wallinger: Credo*, p. 36). Traditionally, Trafalgar Square has been a site for protest. Widely interpreted as a commentary on delusions of grandeur, for Wallinger, his anti-heroic Christ figure, dwarfed by surrounding statues of generals and other symbols of state and nation, and poised on the edge of the plinth in the direction of Whitehall, was a reminder that: 'Democracy is about the right of minorities to have free expression, not the majority to browbeat and marginalise' (quoted by Hunt, p.16).

For his first major project in London since *Ecce Homo*, the artist further explored the theme of public freedom in a controversial installation, *State Britain* (2007). In June 2001, peace campaigner Brian Haw began an ongoing protest opposite the Palace of Westminster against the economic sanctions on Iraq. Most of his shambolic and highly distressing protest, comprising banners, photographs of horrifically maimed Iraqi babies and children, peace flags, hand-painted placards, bedraggled teddy-bears and dolls, as well as contributions from members of the public, was removed by police in May 2006, following the introduction of the Serious Organised Crime and Police Act forbidding unauthorised demonstrations within a one-kilometre radius of Parliament Square.

With the help of assistants, Wallinger painstakingly and convincingly replicated, in its entirety, Haw's original forty metre-long Parliament Square protest for exhibition at Tate Britain, siting it along the Duveen galleries, the cavernous central spine of the gallery. A black tape running across the floor of the galleries represented the line of the exclusion zone, which if interpreted literally would bisect the building, placing one half of Tate Britain inside the zone. Although the Act does not apply to the contents of Tate Britain, Wallinger's provocative line made the implications of the law tangible.

As a political and moral commentary, the raw material of Haw's protest enabled Wallinger to create a modern-day version of the kind of grand-scale, contemporary history painting espoused by such nineteenth-century artists as Théodore Géricualt. *State Britain* also brings to mind the spirit of radical dissent epitomised by William Blake, who believed that individual conscience was judged not by law, but by a higher power (see Clarrie Wallis, *Mark Wallinger: State Britain*, exh. broadsheet, Tate Britain, 2007, unpag.). As Richard Grayson suggests, by representing Haw's moral outrage, fuelled by faith and religious conviction, Wallinger raises serious questions about 'how politics can function in a post-ideological world' (Grayson, 'Mark Wallinger: Tate Britain', *Art Monthly*, no.304, March 2007, p.27).

Perhaps alluding ironically to the radical-chic style of contemporary 'protest' art, implicit in *State Britain* is a critique of the power of art and its institutions to maintain otherwise eroding freedoms. As Adrian Searle concludes: 'What *State Britain* offers is a sort of portrait of British institutions at a time of war, of the lip service government pays to dissent, on the attacks being made on our freedoms in the name of security, on the impotence of protest and of art itself as a form of

protest. How rich this work is, how saddening our state' (Searle, 'Bears against bombs', *Guardian*, 16 January 2007, http://arts. guardian.co.uk/ features, pp.1–6, pp.5–6).

Wallinger's deceptively simple act of reconstruction and relocation deftly draws attention to issues surrounding the curtailment of civil liberties in Britain today. By exploiting the gallery as a public space – in all senses – he invites the public to take note of matters that should be of concern to us all.

More information on Wallinger can be found under 1995 (see pp.122–3).

Mark Wallinger
State Britain 2007

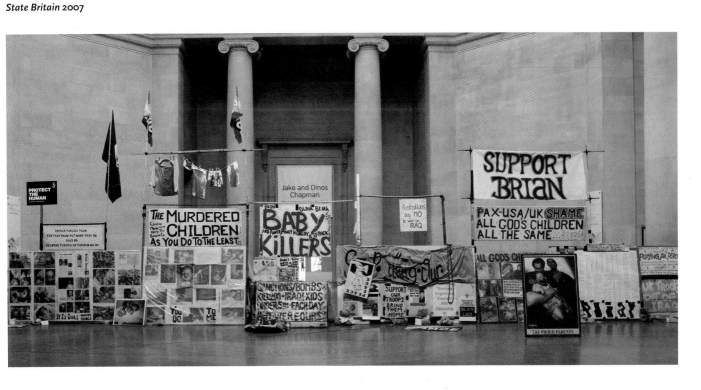

Rikki Blue
Brian Haw in Parliament Square
2007

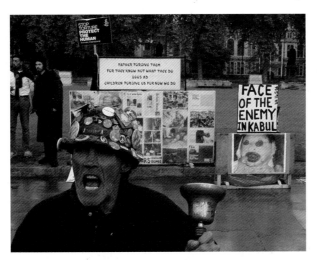

Darren Almond
p.216 Richard Dawson
p.217 the artist;

Art & Language
p.50 Charles Harrison;
p.51 Lisson Gallery,
London

Kutlag Ataman
p.206 Eamonn
McCabe; p.207 the
artist

Terry Atkinson
p.40 Tate; p.41 Gimpel
Fils, London

Gillian Ayres
p.74 the artist;
p.75 Prudence
Cuming Associates,
courtesy Gimpel Fils
Ltd, London

Fiona Banner
p.186 Emma
Summerton;
p.187 Tate
Photography/
Joanna Fernandes

Zarina Bhimji
p.233 Zarina Bhimji.
DACS, London 2007,
courtesy Haunch of
Vension
p.234 Ian Berry/
Magnum Photos

Richard Billingham
p.176 Johnnie
Shand-Kydd;
p.177 Anthony
Reynolds Gallery,
London

Rikki Blue
p.239

Christine Borland
p.138 Gautier
Deblonde;
p.139 (top) Thorsten
Arendt and Christine
Dilger, courtesy Lisson
Gallery, London;
p.139 (bottom)
Jean Luc Fournier,
courtesy FRAC
Languedoc-Rousillon

Glenn Brown
p.166 Alan Smithee;
p.167 Tate

Angela Bulloch
p.140 Fiona Rae;
p.141 (top)
Fredrik Nilson;

p.141 (bottom)
André Morin

Victor Burgin
p.50–1 the artist

Gillian Carnegie
p.218 Tarran Burgess;
p.219 Dave Morgan;
p.219 the artist

Patrick Caulfield
p.60 Tate;
p.61 Prudence
Cuming Associates,
courtesy Waddington
Galleries/DACS

Helen Chadwick
p.60 Zelda Cheatle;
p.61 ICA, London

**Jake and Dinos
Chapman**
p.196 Anna Schori;
p.197 (top) Stephen
White;
p.197 (bottom) Tate
Photography/
Mark Heathcote,
Caroline Shuttle

Nathan Coley
p.235 the artist,
courtesy doggerfisher
and Haunch of
Venison

Hannah Collins
p.100 Antoni Bernad;
p.101 the artist

Phil Collins
p.227 J. Fernandes
and M. Heathcote/
Tate

Tony Cragg
pp.41–2, 66 Lisson
Gallery, London;
p.65 Tate

Martin Creed
p.173 Tate
Photography/
Joanna Fernandes;
p.174 Ingrid Swenson;
p.175 Cabinet, London

Ian Davenport
p.83 (top) Waddington
Galleries, London;
p.83 (bottom) and
p.84 Tate

Grenville Davey
p.89 Hugo
Glendinning,
courtesy Lisson
Gallery, London;

p.90 Chris Felber,
courtesy Lisson
Gallery, London

Richard Deacon
pp.34, 58 Tate;
p.35 British Council
Collection;
pp.57, 59 Lisson
Gallery, London

Tacita Dean
p.148 Andrew
Dunkley, Tate;
p.149 Frith Street
Gallery, London

Jeremy Deller
p.204 Alan Smithee;
p. 203, p. 205 (bottom)
Tate Photography;
p.205 (top)
Martin Jenkinson

Cathy de Monchaux
p.150 Hugo
Glendinning;
p.151 FXP, courtesy
of the artist

Willie Doherty
p.108 Marcella
Leith, Tate;
p.109 Edward
Woodman, courtesy
Matt's Gallery;
p.198 Courtesy the
artist, Matt's Gallery,
London and Alexander
and Bonin, New York;
p.199 John Riddy

Peter Doig
p.110 Marcella
Leith, Tate;
p.111 (top) Victoria
Miro Gallery;
p.111 (bottom) Tate

Tracey Emin
p.156 (bottom)
Johnnie Shand-Kydd;
p.155 (top) Tate
Photography/Mark
Heathcote;
p.157 (bottom)
Lehmann Maupin,
New York;

Ian Hamilton Finlay
p.42 Tate;
p.43 the artist

Lucian Freud
p.67 The Bridgeman
Art Library;
p.77 Tate

Anya Gallaccio
p.200 Gautier
Deblonde;
p.201 (top)
Steve White;
p.201 (bottom) Tate
Photography/
Mark Heathcote,
Caroline Shuttle

Gilbert and George
pp.34, 48 Nigel
Maudsley, courtesy
Anthony d'Offay
Gallery, London;
p.35, cover Tate
p.49 Anthony d'Offay
Gallery, London

Liam Gillick
p.188 Andrea
Stappent;
p.189 (top) Tate
Photography/
Joanna Fernandes;
p.189 (bottom)
Whitechapel Art
Gallery, London

Douglas Gordon
cover, pp.125, 127
Stephen White,
courtesy Lisson
Gallery, London;
p.126 Simon Starling

Antony Gormley
cover, pp.106–7
Marcus Leith, Tate

Richard Hamilton
pp.66–7 Courtesy
Anthony d'Offay
Gallery/DACS

Mona Hatoum
p.118 Tate; p.119
Musée national d'art
moderne, Centre
Georges Pompidou

Damien Hirst
cover, pp.91, 115, 117
Courtesy Jay Jopling,
London;
pp.92, 116 Stephen
Lovell-Davis

Howard Hodgkin
pp.36, 40 Tate; cover,
pp.37, 39, 41 Anthony
d'Offay Gallery

List of Illustrated Works

Tomma Abts
Heeso 2004
Acrylic and oil on canvas
43 × 38 cm
Goetz Collection, Munich, *225*

Mino 2006
Acrylic and oil on canvas
43 × 38 cm
Jill and Peter Kraus, *223*

Teete 2003
Acrylic and oil on canvas
43 × 38 cm
Carnegie Museum of Art, Pittsburgh; A.W. Mellon Acquisition Endowment Fund, cover, *225*

Darren Almond
If I Had You 2003
Four-part film installation
Dimensions variable
Originally commissioned and produced by Fondazione Nicola Trussardi, Milan
Courtesy the artist, Jay Jopling/White Cube, London, Matthew Marks Gallery, New York and Galerie Max Hetzler, Berlin *217*

Until MMXLI.II 2002
C-print
80 × 80 cm
Courtesy of the artist, Jay Jopling/White Cube (London), *217*

Art & Language
Incident in a Museum, Madison Avenue 1986
Oil and mixed media on plywood on oil and mixed media on plywood
243.8 × 379.7 cm
The artist, *51*

Kutlug Ataman
Stills from *Twelve* 2003
Six-screen video installation, each approximately 1 hour
Courtesy of the artist and Lehmann Maupin Gallery, New York, *207*

Terry Atkinson
Art for the Bunker 4: The Stone Touchers 1 Ruby and Amber in the Gardens of their Old Empire History Dressed Men 1985
Acrylic on board
120.7 × 90.2 cm
The artist, courtesy of Gimpel Fils, London, *41*

Gillian Ayres
Dido and Aeneas 1988
Oil on canvas
274 × 305 cm
Gimpel Fils Ltd, London, *75*

Fiona Banner
Turner Prize Installation, *187*

Zarina Bhimji
Forgotten Us 2006
Ilfochrome Ciba Classic Print
127 × 160 cm
Courtesy Haunch of Venison, *233*

This Unhinged Her 2006
Ilfochrome Ciba Classic Print
127 × 160 cm
Courtesy Haunch of Venison, *233*

Richard Billingham
Tony Smoking Backwards 1998
Video projection
Dimensions variable
Courtesy the artist and Anthony Reynolds Gallery, London, *177*

Hedge 2001
Light jet colour print, mounted on aluminium
105.7 × 92.5 cm
Courtesy the artist and Anthony Reynolds Gallery, London, *177*

Christine Borland
The Dead Teach the Living 1997
Plastic, wood, text
Dimensions variable
The artist and Westfälisches Landesmusem, Münster, *139*

Phantom Twins 1997
Leather, sawdust, replica foetal skulls
Dimensions variable
Tate, *139*

Glenn Brown
The Marquess of Breadalbane 2000
Oil on panel
96 × 78.5 cm (oval)
Collection Rachel and Jean-Pierre Lehmann, New York, *167*

The Tragic Conversion of Salvador Dalí (after John Martin) 1998
Oil on canvas
222 × 323 cm
Private Collection, *167*

Angela Bulloch
Betaville 1994
Private Collection, *141*

Works in the *Vehicles* exhibition at Le Consortium, Dijon, 1997, *141*

Victor Burgin
Office at Night 1986
from a series of nine triptychs comprising black-and-white photographs and plastic film
182.8 × 243.8 cm
The artist, *51*

Gillian Carnegie
Fleurs d'Huile 2001
Oil on board
88 × 47 cm
Courtesy of Cabinet, *219*

Section 2005
Oil on linen
19.4 × 101.6 cm
Cranford Collection, London, *219*

Patrick Caulfield
Interior with a Picture 1985–6
Acrylic on canvas
205.7 × 243.9 cm
Tate Gallery, *61*

Helen Chadwick
Of Mutability 1986
Photocopies and assorted media
Dimensions variable
The Board of Trustees of the Victoria and Albert Museum, *61*

Jake and Dinos Chapman
Sex 2003
Cast bronze
246 × 244 × 125 cm
Courtesy of the artists and Jay Jopling/White Cube (London), *197*

Insult to Injury 2003
Francisco de Goya 'Disasters of War' Portfolio of eighty etchings reworked and improved
37 × 47 cm
Courtesy Jay Jopling/White Cube (London), *197*

Nathan Coley
Camouflage Church, Camouflage Synagogue, Camouflage Mosque 2006
Installation view, Mount Stuart, Isle of Bute
Courtesy doggerfisher and Haunch of Venison, *235*

There will be no Miracles Here 2006
Mount Stuart, Isle of Bute
Courtesy doggerfisher and Haunch of Venison, *235*

Hannah Collins
Signs of Life (section) 1992
Silver gelatin print mounted on linen
250 × 600 cm
The artist, *101*

The Truth 1993
Silver gelatin print mounted on cotton
166 × 130 cm
The artist, courtesy Gallery Joan Prats, *101*

Phil Collins
shady lane productions 2006
A production company and research office established at Tate Britain
Courtesy the artist, Kerling Gallery and Tanya Bonakdar Gallery, *227*

the return of the real / gercegin geri donusu 2005
Colour video installation with sound
Courtesy the artist, Kerling Gallery and Tanya Bonakdar Gallery, *227*

Tony Cragg
On the Savannah 1988
Bronze
225 × 400 × 300 cm
Tate Gallery, *65*

Still Life Belongings 1985
Mixed media
172 × 170 × 270 cm
Private Collection, USA, *43*

Martin Creed
Work No. 227: The lights going on and off 2000
Materials and dimensions variable
Courtesy the artist and Gavin Brown's enterprise, Corp., New York, *173*

Work No. 200: Half the air in a given space 1998
White twelve-inch balloons
Overall dimensions variable
Collection Pierre Huber, Geneva
Courtesy the artist and Analix Forever, Geneva, *175*

Ian Davenport
Untitled 1989
Household paint on
canvas
213.4 × 213.4 cm
Collection Lockhart,
83

Untitled (Drab) 1990
Oil on canvas
213.5 × 213.5 cm
Tate, *83*

Grenville Davey
HAL 1992
Two parts
Steel
244 × 122 cm each
Private Collection, *89*

Richard Deacon
Boys and Girls 1982
Vinyl and plywood
91 × 152 × 21.3 cm
British Council
Collection, *35*

Feast for the Eye
1986–7
Galvanised steel
with screws
100 × 80 × 350 cm
The artist, *57*

Fish out of Water 1987
Laminated hardboard
245 × 350 × 190 cm
Hirshhorn Museum
and Sculpture Garden,
Washington, *57*

*For Those Who Have
Ears No.1* 1983
Laminated wood and
galvanised steel
with rivets
366 × 152.5 × 229 cm
Prada Milano Arte,
Milan, *59*

Troubled Water 1987
Wood and galvanised
steel with rivets
and screws
310 × 100 × 140 cm
Private Collection,
London, *57*

Tacita Dean
Disappearance at Sea
1996
16 mm anamorphic
film
Dimensions variable
Tate, *149*

Gellért 1998
16 mm film
Dimensions variable
The artist, Frith Street
Gallery, London and
Marian Goodman
Gallery, New York, *149*

Jeremy Deller
Memory Bucket 2003
Video, 23 mins
Originally
commissioned by Art
Pace San Antonio
Courtesy the artist, Art
Concept, Paris and
The Modern Institute,
Glasgow, cover, *203*

The Battle of Orgreave
Film still
2001
Commissioned and
produced by Artangel,
205

*The History of the
World* 1997–2004
Wall painting
Courtesy the artist and
The Modern Institute,
Glasgow, *205*

Cathy de Monchaux
*Making a day for the
dead ones* 1997
Brass, copper, leather
and chalk
110 × 61 × 4 cm
Joel and Zoë Dictrow,
New York, courtesy
Sean Kelly Gallery,
New York, *151*

*Never forget the power
of tears* 1997
Lead, rusted steel,
leather and chalk
700 × 425 × 20 cm
Courtesy Sean Kelly
Gallery, New York, *151*

Willie Doherty
Border Incident 1993
Cibachrome print
mounted on
aluminium
122 × 183 cm
Matt's Gallery, *109*

*The Only Good One is
a Dead One* (detail)
1993
Double-screen video
projection with sound
Dimensions variable
Weltkunst Foundation,
109

Re-Run 2002
Video installation with
projection on two
screens (colour, thirty
seconds). First shown
XXV São Paulo
Biennial, Brazil 2002
Courtesy the artist,
Matt's Gallery, London
and Alexander and
Bonin, New York, *199*

Peter Doig
Cabin Essence 1993–4
Oil on canvas
230 × 360 cm
Private Collection, *111*

Ski Jacket 1994
Oil on canvas
295 × 351 cm
Tate, *111*

Tracey Emin
*Everyone I have Ever
Slept With 1963–95*
1995
Appliquéd tent,
matress and light
122 × 245 × 214 cm
Saatchi Collection,
London, *157*

Turner Prize
Installation 1999, *157*

Ian Hamilton Finlay
(with Nicholas Sloan)
*The Present Order
is the Disorder of the
Future* 1983
Stone
700 × 600 × 35 cm
The artist, *43*

Lucian Freud
Painter and Model
1986–7
Oil on canvas
159.6 × 120 cm
Private Collection, *67*

Standing by the Rags
1988–9
Oil on canvas
168 × 138 cm
Tate, *77*

Anya Gallaccio
because I could not stop
2002
Unique bronze cast
from an apple tree,
apples, rope
280 x 200 x 150 cm
Courtesy of the artist
and Lehmann Maupin
Gallery, New York;
Blum & Poe,
Los Angeles; Thomas
Dane Ltd, London and
Annet Gelnik Gallery,
Amsterdam, *201*

beat (installation view)
2002
Foreground: *As long
as there were any roads
to amnesia and
anaesthesia still to be
explored*
Seven felled oak trees
Courtesy Lehmann
Maupin, New York,
201

Gilbert and George
Coming 1983
242 × 202 cm
Anthony d'Offay
Gallery, London, *47*

Death Hope Life Fear
1984
Four panels, each
60.5 × 50.3 cm
Tate, *35, 49*

Liam Gillick
*Coats of Asbestos
Spangled with Mica*
2002
Anodised aluminium,
perspex
840 × 1680 cm
Courtesy Corvi-Mora,
London, *189*

The Wood Way 2002
Anodised aluminium,
perspex
dimensions
Installation at
Whitechapel Art
Gallery, London
Courtesy Corvi-Mora,
London, *189*

Douglas Gordon
*Confessions of a
Justified Sinner* 1995
Video installation,
two parts, each
300 × 400 cm
Fondation Cartier
pour l'art
contemporain, Paris,
cover, *127*

*Something Between My
Mouth and Your Ear*
1994
Cassette deck,
amplifier,
loudspeakers, blue
paint, light filters
Dimensions variable
Private Collection,
London, *125*

Antony Gormley
Testing a World View
(detail) 1993
Cast iron, five pieces,
each 112 × 47 × 118 cm
The artist and Jay
Jopling, London,
cover, *107*

Richard Hamilton
Lobby 1985–7
Oil on canvas
175 × 250 cm
Private Collection, *67*

Mona Hatoum
Corps étranger 1994
Video installation
350 × 300 × 300 cm
Musée national d'art
moderne, Centre
Georges Pompidou,
119

Light Sentence 1992
Mixed media
Dimensions variable
Musée national d'art
moderne, Centre
Georges Pompidou,
119

Damien Hirst
Amodiaquin 1993
Gloss household paint
on canvas
208.3 × 198.1 cm
Private Collection,
cover, *117*

The Asthmatic Escaped
1992
Mixed media
221 × 426.7 × 213.4
cm
Private Collection, *91*

*I Want You Because
I Can't Have You* 1992
MDF, melamine,
wood, steel, glass,
perspex cases, fish
and formaldehyde
solution
2 parts, each 121.9 ×
243.8 × 30.5 cm
Private Collection, *91*

*Mother and Child,
Divided* 1993
Steel, GRP
composites, glass,
silicone sealants, cow,
calf, formaldehyde
solution
Dimensions variable
Astrup Fearnley
Museum, Oslo,
6, 115

Howard Hodgkin
Son et Lumière 1983–4
Oil on wood
66.7 × 74.3 cm
Private Collection, 37

*A Small Thing But
My Own* 1983–5
Oil on wood
44.5 × 53.5 cm
Private Collection,
cover, 39

Still Life 1982–4
Oil on wood
32.1 × 34 cm
Private Collection, 41

Craigie Horsfield
*Carrer Muntaner,
Barcelona, Març 1996*
1996
Unique photograph
265.7 × 263 cm
The Saatchi
Collection, 129

*Pau Todó i Marga Moll,
carrer Muntaner,
Barcelona, Març 1996*
1996
Unique photograph
140 × 136.3 cm
The artist and Frith
Street Gallery,
London, 129

Shirazeh Houshiary
*The Enclosure of
Sanctity* 1992–3
Lead, copper, silver
leaf and gold leaf,
five parts, each
100 × 100 × 100 cm
Tate Gallery, 113

Gary Hume
Whistler 1996
Enamel on paint on
aluminium panel
210 × 160.5 cm
Private Collection, 131

*Innocence and
Stupidity* 1996
Gloss paint on
aluminium panel,
two panels, each
170 × 221 cm
Bonnefantenmuseum,
Maastricht, 131

Callum Innes
*Exposed Painting,
Cadmium Orange* 1995
Oil on canvas
110 × 100 cm
Frith Street Gallery,
London; Collection
Harry Handelsman,
121

Monologue 1994
Oil on canvas
210 × 190 cm
Kunsthaus Zurich, 121

Derek Jarman
*Michael Gough as
St Jerome* 1986
Film tableau after
Caravaggio's *St Jerome
in his Study*, 53

Isaac Julien
Vagabondia 2000
Video installation
Dimensions variable
Collection of Carlos
and Rosa de la Cruz
Courtesy Victoria Miro
Gallery, London
Originally
commissioned by
Hans-Ulrich Obrist
with support from
Carlos and Rosa de la
Cruz and Film and
Video Umbrella, 179

*Untitled (from
Mazatlan)* 2001
Lightbox
51.5 × 39 × 12.5 cm
*The Long Road to
Mazatlan* 1999
Collaboration Isaac
Julien and Javier de
Frutos
Director: Isaac Julien
Choreography,
movement material:
Javier de Frutos
Courtesy Victoria
Miro Gallery, London,
179

Anish Kapoor
Void Field 1989
Sandstone and
pigment
Dimensions variable
The artist and the
Lisson Gallery, 81

Jim Lambie
The Kinks 2005
Mixed media
installation
Courtesy the artist,
The Modern Institute,
Glasgow, Sadie Coles
HQ, London and
Anton Kern Gallery,
New York, 221

Zobop 2003
Installation view, *Days
Like These: Tate
Triennial*, Tate Britain,
London
Tate
Courtesy The Modern
Institute, Glasgow, 221

Langlands & Bell
*The House of Osama
bin Laden* 2003
Screen shot from
interactive animation
Courtesy the artists
and V/Space LAB,
209

Zardad's Dog 2003
Screen shot from
substitute projection
2004
Courtesy the artists,
209

Richard Long
Chalk Line 1984
71 × 1028 cm
The artist, courtesy
Anthony d'Offay
Gallery, London, 37

Red Walk 1986
Printed text (red)
158 × 109 cm
Anthony d'Offay
Gallery, London, 63

Untitled 1988
River Avon mud on
paper 50.8 × 39.1 cm
Anthony d'Offay
Gallery, London, 69

White Water Line 1990
China clay and water
solution
Installed at Tate
Gallery, London
3 October 1990–6
January 1991, cover, 73

Stephen McKenna
*Clio Observing the Fifth
Style* 1985
Oil on canvas
200 × 280 cm
Private Collection, 53

Steve McQueen
Deadpan 1997
16 mm black and
white film, video
transfer, silent
4 min 30 sec
The artist, courtesy
Anthony Reynolds
Gallery, London and
Marian Goodman
Gallery, New York, 155

Drumroll 1998
Colour video
projection, triptych,
with sound
22 min 1 sec
The artist, courtesy
Anthony Reynolds
Gallery, London and
Marian Goodman
Gallery, New York,
155

David Mach
101 Dalmatians
101 plaster dogs and
assorted household
objects
Dimensions variable
Temporary installation
at the Tate Gallery
14–28 March 1988, 69

Malcolm Morley
*Day Fishing in
Heraklion* 1983
Oil on canvas
203.2 × 238.8 cm
Courtesy the artist and
Sperone Westwater, 33

Mike Nelson
The Cosmic Legend of the Uroboros Serpent
2001
Mixed media installation
Dimensions variable
Courtesy the artist and Matt's Gallery, London, *181*

Mirror Infill 2006
Installation view
Commissioned and produced by Frieze projects
Courtesy the artist and Matt's Gallery, London, *237*

AMNESIAC SHRINE or Double Coop displacement (detail)
2006
Installation view, Matt's gallery
Courtesy the artist and Matt's Gallery, London, *237*

Chris Ofili
The Adoration of Captain Shit and the Legend of the Black Stars (Part 2) 1998
Acrylic, oil, resin, paper collage, glitter, map pins and elephant dung on canvas with two dung supports
243.8 × 182.8 cm
Warren and Victoria Miro, *147*

Afrodizzia (2nd Version) 1996
Acrylic, oil, resin, paper collage, glitter, map pins and elephant dung on canvas with two dung supports
243.8 × 182.8 cm
Courtesy Chris Ofili – Afroco and Victoria Miro Gallery, cover, *145*

No Woman, No Cry 1998
Acrylic paint, oil paint, polyester resin, paper collage, map pins, elephant dung on canvas
243.8 × 182.8 cm
Victoria Miro Gallery, *147*

Thérèse Oulton
Pearl One 1987
Oil on canvas
238.8 × 213.4 cm
Marlborough Fine Art (London) Ltd, *63*

Cornelia Parker
Mass (Colder Darker Matter) 1997
Charcoal retrieved from a church struck by lightning, Lytle, Texas, USA
366 × 320 × 320 cm
The artist and Frith Street Gallery, London, *143*

Twenty Years of Tarnish (wedding presents)
1996
Two silver-plated goblets, each
13 × 6.5 × 6.5 cm
The artist and Frith Street Gallery, London, *143*

Simon Patterson
The Great Bear 1992
Lithograph on paper
108.5 × 134 cm
Tate, *133*

Untitled 1996
Dacron, aluminium, steel and mixed media, three parts, each
550 × 380 × 272 cm
Lisson Gallery, *133*

Grayson Perry
Boring Cool People
1999
Earthenware
63.2 × 26.8 × 26.8 cm
Courtesy Victoria Miro Gallery, London, *195*

Golden Ghosts 2001
Earthenware
63.2 × 26.8 × 26.8 cm
Courtesy Victoria Miro Gallery, London, *193*

Coming Out Dress
2000
Cotton and Rayon
250 × 250 cm
Collection of the artist. Original dress commissioned by the Contemporary Art Society Special Collection Scheme on behalf of Nottingham Castle Museum and Art Gallery, with funds from the Arts Council Lottery, *193*

Vong Phaophanit
Litterae Lucentes 1993
Nine Laotian words in red neon on
50 × 4.5 m wall
installed at Killerton Park, Exeter, Devon, *103*

Neon Rice Field 1993
Neon and rice
1500 × 500 cm
The artist *14*, *103*

Steven Pippin
The Continued Saga of an Amateur Photographer 1993
Photographs and video
Each photograph
50.6 × 8.1 cm
Tate, *159*

Laundromat-Locomotion (Horse & Rider) 1997
Twelve black and white photographs
76.2 × 76.2 cm
The artist and Gavin Brown's enterprise, New York, *159*

Fiona Rae
Untitled (yellow) 1990
Oil on canvas
213.3 × 198.1 cm
Tate, *85*

Untitled (yellow and black) 1991
Oil and charcoal on linen 213.4 × 182.9 cm
Collection the artist, courtesy Waddington Galleries, *85*

Michael Raedecker
echo 2000
Oil, acrylic and thread on canvas
254 × 198 cm
Courtesy Andrea Rosen Gallery, New York, *169*

ins and outs 2000
Acrylic and thread on canvas
203 × 152 cm
Courtesy The Approach, London, *169*

Paula Rego
The Maids 1987
Acrylic on canvas backed paper
213.4 × 243.9 cm
The Saatchi Collection, London, *77*

Sean Scully
Paul 1984
Oil on three canvases
259 × 320 × 24 cm
Tate, *79*

White Window 1988
Oil on canvas
245.5 × 372.5 cm
Tate, *105*

Yinka Shonibare
Un Ballo in Maschera (A Masked Ball) 2004
High definition digital video, 32 min loop
Courtesy of Stephen Friedman Gallery, London, *211*

The Swing (after Fragonard) 2001
Dutch wax printed cotton textile, life-size mannequin, swing and artificial foliage
330 × 350 × 220
Tate. Purchased 2001, *211*

Simon Starling
Tabernas Desert Run
2004
Lamda print
76.9 × 103.4 × 4.7 cm
Courtesy the artist and The Modern Institute, Glasgow, *215*

Shedboatshed (Mobile Architecture No.2), Production Stills, Basel, Switzerland 2005
Mixed media
Courtesy the artist and neugerriemschneider, Berlin, *215*

Shedboatshed (Mobile Architecture No.2) 2005
Mixed media
400 × 600 × 600 cm
Kuntsmuseum Basel, Turner Prize Installation, cover, *213*

Tomoko Takahashi
Learning How to Drive
2000
Mixed media installation
Courtesy the artist and Hales Gallery, *171*

Sam Taylor-Wood
Atlantic 1997
Three-screen laser disc projection with sound, shot on 16mm film
Dimensions variable
The artist and Jay Jopling, London, *153*

Five Revolutionary Seconds XI (detail)
1997
Colour photograph on vinyl with CD
72 × 757 cm
Rebecca and Alexander Stewart, Seattle, WA, *153*

Wolfgang Tillmans
I don't want to get over you 2000
Inkjet colour print
366 × 301 cm
Courtesy the artist and MaureenPaley, London, *163*

Turner Prize installation shots, 2000
A Selection of Photographs
Courtesy the artist and MaureenPaley, London, *165*

Mark Titchner
Ergo Ergot 2006
Wood, steel, motors, electrical and mechanical components, DVD loop, monitors and speakers
Courtesy the artist and Vilma Gold, London, *229*

How to Change Behaviour (Tiny Masters of the World Come out) (detail)
2006
Digital print, wood, paint, metal, magnets, electrical components, quartz crystals
Comissioned by Arnolfini with support from the Elephant Trust
The Saatchi Gallery, London, *229*

David Tremlett
Walls and Floors 1992
Wall drawing, pastel and masking tape
487.5 × 888 cm
Courtesy Hester van Royen, *93*

Wall Drawings at Abbaye de St Savin, France 1991, *93*

Keith Tyson
Bubble Chambers: 2 Discrete Molecules of Simultaneity 2002
Mixed media on aluminium
Two panels, each 305 × 305 cm (framed)
Collection Norman and Norah Stone, San Francisco, Courtesy Thea Westreich Art Advisory Services, cover, *185*

Turner Prize Installation 2002, *183*

John Walker
Form and Sepik Mask 1984
Oil on canvas
243.8 × 152.4 cm
The artist, *45*

Mark Wallinger
Brown's 1993
from the series of 42 works
Oil on linen, each 110 × 110 cm
The Artist, courtesy of Anthony Reynolds Gallery, London
Installed at the Tate Gallery 1 November–3 December 1995, *123*

Half-Brother (Exit to Nowhere/ Machiavellian) 1994–5
Oil on canvas
230 × 300 cm
Tate, *123*

State Britain 2007
Mixed media
Installation view at Tate Britain
4000 cm,
239

Rebecca Warren
2001, 2002, 2003, 2004 or 2005
2006
Mixed media vitrine
42.5 × 137.8 × 28.6 cm
Courtesy Maureen Paley, London, *231*

The Garden of My Spouse I
2006
Reinforced clay, MDF plinth
87 × 71. × 79 cm
Courtesy Maureen Paley, London, *231*

Gillian Wearing
Sacha and Mum 1996
Single channel video artwork in colour with sound
Tate, *137*

60 Minutes Silence
1996
Video projection in colour with sound
Dimensions variable
Arts Council Collection, Hayward Gallery, cover, *135*

10–16 1997
Single channel video artwork in colour with sound
Tate, *137*

Boyd Webb
Pupa Rumba Samba
1986
unique colour photograph
123 × 154 cm
William College Museum of Art, Mass., *71*

Rachel Whiteread
Ghost 1990
Plaster on steel frame
269 × 355.5 × 317.5 cm
The Saatchi Collection, London,
99

House 1993
Commissioned by Artangel Trust and Beck's (corner of Grove Road and Roman Road, London E3, destroyed 1994), cover, *97*

Untitled (Amber Bed)
1991
Rubber
129.5 × 91.4 × 101.6 cm approx.
Fundació "la Caixa", Barcelona, *87*

Untitled (Sink) 1990
Plaster
107 × 101 × 86.5 cm
The Saatchi Collection, London, *87*

Alison Wilding
Assembly 1991
Steel and PVC
123 × 174 × 547 cm
Private Collection,
95

Red Skies 1992
Patinated mild steel, acrylic, brass and bronze
217 × 99 × 86 cm
Private Collection,
95

Stormy Weather 1987
Galvanised steel, oil paint and bronze
225 × 115 × 170 cm
Weltkunst Foundation, *71*

Jane and Louise Wilson
High Roller Slots, Caesar's Palace 1999
C-type print mounted on aluminium
180 × 180 cm
Lisson Gallery, London, *161*

Stasi City 1997
Two double wall projections, two sculptures and a series of photographic stills
Dimensions variable
Lisson Gallery, London, *161*

Richard Wilson
Sea Level 1989
Galvanised steel grilling, sheet steel and gas-fired space heater
Dimensions variable
Arnolfini Gallery, Bristol, *79*

20:50 1987
Used sump oil and steel
Dimensions variable
The Saatchi Collection, London, *71*

Bill Woodrow
Self Portrait in the Nuclear Age 1986
Shelving unit, wall map, coat, globe and acrylic paint
205 × 145 × 265 cm
Cordiant PLC, *55*

Catherine Yass
Corridor: Chaplaincy
1994
Transparency, lightbox
89 × 72.5 × 14 cm
Private Collection, Zurich, *191*

Descent: HQ5: 1/4s, 4.7˚, 0mm, 40 mph
2002
Ilfochrome transparency, lightbox
164 × 129 × 12.5 cm
Courtesy aspreyjacques, London, *191*